The Disappearing Christ

The Disappearing Christ

Secularism in the Silent Era

Phillip Maciak

Columbia University Press

New York

Columbia University Press
Publishers Since 1893
New York Chichester, West Sussex
cup.columbia.edu

Copyright © 2019 Columbia University Press
All rights reserved

Library of Congress Cataloging-in-Publication Data
Names: Maciak, Phillip, author.
Title: The disappearing Christ : secularism in the silent era / Phillip Maciak.
Description: First Edition. | New York : Columbia University Press, 2019. |
Includes bibliographical references and index.
Identifiers: LCCN 2018060752 (print) | LCCN 2019015861 (e-book) |
ISBN 9780231547000 (e-book) | ISBN 9780231187084 (hardcover) | ISBN
9780231187091 (trade paperback)
Subjects: LCSH: Jesus Christ—In motion pictures. | Silent films—History
and criticism.
Classification: LCC PN1995.9.J4 (e-book) | LCC PN1995.9.J4 M33 2019 (print) |
DDC 791.43/651—dc23
LC record available at https://lccn.loc.gov/2018060752

Cover design: Chang Jae Lee
Cover photo: *The Life and Passion of Jesus Christ*
(Ferdinand Zecca, 1907).
Courtesy of the Library of Congress.

TO my parents
FOR Melanie and Maeve

Contents

Acknowledgments ix

Introduction // The Disappearing Christ and Other Stories 1
 Overture: Anno Domini 1959 1
 The Historical Jesus in Broad Daylight 7
 Unseen Somethings: American Studies and Postsecular Critique 11
 Things Normally Unseen: Film Studies and Postsecular Critique 17
 Outline of the Book 24

1. A Rare and Wonderful Sight: *Ben-Hur*'s Historicism 28
 Holy Land Disappointment: Prescott, Stephens, Melville 32
 Never Long Invisible: *Ben-Hur's* Eyewitness Narrative 42
 Garfield Minus Jesus: *Ben-Hur* in Pictures 52

2. Looking Sideways: Media Theories of Jesus Christ 55
 Media Theories of Secularism 60
 A New Medium: Elizabeth Stuart Phelps 66
 The Christ Selfie: F. Holland Day 83

3. Tricks and Actualities: The Passion Play Film and the Cinema of Attractions 98

St. John in Shirtsleeves: The Passion Play Before Film 100

Spectacular Realism: Between Tricks and Actualities 104

The Rickety Platform and the Elegant Dissolve: Tricks and the Passion Play 108

The Passion of Gene Gauntier: Actualities and the Passion Play 122

The Passion Play Film in Transition 130

4. The Double Life of Superimposition: W.E.B. Du Bois's Black Christ Cycle 134

Double Consciousness and the Cinema of Attractions 138

Fables of the Reconstruction: The Dunning School 145

D. W. Griffith's Alternative Facts 149

On Superimposition 157

Spectators at a Crucifixion: The Black Christ Cycle 159

Coda // Resurrectionists: Toward a Post-Cinematic Postsecular 176

The Resurrection is in Technicolor: Cecil B. DeMille 178

The Resurrection is CGI: Mel Gibson 184

Post-Cinematic/Postsecular 189

The Resurrection is Straight to Video: Abbas Kiarostami 196

Notes 205

Bibliography 225

Index 235

Acknowledgments

As a ritual of both procrastination and hope, I've written dozens of drafts of this acknowledgments section over the past number of years, imagining the (hypothetical) satisfaction of thanking the many, many people who have been my friends and mentors along the way. But, for fear of jinxing the eventual publication, I've never saved one until now. This is just to say that, if you aren't in here, you were probably acknowledged in some ghost document several years ago, and, if you *are* in here, I probably did a better job of acknowledging you in a previous draft. So: thanks, and sorry.

Starting at the beginning, Alexis Amrhein Salerno, Julianne Petricini, Sr. Tonya Severin, and Bill Stringert taught me how to write and think with joy and skepticism. Judy Frank, Dale Peterson, and Stanley Rabinowitz taught me that scholarship is about conversation and that there was thus something deeply right about "conversational" writing done well. Still, this project properly started the day I met Eric Lott at the University of Virginia. Eric's wild enthusiasm for my early work on this subject is why I pursued it in the first place. I thank him for helping me to imagine what cultural studies could do, and I thank Jennifer Wicke for helping me figure out how I could do it. When I arrived at the University of Pennsylvania, I met the three women who became the greatest stewards, skeptics, and—ultimately—saviors of this project. I am grateful to Amy Kaplan for believing in me so completely, so immediately, and so matter-of-factly, for giving me plenty of second-chance swings, and for telling me that there are some things you can't and shouldn't write your way around; Nancy Bentley for being a radiant example of humanity in this profession; and Karen Redrobe, for the energy she put into pushing me toward the real questions these films were asking and the deep empathy she's shown me in the years since I sat in her office.

ACKNOWLEDGMENTS

It's a cliché to say that writing a book such as this is a collaborative effort, but it's a cliché, I suspect, because it's true. Over the past decade, I've been very lucky to work with and alongside a number of groups, and I think it's appropriate here to acknowledge, not just the people who've helped me, but the effort that goes into creating and sustaining communities like these. First, and most importantly, I can't begin to express an appropriate amount of gratitude to my friends, my Philadelphians, my graduate school writing group: Dave Alff, Rachel Banner, Ashley Cohen, Grace Lavery, Christen Mucher, and Chris Taylor. Thanks especially to Chris and Dave and Rachel who've done the invaluable work of bearing with me and the irreplaceable work of staying with me. I have also to thank the improbably kind collective of teachers and scholars that make up the University of Pennsylvania English department. I don't know what I ever did to earn the wisdom about the genres of work and life that has been imparted to me over the years by Jim English, Jed Esty, and Paul Saint-Amour. I thank them, and their (current and former) colleagues who showed me how to exist in relation to other thinkers while still being a person in the world: Thadious Davis, Michael Gamer, Tsitsi Jaji, David Kazanjian, Zachary Lesser, Heather Love, Jo Park, Salamishah Tillet, and Lance Wahlert, as well as the extraordinary enclave of Penn Cinema Studies, Tim Corrigan, Peter Decherney, Nicola Gentili, and Meta Mazaj. While in grad school, Greg Jackson and Sarah Rivett's Penn-Princeton-Rutgers secularism reading group helped me through *A Secular Age* for the first time, and Jarrett Anthony helped motivate me to get on the NJ Transit to New Brunswick every month with an enormous hardcover book in my bag.

After Penn, I was lucky enough to land in the famously collegial, if sweaty, environs of Louisiana State University's English department. I thank Chris Barrett, Kathryn Barton, Michael Bibler, Paolo Chirumbolo, Lauren Coats, Brannon Costello, Lara Glenum, Zack Godshall, Angeletta Gourdine, Benjy Kahan, Mari Kornhauser, Isiah Lavender III, Michelle Massé, John Miles, Rick Moreland, Laura Mullen, Emily Nemens, Lisi Oliver, Solimar Otero, Joshua Overbay, Mary Pappalardo, Pallavi Rastogi, Irina Shport, Trish Suchy, Sue Weinstein, Sharon Aronofsky Weltman, Sunny Yang, and Dustin Zemel for being such terrific friends and colleagues. I thank Chris Rovee for all the grilled oysters, and Joe and Paula and Katherine and Barton for Meatless Mondays. I especially want to thank Jim Catano, Elsie Michie, and Anna Nardo for being mentors and advocates always. In my first years on the job, I stumbled into the spectacular windfall that is the First Book Institute at Penn State's Center for American Literary Studies. I thank its great-hearted founders Sean X. Goudie and Priscilla Wald for imagining and then performing such an uncommonly grand gesture of generosity; Doug Guerra, Shaundra Myers, Jennifer Rhee, and Andrew Rippeon for their vision; Sarah Ensor for closing a bar with me

to talk about Eve Kosofsky Sedgwick and prayer; and Jesús Costantino and Tara Fickle for going rogue with me in the FBI Splinter Group. While bouncing back and forth between Louisiana and Missouri, I was also lucky to find my way into the Visual and Material Culture Seminar in the American Culture Studies Program at Washington University in Saint Louis; I thank Rachel Lindsey, Jasmine Jamillah Mahmoud, Vernon Mitchell Jr., Maire Murphy, Rhaisa Williams, and its coordinators Douglas Dowd and Heidi Aronson Kolk for creating and tending to such a uniquely generative intellectual community. For the past five years, I've hovered around the margins of Washington University, and I'm proud now to be a part of this community. I thank Guinn Batten, Pete Benson, Iver Bernstein, Dillon Brown, Colin Burnett, Pannill Camp, Danielle Dutton, Musa Gurnis, Long Le-Khac, Diane Wei Lewis, Bill Maxwell, Edward McPherson, Heather McPherson, Paige McGinley, Amber Jamillah Musser, Bill Paul, Vivian Pollak, Marty Riker, Jessica Rosenfeld, Wolfram Schmidgen, Vince Sherry, Brett Smith, Gaylyn Studlar, Abram Van Engen, Julia Walker, Rebecca Wanzo, and Rafia Zafar for their hospitality.

Finally, for the past seven years, I've had what my role model Hua Hsu calls a "moonlit side hustle" as a culture writer for public-facing outlets, in particular the *Los Angeles Review of Books*. Doing this has been, predictably, distracting, but it's also proven to be absolutely necessary to me as a writer, as a scholar, and as a person. So, I thank the Dear Television extended universe, for being my ideal readers: Aaron Bady, Jane Hu, Evan Kindley, Lili Loofbourow, Sarah Mesle, and Anne Helen Petersen. Though they aren't necessarily a group together, I want to thank all of the editors who've edited me in public, for showing me how to say what I want to say, not in a contrived public voice, but in my *own* voice, starting with Sal Cinquemani, Tom Lutz, Mike Goetzman, Chloe Schama, Nona Willis Aronowitz, Dan Kois, Evan Kindley, Sarah Mesle, and Sarah Blackwood.

Of course, this book has also benefited from a number of small individual acts of heroism in the form of quick asides, promptly answered emails, shared conspiracies, conference questions, lunches, and warnings. For those, I thank Tanine Allison, Camilla Ammirati, Peter Balaam, Marina Bilbija, Beth Blum, Edward Blum, Scott Bukatman, Mark Cauchi, Steven Choe, Ashley Cohen, Ann Douglas, Nava EtShalom, Ben Fagan, Meredith Farmer, Jonathan Fedors, Elizabeth Fenton, Lucy Fischer, James Fiumara, Julius Fleming, Oliver Gaycken, Isabel Geathers, Kristin Gilger, Sarah Hagelin, Lauren Heintz, Jared Hickman, Monica Huerta, Noah Isenberg, Aundeah Kearney, Greta LaFleur, Adam Lowenstein, Joanna Luloff, John Lardas Modern, Dana Nelson, Emily Ogden, Eden Osucha, Katie Price, Eric Rettberg, Molly Robey, Will Schmenner, Scott Selisker, Riley Snorton, Cheryl Spinner, Emma Stapely, Greg Steirer, Anu Thapa, Mary Titus, Rafael Walker, Omari Weekes, Lisa Woolfork, and Jason Zuzga. Special

thanks also to my friend, the Reverend Sarah Kooperkamp (and her dad Rev. Earl Kooperkamp) for taking me seriously when I wanted to talk about liberal theology, and for teaching me a great deal about justice, service, and friendship. Perhaps most crucially, this book has benefited from a number of rather large individual acts of heroism in the form of deep readings of long chapters. For those, I thank Warren Breckman, Jane Gaines, Jefferson Gatrall, Daniel Morgan, Barbara Therese Ryan, Benjamin Schreier, Milette Shamir, Rachel Greenwald Smith, Michael Warner, and Robyn Wiegman. Mark Goble waded in, saw this book, and advocated for it very early, and Lindsay Reckson read a great deal of it, with merciful clarity and insight, very late. Peter Coviello and S. Brent Plate are the patron saints of this book, and Philip Leventhal at Columbia University Press has been its guardian angel, appearing right whenever I need him, and never fully disappearing.

The work of this project has been supported by a variety of organizations and institutions over the past number of years. An ATLAS (Awards to Louisiana Artists and Scholars) grant gave me time and support when I needed it most, but I am also grateful to the Manship Fellowship, the Penn Humanities Forum, the Pitt Humanities Center, the Center for American Literary Studies at Penn State, and the Dalglish Chew and Stuart Curran funds. For the images in this book, I am grateful for the knowledge, creativity, and time of a variety of archivists and researchers: Dorinda Hartmann, Rosemary Hanes, and Mutahara Mobashar at the Library of Congress; Susan Hormuth, for some remote research help; Sophia Lorent at the George Eastman Museum; and the Modernist Journals Project at Brown and Tulsa Universities.

My family has been wonderfully patient with the degree to which book-writing has stranded us for many summers in the Midwest. Thanks to the Maciaks of Pittsburgh and the Micirs of Philadelphia for your support and encouragement. Thank you especially to my grandparents Vincent Maciak, Margie Maciak, Ann Ostrzycki, and, in particular, John Ostrzycki, who passed away a few weeks before I started kindergarten and whom I've always felt was with me through all the years of this long education. The family section should also be the place where I thank Thom Matera, for the miraculous persistence of his friendship across time and space.

My parents, Barry and Sandy Maciak, always made it clear to me that education was important. They have nurtured every interest and talent I've ever had, and they've worked terrifically hard to make sure I could pursue them. For that alone, I owe them more than I can imagine, but, a few years ago, when my daughter Maeve was born, they packed up all their stuff, left Pittsburgh—the city they'd lived in their entire lives—and moved a mile away from us in St. Louis, so that they could help raise their granddaughter, and so that they could give us

the time to write our books. This was a life-changing thing to do, for everyone involved, and their willingness to do it with their whole hearts is why I dedicate this book *to* them, as a gift, as a partial repayment, as an acknowledgment of this almost unbelievable act of kindness.

But this book is *for* Melanie Micir and our daughter Maeve Anna Maciak-Micir. In a lot of cases, this profession requires a book of its professors, but this profession also requires—or at least asks for—bigger sacrifices than that. During the five years that I spent turning my dissertation into this book, Melanie and I lived in limbo between Baton Rouge, Louisiana, and Saint Louis, Missouri. For two of those years, we lived fully apart. I've learned a lot during the process of producing this manuscript, but maybe the most essential thing I learned is that living apart from this person (now these two people) is something I cannot, will not, and certainly should not ever do. Melanie read every page of this over and over, but I acknowledge her here for reasons entirely separate from her role as my best editor and prose style icon. (For what it's worth, from an intellectual standpoint, Maeve did practically nothing to help me write this book—though I do love her very much.) I acknowledge her—them—because they have given me a reason to do good and be good and work at all. I have promised to live up to them, and this book is for them and the life that we have now, and will have, together.

Parts of the introduction and chapter 4 appeared, in much earlier form, as "Spectacular Realism: The Ghost of Jesus Christ in D. W. Griffith's Vision of History," *Adaptation* 5, no. 2 (September 2012).

Chapter 1 appeared, in slightly different form, as "A Rare and Wonderful Sight: Secularism and Visual Historiography in *Ben-Hur*," *J19: The Journal of Nineteenth-Century Americanists*, 3.2 (2015): 249–275.

The Disappearing Christ

Introduction

The Disappearing Christ and Other Stories

OVERTURE: ANNO DOMINI 1959

It seems safe to say that most people, if they think of it at all, don't think of *Ben-Hur: A Tale of the Christ* as primarily a story about Jesus Christ. Brave twenty-first-century readers of Lew Wallace's best-selling 1880 novel who take in hundreds of pages of earnest amateur scholarship about first-century Palestine could be forgiven for not imagining that the tale of the Christ that weaves throughout the narrative is the *most* important part of the text. Indeed, a vast majority of the novel's pages are devoted to the chariot races, Roman orgies, and sea battles that made *Ben-Hur* such a popular yarn in the late nineteenth century and would make it such an eminently adaptable tale. But whether or not we perceive him to be the novel's main focus, Christ is hard to miss within the text. For after having shadowed Christ's life at each step—like Waverley to Bonnie Prince Charlie, or, alternatively, like Brian to Christ in Monty Python's treatment of the material—our protagonist Judah Ben-Hur witnesses some of the miracles as well as the crucifixion and finally becomes a founding figure in the early Christian church. So, although the bulk of the text deals with Ben-Hur's exploits, Christ anchors the narrative and lends it significance. Seemingly embarked upon an endless, chaotic series of mishaps for much of the story, Ben-Hur is always compelled back to Christ, regardless of whether or not he knows why.

The story of Judah Ben-Hur, in other words, is the content of *Ben-Hur: A Tale of the Christ*, but the gospel narrative is its underlying form. Jesus is the sun around which Ben-Hur orbits. Wallace's narrative voice frequently breaks from Ben-Hur's story to offer a kind of historical bookmark as to where on the Christ timeline our protagonist finds himself, and he even goes so far as to say

that every word of the novel is written in "anticipation" of the crucifixion. When Christ does appear, Wallace offers dense passages of description about the figure's appearance, and those characters lucky enough to behold him throughout the narrative are inevitably awestruck. Indeed, anybody confused or uncertain as to whether *Ben-Hur* is a story of the misadventures of a falsely accused Jewish nobleman named Ben-Hur or of the miraculous foundation of Christianity need only look to the novel's subtitle. Revenge, the quest for glory, and the revolution of the oppressed are all motives that appear in *Ben-Hur* at different points, but the gospel narrative is its *telos*. Christ is a minimal, but by no means marginal, element in this tale.

Yet the afterlife of *Ben-Hur* in pictures—an illustrated novel, a nineteenth-century theatrical production, a series of epic motion pictures, and all manner of ephemera from board games to comic books—is the tale of a disappearing Christ. Despite the fact that the plots of these adaptations are structured in ways that directly echo the construction of the novel, Jesus Christ barely, if ever, appears in them. The best-selling 1890 "Garfield Edition" of the novel, for instance, features hundreds of illustrations over two volumes—but not one of Christ's otherwise copiously described face. While this reticence about the image of Jesus is out of sync with the novel's text, it *is* in part a legacy of the novel's author. Wallace, a bold novelist but only a tentative sort of Christian, wary of the tenuous line he was already treading by writing a novel that described the face of Christ in such detail, refused to allow any actor to portray the character in late-nineteenth-century theatrical productions. Christ's lines were declaimed offstage, and his presence was denoted by a bright white spotlight in an empty area of the stage.

This prohibition had calcified into a convention by the time of Sidney Olcott's 1907 film in which Christ's narrative does not figure at all. (The film is entirely focused on the climactic chariot race which, to be perfectly honest, doesn't even really need Ben-Hur in order to work.) The narrative is restored in Fred Niblo's 1925 silent epic, but Christ is portrayed exclusively by a gloriously lit hand reaching from offscreen (figure 1.1). The figure is represented, in a similarly incomplete yet reverent fashion, by the rear end of an unfortunate actor in William Wyler's 1959 film.[1] Indeed, this disappearance of Christ has become such a part of *Ben-Hur*'s legacy that a 2016 adaptation, directed by the Russian action auteur Timur Bekmambetov and produced by evangelical moguls Mark Burnett and Roma Downey, was trumpeted as making "the tale more Biblical than ever before" by *including* the Christ story.[2] Such is the cultural reception of *Ben-Hur* that 127 years after the publication of the original novel, it's possible for MGM to advertise that they've turned a story about the life and death of Jesus Christ *into*

INTRODUCTION 3

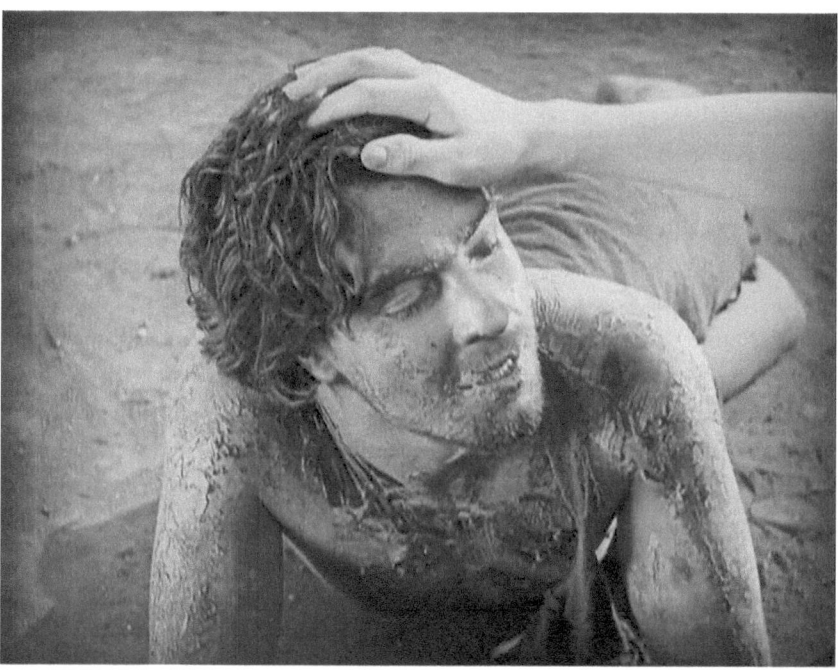

FIGURE 1.1 *Ben-Hur: A Tale of the Christ* (Fred Niblo, 1925)

a story about the Bible. Wallace's vexing regulation notwithstanding, it remains surprisingly easy, from the perspective of the ordinary reader and spectator, to excise Christ from *Ben-Hur: A Tale of the Christ*.

This book is a pre-history of that disappearance. Or, perhaps, it is a story of how that disappearance—and its wobbling between reverence and erasure, invisibility and hypervisibility—is itself an illusion. The disappearance of Christ from the story of *Ben Hur* is strange, but it is not surprising. Indeed, the narrative of secularization that has undergirded the field of American cultural study until nearly the turn of the twenty-first century is based in the same kind of perceptual vanishing. A reader or spectator encountering each of these visualizations in turn—from the excessively described Jesus of the postbellum novel to the carefully concealed carpenter of the Cold War—might perceive a narrative of loss, a figure whose fortunes are in decline. *Ben-Hur*'s disappearing Christ, in other words, would be a stark illustration of Christianity's exile from the public sphere, a disenchantment mirrored in the literal marginalization of the Son of God even within the frames of his own "tale." Another spectator,

however, might perceive the way these images use Christ's absence to all the more strongly reinscribe his importance: the way that his presence still gives structure, purpose, even a politics to these pictures. This obscured figure, in other words, does not represent the loss of religion; it represents the reconfiguration of religion around divine absence. Jesus can vanish from our sight, but he is always in the frame—and paying attention to that frame can give us a sense of the rhythms and structures of secularism. There is in fact no such thing as the disappearing Christ.

This book endeavors to register the progress of secularization by paying attention to films and works of visual culture about the Son of God. This may seem like a counterintuitive project, but by the late nineteenth century, the figure of Jesus had become a convergence point for prophets of religion and rationalism alike. The early nineteenth century had already seen European "higher criticism" establish Jesus as a historical figure, and everything from American evidential theology to the transnational Spiritualist movement made claims based on the sudden empirical knowability of Christ. To represent Jesus at all—whether in paintings, photographs, slide lectures, biographies, novels, or films—was to take a stand in an ongoing debate about the status of religious belief in modern life. Hence, the visualization of Jesus Christ, as a practice, forced filmmakers, writers, and artists to show their work by locating their representation on a spectrum between what was historically verifiable and what was simply an article of faith. *The Disappearing Christ* argues that these multimedia meta-commentaries, inasmuch as they literally concern the balancing of religion and culture within the text, themselves constitute found theories of secularism.

In 2014, Peter Coviello and Jared Hickman stated plainly: "The secularization thesis is dead."[3] This thesis, a clear narrative of secular progress from "superstition to rationality, credulity to skepticism, eschatological fanaticism to liberal tolerance," had buttressed nearly a century of work in the humanities and social sciences, subtly (or not so subtly) giving shape to the stories we tell about the evolution of theology, literary history, and the mythology of U.S. democracy. But Coviello and Hickman are right to pronounce it dead—this is avowedly the era of the "postsecular." What that ultimately means, however, is an open question. Tracy Fessenden, in an essay aptly titled "The Problem of the Postsecular," writes that, in its broadest terms, the postsecular denotes "an environment in which the categories of the religious and the secular no longer divide the world cleanly between them, and signals the need for new ones."[4] The titular "problem," however, is that these "new" categories have not been forthcoming. In other words, the problem of the postsecular is that even scholars eagerly eschewing the secularization thesis are inevitably held captive

to its terms. Postsecular scholarship, then, runs the risk of either recapitulating the very narrative it rejects or moving so far away from thorny questions of theology, belief, and spiritual practice that both the religious and the secular are flattened, rendered indistinct. The promise of such scholarship is that it might find insight in that tension without allowing it to ever fully, or at least uncritically, resolve.

This book, admittedly, does not offer a solution to this problem. Rather, *The Disappearing Christ* seeks to turn the gaze of the postsecular toward texts that have so far escaped its notice. In order to excavate the aforementioned found theories of secularism, this book focuses on a broad archive of popular texts—nearly forgotten bestsellers, popular magazines, widely viewed early films now preserved only in archives—alongside more canonical works and figures. What the demise of the secularization thesis has meant, in terms of methodology, is a move away from deference to established cultural metanarratives or strong theories of social change. It's thus not surprising that scholars working in this postsecular moment have often turned to the popular, to texts that might be seen to fall outside and challenge the established narratives of literary and cultural history. Determining whether and how they do is the occupation of much of this work. Popular culture can provide a unique window into the actual lived experience of the secular age with all of its eccentricities and even contradictions. Not discounting the theorizations of brilliant minds whose writings often circulated in limited networks or works of philosophy and theology that were read primarily by those predisposed to share the same metaphysical assumptions, the new study of secularism requires a perspective that moves easily from low to high, popular to boutique audiences. By applying close visual and textual analysis to the ways in which popular works anticipate, cater to, or even condescend to popular audiences, we can begin to trace the actual contours of a world that was perhaps never "cleanly" divided between the religious and the secular in the first place.

The Disappearing Christ's primary intervention in this field is the introduction of early cinema to questions of the postsecular. Although the past several decades have seen a boom in scholarship on secularism in the nineteenth-century United States, few of those works have broached the period between Reconstruction and the first World War, and even fewer have addressed the paradigm-shifting media event that occurs squarely in the middle of that period. Very simply, this book argues that early cinema—and the literary and visual cultures that anticipated and eventually surrounded it—is a reflection, an index, and even a mechanism of the process of secularization as it occurred in the United States at the turn of the twentieth century. Negotiating between the

trick and the actuality, the dueling impulses of belief and skepticism, early film affords us the unique opportunity to *see* the life of secularism in the West. This is both a historical and a formal task. Cinema, from its very beginnings, has been a medium to which even the most dispassionate critics and scholars have afforded a kind of "magic" power. To tell the story of the emergence of such a miraculous apparatus put so vigorously in service of a kind of scientific realism, as we see in film's earliest years—at precisely the moment when historians tell us secularism is entering the era of its hegemony in U.S. culture—is to tell a story of secularism itself, or at least a microcosm of it. Film—its aesthetic, its reception, the debates over its true purpose—is a laboratory for identifying, with great specificity, the crossed lines, contradictory imperatives, and ambivalent feelings that characterize the secular. The medium's messy emergence is a testament to just how indistinct the divide between sacred and secular was, is now, and, perhaps, ever shall be.

Although the emergence of cinema is, indeed, the structuring event of this book, our narrative does not begin with the first film screening in 1895. *The Disappearing Christ* follows historicist accounts of early cinema by considering it a "screen practice" that evolved alongside and even in tension with other screen practices (slide lectures, panoramas, optical toys) as well as works of literature, photography, and visual art throughout the nineteenth century. The roots of "cinema," as a discourse, began long before moving images were projected on a screen, and, while this book does not suggest a teleological narrative of the medium—discovery, rather than emergence—it does argue that theorizations of the visual in written works of literature and even theology contributed to the conditions from which film would eventually emerge. It is not controversial, for instance, to suggest that films in the silent era were formally indebted to the Victorian theater or that cinematic realism significantly echoes works of American literary naturalism. This book further argues that theological and popular debates about Christianity and visual representation in the late nineteenth century might have had their own influence on cinema's evolving aesthetic. Although we may figuratively refer to literary prose as "visual," of course, the written word cannot and should not be assumed to have any sensory aspect. Writing can be evocative and rich in imagery, but it can only ever contain what Elaine Scarry, for instance, calls "mimetic content," or something like "instructions" to aid the reader's imaginative visualization of objects or people or places.[5] Even so, such instructions have always had an ambivalent relationship to the visual. Furthermore, cinema emerged in dynamic tension with works of literature and theology that were virtually obsessed with the evidence of things not seen.

THE HISTORICAL JESUS IN BROAD DAYLIGHT

The arrival of what is now known as the "historical Jesus" on American shores was an event as scandalous as it was productive. Beginning in the 1830s, and centered primarily in Germany, scholars of what is called "higher criticism" utilized the tools of nineteenth-century scholarly historiography and philology to portray Jesus Christ as a historical figure, rather than a strictly divine character, and cast light on the fallibility of the source texts that had been used for centuries to bolster Christian theology.[6] The *ur*-text of this movement was David Friedrich Strauss's 1835 *The Life of Jesus, Critically Examined*, which made the then-daring suggestion that the gospel stories (particularly the miracles) were primarily myths designed to correspond to and confirm a broad variety of ancient prophecies. The revolution unleashed by Strauss and his peers unsettled some of the fundamental assumptions about the authority of the gospel accounts, and it sent shock waves throughout Europe.[7]

In large part as a result of this, the nineteenth century saw the emergence of Jesus Christ as a character that could be interpreted and reinterpreted, and whose identity, no longer solely identified with the supernatural salvation of the human race, was often perceived to be most readily available through the act of imaginative adaptation. As Warren Susman noted in 1964: "For once the chief mythic character of the Christian religion, the man-god who died and was reborn, became a figure within the limits of rational historical inquiry; he became subject to special interpretations and uses."[8] This book is not a study of the historical Jesus in America, nor is it a study of iconography. Unlike Richard Wightman Fox's *Jesus in America* and Stephen Prothero's *American Jesus*—excellent, encyclopedic catalogues of the hundreds of ways Christ was adapted and appropriated during this period and beyond—my focus is not on Christ as a character, but on the media used to represent him and the theories of history and visuality brought to bear on that act of representation.[9] All the same, the story of *The Disappearing Christ* begins with the historical Jesus.

The 1848 publication of George Eliot's English translation of Strauss's *The Life of Jesus, Critically Examined* in America was not greeted with much warm feeling by U.S. theologians. Horace Bushnell, for one, was scandalized. Claiming that the text represented the "new infidelity," and that its "bondage under the method of science" promised the "virtual annihilation of the gospels," Bushnell denounced the work and its supporters.[10] Ralph Waldo Emerson was not so shocked as Bushnell, and, indeed, did not object in fact to the conclusions of Strauss—though he was in accord with Bushnell in objecting to the scientific study of scripture

in principle—but reacted rather more dismissively. Referring implicitly to controversies around Strauss and others in his "Divinity School Address," Emerson took issue with the higher critics' materialism. "The *person* of Jesus," he declares, "is unimportant"[11] (emphasis mine). Imagining that belief in the truth of Christian revelation might be contingent upon the occurrence of Christ's miracles or anything so grossly material, to Emerson, was to miss the point. Andrews Norton, the Unitarian dean of Harvard Divinity School, offered some variations on these critiques, defending the eyewitnesses. "The Gospels," he wrote in a rebuttal to Strauss appended to his volume titled *Internal Evidences*, "are the history of a miraculous communication from God to men.... If God has thus revealed his existence and his purposes toward us, the truths of religion rest on an immovable basis—the witness of God himself."[12] By 1871, the liberal Protestant minister Henry Ward Beecher could write, in the preface to his *Life of Jesus, the Christ*, of the scourge of an intellectual problem then at least two decades old in America:

> The Lives of Christ which have appeared of late years have naturally partaken largely of the dialectic and critical spirit. They have either attacked or defended. The Gospel, like a city of four gates, has been taken and retaken by alternate parties, or held in part by opposing hosts, while on every side the marks of siege and defence cover the ground.... As long as great learning and acute criticism are brought to assail the text of the Gospels, their historic authenticity, the truth of their contents, and the ethical nature of their teachings, so long must great learning be brought to the defence of those precious documents.
>
> ... But such controversial Lives of Christ are not the best for general reading.[13]

In Beecher's figuration, the faith of American Christians was under attack from the atheist hordes of Germany and France. Beecher, who rose to fame as an abolitionist in the 1850s, invokes this martial imagery to cast the situation of American theologians like himself as its own civil war.

Intellectual resistance to the historical Jesus in the United States, however, quickly morphed into zealous and inventive appropriation. There were Christs who preached the righteousness of slavery and ones who preached abolitionism; Jesus figures feminist and feminized; and, by the early twentieth century, there were books about Jesus Christ's teachings on the topics of business administration and physical fitness.[14] Beecher's own blockbuster biography of Christ in 1871 used the water-into-wine miracle at Cana to boost interest in the temperance movement. As a result of the popularity of this genre of writing, a whole satellite industry of "harmonies"—texts that streamlined the events of the four gospels into one continuous narrative—emerged to aid in the task of adaptation.

In 1900, Ernest DeWitt Burton and Shailer Mathews even published a book of New Testament source criticism—*The Life of Christ: An Aid to Historical Study and a Condensed Commentary on the Gospels*[15]—designed explicitly to serve as an outline for amateur lives of Christ written by Sunday school students. Thus, after a fraught debut in America, the back half of the nineteenth century crystallized Christ's omnipresence as an opinionated citizen, an unceasingly concerned party in the debate over the welfare of his chosen nation and its denizens.

Imagining how Jesus would react in the face of late-nineteenth-century social dilemmas in the way that these authors did cleared the way to imagine a Christ who was himself contemporary. Charles Sheldon famously coined the phrase "What Would Jesus Do?" in this period, and, in 1894, William T. Stead imagined Jesus literally stepping onto the streets of Chicago to demonstrate "the reality of the Citizen Christ."[16] At the start of the entry on "The Bible and Social Reform" in the *Encyclopedia of Social Reform*—a mammoth 1897 volume edited by W. D. P. Bliss, a U.S. Christian Socialist writer and cofounder of Boston's "Church of the Carpenter"—we find a remarkable scene of reading in this vein. "Whoever would understand the social question and contribute to its solution," the entry says, "must have on his right hand the works on political economy and on his left the literature of scientific socialism, and must keep the New Testament open before him."[17] This is a representative image of the broader Social Gospel movement as it had developed after the Civil War. Enlivened in part by the new applicability and accessibility of Christ in this period, the Social Gospel endeavored to fashion a progressive theology capable of contending with and even appropriating secular challenges to religious faith.[18] The Social Gospel turned the Victorian crisis of belief into a craze for reinvention—and Christ was often its bellwether.

By creating a compelling character that spoke the words of Christ, walked the streets of Chicago, and consorted with union members and immigrants, the purveyors of Social Gospel theology enabled their followers to imagine themselves as part of a community with Christ, enfranchised through historical kinship. Although scholars have pointed out the limitations and blindnesses—especially in terms of race, gender, and sexuality—of these liberal theologies, their initial impulses were rooted in social justice. As W. E. B. Du Bois—whose own social gospel would provide one of the sharpest challenges to secularism in the early twentieth century—wrote,

> Jesus Christ was a laborer and black men are laborers; He was poor and we are poor; He was despised of his fellow men and we are despised; He was persecuted and crucified, and we are mobbed and lynched. If Jesus Christ came to America He would associate with Negroes and Italians and working people.[19]

This renewable, reusable counterfactual experiment (*If Jesus Came to _____*) structured the imaginations of generations of writers and provided the context for the literary and visual works at the center of this book.

These developments in biblical historiography and their popular appropriations coincided with an increased attention to the visual in both Protestant theology and popular culture. What Jenny Franchot has called the "Catholicization" of American Protestantism in the nineteenth century partly took the form of a growing comfort with graven images, and the thousands of prints, postcards, and reproductions of religious art that circulated in this period overwhelmingly bear out this observation.[20] Even aside from this growing comfort with iconography, as Gregory Jackson has shown, since at least Jonathan Edwards, Protestant ministers and theologians had been deploying vision-oriented homiletics to evoke participatory, virtual experience for congregants.[21] The twin emergence of higher criticism and new visual media at midcentury, however, catalyzed a new anxiety (and sense of possibility) about seeing. In 1855, Andrews Norton—quoted earlier in opposition to higher criticism—wrote, "We do not care to have the sun admitted to us through an opening into a darkened room. We desire to see the objects exhibited by it in broad daylight."[22] Here Norton is expressing a sentiment common to American writers of his time. With new science and technology both revealing the limitations of the senses and offering solutions to those limitations, it makes sense that Norton would yearn for this fantasy of direct experience in contrast to the mediated experience of the camera obscura he describes. Norton was an advocate of what E. Brooks Holifield has called Evidential or Baconian Realist Christianity: an American mode of theology that attempted, in the context of that era's frenzy for the visible, to reconcile Christian history with modernity. Evidential Christianity—theology based on the claim that Christ's miracles provided proof of the authenticity of Christian revelation—had descended from European Protestant scholasticism and Scottish Common Sense Realism to form the core of New England Protestant theology in the antebellum period. Citing texts like Hebrews 2:4—"God ... [bore] them *witness*, both with signs and wonders, and with divers miracles, and gifts of the Holy Ghost, according to his own will"—these rationalists sought a foundation for faith in empirical reason. Moreover, they sought this foundation through the very sight of the evangelists. It was they who saw the miracles, and thus their eyewitness testimony that provided the basis for a rational faith.[23] For many Americans in the nineteenth century, you could neither believe your own eyes nor let go of the illusion that they were telling you the truth. The resultant flattening of rationalism and mysticism—which finds its most flamboyant evidence in the perennially resurrectable Christ—was at the heart of an emergent, hegemonic secularism in the United States. Whether

in the realm of theology, science, or popular culture, nineteenth-century Americans famously questioned their own vision; the disciplinary regime of liberal secularism in this period insisted upon a very particular answer.[24]

Historians have long projected this period of popular religious imagination onto the secularization thesis's narrative of decline. The instrumentalization of Christ, his transubstantiation into an element of what Van Wyck Brooks called a "usable past," and this new figure's re-entry into theological discourse is a signal that formerly rich traditions had gone to seed. This view was advanced in the 1980s and 1990s by many scholars in American Studies who pushed back against accounts that described the disappearance of religion in modernity only to advance an amended vision of religion's "declension." Jackson Lears claimed that the "weightlessness" and "evasive banality" of turn-of-the-century Christianity were the downside of the democratization of religion, and R. Laurence Moore argued that cultural and commercial appropriations of Christian imagery "contributed to a process of democratization that did not yield impressive enlightenment." Perhaps most famously, Ann Douglas schematized this corrosion, calling it the "feminization of American culture."[25] The Christ reborn as a contemporary citizen thus plays a heroic, if largely symptomatic, role in the secularization narrative that has structured decades of scholarship on American Christianity.

UNSEEN SOMETHINGS: AMERICAN STUDIES AND POSTSECULAR CRITIQUE

The secularization thesis is, fundamentally, a narrative. It is, in Charles Taylor's words, a "story of loss" or "subtraction" of religion from the public.[26] It is, in Talal Asad's words, "a triumphalist history" of the secular values of rationalism and universalism.[27] It is a narrative of progress, a narrative in which, as Janet Jakobsen and Ann Pellegrini put it, "each step forward in time also marks a moral advance: a move away from religious authority and toward greater intellectual freedom and more knowledge, leading eventually to governance by reasoned debate and ultimately to democracy and peace."[28] It is a narrative in which the liberal democratic subject, simply by putting one foot in front of the other in a secular age, becomes the hero. In some important ways, then, the question of secularism is a question of narrative, of the management of form and content. Taylor frames the thesis as a subtraction *story*, but, in literary terms, we might rather say it is a *plot*. The events, religious and cultural, that fall under the purview of a historian of modernity constitute an undifferentiated archive, a story awaiting emplotment. For much

of the twentieth century, that plot followed the outline described earlier herein. But, after the late-twentieth-century flashpoints of the Iranian Revolution of 1979, the terrorist attacks of 9/11/2001, and the ensuing rise in Islamophobia in the United States—events that troubled neat progress narratives and revealed the violent labor of secularization rather than its natural and inexorable pull—scholars have sought a different approach. The varied works we might describe as *postsecular* thus form a collective, contentious narratology of the secular age.[29]

To say that the secularization thesis is a narrative and that its critics are, in some manner, operating in a mode of narrative critique might read to some as a way of diminishing its importance or condescending to the stakes of postsecular criticism. To be clear, it is precisely because the secularization thesis is a narrative that it is so difficult to pin down, contest, or indeed ever fully extinguish. As Jakobsen and Pellegrini note, "despite [its] incoherence and despite the factual swerve, the narrative continues to exert great political force."[30] The secularization thesis lives, neither solely in the institutions it supports nor in the reputations of the scholars who have upheld it, but rather in the social and political imagination that sustains and renews it. It is, quite literally, a part of the way Americans *see* the world around them, whether they perceive themselves inside or outside its influence. It is both the subject of argument and the ground upon which that argument is fought. Thus, the project of the postsecular is currently occupied as much with blazing a new path beyond this master narrative as it is with looking inward in order to identify the ways the secularization thesis might still structure even the premises of its own critiques. Even after the "death" of the secularization thesis, "the work of deterritorializing criticism in this way, endeavoring to unwrite secularist presumption," write Coviello and Hickman, "is just getting underway."[31]

So, having thus unsettled this faulty narrative of progress, how do we move forward in earnest? A key starting point is sorting out the relationship between the religious and the secular. It would be easy, for instance, to replace the secularization thesis with its opposite. Rather than witnessing the decline of religion, in a shocking plot twist, it is revealed that secularism has been religion all along. Religion thrives by using the secular as its avatar. Instead of figuring the secular as a "mask" or a "disguise" for religion—a way nominally secular institutions and practices simply rebrand essentially religious ideals—postsecular scholarship looks to tease out the ways in which, as Asad suggests, "the sacred and the secular depend on each other," or, as Charles Taylor frames it, "the immanent frame" of the secular influences the expression of everything on the spectrum from belief to *un*belief.[32]

Taylor himself has suggested an alternative to the plot of the secularization thesis. In his view, modern history is not a story of religion's irrevocable decline, but rather a story of a move from "a society whose belief in God is unchallenged,

unproblematic, to one in which it is understood as one option among others."[33] As a result of this, modern believers, even those most devout, must be constantly self-conscious about their faith—this is a shift from the "porous" self of the premodern era to the "buffered" self of modernity. The modern believer, then, in the midst of such a wild variety of ways of explaining the world, "cannot help looking over [his or her] shoulder from time to time, looking sideways, living [his or her] faith also in a condition of doubt and uncertainty."[34] Looking sideways, for Taylor, is the state of secularism: a confident, unbridled vision always leavened with the possibility of doubt.

For Taylor, secularization is a story of diversity, not declension. In the nineteenth century, he contends, the explosion of new theologies, denominations, and modes of belief created a "nova effect," or "multiplication of new options around the polemic between belief and unbelief."[35] Religion does not disappear, but instead becomes part of this diversity of ways of being. What proponents of the secularization thesis might perceive as a period of decline and fall, Taylor figures as a period, a space, of free association and theoretically limitless recombination between sacred and secular forms. This is what he calls the "middle realm":

> The salient feature of the modern cosmic imaginary is not that it has fostered materialism, or enabled people to recover a spiritual outlook beyond materialism, to return as it were to religion, though it has done both these things. But the most important fact about it ... is that it has opened a space in which people can wander between and around all these options without having to land clearly and definitively in any one.[36]

Taylor thus endeavors to replace the plot of the secularization thesis with a kind of utopian plotlessness, the wandering of the middle realm. The nova effect replaces the simplistic directionality of the secularization thesis with the idealized multidirectionality of religious pluralism.

For scholars of nineteenth-century cultures—especially in the United States—this is a move as appealing as it is ultimately problematic. Religion has long had a vexed relationship with American Studies, either surfacing in the antagonistic role afforded it by the secularization thesis or being overlooked entirely.[37] To imagine its return to the forefront as a prime mover in the improvisatory ferment Taylor describes is an attractive proposition. But this part of Taylor's story has been subject to sustained critique, and at the root of these critiques—beyond a discomfort with the way *porous* and *buffered* describe a similar transition to the *enchantment/disenchantment* dyad of the secularization thesis—has been the question of agency or choice. Taylor's narrative of secularism suggests that

the nineteenth century saw a democratization of American faith, a profusion of choices for where one might place oneself on a spectrum between belief and unbelief. This is the nova effect of religious pluralism, which, apart from Taylor's conceptualization, has been rigorously excavated from antebellum Christian theology by scholars such as Mark Noll and Nathan O. Hatch.[38] Yet, scholars of the postsecular turn in American Studies have cast a skeptical eye on this enshrinement of "choice" as a defining characteristic of the secular age. As John Lardas Modern writes,

> For those living within the secular imaginary, decisions about religion were often one's own, yet the range of available choices had been patterned and often shaped by circumstance. Institutions making their invisible demands. Media generating models of particular choices. Machines enabling you to interact with your decisions and those of others. A choice being made before it presents itself as such. Unseen somethings haunting the day.[39]

The postsecular critique of Taylor's nova effect narrative, as presented by Modern, is that the choices that have come to define American secularism were never really choices at all. In other words, to live within the "secular imaginary" is to *feel* one's own agency even as the spectrum of choices is limited, conditioned, and shaped by forces so distant from one's daily experience that one may not even realize they are there.

The "unseen somethings" Modern invokes here might otherwise be described as norms. The reason that Modern's *somethings* can remain *unseen* within secular culture is that they are naturalized: they do not *appear* to be coercive or compulsory, and indeed, these norms fly under the cover of a broad notion of tolerance. "The political solution that secularism offers," writes Saba Mahmood,

> lies not so much in tolerating difference and diversity but in remaking certain kinds of religious subjectivities (even if this requires the use of violence) so as to render them compliant with liberal political rule. Critics who want to make secularism's claim to tolerance more robust must deal with this normative impulse internal to secularism.[40]

In a nineteenth-century American context, Mahmood's "normative impulse internal to secularism" has been narrated as the emergence of what Tracy Fessenden calls a "nonspecific Protestantism" in historical writing of the time and what Modern refers to as the "normative sociality" of true religion.[41] Secularism, as it flourished after the enshrinement of disestablishment in the U.S. Constitution

and evolved in the aftermath of the second great awakening—the so-called "democratization of American Christianity"—rather than leading to diffusion and diversification, cohered into a discourse that resembled and reified many attributes of Christianity. Religion did not decline, but certain styles of religious expression and thought became "good" while others became "bad"; within a secularization narrative based on religion's decline, Protestant Christianity became the default, "unmarked" definition of religion itself.[42] It is as much a mistake to perceive secularization as a process of religious decline as it is a mistake to see it as a period in which religion and the secular freely intermixed and improvised with each other. Rather, secularization was a process by which the relationship between reason and the sacred became scripted, formalized, and disciplined. To be secular was never to be without religion, but rather to be religious in a particular way, to adhere to a set of liberal Christian conventions, and to have those conventions rigorously policed by a social world trained to anticipate them.

This process of secularization, as Mahmood's invocation of "violence" suggests, was not an innocuous one. In fact, in the turn-of-the-century American milieu that is the subject of this book, the violence enforcing secularism's "normative sociality" took very particular forms. As Molly McGarry suggests about the post-Reconstruction United States, "the imagination of this era as one of liberal rationality and national unification"—the rhetorical hallmarks of secularism as they were of post-Reconstruction national politics and historiography—deliberately papers over what she calls the "counter-cultural" religious movements that came into being outside the "nonspecific Protestantism" of secular culture. Outside the norms of secularism, one could easily be deemed too superstitious, too atheistic, too conspicuously religious or not. In the service of this unification, the U.S. Supreme Court justified laws designed to oppress the new nineteenth-century religion of Mormonism, and popular occult movements like Spiritualism and Theosophy have been erased from the historical record for their perceived anachronism, eccentricity, and insistence on defining sexuality and gender on their own terms.[43] The "incorporation of America," as it has been called, was a process as based in exclusion as inclusion.

Of course, race, in the period after the Civil War, was a particularly fraught example of secularism's "unmarked" categories. As Vincent Lloyd frames it:

> Race and secularism are intertwined. Put more starkly, whiteness is secular, and the secular is white. The unmarked racial category and the unmarked religious category jointly mark their others. Or, put another way, the desire to stand outside religion and the desire to stand outside race are complementary delusions, for the seemingly outside is in fact hegemonic.[44]

In the post-Reconstruction era, the lynch mobs of Jim Crow were militias designed for the regulation and policing of such unmarked categories. White supremacist violence—always shot through with the language of religious ritual and Christian messianism—was the catalyst and mechanism of the "unification" that characterizes this period in histories of postbellum America. The number of twenty-first century Americans—even those who self-identify as left-leaning—who perceive monuments to the Confederacy erected during the Jim Crow era as elements of "history" to be protected rather than vestiges of this terroristic mythologization of unity serve as a reminder of how fully and well secularism's "unseen somethings" have structured America's present and past. (As Tracy Fessenden has shown, even liberal progressive theologies centered around women's rights in this period leveraged themselves against the racial other.) Although the imaginative literature of the liberal Protestant social gospel might seem to bear out the idea of a "middle realm" of theosocial innovation, the thousands of black Americans "crucified"—as W. E. B. Du Bois and many other African American writers would figure it—on the lynching tree serve as undeniable evidence of the costs of this fiction.

The example of the intertwined nature of race and secularism—especially in the current political moment when the normally unseen separations between "us" and "them" that structure American culture are being rendered so flamboyantly visible by a nativist president seemingly unaware that those somethings were meant to be unseen—reminds scholars of the urgent stakes of postsecular critique. *The Disappearing Christ* extends this work at the level of form. Part of the methodological task of this turn is not only to name the unnamed assumptions of the secular but also to track the way they are strengthened—the way secularism becomes hegemonic—through particular cultural objects and formal conventions. The processes by which secularism emerges are inseparable from secularism itself; describing the workings of national media and education on the construction of citizenship, Talal Asad contends, "this transcendent mediation *is* secularism."[45] Narrative, form, aesthetics—this is where secularism's often cruel magic happens.

With this in mind, *The Disappearing Christ* tracks a particular aesthetic across media during this period that developed in response to these crises of vision, knowledge, and faith and came to define American secularism at the beginning of the twentieth century. I call this aesthetic *spectacular realism*.[46] To square objectivity and faith, to cite evidences both spiritual and material, to read with the works of political economy, scientific socialism, and the New Testament all open before you—this was the seemingly impossible task of popular art and culture in this period. How does one produce a credible vision for the spectator who is

looking sideways? Although its conventions vary depending on the medium, the priorities of spectacular realism remain the same. It insists on loud declarations of historical objectivity, the citing of sources, the verisimilitude of multimedia realisms, and yet its subjects are miracles, hauntings, the acts of apostles, scientists, and magicians. It is the aesthetic of the contact zone between realism and fantasy, the uncanny superimposition of disbelief and its suspension, the seamless balancing of the naïve pleasure of credulity with the smug pleasure of incredulity. Spectacular realism is the aesthetic of secularism just as it is the aesthetic of cinema, the media form at the center of this book. Cinema, a medium whose power has long been defined as its ability to reveal things normally unseen, is also a medium that draws power from its ability to quietly construct and police the very invisible boundary we praise it for transcending. Cinema, the medium of unseen somethings, is secular.

THINGS NORMALLY UNSEEN: FILM STUDIES AND POSTSECULAR CRITIQUE

If the story of secularization is, to some extent or another, a narrative of the contemporary world, then cinema must be a part of that story.[47] As yet, though, film studies scholars have been slow to turn to secularism as an analytic category. The study of religion and film has long been an element of academic scholarship, but the study of secularization as a process has mostly been studiously avoided. I suspect that part of this disinterest is a result of the fact that the field of early cinema studies—a subfield methodologically close to recent formal-historical work in postsecular American Studies—rejected its master narrative almost wholesale in the 1990s. With the rise of historicism in film studies, and the turn to the archival in the study of early cinema, many prominent scholars—Charles Musser, Tom Gunning, André Gaudreault, Miriam Hansen—publicly refuted the widespread teleological view of film studies (photography leads to primitive cinema, and primitive cinema leads to cinema proper). Widely used phrases such as "screen practice"—which refers to everything from optical toys to slide lectures to projected moving images—and influential theorizations such as the "cinema of attractions" and the "cinematic public sphere" that emerged from this era now allow critics to discuss the emergence of cinema as an evolving and incomplete conversation between visual media rather than the fated convergence of technology and aesthetics.[48] In other words, it has been a while since film studies—particularly the somewhat specialized field of early cinema studies—has been

gripped by anything so monolithic as the secularization thesis, and so much of the angst driving scholars of the postsecular in literary studies, for instance, is simply missing.

Nevertheless, the relative absence of this discourse in film studies cannot be attributed solely to film scholars' preternatural cool about the sacred/secular anxieties that have gripped other disciplines in the humanities from anthropology to English. Indeed, looking back to that moment of the historicization and recuperation of early cinema in the late 1980s and early 1990s, we find a treatise on the topic hidden in plain sight. A seminal essay in the development of "the cinema of attractions" as a concept, Tom Gunning's 1989 "An Aesthetic of Astonishment: Early Film and the (In)credulous Spectator," is one of the most-cited essays on film's belief-function. It is also, not incidentally, an essay about film's *un*belief-function. Without necessarily naming itself as such, "An Aesthetic of Astonishment" is perhaps the foundational essay on secularization in early cinema studies.[49]

Gunning's essay begins with the familiar, imagined scene of those very first filmgoers at the Salon Indien of the Grand Café in Paris seeing the program of short films shot by the Lumière brothers in 1895. The lore had long held that those lucky spectators sat rapt at this marvelous new invention until the Lumière brothers showed them a train arriving at a station. Perhaps this particular moving image was a stop too far for this audience, already stretched to wit's end by the shock of cinema, but, so the story goes, the audience gasped and shrieked in fear. Snookered by the film medium's realism, the spectators at the Salon Indien briefly feared for their lives as the train hurtled toward them. It is the "primal scene" of the emergence of cinema, rendered all the more so, as Rachel Moore has noticed, by the way it deliberately evokes turn-of-the-century anthropological narrations of "first encounter" with supposedly primitive tribes.[50]

This origin story of the early cinematic spectator not only is factually wrong, the essay argues, but also leads us to a fundamental misunderstanding of what film is. For Gunning, the "naïve spectator" is the founding myth of an early cinema studies that sees spectators as passive, captivated, willingly or unwillingly surrendered to the all-powerful realism of the motion picture. And that spectator implies a cinema to match. "Thus conceived," he writes, "the myth of initial terror defines film's power as its unprecedented realism, its ability to convince spectators that the moving image was in fact palpable and dangerous, bearing toward them with physical impact. The image had taken life, swallowing, in its relentless force, any consideration of representation—the imaginary perceived as real."[51] This is a dramatization of the secularization thesis, set in Paris in 1895, and cinema is the engine of disenchantment.

Gunning turns to history in order to complicate this understanding, replacing the rube with a rationalist. Discussing the magic theater of Méliès as a relevant intertext, he writes:

> The audience this theatre addressed was not primarily country bumpkins, but sophisticated urban pleasure seekers, well aware that they were seeing the most modern techniques in stagecraft. Méliès's theatre is inconceivable without a widespread decline in belief in the marvelous, providing a fundamentally rationalist context.[52]

To some extent, then, the myth of the naïve spectator is precisely incorrect because it overlooks the complex process of secularization in favor of a simplistic model of progress. Just as scholars had imagined cinema's "invention," as opposed to its messy becoming alongside other screen practices and visual ephemera, so too did such scholars imagine a process of secularization that could turn on a pin. Gunning's evocation of the "decline in belief in the marvelous" might echo Taylor's subtraction story of secularization, and the "sophisticated urban pleasure seekers" might seem to bear a passing resemblance to the "triumphalists" critiqued by Asad (at least in contrast to the "country bumpkins" afraid of modern life) but in this framework, the disavowal of magic requires the specter of belief to become pleasurable. The train produces a fleeting temporality animated by something like rationalist belief. If the myth of the credulous spectator is cinema's version of the secularization thesis, the historicized retelling in this essay is a more credible account of the secular.

Indeed, from here, Gunning moves into something resembling a postsecular critical ambivalence toward the relationship between religion and culture in this and earlier periods. Rather than swapping out the naïve spectator for a self-congratulatory, disenchanted liberal, Gunning zeroes in on film's unique capacity to render visible—or at least experiential—the kind of "looking sideways" that Taylor describes. He writes that "far from being placed outside a suspension of disbelief, the presentation acts out the contradictory stages of involvement with the image, unfolding, like other nineteenth-century visual entertainments, a vacillation between belief and incredulity."[53] This is the seed of a postsecular understanding of cinema, a spectator located between the reviled state of bumpkinhood and the idealized, aspirational sophistication of the rationalist, and a medium invisibly appropriating and playing upon the most desirable impulses of each state.

Such an idealized, impossible middle is a significant part of early writing on the medium. As late as 1916, well after the initial shock of cinema that Gunning

describes, the most influential theorists of the medium conventionally utilized the vocabulary of the miraculous to describe cinema's realist possibilities. Indeed, these early works of film theory often operate in a stylistic mode that one might call prophetic. Foremost among these prophets of cinematic realism is Vachel Lindsay, whose *The Art of the Moving Picture* (1915) is a wild, quasi-theological ode to cinema's power. With the dawn of film technology, Lindsay tells us, "miracles in a Biblical sense have occurred"[54]—and that miraculousness is tied up with film's ability to reveal or discover hidden elements of reality:

> By faith and a study of the signs we proclaim that this lantern of wizard-drama is going to give us in time the visible things in the fullness of their primeval force, and some that have been for a long time invisible.[55]

The motion picture camera is thus a miraculous machine, able to see through visible objects to their origins and able, moreover, to unearth and capture that which has faded from view. Hugo Münsterberg, one year later, wrote in his seminal volume, *The Photoplay*, "By the miracles of the camera we may trace the life of nature even in forms which no human observer finds in the outer world."[56] The realist camera must, if it is to fulfill its role, record *more* than objectively observable reality. It must tease spiritual and temporal transcendence even as it reminds spectators of the materiality and grit of the contemporary moment.

Indeed, early cinema's pleasure, Gunning argues—here and elsewhere—is rooted in the "ambivalence of shock": the spectator's affective, in-the-moment management of film's aesthetic provocations.[57] Rather than "detached contemplation," early cinema spectators encountered film with their impulses of credulity and incredulity triggered in equal measure. Rachel Moore, writing about this same "primal scene" in order to ask why it had such staying power in film theory throughout the century, figures this spectatorial "involvement" in somewhat different, but resonant, terms. "Within the isolation and secrecy of the cinema," she writes, "a new intimacy was established with a world that was, in many ways, its double and, in other ways as well, its negation."[58] By appearing as an image born of modern technology that, all the same, activates the feeling of some premodern, perhaps "porous," encounter, cinema ritually reproduces the shock of modernity for spectators otherwise detached from it. Every screening is a progress narrative in miniature. This "involvement" or "new intimacy" with the moving image not only suggests film as a training ground for belief in a secular age, but also positions its processes and mediations as the very labor of secularism itself. As Miriam Hansen wrote, "in the effort to re-align itself with the culture standards of the bourgeois public sphere, the cinema implicitly adapted the

mechanisms of exclusion and abstract identity characteristic of the paradigm."[59] To the extent that cinema, in Gunning's words, "acts out" a complex negotiation between reason and belief, it does so as a form of instruction. Spectators may not be naïve dupes, but neither are spectators liberated by the cinema experience. This medium is magic because it so seamlessly leads its spectators into imagining themselves as both rational and open to the transcendence of reason: it is one of secularism's most effective disciplinary technologies. Animated by the convergence between reason and the supernatural, it is also productive and protective of that convergence. Hansen rightly notes that cinema not only "adapts" but also reproduces the modes of inclusion, exclusion, and even violence that characterize secularism. Cinema and secularism have nearly always been inseparable in this way; cinema makes secularism happen.

Gunning's essay and others at the time laid the groundwork for a robust study of the way film and secularism are intertwined: the way film's quick evolution into the narratively integrated form we recognize today mirrors the simultaneous hegemonization of secularism, the theories of cinematic realism that double as theories of secular belief, the way the cinematic experience does not replace but rather surrogates the experience of communal worship. The path was set, to borrow a deliberately "estranging" formulation from Wendy Hui Kyong Chun, for a study of cinema and/as secularism. In other words, film studies could both explore cinema *and* secularism, and also catalogue and deconstruct the ways the two are intertwined and even expressive of each other.[60] Indeed, in 1990 in Quebec, the first conference of DOMITOR, the international organization for the study of early cinema—co-founded by Gunning—focused on the theme of religion and early cinema and featured screenings of many rare early Passion Play films like those I will discuss in chapter 3 of this book. Its proceedings were even collected into a bilingual, now regrettably out-of-print, 1992 collection entitled *An Invention of the Devil?*[61] The emergence of DOMITOR, and the rise in prominence of scholars such as Gunning, Hansen, Musser, and Gaudreault, brought historicist early film studies into the scholarly mainstream. Still, though the years since this first conference have blossomed with scholarship on the intersection of early cinematic form with race, urbanization, feminism, and even the tradition of magical theater itself, religion and secularism represent something of a lost thread. That early work on religion and cinema ought to mesh methodologically with the work currently being done in postsecular studies. The attention to technology, social crises, and form that scholars such as Modern, McGarry, and Fessenden have brought to nineteenth-century literature and popular culture is similar to the approach Gunning and the scholars of DOMITOR endeavored to bring to nineteenth-century cinema and the

era of attractions. However, very few scholars have picked up where the aesthetic of astonishment and the invention of the devil left off.

A promising version of a postsecular approach to film is emerging simultaneous with this book. The idea of *postsecular cinema*, as described by Mark Cauchi and John Caruana, "captures the work of those filmmakers whose films explicitly hover over that grey zone that dissolves the strict boundaries that are often established between belief and unbelief."[62] Whereas this book focuses on the historical convergence of early cinema and secularization, the work of Cauchi and Caruana focuses on the historical convergence of postsecular critique and a twenty-first-century international art cinema increasingly invested in matters of faith and materiality in the secular age. In their reading, postsecular cinema studies implies not only a methodological approach but also a fairly specific archive of texts and artists, anchored, in particular, by the work of Terrence Malick, Lars Von Trier, and their stylistic influences. This work builds on the popular disciplinary subfield of "religion and film," largely rooted in religious studies and practiced by scholars of religion and philosophy. This field has produced invaluable work in film studies, especially within film history and historiography, though it has not taken up the question of secularism in those terms until very recently. Recent work by Judith Weisenfeld, Terry Lindvall, and Cara Caddoo has done much to flesh out the industrial and cultural context within which Christianity intersected with film in its early period. And Priya Kumar's work on the nationalist-secular construction of the "normative spectator of popular Hindi cinema" outlines a useful model for the study of secularism and spectatorship. S. Brent Plate's short *Religion and Film: Cinema and the Re-creation of the World*, for its part, constitutes one of the best and most usable arguments for the convergence between film theory and theology as parallel narratives of world "creation" and re-creation. But, as Plate himself points out, much of the scholarship in religion and film utilizes what he calls a "spot-the-Christ-figure" approach to analysis, harvesting films for moral or theological content, but neglecting the complex relationship between medium, faith, and culture.[63]

The Disappearing Christ seeks to bring film studies into conversation with postsecular work at the level of form. Early cinema, as we now understand it historically, is a period during which social, technological, even phenomenological shifts in understanding were registered visually. Part of the argument of this book is that secularism itself can be a visible phenomenon. The postsecular historicism of Coviello, Hickman, Modern, McGarry, Fessenden, and the others I have cited in this introduction is a practice of excavating and revealing the intricate mediations of secularism at work in visual, literary, and material texts: the graphic diagrams of a phrenology manual, the spirit photography of William

Mumler, the poetry of Walt Whitman, or the novels of Harriet Beecher Stowe. The normative sociality of secularism becomes legible when scholars like these read it in these archives. This book contends that the shape of secularism is likewise visible in the formal negotiations of the silent era, and that film theories—whether the ecstatic primitivism of Vachel Lindsay, the historical formalism of Tom Gunning, or the phenomenology of Vivian Sobchack—have always been theories of the secular.

That being said, I realize, of course, that the largely Christian archive I read here is a limited one. This book focuses on visualizations of Jesus because these portrayals are a kind of aesthetic limit case, uniquely exposing the connective tissue of the secular age onscreen. I do not believe that the Christological texts I engage here are *representative* of secularism writ large—nor that American Christianity is representative of secularism writ large—but I do believe they can be *revelatory* indices of it. This book argues that the process of secularization becomes visible through the formal negotiations of early cinema, and I have provided a curated set of case studies as evidence. Moreover, in insisting on some common cause among film studies, visual culture studies, and postsecular critique, I am insisting on future possibilities beyond the small archive I trace here. This methodology, in other words, ought to be portable. In identifying—*seeing*—these mediations in film's earliest years, the ambition of this book is that it might unlock a way to read *for* the secular in film—not just in films about Jesus, and not just in films that discursively tackle the questions of the postsecular. I argue, for instance, that the balance and intermingling of trick and actuality aesthetics in early Passion Play films shed light on the way that film evolves as a disciplinary technology for what Tracy Fessenden calls the "nonspecific Protestantism" that underlies secularism in the United States. However, a similar methodology could easily be applied to early Hindi devotional films of this same period, likely with different implications for the life of secularism in turn-of-the-century India.[64] In a U.S. context, there is a great deal of work to be done on the way that the hegemonic Protestant optic I trace here shaped the early cinematic portrayal of Judaism, Islam, and Buddhism. It's no secret that representations of these faith traditions and their practitioners were tied to discourses of xenophobia and nativism in this period, demeaned and exoticized by the nominally secular eye of film. What might a postsecular approach to early U.S. cinema's orientalisms look like? Outside the period of early cinema and the daunting specter of American Christianity, possibilities like these multiply. Works by Bliss Cua Lim on temporality and haunting in pan-Asian cinema, Arnika Fuhrmann on queerness and Buddhism in contemporary Thai film, Jane Iwamura on virtual orientalism, and Birgit Meyer on Ghanaian Pentecostal video films have all recently demonstrated the usefulness

of understanding cinema's mediating role *between* religion and culture outside an American Christian context, even if they do not specifically deploy the vocabulary of the postsecular. Part of the argument of *The Disappearing Christ* is that the very form of film itself necessarily conceals an illuminating conversation about culture and belief. We need only look for it.

OUTLINE OF THE BOOK

I began this introduction with the tale of Christ's disappearance from the afterlives of *Ben-Hur*, and so the book begins in earnest by returning to the form and fortunes of *Ben-Hur: A Tale of the Christ*. The first chapter, "A Rare and Wonderful Sight: *Ben-Hur*'s Historicism," examines the collision and cooperation among scientific historiography, theology, and historical romance in the wake of the nineteenth-century American obsession with Palestine as the Holy Land. The chapter focuses on Lew Wallace's wildly popular novel, an audacious literary experiment in applying the precision of empiricist practice to the telling of a life of Christ. Reading the novel alongside both the romantic historiography of W. H. Prescott and what I call the "Holy Land Disappointment" genre of literary travelogue exemplified by John Lloyd Stephens, I argue that Wallace conceived *Ben-Hur* as work of visual historiography. In a culture explicitly at war over the sacred and the secular, *Ben-Hur* emerges as a high-wire synthesis, a modern gospel written *for* a skeptical American readership. Despite, or perhaps because of, the way Wallace constantly flags and fetishizes the dual work of rationalist inquiry and faithful devotion, *Ben-Hur* models a reproducible script for liberal secular belief.

The second chapter—"Looking Sideways: Media Theories of Jesus Christ"—moves from Lew Wallace's wide-angle historical fantasy and its proscriptions for secular subjectivity to the close-up Christs of Elizabeth Stuart Phelps's 1897 *The Story of Jesus Christ* and F. Holland Day's 1898 *Seven Last Words of Christ*. I consider the way both of these artists conceived of themselves as mediums for the life of Christ. In these works, we see two artists striving to reveal the mediations of secularism that Wallace sought to naturalize in his novel. Phelps, whose visual imagination established an elaborate and popular material eschatology in her earlier "Spiritualist Novels," produces an intimate Jesus, free of nearly all the scholarly trappings of Wallace, and argues that it is precisely her gender that allows for such immediacy with the figure. Day, for his part, engages the camera in close-up in order to channel something like a subjective vision of Christ's

suffering. The mediations of these artists—through feminist and queer lenses, respectively—polemically set up alternate paths outside of the normative sociality of secularism. Though neither can fully imagine a formal or social escape from the mediations that exclude them, they acknowledge this embeddedness with rare precision.

In Day and Phelps, we begin to see a vision of secular optimism rooted not in the improvisatory freedom of the middle realm but in the impulse to look critically, *look sideways*, at the mediations that constitute the immanent frame itself. But to imagine a visual culture rooted in this sort of critical distance is to imagine an alternate history in which cinema did not evolve as it did. My third chapter, "Tricks and Actualities: The Passion Play Film and the Cinema of Attractions," reads the emergence of cinema as the emergence of a truly secular medium. In particular, I examine the appropriation of the emerging tropes of cinematic realism in extremely popular early films of the life of Christ from the United States to Europe. The Passion Play films, especially in their representations of Christ's miracles, freely superimposed signifiers of realism and fantasy, modeling and containing the impulses of skepticism and belief by scripting their opposition. As Wallace's readers negotiated faith and reason, these early film spectators negotiated reality and its filmic representation through the miraculous visuals of the Passion Play film. In this early genre—and its tension between narrative and spectacle—we see the establishment of spectacular realism, the new media aesthetic of a secular age.

My fourth chapter, "The Double Life of Superimposition: W. E. B. Du Bois's Black Christ Cycle," juxtaposes W. E. B. Du Bois's multiple stories and illustrations of a "Black Christ" against the spectral white savior that appears at the end of D. W. Griffith's *Birth of a Nation*. Du Bois, I argue, mobilizes something like an aesthetic of attractions drawn from early cinema in order to disrupt the seamless narrative logic of white supremacy that Griffith conjures in his film. Griffith represents narrative cinema's original sin, the yoking of aesthetic innovation with the corrosive racial politics of the Jim Crow era; Du Bois represents the transcendent resistance to those racial logics, the formation of an African American modernism rooted in the mobilization and redeployment of volatile cultural forms. Between 1911 and 1933, Du Bois produced an illustrated, multiperspectival story cycle about Christ's presence in which an appearing and disappearing black Christ is positioned to critique the ambivalent relationship among violence, spectatorship, and Christian ethics in the Jim Crow South. Although Du Bois is already well known as a leader of the NAACP's social and political fight against *The Birth of a Nation*, I argue that the Black Christ Cycle's aesthetic resistance illuminates the way that Griffith's

vision of white supremacy—inherited from the Dunning school—is rooted in the violence of secularism. Du Bois imagines a postsecular aesthetic politics superimposed upon the birth of narrative cinema.

The book closes with a coda that considers the dynamic of appearance and disappearance that we see in this period as it reappears in our contemporary digital age. "Resurrectionists: Toward a Post-Cinematic Postsecular," tracks the use of spectacular special effects to represent the resurrection in Cecil B. DeMille's 1927 *The King of Kings* and Mel Gibson's 2004 *Passion of the Christ*. Seamless triumphs of narrative cinema, these films nevertheless hearken back to the cinema of attractions by staging resurrections that call attention to the technical possibilities of the film apparatus. I then turn to the question of whether the emerging discourse of "post-cinema"—which accounts for the spread of "cinematic" content across various digital platforms—can offer any ideas about the development of a postsecular cinema. If close attention to the spectacular aesthetics of early cinema can help us to theorize the secularism that evolved at that time, this last chapter suggests that contemporary narratives of the "death of film" can shed light on the current state of secularism in American culture. *The Disappearing Christ* contends that the labor of visualizing a modern gospel was—and *is*—the labor of secularism itself.

This book focuses on a transitional moment in U.S. culture. If the discourse of the postsecular has largely neglected the emergence of film as a medium, it has done so in part by also neglecting the period of American history after the Civil War and before World War I. Tracy Fessenden, Molly McGarry, and especially Lindsay Vail Reckson have paid useful attention to this period, but a vast majority of the monographs and articles associated with this postsecular gold rush in American Studies focuses either on the antebellum period or the years after the emergence of High Modernism. This was the time of Reconstruction and the Great Sioux War, the time of Jim Crow, the time of the professionalization of history writing and the intensification of feminist and labor movements, the time of X-rays, airplanes, and Kinetoscopes: it was a time defined as much by its traumatic crises as it was by the ways in which popular culture, Christianity, and the state collaborated to contain those crises by prioritizing order and unity over justice, reparation, and difference. Needless to say, the normalizing mechanics of secularism had a significant role to play in all of these movements. A broader consideration of this period's religious and secular scripts—*Secularism in Postbellum America*, perhaps?—has yet to be written. This book is a case study within that larger history. By focusing on the secular dynamics that can be found within the emergence of cinema, I do not argue that every writer or filmmaker studied here held the question of religious faith in the forefront of their minds. Nor do I

proffer a modified version of the modernity thesis, suggesting that the emergence of cinema is merely a result of secularism's growing hegemony. I do not imagine my subjects as either evangelists or unwitting accomplices.[65] Rather, I argue that, because cinema as a discourse has always been occupied with the management of skepticism and belief, the liberatory potential and integrative reality of cultural production, it is impossible that the medium itself does not carry the traces of secularism's norms and visions in its very bones. Cinema was born secular, and *The Disappearing Christ* is its nativity story.

I

A Rare and Wonderful Sight

Ben-Hur's *Historicism*

An admixture of historical romance and Sunday School fable, Lew Wallace's 1880 novel, *Ben-Hur: A Tale of the Christ,* was praised upon release for its meticulously accurate portrayal of the Palestinian landscape, its thrilling action sequences, and its reverent depiction of scenes from the New Testament. Wallace, however, wrote *Ben-Hur* without ever having set foot in Palestine. To correct this deficiency and write a fictionalized eyewitness account of the life of Christ without boarding a steamship across the Atlantic, Wallace turned to Holy Land travel narratives and works of sacred geography that extensively described important locations from the Bible, as well as German-made maps and archaeological documents that he had shipped from Europe at great expense. "In making [Palestine] the location of my story," he wrote, "it was needful not merely to be familiar with its history and geography. I must be able to paint it, water, land, and sky, in actual colors . . . I had to be so painstaking!"[1] For a fictional work, Wallace perceived that he might be held to a standard that transcended mere accuracy—the impossible production of "actual colors," not just mimetic representations. Thus, the story of the writing of *Ben-Hur* is not just a story of creative scholarship but of the notion that painstaking and faithful scholarship might yield something otherwise inaccessible to the reader.

Research, for Lew Wallace, was a transcendent act. Toward the climax of *Ben-Hur,* the narrator directly addresses his reader with a moment of apology for the dense narrative that came before. The narrator says that the long passages of historical and geographical detail that characterize the novel—from minutely described landscapes to elaborate discussions of Jewish custom—were

all written "in anticipation of this hour and this scene; so that he who has read them with attention can now see all Ben-Hur saw of going to the crucifixion—a rare and wonderful sight."[2] This passage articulates a direct link between the descriptive historiography Wallace routinely employs and a quasi-religious vision. It is also *Ben-Hur*'s narrative theory: a hybrid of historical, theological, and literary perspectives on narrative authority. The effective novelist, like the persuasive evangelist and the rigorous historian, enables readers to miraculously *see* the past.

Ben-Hur is a novel about the impossible possibility of becoming an eyewitness to history. In the nineteenth century, spurred in part by the claims of evidential theology—which prioritized the gospels as eyewitness accounts—and a broader cultural emphasis on the scientific and spiritual capacities of vision, thousands of American Christians sought to replicate this point of view. To see, as Wallace intended his reader to do, is an imaginative act theorized in resonant ways by the historian William H. Prescott and put into practice by thousands of nineteenth-century tourists in the Holy Land. For Wallace, to achieve faith in Christian revelation—manifest in the truths of the gospels, both material and ethereal—the reader must first attain knowledge of the history, geography, political context, and cultural dynamics of the period of early Christianity. In other words, true faith must be compatible with good history and vice versa. For the theologians of evidentialism, writing in reaction to European higher critics whose source criticism unsettled the authority of the evangelists, true faith was to be found in establishing the stability and credibility of those eyewitnesses. For Prescott, good history inhered in the ability to create a virtual experience of the past for the reader: in effect, to put readers in the position of the eyewitnesses themselves. While evidentialist Christians sought to reinforce Christian belief and Prescott wrote to excavate the histories of Spanish colonialism, their methodologies and priorities echoed each other. In this historical-theological discourse, then, the past was positioned as an object to be seen, and Wallace's highly descriptive narrative emerges from the fraught space of this discourse.[3]

Lew Wallace's eyewitness—a point of view leveraged between the reader in the present, the reader transported to the past by Wallace's narrative gaze, and Ben-Hur himself—is the impossible model of the secular subject. Although *Ben-Hur* the novel is animated by Ben-Hur the character's authoritative witness of these scriptural and nonscriptural events, it is also full of gaps, moments when the reader is asked to collaboratively imagine the experience of being near to Jesus in his time. Gregory Jackson has called this interactivity

the "substitutionary mode of readerly incorporation." For a Christian to read *Ben-Hur* was to engage with a text that functioned more like a board game than a traditional novel. The character Ben-Hur, in this reading, "stands in as a token readers occupy to fill in the missing interval with details from their lives, from, that is, Christ's story as *they* live it. They occupy Ben-Hur to occupy Christ, to occupy themselves as Christ."[4] This interactivity—the feeling of personalization, incorporation, and intimacy it might produce—was, of course, scripted. It was scripted by the synoptic gospel narrative, but, moreover, it was scripted within a set of methodologies that very pointedly depicted the contours of *modern* faith. Awash in a sea of descriptive ethnographic detail, metahistoriographical flourishes, and a suggestive slippages between accuracy and faithfulness, *Ben-Hur* asks readers to occupy a secular negotiation of the norms of rationalism and belief as much as they occupy a compelling renarration of Christ's life. Readers, aware of this constantly visible apparatus of interactivity, choose the way they supply details of their lives and prejudices and even opinions. This enshrinement of choice as a liberal ideal echoes Taylor's "nova effect" narrative of nineteenth-century secularism. But, within *Ben-Hur*'s literary economy—buttressed by evidentialism, romantic historiography, and the recreational skepticism of the Holy Land travelogue—every choice reaffirms Wallace's carefully constructed framework of how reason and faith, histories scientific and sacred, ought to support and mutually authenticate each other. To read *Ben-Hur*, then, no matter what one's theological perspective, was to practice at being secular.

Ben-Hur is not a visual text; it is, however, practically obsessed with visualization. It is exemplary (perhaps excessively so) of Elaine Scarry's characterization of literary prose as "instructions" for seeing. The profusion of descriptions of various kinds in *Ben-Hur* does not make it any more or less successful than any other nineteenth-century realist novel at generating a mental picture for readers. However, the novel's own self-conscious, metanarrative insistence on its status as a set of instructions or preparations or "necessary" descriptive detours is evidence of Wallace's impulse to teach, to tell, readers *how* to see. In this way, *Ben-Hur* exists squarely in the tradition of literary portraiture that was popular—especially, as Jefferson Gatrall points out, in the genre of the Jesus novel—at the time. Without claiming any actual transcendence of the words on the page, it's worth foregrounding the facts that Wallace's novel was composed with the popular idea that it would produce something analogous to a portrait of Christ, and that its ambitions were very explicitly framed—through this set of genre conventions, as well as Wallace's appropriations of both Prescott and Holy Land travelogue writing—as ambitions toward visibility. *Ben-Hur* would, of course, be an

important source text for films at three different crucial moments in the history of Hollywood cinema, but its impact would not be limited to the longevity of its story. Wallace's *Ben-Hur* is a set of practical instructions for a particular style of secular spectacle. In describing the "shrewd" crowds witnessing—and believing in—Christ's miracles and providing the testimony of Ben-Hur as eyewitness, Wallace theorized a model of spectatorship and belief that would become central to the era of early cinema.

This chapter tracks the way that a variety of sacred and secular discourses about the visual converge in Lew Wallace's historiography, ultimately producing a novel that could serve as a training manual for belief in a secular age. In the first section, I focus on the genealogy of *Ben-Hur*'s interest in the eyewitness narrative. Specifically, I suggest that Wallace's hybrid historical vision is indebted to two popular, though seemingly unrelated, discourses: the romantic historiography of William H. Prescott and the travel narratives of nineteenth-century pilgrims in the Holy Land. Wallace took from Prescott the idea that good historical writing ought to produce, for the reader, a visual experience of the past. His were secular works of scholarship, but they required a kind of imaginative faith from the reader, and Wallace saw the potential of this style for his tale of Jesus. At the same time, *Ben-Hur* was influenced by popular narratives of Holy Land travel. Although many travelers returned from pilgrimage to produce documents testifying to life-changing visual encounters with the locales of scripture, a few produced works of what I call "Holy Land disappointment," recounting an inability to bolster their faith through sight of the holy landscape. *Ben-Hur* seeks to mobilize Prescott's methodology alongside the Holy Land pilgrim's desire to see *and* believe in order to produce a synthetic, time-traveling narrative of Christ's life that will not disappoint modern, skeptical readers. This convergence, in other words, produces a model for how religious believers might adapt to the normative secular values of rationalism, pluralism, and individualism without practicing their beliefs in ways deemed overly superstitious or credulous. In the second section of this chapter, I finally turn to *Ben-Hur* in context of the popular genre of the life of Jesus. In its excessive detail and its metahistoriographical asides, *Ben-Hur* mirrors texts like Ernest Renan's 1860 *Life of Jesus*, which famously refers to the contemporary Palestinian landscape as "the fifth gospel," and which set a popular standard for the way a story about Jesus could mobilize both historical method and imaginative interactivity. *Ben-Hur* used the formal example of Renan and others to materialize Ben-Hur, Jesus, and the fifth gospel itself, crafting a new eyewitness narrative with all the apparent rigor of modern historiography.

HOLY LAND DISAPPOINTMENT: PRESCOTT, STEPHENS, MELVILLE

In an 1893 essay entitled, "How I Came to Write *Ben-Hur*," Wallace describes a writing process that is equal parts scholarly research and divine inspiration. After discussing the method by which he conducted research in Biblical geography for the book, Wallace presents a curious scene of writing from his home in Santa Fe:

> My custom when night came was to lock the doors and bolt the windows of the office proper, and with a student's-lamp, bury myself in the four soundless walls of the forbidding annex.... In the hush of that gloomy harborage I beheld the Crucifixion, and strove to write what I beheld.[5]

In this account, Wallace presents himself as both empiricist and visionary, faithful recorder of observable reality and beneficiary of special revelation. He is insistent on showing his work in terms of his elaborate research process, but he is also committed to a picture of artistic creation that is based in a special relationship to the divine. "I strove to write what I beheld," reads as an almost Howellsian profession of realist aesthetics, but what Wallace beheld was by no means a traditional object of realist study.[6] Here Wallace narrates the transcription of a vision as if it were a work of reportage. More than that, though, he positions the research process—which is not trumped or elided by his beholding of the crucifixion but transfigured by it—as the precondition of this experience.

This theory of the practically supernatural possibilities of research is reflected in the work of nineteenth-century historian William Hickling Prescott, a pioneer in the field of Latin American history and a primary influence on Wallace. In an oft-quoted letter written while he was composing his epic three-volume *The History of the Conquest of Mexico*, Prescott told a friend, "I am in the capital of Montezuma, staring out at the strange Aztec figures and semi-civilization."[7] Setting aside the unsettling racial overtones of this sentence—explored elsewhere by Eric Wertheimer—there are two remarkable elements of Prescott's letter that put it in dialogue with Wallace's vision of the crucifixion.[8] First, Prescott was not anywhere near South America when he wrote the letter. In fact, despite laying the foundation for nearly a century of work on Latin American and South American history, Prescott never traveled south of the border. Further, even if he had been standing at the vantage point he outlines, Prescott would not necessarily have had a clear view of what lay before him. As a result of an apparently high-stakes collegiate food fight at Harvard, William Prescott, like Homer and

Milton before him, suffered from extreme eye pain and was nearly blind for most of his adult life.⁹ Thus, we must understand that Prescott is not actually beholding the ruins of Montezuma's capital; rather, he is describing the experience of writing and research. Indeed, he follows the comment just quoted by explaining, "I received last month a rich collection of original documents from a learned Spaniard in London.... It is interesting enough to hold in one's hand the very letter written three hundred and twenty years since, by the celebrated emperor."¹⁰ Prescott is thus equating nearness to archival material with a visual experience of the past. Like Wallace, to fully understand the complexity of history is to attain a kind of new visual faculty.

Often grouped with George Bancroft and Francis Parkman as a U.S. "romantic historian," William Prescott—who would not necessarily have approved of that appellation—made his name as the author of massive, multivolume histories of Spain and colonial Central and South America. Though Prescott was by no means a pioneer or figurehead in any of the numerous innovations in historiography for which the nineteenth century is rightly famous, he was one of the most well-read of a generation of American scholars occupying an interstitial space between the amateur historians of the revolutionary period and the scientific historians who led the professionalizing charge into academia in the latter half of the century. Peter Novick, in his magisterial history of "objectivity" in U.S. historical writing, classes Prescott as a "gentleman amateur" who, despite his masterful work with original sources, was eventually rejected by younger historians for his distinctly "literary" style and clear moral prerogative.¹¹ Likewise, Eileen Ka-May Cheng suggests that although Prescott practiced a highly successful version of historiography that "brought together a belief in a truth that was independent of the historian's interpretation with a recognition of the subjective element of historical truth," this methodological balancing act made him hard to characterize among his peers.¹²

At the same time, works like his 1843 *History of the Conquest of Mexico* set a standard for the integration of archival research into narrative history. As Novick reports, Prescott was so frequently praised by scientific historians for his research methodologies that he was occasionally lumped in their number. Even today, though, Prescott's works read more like Sir Walter Scott than Leopold von Ranke, and this is primarily because of his unique style of narrative address and, most strikingly, his emphasis on capturing the experience of history: what it might have felt like to be present for the momentous events he records. As Cheng writes, these stylistic embellishments were consistent with a broader romantic theory of history as art: "To convey the truth of an event, the historian could not just relate what had happened in the past; he had to recreate the subject's

experience of that event and enable readers to relive that experience."[13] This urge to recreate the experience of the past is manifested in Prescott's work through a constant reference to the visual. From his elaborate descriptions of landscape and architecture, to scenes written from the imaginatively constructed point of view of historical actors, Prescott's representations of the historical past were a "consistently *seen* affair."[14]

This foregrounding of the visual was meant, of course, to present a vivid, accessible version of the past to the ordinary reader, but, according to John Ernest, it was also a necessary part of Prescott's theory of history writing. The imaginative leap from reading about the past to seeing it is not escapist or even magical but instead crucially rooted in the contemporary.[15] In other words, Prescott wrote history in order to reveal the relevance of the past, and by both placing his reader *on the scene* of that history *and* emphasizing the reader's rootedness in the present, the historian created the possibility for a bridge between the two times. Vivid history becomes a vehicle for self-reflection on an individual and societal level. In order for this to happen, for the moral juxtapositions in the text to strike a chord, the reader's imagination must be strongly activated by the historian. The reader must feel himself or herself to be a part of both this distant history and the present moment. "Visual" history is a euphemism for this kind of readerly involvement. This is at the heart of criticisms about Prescott's "romanticism" and political bias, but it is also what has made his writing so influential.

In this deft combination of archival rigor and imaginative faith, Prescott was thus an intuitive model for aspiring historical novelists—and Lew Wallace certainly was one of these. As a young man, he voraciously read *Conquest,* filling his copy with marginal notes and eventually learning Spanish in order to read some of the source texts, and his first venture into the realm of fiction-writing, *The Fair God* (1873), was a fairly direct stylistic aping of Prescott and novelization of his subjects.[16] Wallace drew both literary influence and historical methodology from Prescott's work. In particular, Wallace adapted from Prescott the impulse to help readers experience the events of history visually. As was noted earlier, during the production of his novel Wallace was gripped with anxiety that he be able to "paint" the scenes of the Holy Land in "actual colors." Specifically, he was concerned about his ability to render the landscape of the Holy Land. The first, and likely most crucial, reason that Wallace felt compelled to do justice to the landscape of Palestine was that his prospective readers, exposed to the dozens of Holy Land travelogues published throughout the mid-nineteenth century, would likely already be very aware of that landscape. Thanks to the nineteenth-century rage for Holy Land travel narratives, the American reading public was already awash in reported scenes of Palestine; thus, any new work,

fictional or otherwise, would presumably be held to the standard of popular texts like William Thomson's 1858 *The Land and the Book*.

Beyond this, however, Wallace's detailed attention to landscape was also seemingly influenced by Prescott. Writing in his *Conquest of Peru*, for instance, Prescott praises an early Spanish historian in this way: "By the vivid delineation of scenes and scenery, as they were presented fresh to his own eyes, he has furnished us with a background to the historic picture,—the landscape, as it were, in which the personages of the time might be more fitly portrayed."[17] Prescott deems this source important, in other words, because it is the document of an eyewitness, an account of what the past *looked like*. This priority is nowhere clearer than in Prescott's own descriptions of landscape, architecture, native vegetation, and even wildlife. In Book III, for instance, Prescott takes the opportunity of Cortes's long march into Mexico to luxuriate in long passages of geographical description that combined physical detail with evocations of the experience of Cortes's soldiers:

> Behind them, they beheld, unrolled at their feet, the magnificent *tierra caliente*, with its gay confusion of meadows, streams, and flowering forests, sprinkled over with shining Indian villages; while a faint line of light on the edge of the horizon told them that there was the ocean, beyond which were the kindred and the country, they were many of them never more to see.[18]

Not only does this passage give vivid descriptions of the *tierra caliente*, it endeavors to describe the scene at a particular moment in time and for a particular observer. He describes the "shining" villages and the light on the horizon, and he situates these subjective observations within the point of view of a homesick soldier longing once again to see Spain. Alternatively, Prescott sometimes eschews the perspectives of others in order to insert himself and the reader into a particular scene on their own. For example, in his epic description of Montezuma's aviary, Prescott uses the word "here"—a device Wallace appropriates for his own works—to call attention to individual birds, as if he and the reader stand before them together: "Here was the scarlet cardinal, the golden pheasant, the endless parrot-tribe with their rainbow hues."[19] These passages demonstrate the line between subjectivity and objectivity that Prescott nimbly negotiated. In terms of their temporality and visuality, these passages present impossible vistas for the modern reader, and yet, Prescott might argue, that does not compromise their faithfulness to the past or their accuracy as descriptions.

Prescott, in other words, wrote history from the perspective of the eyewitness— whether that eyewitness be the soldier in colonial Mexico, the transported contemporary reader, or Montezuma himself—regardless of his material access to such a

perspective. In this focus on the eyewitness, Prescott's history had much in common with what Hilton Obenzinger has called the "Holy Land Mania" of the nineteenth century in America, or the mass pilgrimage of thousands of American tourists to Palestine. The idea that the description of place was intimately connected with both the experience of history and the horizons of religious experience was becoming a very popular idea in the nineteenth-century United States thanks in large part to the increasing accessibility of transatlantic travel to Americans of means.[20] In the early part of the century, American scholars such as Edward Robinson traveled to the Middle East where they produced lengthy texts of sacred geography: works that traced the material narratives of the Bible in order to verify the accuracy of the gospels. More than that, as Robinson noted in the preface to his *Biblical Researches*, the task of sacred geography was performed *for* readers so that they might "judge of the opportunities for observation enjoyed by the travelers, as well as of the credibility of their testimony and the general accuracy of their conclusions."[21] So, with the proliferation of these texts, a large populace of Christian readers in the United States were trained to associate the authenticity of accounts of Christ's life with the material sites of the Holy Land. Naturally, these works also prompted waves of tourism to Palestine. Drawn to the geography of the Holy Land by the demands of a Christianity that insisted on the credibility of the "eyewitness" histories of the gospels, the tourists, as Melani McAlister puts it, sought to "see for themselves the proofs of authenticity of Christian narratives."[22] Out of this historical phenomenon emerged an entire archive of literature—from amateur Holy Land travelogues to academic works of "sacred geography"—that testifies to the great spiritual effects that can be wrought by walking in the literal footsteps of Christ.

In this aspect, Holy Land tourism owes a great deal to the emerging movement in Christian theology that E. Brooks Holifield has called "evidential theology," a movement occupied with seeking out and assessing the "proofs" of Christian revelation.[23] The Holy Land travelogue was a natural outgrowth of this theological movement, and while a large number of the authors of such books were amateurs, many of the genre's most popular practitioners were themselves evidentialist scholars and ministers. Edward Robinson, for instance, was a professor of geography and Biblical literature at Andover and Union Seminaries, and visited Palestine in the early nineteenth century in order to produce *Biblical Researches in Palestine and the Adjacent Regions* (1838). Robinson was meticulous in his "researches," and much of the text reads as dry academic writing, more documentary than devotional, but the work is also peppered with personal reflections on the journey that would not seem out of place in the journals of amateur travelers. For instance, Robinson wrote of being deeply moved by his first sight of Jerusalem: "From the earliest childhood, I had read of and studied the localities

of this sacred spot; now I beheld them with my own eyes; and they all seemed familiar to me, as if the realization of a former dream."[24] This travel was not only the fulfillment of childhood faith in the images of the scriptures but also the fulfillment of a lifelong academic study of the subject.

For Robinson, academic interest and personal faith were inseparable. The overt Christian tenor of these visions is even more apparent later in the text, describing Robinson's second visit to Jerusalem. He wrote this from the site of the Church of the Holy Sepulcher, at the site of Christ's crucifixion:

> The glory of Jerusalem has indeed departed. From her ancient high estate, as the splendid metropolis of the Jewish commonwealth and of the whole Christian world, the beloved of nations and 'the joy of the whole earth,' she has sunk into the neglected capital of a petty Turkish province.... The cup of wrath and desolation from the Almighty has been poured out upon her to the dregs; and she sits sad and solitary in darkness and in the dust.... That which our Lord wept over in prospect, we now see in the terrible reality.... How fearfully, and almost to the letter, this 'burden' of Jerusalem has been accomplished upon her, the preceding pages may serve to testify.[25]

Referring here to the oft-reported decrepitude of Jerusalem in this period as well as the apparently gaudy decoration of this holy site, Robinson was indeed disappointed. Here, though, that disappointment only serves to confirm Christ's prophecy of a "poor Jerusalem" degraded by time. Moving nimbly in this passage between Biblical language and first-person reportage, Robinson presented his account as a testimony to the transhistorical validity of the Biblical text. Scripture is not only confirmed by the sites of the Holy Land, it is imagined to be capable of forecasting the place's present state. What is remarkable about Robinson in this passage is not his belief in the material evidences of the Holy Land, but rather his unproblematic cross-pollination of the scholarly and the faithful. Robinson allowed the landscape to fortify both his research and his personal experience of Christianity. Like Prescott, Robinson chose to put his faith in sight.

As Melani McAlister writes, in regard to this Holy Land mania, "reality was never secured until it was positioned as an object to be viewed."[26] This reality, however, was not always reliably secured by tourists in Palestine. For all the impressed pilgrims like Robinson, there were plenty of writers whose experiences left them in a less than transcendent state. This was the experience of famous pilgrims such as John Lloyd Stephens and Mark Twain. In traveling to Palestine with the Biblical text and the promises of nineteenth-century Christian pilgrims in mind, these writers, in viewing the scenes of the Bible, found themselves let down,

deeply and spiritually disappointed, by the material claims of Christian popular culture. As often as the Holy Land reinforced the beliefs of tourists, "again and again, the shock of direct experience led travelers to a monumental deflation."[27]

One such disappointed pilgrim was the travel writer John Lloyd Stephens. Stephens begins his 1837 *Travels in Egypt, Arabia Petraea, and the Holy Land* by describing his arrival in Egypt. In the first few pages, he ruminates upon the dissolution of what he calls "the illusion of the distant view," or the brief impression that what one imagines is what one will actually see in these places of legend and myth:

> Indeed, it would be difficult for any man who lives at all among the things of this world to dream of the departed glory of Egypt when first entering the fallen city of Alexander; the present and the things of the present are uppermost; and between ambling donkeys, loaded camels, dirty, half-naked, sore-eyed Arabs, swarms of flies, yelping dogs, and apprehensions of the plague, one thinks more of his own movements than of the pyramids.[28]

In this passage Stephens describes an objectified modernity—"the things of this world," "the present and the things of the present"—that ultimately prevents the imagination of Cleopatra and Alexander from remaining foremost in the mind's eye. Traveling to the Middle East, adventurers hoped, with Orientalist fervor, that the objects of the past could conjure an image of the past. The hope was that one might behold in Egypt the mythical "Land of Egypt," not just material evidence of contemporary commerce. The "things of this world" were blamed for preventing travelers like Stephens from seeing the things of another world—the world of the imagination—and so the journey ends inevitably in disappointment. But this disappointment takes on a different character entirely when the objects beheld are not merely bazaars and monuments in Egypt, but sacred sites and relics in the Holy Land.

Stephens's tour through the Holy Land is suffused with an aesthetic of resignation. Stephens is indeed rather at peace about the repeated disappointment of failing to be awestruck or imaginatively transported by the sights and sites of Palestine, and it is in this spirit that he begins his chapters:

> Beginning my tour in the Holy Land at the birthplace of our Savior, and about to follow him in his wanderings through Judea, Samaria, and Galilee, over the ground consecrated by his preaching, his sufferings, and miracles, to his crucifixion on Calvary, I must prepare my readers for a disappointment which I experienced myself.[29]

Here Stephens refers to the gilded transformation of many of these holy sites by early Christian preservationists and Roman royalty, but the warning to readers sets the tone for his travels through these lands, and it is not only the weighting down of the manger with marble that thwarts Stephens's desire for transcendence. Beholding the "consecrated" ground of Jerusalem for the first time, Stephens admits, "All was tame and vacant. There was nothing in its appearance that afforded me a sensation; it did not even inspire me with melancholy."[30] Stephens meets the "appearance" of Jerusalem with numbness. The pilgrim wishes to be inspired by the sight of the Holy Land—to make real before his or her eyes the connection between landscape and holy text, between belief and experience— but Stephens's narrative reveals only the disappointment of those expectations.

This disappointment, however, as we know from Edward Robinson, is not a necessary reaction. Throughout his journey, Stephens notes that many thousands around him are moved by what they see. Here Stephens separates the act of viewing a holy place and the reaction of being moved by it. Speaking of Christ's tomb, Stephens records a revealing thought:

> If I can form any judgment from my own feelings, every man other than a blind and determined enthusiast, when he stands by the side of that marble sarcophagus, must be ready to exclaim, "This is not the place where the Lord lay"; and yet I must be wrong, for sensible men have thought otherwise. . . . The feelings of a man are to be envied who can so believe. I cannot imagine a higher and holier enthusiasm, and it would be far more agreeable to sustain than to dissolve such illusions; but, although I might be deceived by my own imagination and the glowing description of travelers, I would at least have the merit of not deceiving others.[31]

First of all, Stephens significantly links "blind" and "determined," suggesting that those who are moved by these sites arrive determined to achieve this sensation, but also that they must willfully deceive themselves—contradict their own vision—in order to do so. Those pilgrims who experience a transcendent sensation at the sight of the Holy Land, Stephens tells us, generate that sensation out of their own belief and out of their own desire to be satisfied, and not, fundamentally, out of what they see. Stephens does not denigrate those believers, but he insists on their primary status as believers rather than observers. These are "sensible" men, but the double meaning in this adjective adds a rueful irony. They are sensible inasmuch as they are well-studied and rational persons, but they allow their sense to be "deceived" by imagination and by the expectations for transcendence or revelation set out by the literature of Holy Land travelers before them.

Here Stephens is theorizing belief as a mode of seeing not solely reliant on visual stimuli: a sensibility masquerading as faith.

Whereas Stephens was in many ways a dispassionate observer—a kind of anthropologist traveling to Palestine as much to observe the pilgrims as to observe the ruins—Herman Melville traveled to Palestine in 1857 with much more hope for the experience. If Stephens adopted the tone of a debunker, methodically revealing a hoax, Melville's writing about the Holy Land is suffused with a tone of betrayal. "Wedged and half-dazzled, you stare for a moment on the ineloquence of the bedizened slab," he wrote of the experience in his journal, "and glad to come out, wipe your brow glad to escape as from the heat & jam of a show-box. All is glitter & nothing is gold. A sickening cheat."[32] This is Melville's Holy Land. It is not merely disappointing to the hopeful pilgrim. Instead, it is a place of almost theatrical deception. Melville describes an environment designed to stagger and impress the viewer. In the phenomenally descriptive phrase "half-dazzled," one gets the sense that there is an aggressively garish grandeur about the tomb. "Dazzle" in this context attains the quality of an active verb: the church dazzles its visitors in the way that a thief assaults a victim. Moreover, Melville, with casually grim wordplay, refers to the tomb as a "show-box," as if the whole ordeal were akin to a trip to the popular theater (a venue, not incidentally, that would cement the popularity of *Ben-Hur* in a few years). Finally, and most interestingly, Melville says that "all is glitter & nothing is gold." Though this is conceivably an accurate description of the low-price finery that bedecks the tomb, it is also a fascinating theorization of precisely how the deception of the Holy Land takes place. For Melville, the disappointment has to do with a distinction between form and substance, surface and depth. Christian tourists such as Robinson project the "glitter" of imaginatively constructed belief onto the otherwise empty surfaces of the Holy Land. Christ's tomb is easily made emblematic of that dynamic.

"No country will more quickly dissipate romantic expectations than Palestine," Melville wrote elsewhere. "To some the disappointment is heart-sickening."[33] Indeed, Melville's journey to the Holy Land in 1857 was so devastating that it haunted him for the rest of his career. Written in a merciless rhymed tetrameter, filled with passionate if occasionally indistinguishable characters, and oozing a kind of jilted rage born of personal experience, *Clarel: A Poem and Pilgrimage in the Holy Land* (1876) is the literary record of that "heart-sickening" pilgrimage. In the poem, which documents the spiritual and mental unspooling of a group of American tourists in Palestine, Melville presents alternately biting and despairing portraits of modern searchers for whom the sacred landscape reveals nothing but dust and death.

Melville's epic functions as a meditation on what he perceived to be the faulty premises of nineteenth-century pilgrimage, and while it was by no means as popular as Stephens's account, it offered a haunting evocation of the crisis at the root of the Holy Land disappointment mode. Specifically, *Clarel* is a reeling exposition of the limits of sight as a path to redemption. In the Holy Land tour genre, the believer is someone for whom the truths of faith are readily visible, but in Melville's wayward protagonist, we see the modern believer figured as someone for whom this project has failed. Although material closeness to the sites of the Holy Land may be able to conjure a temporary sensation of faith, for Melville these are futile attempts to "realize the unreal."[34] To structure spirituality in this way is to put faith in the corrupt body and impoverished imagination of modernity and thus to lose faith in a transcendent, transhistorical Christianity. Despite its status as a conversion narrative in reverse, Melville's poem is a critique of secularism. The linkage of vision, materialism, and faith that occasions and buttresses accounts of transcendence in the Holy Land scripts the encounter. Rather than providing access to some sort of otherwise inaccessible contact with a sacred past, the nineteenth-century pilgrimage renders that access too easy, too obviously constructed with the contemporary spectator in mind. To "realize the unreal," in this way, is the style of secularism.

Mid-way through the first book of *Clarel*, Melville describes the state of believers like Robinson:

> hearts in each degree
> Of craze, whereto some creed is key;
> Which, mastered by the awful myth,
> Find here, on native soil, the pith;
> And leaving a shrewd world behind—
> To trances open-eyed resigned—
> As visionaries of the Word
> Walk like somnambulists abroad[35]

Though not able to see Christ crucified on Calvary, Melville's narrative eye can see, with clarity, what he perceives to be self-deceived pilgrims. However, Melville goes one step further to describe these pilgrims as taking part in a performance of deception. Recalling the spiritualists and mesmerists whose writings and performances abounded at this time in Britain and America, Melville calls the pilgrims "somnambulists abroad," or dupes eager to leave behind a "shrewd world" in order to be controlled by the false science of the mesmerist.[36] To give oneself over to the kind of visionary transcendence proclaimed by Holy Land

tourists was to resign "open-eyed" to a trance: to willfully sacrifice not only one's senses but also one's autonomy. Melville perceives those believers as willing captives to a mass deception that claims transcendence but remains rooted firmly in the most contrived popular deceptions of this world. Four years later, Lew Wallace would publish *Ben-Hur: A Tale of the Christ*, an attempt to recuperate, bolster, and even expand the claims of Melville's "somnambulists."

Lew Wallace himself was a skeptic on religious matters. Although he later claimed that he found faith while writing the novel, his original conception of *Ben-Hur* was as a kind of precocious experiment: to create a novelistic account of Christ's life to which even a skeptic like himself could not object. (Apocryphally, the idea for *Ben-Hur* was said to have come about after a long train ride with the "Great Agnostic" Robert Ingersoll.) Wallace was well aware of the tradition exemplified in Stephens's account when he wrote *Ben-Hur*. As a result, I argue, the novel is preoccupied with creating an eyewitness testimony based in the historical optics of Prescott, reverse-engineering a virtual historical experience that would not feel, in the words of Melville, like a "sickening cheat." For Wallace, the key element of a successful eyewitness testimony would be the setting up and meeting of expectations. Given that the main challenge of Holy Land travel was the possibility that a pilgrim might see and not be moved, Wallace constructed his text as a counterpoint. Throughout *Ben-Hur*, Wallace ratchets up expectations for the sight of Christ and for the experience of his miracles, and, time and again, witnesses behold the man and his deeds and are moved by them. In communion with these witnesses, Wallace positions the reader to continually acknowledge and reaffirm both the descriptions he provides and the methodologies he uses. Wallace almost compulsively (compulsorily) asks the reader to visualize and be moved by the same union of materialism and magic that so disappointed Stephens and Melville.

NEVER LONG INVISIBLE: *BEN-HUR*'S EYEWITNESS NARRATIVE

While I suggest that *Ben-Hur* is indebted to the generic conventions of the Holy Land travelogue as well as to the almost mystical historiography of William Prescott, it is also, as a work of historical fiction, in dialogue with another divisive genre of the nineteenth century: the life of Jesus. The dozens of biographies of Christ's life produced throughout the middle of the nineteenth century led to a great deal of debate both between believers and skeptics and

within communities of belief as well. But these lives of Jesus did not simply produce theological upheaval: they also created a new mode of literary production. Featuring dense historical detail, with explicit, repeatedly stated, emphases on realism over myth, great attention to the landscape of the Holy Land, and a necessary tone of defensiveness against potential critics, the lives of Jesus published during this time codified what were essentially genre conventions that could be appropriated and revised as individual authors saw fit. These conventions appeared in biographies of Christ that sought to tear down and build up the higher criticism. It is natural, then, that these works might begin to resemble novels and that the genre of the Jesus novel would emerge in the mid-nineteenth century in Europe and America. As Jefferson Gatrall has exhaustively catalogued, the Jesus novel formalized these attributes of the lives of Jesus, usually placing an avatar for the reader in close proximity to the savior.[37] In this mold, Wallace's *Ben-Hur* was an exceptionally popular but prototypical example of the Jesus novel, a virtuosic naturalization of the assumptions about history, reason, and faith that structured the nineteenth-century lives of Jesus.

Among popular lives of Jesus during this time, the French Catholic Ernest Renan's 1860 *Life of Jesus* is perhaps the most instructive precursor to Wallace's text, not only in its appropriation of the Holy Land travel conventions, but also in its annexation of the novel form to tell the story of Christ. In the long introduction to his *Life of Jesus*, Renan praises previous works of Biblical criticism that allow the reader to "*see* [Biblical figures] living before us with striking reality" (emphasis mine).[38] More importantly, Renan cites his travels to the Holy Land as both the inspiration and necessary research for his composition of the Christ figure. He calls "the sight of the places where the events occurred" the "important source of information" at the center of his text.[39] In a memorable and oft-quoted passage, Renan refers to the Palestinian landscape as "the fifth gospel":

> All this history which at a distance seems to float in the clouds of an unreal world, thus took a form, a solidity, which astonished me. The striking agreement of the texts with the places, the marvelous harmony of the Gospel ideal with the country which served as its framework, were like a revelation to me. I had before my eyes a fifth Gospel, torn, but still legible, and henceforward, through the recitals of Matthew and Mark, in place of an abstract being, whose existence might have been doubted, I saw living and moving an admirable human figure.[40]

This extraordinary testimony to the importance of landscape in historical writing contains all the elements that are crucial to my reading of *Ben-Hur*. There is, first, the notion of place as evidence: history solidifies, becomes less doubtful, when

paired with the place of its happening. What's more, in the passage from his memoir about the crucifixion with which I began, Wallace theorized his research experience in much the same way: the emergence of "an admirable human figure" in the landscape. Wallace perceived his research materials as a fair substitute for Renan's "fifth gospel." Then there is the notion of place as supplement or accessory: the landscape becomes a text, the fifth Gospel, itself an eyewitness. Renan attributes this kind of centrality to the landscape elsewhere in his text. "[The shore of Gennesareth] was the center of [Jesus'] thoughts; there he found faith and love."[41] Christ's sense of his own reality was likewise rooted in place. Finally, there is the rhetoric of *seeing* Christ. For Renan, as for Wallace, dense description of this fifth Gospel was sufficient to produce the visible, living Christ. For those who could not make the transatlantic voyage, works like Renan's and Wallace's can provide the supplement, the evidence of the Holy Land's reality and thus the reality of Christ.

Ben-Hur: A Tale of the Christ begins with a long prologue that traces the journey of three men following a star to the manger of Christ's nativity. Of these three kings, one—Balthasar—eventually reappears as a supporting character in Ben-Hur's narrative, but, over and above the establishment of this figure, the prologue serves as an overture to the kind of description that characterizes the rest of Wallace's novel. As these kings wander through the sites of the ancient world, we see, through their eyes, a thoroughly researched vision of Palestine at the time of Christ. The novel literally begins with a description of a mountain—"The Jebel es Zubleh is a mountain fifty miles and more in length, and so narrow that its tracery on the map gives it a likeness to a caterpillar crawling from the south to the north"—but this geographical orientation is only a small taste of what lies within.[42] After five chapters establishing the identity and backstories of the wise men, Wallace comes upon the showpiece of *Ben-Hur*'s first book.

Entitled "The Joppa Gate," the sixth chapter of *Ben-Hur* serves as a theoretical introduction to and performative enactment of Wallace's theory of historical narrative. Moreover, it is a step-by-step guide to the way in which the novel constructs the position of the eyewitness. Wallace begins:

> Nearly three-thousand years have passed, and yet a kind of commerce clings to the spot. A pilgrim wanting a pin or a pistol, a cucumber or a camel, a house or a horse, a loan or a lentil, a date or a dragoman, a melon or a man, a dove or a donkey, has only to inquire for the article at the Joppa Gate. Sometimes the scene is quite animated, and then it suggests, What a place the old market must have been in the days of Herod the Builder! And to that period and that market the reader is now to be transferred.[43]

The first thing that strikes the reader about this passage is not necessarily its emphasis on descriptive detail. Instead, we perceive that the narrator of this passage has a very ambivalent attitude toward time and space. At the beginning of the passage, the narrator is in present-day (1880) Palestine. But, with a turn of phrase, "the reader is now transferred": reader and narrator seemingly travel back in time to the days of the nativity of Christ. *Ben-Hur*, in this way, does not seek to disguise the contemporary perspective of the narrator in order to conjure some sense of immersion or escape. The narrative perspective of *Ben-Hur* is always, explicitly, the present. Instead, it foregrounds the temporal distance only to constantly and conspicuously collapse it. It is through this manipulation of the novel's narrative temporality that Wallace enables his readers to become eyewitnesses, and that we come to understand this eyewitness perspective as a *contemporary* rather than a historical way of seeing.

Despite the fact that the narrative eye moves whimsically back and forth within time, Wallace still presses the urgency of the moment, the escapability of time. The singularity of the moment is crucial to the "understanding" that Wallace seeks to engender in the reader: "A passing acquaintance with the people of the Holy City will be necessary to an understanding of some of the pages that follow.... Better opportunity will not offer to get sight of the populace."[44] This passage is explicitly narrated from a distance of three thousand years, yet it affords a sight of a real historical scene. Also, for the first time, we read a passage in which foreknowledge—"a passing acquaintance"—is necessary for an understanding of the miraculous "tale of the Christ." Wallace thus casts the task of narrative storytelling, of evidential realism, as itself miraculous.[45]

Despite the supernatural time travel, this is all very blandly touristic. The reader is pulled hither and yon to afford the best "sight" of any given event, in the same way a tour group is given tips on the best vantage points from which to behold a certain vista. The propulsive motion of the narrative is motivated by the relative ability or inability to see a particular thing. This active, opportunistic aesthetic remains throughout the text except in moments when Wallace signals that something is, in fact, "necessary" to behold. This serves as a representative passage for a technique used repeatedly throughout the text: in order to "understand" the following narrative, it is "necessary" to see these people. Wallace, in this instance, functions as both tour guide and research assistant. The visibility of the Palestinian populace (the reader's mental picture of this people, crudely objectified as elements of scenery) is an indispensible element of an understanding of the Christ narrative, for Wallace. This is not the only occurrence of the trope. Elsewhere a brief discussion of Jewish politics is prefaced with "a few words on the subject ... are essential to such as may follow the succeeding narrative critically."[46]

Also, of course, there is the passage (quoted earlier) in which Wallace admits that parts of the first book were "written to give the reader an idea of the composition of the Jewish nationality as it was in the time of Christ. They were also written in anticipation of this hour and this scene so that he who has read them with attention can now see all Ben-Hur saw of going to the crucifixion."[47] In this context, we might imagine the rest of the novel—the romance, the geography, the ethnography—as *necessary* research for that tale. Wallace is not just taking us on a time-travel tour of the Holy Land: he is engineering for us a vision of Christ's passion using all available resources.[48]

In the rest of "The Joppa Gate" chapter, Wallace goes on to foreground the reader's physical, material presence in the scene as a frame for the rest of his description. "A little mixing with the throng," he casually notes to the reader, "will make analysis possible."[49] Again, we see the union of vision and analysis, the intellectual act and the act of faith. The reader must observe the "throng," not as a set piece erected by the author, but as a pre-existing scene to which the author provides a view. To "mix" is to become intimate with, to become inseparable from, the subject of the narrative. A little later on, the narrator declares, "Here stands a donkey, dozing under panniers full of lentils, beans, onions, and cucumbers, brought fresh from the gardens and terraces of Galilee."[50] Wallace, echoing Prescott, makes a spatial reference ("here") that is incomprehensible unless the reader joins with the narrator in imagining a space. For the scene to become visible, even in light of the mass of detail, "the reader's fancy must come to his aid."[51] These strategic gaps in narrative force the reader, already inundated with physical detail, to fill in *more* detail. Moreover, this passage emphasizes the fleetingness of the moment, and in so doing enhances its specificity. The produce is brought "fresh" from gardens and terraces. The reader is asked not simply to behold a *typical* scene. Instead, the reader is asked to behold and join in producing a specific, fully formed, credibly described moment, a moment at which this ancient Galilean produce has not yet reached its sell-by date.

As we can see, Wallace's construction of the eyewitness—his transformation of the reader into an eyewitness—is more complicated than the mere mobilization of a rhetoric of the visual. Instead, *Ben-Hur* draws the reader into the compilation of detail. Wallace provides so much description that it would be easy to imagine the reader to be overloaded, but this occasional strategic omission forces the reader to provide yet more information. The Joppa Gate scene is thus as comprised of the reader's own imagination of the scene as it is of Wallace's research, and the novel's constant reference to what is "necessary" or "essential" for the reader to know positions the narrative as a collaborative system between reader and narrator. In this way, it would be easy to imagine a kind of interaction

operating in the text, along the lines of the "spiritual sight" that Gregory Jackson describes in works of homiletic fiction. Indeed, according to his definition of the homiletic novel as one that uses Protestant hermeneutics to engender a virtual experience for the reader, *Ben-Hur* rather neatly fits this generic categorization.[52] *Ben-Hur* provides a plethora of detail, thus surmounting the gospel accounts in its impression of historical authenticity, but it also provides the bare bones of Christian history. The reader must bring to the table only faith. However, it is not merely religious faith that is required. Rather, the reader must bring faith in the archive, faith in the details Wallace provides, and faith in the scholarly research process he used to uncover them. *Ben-Hur* is not a didactic text. If anything, it satisfies the popular desire for an aesthetic of the operational. Wallace provides everything you need to feel as though you've made a decision for yourself. It is, in this way, a paean to the choices that are so central to liberalism. *Ben-Hur* is a workbook for secular agency, all the more so because its aesthetic of interactivity is so transparently artificial.

As Wallace repeatedly noted, however, all of this geographical detail and cultural history is prelude to that "rare and wonderful sight" of the crucifixion, of Christ himself. Midway through the novel, Wallace tells us:

> Henceforth to the end, the mysterious child [Christ] will be a subject of continual reference; and slowly though surely, the current of events with which we are dealing will bring us nearer and nearer to him, until finally we see him a man—we would like, if armed contrariety of opinion would permit it, to add—A MAN WHOM THE WORLD COULD NOT DO WITHOUT.[53]

Reading this passage—momentarily sidestepping the fact that Wallace uses capitalization as if he's commenting on an Instagram post—and recalling the "anticipation" with which Wallace refers to the crucifixion, it is easy to imagine that the narrative momentum of *Ben-Hur* is built around gaining sight of Jesus Christ. All of the matrices on which *Ben-Hur* is built—its temporality, its spatial imagination, its visual detail—are understood to be irresistibly drawn toward the sight of Christ. Even though Christ is only occasionally glimpsed in the actual pages of *Ben-Hur*, a reviewer from the *Los Angeles Times* is right in suggesting that his presence in the tale is like a "shadow of the cross" that is "never long invisible" to the reader.[54] The possibility and assurance of *seeing* Jesus Christ is the central force of Wallace's narrative. This is, of course, a figure for the way in which Christ's story—by the time we "see him a man," the narrative of the Passion will already be in motion—structures the development of the novel. But this statement is also a statement of the novel's form and priorities. Ben-Hur's trajectory

does not merely mirror Christ's; indeed, Ben-Hur takes a veritable tour of the Roman Empire as a prisoner on a galleon and a chariot racer, while Christ moves quietly into his public ministry. Instead, his every movement is meant to bring the reader within a close-enough distance to witness the crucifixion.

Despite reveling in this anticipation and the slow "current of events," Wallace is peculiarly uninhibited about revealing the face of God throughout. Indeed, *Ben-Hur* contains a frankly surprising amount of physical description of Jesus. As Jefferson Gatrall describes it, "Wallace's portrait is among the most detailed physical descriptions of the historical Jesus in the nineteenth century."[55] Granted, he only appears in the text on a few occasions, but each of these is accompanied by at least a paragraph of physical description. In the most lavish instance, Wallace offers nearly a page and a half of detail about everything from the savior's face—"eyes, dark-blue and large . . . softened to exceeding tenderness by lashes of the great length sometimes seen on children, but seldom, if ever, on men . . ."—to his clothes—"an undergarment full-sleeved and reaching to the ankles, and an outer robe called the talith; on his left arm, he carried the usual handkerchief"—to his hairdo—"long, and slightly waved, and parted in the middle, and auburn in tint, with a tendency to reddish golden brown where most touched by the sun."[56] To the person of Christ Wallace devotes the same attention that Prescott devotes to the landscape of Mexico. Thus, the appearance of Christ becomes part of the text's evidence. The accurately described period dress historicizes the figure, and the facial features humanize him. The physical presence of Christ is thus folded into the same narrative that, with authority and confidence, describes the landscape. Christ, as miraculous a character as he is, is also, like the landscape of Mexico or the customary dress of Jews in the first century, a natural fact.

Wallace presents his narrative duty as one that clears away what he calls "the countless obscuring processes of time."[57] Wallace, in other words, proclaims his desire to create a text that allows unmediated access to the past, even as his narrative style is that of a constantly interjecting tour guide. Throughout the text, Wallace is preoccupied with the act of making visible, with performatively clearing away any obscuring forces that may threaten to compromise a clear view of the period. *Ben-Hur* must produce the experience of the eyewitness, not simply describe it. Wallace, for instance, narrates the appearance of the star of Bethlehem to the shepherds in this way:

> And this was what they saw. A ray of light, beginning at a height immeasurably beyond the nearest stars, and dropping obliquely to the earth . . . its core a roseate electrical splendor. . . . The khan was touched luminously, so that those upon the roof saw each other's faces, all filled with wonder.[58]

The passage begins with the direct statement "this was what they saw." *This* is what they saw: this text, this description constitutes and replicates their vision. Wallace rhetorically removes any mediation here. Obviously, he *is* describing the scene, but his language endeavors to collapse his description and the event. Moreover, the final line of this passage—they "saw each other's faces, all filled with wonder"—confirms the vision by confirming that it is shared. These shepherds are witnesses to the miracle *and* witnesses to each other. The wonder on the faces of the shepherds is as much an evidence of the divine as the star itself. The reader is thus invited, on various occasions in the text, to join in communities of witness.

Another crucial element of this passage lies in the phrase "roseate electrical splendor." This line refers to the light of the star, but it does so somewhat anachronistically. The shepherds of the New Testament would likely not have seen such a star and thought of the wonder of electricity. A group of shepherds—or readers—in the nineteenth century, dimly aware of rapid advances in electrical engineering that had occurred over the course of the past eighty years, and conversant with accounts of electrical motors displayed at world's fairs, however, might have analogized the star in such a way. Wallace, in this passage, annexes one of the largest contemporary sources of "wonder" to describe this scene from the first century. This dynamic of analogy is repeated throughout the text, and serves not to distract the reader from the revelations of the Holy Land, but to aid their modern understanding of the enchantment of the story as well as the story's desired sense of immediacy. Wallace frequently makes reference to the continuity of the experience of Palestine—the streets of Jerusalem appeared "then as now," he writes—and, in an even more blatant way, he often proffers comparative historical analyses.[59] This collapsing of time is a central tool in Wallace's construction of the eyewitness perspective, just as it was for Prescott.

Wallace does not, however, deliver every miraculous event so directly to the reader. It is a notable feature of Wallace's novel—one that is certainly in line with its priority, not of reproducing the miraculous narratives, but of producing a credible witness to them—that in *Ben-Hur* there are no descriptions of the miracles that are not either narrated by Ben-Hur himself or experienced by his family. "You are shrewd men," Ben-Hur says to a group gathered debating the issue of Christ's divinity. "What would you say of a man who could be rich by making gold of stones under his feet, yet is poor by choice?" The crowd asks how he could be sure such a man existed, and Ben-Hur answers thusly: "I saw him turn water into wine."[60] Christian social ethics make a brief cameo appearance in this line, but they are ultimately only supplementary to the main point that Ben-Hur is

an eyewitness to the miracles. The reader has not seen, because Wallace has not described, the miracle of water turned to wine. Again, though, Wallace's narrative scheme is not dependent upon our ability to see the miracles. It is rather dependent upon Ben-Hur, whose vision we understand to be credible and even modern, to see the miracles.

This is the true beginning of Ben-Hur's arc toward conversion. While Wallace's protagonist is, nominally, an ordinary Judah living in first-century Palestine, that is not entirely how the reader perceives him. Wallace makes a great show of telling the reader that his flamboyant historiographical apparatus is whirly-gigging its way across the novel's pages in order to prepare the reader for the sight of Jesus, but this is a bit of a misdirection. Because we are so often tethered to Ben-Hur's consciousness—because he is our avatar here—Wallace's methodology begins to adhere to him. Wallace makes no claim that Ben-Hur is somehow clairvoyant about the secular critical-historiographical discourse of the late nineteenth century, but every description of his psychology and life is routed through that discourse and seen by virtue of its lens. Thus, when Ben-Hur converts, when he becomes a believer, his belief scans as contemporary. Ben-Hur's own "shrewd" mind is, in many ways, a mind constructed with modern tools. To place him at the scene of Christianity's foundation is to naturalize that style of faith all the way back to its origins. In one way, we might interpret this novel as presenting a conversion from secular to sacred, but what we actually behold is the sanctification of secular reasoning.

A few pages later, we are put face to face with the healing of the sick. As the ultimate fulfillment of our "anticipation," the archetypal scene of faith rewarded materially, Wallace makes lepers of Ben-Hur's mother and sister, only to have them healed by Christ himself. After a long scene in which Ben-Hur's family members are accosted by raging mobs, Christ enters the scene. He is, of course, immediately recognized by the faithful lepers: "She [Ben-Hur's mother] also beheld his face—calm, pitiful, and of exceeding beauty, the large eyes tender with benignant purpose."[61] Wallace then produces the following dialogue, drawn largely from the scriptural text:

'O master, Master! Thou seest our need; thou canst make us clean. Have mercy upon us—mercy!'

'Believest thou I am able to do this?' he asked.

'Thou art he of whom the prophets spake—thou art the Messiah!' she replied.

His eyes grew radiant, his manner confident.

'Woman,' he said, 'great is thy faith; be it unto thee even as thou wilt.'[62]

Ben-Hur's mother and sister then examine themselves, only to proclaim that they are healed. As if to crown this performance, Wallace makes sure to tell us: "To this transformation . . . there was a witness other than Amrah . . . there will be little surprise at learning that the young Jew [Ben-Hur] was present when the leprous women appeared."[63] Little surprise, indeed. So this too is an eyewitnessed event, and it is no less astonishing than any of the other miracles Ben-Hur beholds. "His heart stood still," Wallace tells us, "he became rooted in his tracks—dumb past outcry—awe-struck."[64]

In this scene and elsewhere in the novel, Wallace makes it a priority not to hide the evidences under a bushel. Whenever a miracle occurs, whenever faith is rewarded, Wallace presents Ben-Hur as eyewitness among a community of other converted eyewitnesses. (It's important to note that Ben-Hur, despite being moved by every encounter with Christ, does not understand the figure as the messiah until fairly late in the text.) Like the shepherds, whose wonder-struck faces verify each other, the scene of the crucifixion, "the rare and wonderful sight," is also witnessed en masse. This technique is the last of the arrows in Wallace's quiver, as he aims to disrupt narratives of disappointment. To have a private vision is one thing, but to share a vision—as the Holy Land tour groups aim to do—is something else entirely. A shared experience is, in this sense, the most verifiable kind.

Nearing the final book of *Ben-Hur*, the book most concerned with the Christ narrative, Balthasar and Ben-Hur behold Christ together, the figure pointed out by none other than John the Baptist. "At the same instant, under the same impulse," Wallace writes, "Balthasar and Ben-Hur fixed their gaze upon the man pointed out, and both took the same impression, only in different degree."[65] This scene is a direct prelude to the longest stretch of Christ description in the text. Not only, then, is the gaze of Ben-Hur set up as the frame for this description—the eyewitness that enables it to occur—but that gaze is also verified against Balthasar's. Though this is by no means an objective gaze, it is at least a gaze that is consistent throughout the crowd, "the same impression, only in different degree." After providing some description, Wallace interrupts himself to cast back to this consensus again:

> These points of appearance, however, the three beholders observed briefly, and rather as accessories to the head and face of the man, which—especially the latter—were the real sources of the spell they caught in common with all who stood looking at him.[66]

Dozens of times, the narrator instructs the reader to "look" or to turn in a certain direction, observe a certain occurrence, but never when Christ is present. It is

only ever Ben-Hur who sees this man, and Wallace who transcribes his observations. We see Christ in the same way that followers of evidential Christianity saw him and in the same way Prescott's readers beheld the *tierra caliente*: through readerly interaction with an eyewitness account. Furthermore, this eyewitness account is fortified, in part, by its status as part of a consensus. Ben-Hur, in this scene, is under a "spell": he feels some amount of transcendence beholding this figure, but it is a spell that he has "caught in common." Ben-Hur is the key eyewitness, but he is not the only one. Indeed, what we behold in these moments is less a unique and original vantage on the story of Christ than the spectacle of large groups of people *seeing in the same way*. There are dozens present, and dozens more present at the various events of Christ's life, from whom Wallace compiles testimony. They all see the same thing: the "same impression, only in different degree." Not only is *Ben-Hur* a training manual for secular belief, it is also a demonstration of its normative impulse, its power to create communities out of adherence to sometimes contradictory stimuli. No one here is converted through intense consideration and debate; these conversions occur compulsorily, with natural, inevitable ease. Together, for Wallace, these scenes produce a synoptic account of secularism.

GARFIELD MINUS JESUS: *BEN-HUR* IN PICTURES

In 1891, Harpers Publishers put out a two-volume illustrated edition of Wallace's novel. The volumes had gold-stamped covers and gilt edges, and every single page of text was accompanied by elaborate ornamental illustrations by the artist William Martin Johnson. In addition to this, the volumes featured a full-page portrait of Wallace and a reproduction of a fan letter sent to the author by President James Garfield, who would later appoint Wallace the U.S. ambassador to the Ottoman Empire based on his assumption that Wallace's knowledge of the East would provide him great insight into diplomatic relations with Turkey. In terms of this chapter's argument about the inherent visual dynamics of *Ben-Hur* and what they suggest about American secularism at the end of the nineteenth century, this illustrated edition—or Garfield Edition, as it came to be known—is of great interest. What is even more significant is that, in addition to the exterior ornamentation and elaborate imaginative illustration seeking to represent details from the scenes of Wallace's novel, the Garfield Edition features nearly twenty full-page plates that show contemporary photographs of Palestine, the fifth gospel itself. Beginning at the Joppa Gate, Wallace time-travels on a whim and

grounds his reader very emphatically in the present moment. These photographs reproduce that movement: the scenes we read are descriptions of first-century Palestine, yet the images presented are contemporary.

Despite this overabundance of visual art in the Garfield Edition—art that would assault readers whether they beheld the volume as an object, read its pages, or even flipped through and landed on the heavy-stock photograph plate pages—there is a conspicuous absence. In the nearly one thousand drawings that decorate each page of the text, representing everything from chariots and galleons to pots and pans, there is no attempt to represent Christ's face, which, as we know, is elaborately described in Wallace's text. As we also know, this was only the first of many instances of the disappearance of Christ from adaptations of *Ben-Hur*. What remains in the Garfield Edition and in the films that followed it is a focus on what Wallace refers to as the "accessory" details of his narrative: the material detritus of first-century Palestine. Images clutter the pages and become a part of the reading experience of the book. As Theodore Hovet describes this experience, the Garfield Edition enables the reader to "read without looking; to look without reading."[67] In other words, to read the Garfield Edition is to be forced, page after page, to reconcile the act of reading and interpretation of words with the recognition and interpretation of images. Likewise, to watch these films is to take in a landscape and mise-en-scene sanctified by a presence rarely, if ever, seen. Moreover, it is to conflate, transhistorically, the sacred past of Christianity with indexical images of the Holy Land in the present.

The photographs reveal the Garfield Edition to be an edition particularly in tune with the structural hybridity of a book that understands itself to be a true miraculous narrative and a reliable history at the same time. Nevertheless, this hybridity is not just a local feature of the text. *Ben-Hur* is a document of this scripted negotiation between faith and the idea of the visual. To look for transcendence in the phenomenal world was to set oneself up for disappointment, but to root one's faith in an unseen past was quickly becoming untenable for modern Americans. *Ben-Hur* offered an attractive middle way: a visual narrative bolstered by the signifiers of contemporary historical method and anchored by belief in the gospels that asked readers for the imaginative faith required to become eyewitnesses themselves. Despite, or perhaps because of, the way Wallace invites readers to interact with the novel, to make choices within it, to visualize based on descriptive prompts, *Ben-Hur* manages the expectations of those readers, constructing a frame in which certain types of evidence are satisfying and others are not, certain professions of faith must be met with respect and others with scorn. That *Ben-Hur* works against disappointment toward eliciting a *feeling* of satisfaction in this account of the holy landscape or that description

of Christ's face—that it registers approval of these methods through positive affect—is its most significant innovation. I have said that *Ben-Hur: A Tale of the Christ* is a training manual for secularism, and this is how that works. When readers of *Ben-Hur* encounter the kind of rationalist belief Wallace constructs for them at the convergence of Prescott, Renan, and the Holy Land travelogue, above all, it just might *feel* right. The next chapter turns to two artists in the late nineteenth century for whom this style of secularism felt wrong.

2

Looking Sideways

Media Theories of Jesus Christ

It wasn't that hard to see Jesus in America in the last decade of the nineteenth century. Despite the conspicuous absence of Christ's face from the Garfield Edition of *Ben-Hur* and Lew Wallace's somewhat hilarious prohibition against the embodiment of the savior in stage adaptations of his novel, images of Jesus were not particularly scarce, nor had they been since the middle of the century. As David Morgan has extensively catalogued, the last third of the century was a boom time for mass-produced picture cards, classroom textbooks, gift books, and elaborately illustrated lives of Christ.[1] However, the images of Jesus Christ circulating by the 1890s were not limited just to illustrations and reproductions of religious fine art: photographers had begun to train their cameras on religious models with increasing frequency.[2] American travelers visited Oberammergau, Bavaria, in 1880 (and again in 1890) and returned to the United States with elaborate photographic slide lectures that narrated the famous Passion Play they had seen performed there. In 1897, the first of many Passion Play films—depicting the birth, life, and death of Jesus—was exhibited in the United States. (I discuss both of those phenomena in chapter 3.) Most remarkably, in 1898, the Italian amateur photographer Secondo Pia took the now-famous photograph of the Shroud of Turin which—in its negative format—appeared to reveal the previously invisible face and body of Jesus. The now-iconic image and the attendant controversy over its veracity circulated around the world. Though photographers were certainly more comfortable with the visualization of Christ than was Lew Wallace, these photographic experiments echoed that novelist's desire to put the idea of the historical Jesus into contact with modern technologies of representation. The revelation of Jesus in the 1890s could, in some ways, be understood as a documentary process, or, at least, a process aided and abetted by new technologies of vision, historical research, and mechanical reproduction.

Still, not every savior was the subject of such a documentary process. After traveling to Europe to witness the 1890 production of the Oberammergau Passion Play, for instance, the young photographer F. Holland Day returned to his home in Massachusetts thrilled and ready to embark upon what a friend referred to as his "Modern Sacred Art Affair." Day researched Biblical costumes and customs, scoured books of religious art, starved himself, and, between 1896 and 1898, took more than two hundred photographs of himself as Jesus Christ. This elaborate scholarly preparation might suggest a more traditional nineteenth-century Christological project like Wallace's, but Day's photographs betray a different sensibility. The images, even the most picturesque vistas, are spare, and while their detail may be exacting, it is not copious. Day's Christ is ethereal, but he is also intimate, personal in the truest sense. Indeed, the most affecting and well-known of his works from this period, the 1898 *The Seven Last Words*, consists of a series of seven close-ups of Day—head bedecked in a crown of thorns—in soft focus, with all but the face blurred almost beyond recognition. Day may have intensely researched his "affair," but the scientific precision and anatomical attention to physiognomic detail that characterize other works of art, scholarship, and even literary fiction about Christ in this period are missing.

While Day was at work on his Christ series, the popular novelist Elizabeth Stuart Phelps published *The Story of Jesus Christ: An Interpretation* (1897), her nonfictional narration and harmonization of the gospel stories. *The Story of Jesus Christ* is superficially unremarkable. It shares with many of its forebears and contemporaries a vaguely "personal" approach to Christ inherited from American sentimental literature and available in other similar works such as Henry Ward Beecher's 1871 *The Life of Jesus, the Christ*. It is also illustrated in a conventional late-nineteenth-century style, with plates of European masters, popular Biblical illustrators, and photographs of the contemporary Middle East interspersed in its pages. It is, however, much like Day's photographs: a uniquely intimate portrait of Jesus, not especially reliant on the "scientific" historiographical work that buttressed the accounts of her peers. Indeed, though Phelps's preface makes sure to offer a disclaimer that the author consulted relevant historical sources and was well-versed in the contemporary genre to which she was contributing, the book glides free of the groaning weight of ethnographic, archaeological, and even physiological description that characterized comparable works, from the Holy Land travelogues to Renan to Beecher to Wallace. What's more, amid the proliferation of fictional and nonfictional renarrations of the life of Christ in the United States in this period, Phelps is among the very few to adopt an omniscient third-person point of view that deems itself able to narrate Christ's psyche. Phelps stops short of imagining the world from Christ's first-person

perspective—though, as we shall see, she comes awfully close—but nevertheless, *The Story of Jesus Christ* is defined by an intimacy with its subject. Like Day, Phelps pictured her Christ in close-up, deliberately blurring the lines drawn by scholars and novelists who sought to render "scientific" the method of the Christ biographer.

Day was a photographer and Phelps a novelist. Their "portraits" of Christ share neither a medium nor, likely, a common religious point of view. What they do have in common, however, is both a resistance to the common scientific approach to the life of Christ and perspectives outside the norm for artists seeking to visualize this figure in America. In chapter 1, I outlined the way in which Lew Wallace endeavored to produce a "visual" historiography by positioning the reader as a kind of impossible eyewitness to the events of the gospels. Wallace appropriated the scholarly style, metanarrative flourishes, and demographic descriptions of the biographers of the higher criticism, and his romantic pivot sought to give readers the idea that these descriptions were theirs, that they were seeing through the eyes of those anonymous historical figures who once stood in front of the Joppa Gate or beheld the crucifixion of Christ. By no means an immersive work of fiction (Wallace interrupts his own storytelling enough to forfeit this aspect), *Ben-Hur* functions importantly as a novel that sought to give the reader a place, a natural vantage point, within the text itself. In line with other "Jesus novels" of this period, *Ben-Hur* is animated by what Jefferson Gatrall calls a "perspectivalism," turning readers, if only rhetorically, into spectators and fleshing out their vision by means of literary portraiture indebted to the historiographical advances of the nineteenth century.[3]

As I have also argued, however, this narrative system contributed to the hegemonization of the "secular"—as a reconciliation between liberal rationality and what Tracy Fessenden calls a "non-specific" Protestantism through the metaphorics of "vision" or "sight"—in this period that has since been critiqued by scholars of the postsecular turn. In this chapter, I argue that Day and Phelps anticipate this more contemporary critique, registering their objections to writers like Wallace both polemically and through their own metaphorics of sight and vision. Day's fuzzy-edged, soft-focus images, and the emotionally, if not physically, detailed descriptions of Phelps resist and refigure what I have identified as the aesthetic markers of a secularism beholden to the convergence of science and faith, enlightened skepticism and belief. Beyond that, these critiques are rooted in sexuality and gender. As Shawn Michelle Smith has argued, Day's Christ photos evoked "the Passion of Christ to register Day's passions, drawing homoerotic desire into view in its invisibility."[4] His Christ is animated, in part, by the confrontational spectacle of Day's queer form embodying this sacred iconography.

In turn, Phelps—a vocal feminist activist—beyond portraying the kind of "feminized" Christ that had become conventional in biographies and sermons earlier in the century, repeatedly contended that her subject is only visible through her point of view as a woman. Her Christ, in other words, is a unique product of a female gaze. Unlike Wallace and many other writers of this period, Day and Phelps turned away from the promise of "objectivity" and embraced their own subjective experience as a lens through which to render Christ visible. These artists refused the space between themselves and Christ and sought to expose mediation through their intimacy with it.

Jesus Christ, according to both artists, had been communicated to readers and viewers of the nineteenth century by way of bad *media*. In 1906, writing about the past century of advances in Biblical criticism, the historian Albert Schweitzer wrote, "There is no historical task which so reveals a man's true self as the writing of a Life of Jesus."[5] By the 1890s, however, those revelations had become increasingly rote, highly conventional, and predictable. For Phelps, those "media" were the overwhelmingly male authors of lives of Jesus, limited by their gender and their commonplace assumptions about how religion ought to be adapted to the challenges of modernity. For Day, in a more literal sense, the medium was photography itself. The camera had come to be understood as a tool for documenting reality, but Day saw how it could become a tool for accessing something that transcended documentation. Pinpointing the failure of the media of Jesus Christ—which, for Day and Phelps, was the failure of "scientific" approaches to both photography and history—is also a way of pinpointing secularism's failure of inclusion, its denial of agency, its inescapable mediation under the sign of immediacy.

Neither of these works are acts of radical resistance—both Day and Phelps were artists of immense privilege, and, while certainly influenced by Spiritualism, their works bore hardly any of its overt political import—but they both provide something like a counterpoint to the style that developed in Wallace and that would later thrive in motion pictures. Charles Taylor describes the believer in a secular age who "cannot help looking over [his or her] shoulder from time to time, looking sideways, living [his or her] faith also in a condition of doubt and uncertainty."[6] Whereas Taylor might suggest that each glance sideways offers a road not taken—a road that possibly *could* be taken—postsecular critics might instead argue that this looking sideways, with its suggestion of choice without the actuality of radical deviation, encapsulates the problem and condition of secularism. I slightly reappropriate this phrase here to name the impossible deviations Phelps and Day endeavored to make in their works. Rather than a mechanism of secularism, I argue that this style of looking sideways presents an aspirational

critique of its norms. In so doing, I yoke Taylor's phrase with another usage. Kathryn Bond Stockton, in her book *The Queer Child, or Growing Sideways in the Twentieth Century*, conceptualizes "sideways relations, motions, and futures" as queer modes of accessing a kind of freedom or growth when normative outlets for these impulses are blocked off. "Our futures," she writes, "grow sideways whenever they can't be envisioned *as* futures."[7] To varying degrees, then, I argue that Phelps and Day, whose access to the immediacy of revelation was restricted by their gender and their sexuality, imagine a future by *looking* sideways. They provide, in other words, an imperfect pre-vision of the postsecular, a set of alternate paths for the inevitable secularization of Jesus in this period. It wasn't hard to see Jesus in America at the end of the nineteenth century, but F. Holland Day and Elizabeth Stuart Phelps saw him differently.

In this chapter, I consider the way both of these artists conceived of themselves as mediums for the life of Christ. I begin with a consideration of the ways in which the concerns that animate Phelps and Day's work are ultimately concerns of mediation. Drawing on histories of this period that foreground the "promise of immediacy" in nineteenth-century theological writing, as well as on scholars of religion and media in the contemporary moment, I argue that any theory of secularism must inevitably also be a theory of media. I then turn to Phelps's *Story of Jesus Christ* as itself something like a "vernacular" theory of secularism and media. Looking to her popular *Gates* trilogy of novels as well as her lifelong fascination with Spiritualism itself, I argue that Phelps frames her biography as specifically a new "mediation" of the Christ story. From the men who've told the tale to the scholarly apparatuses they've performatively applied to it, the story of Jesus Christ has been communicated by way of mediums who are not equipped to fully understand it. Phelps presents herself as a new medium for this old narrative. *The Story of Jesus Christ* tells a story that is well in line with the "normative sociality" of secularism in this period, even as it works hard to unmask the gendered construction of that frame. Finally, I turn to Day, who becomes perhaps the most unusual medium for the visualization of Christ. Following his recent recovery in art history as a pioneer of homoerotic photography, I argue that what Shawn Michelle Smith calls his "politics of pictorialism" can also be read as an act of formal resistance to the normative sociality of secularism. By blurring the edges, veiling the precision that helped characterize photography as a scientific, documentary form, Day illuminated the constructedness of those conventions. Day's photographs reframe the way his contemporaries imagined Christ to intersect with modern life by having his images actively resist the aesthetic conventions and reading practices that characterized photography at the time.

MEDIA THEORIES OF SECULARISM

The question of agency is a fundamental question of postsecular critique. Charles Taylor's criticism of the secularization thesis rests in his contention that, rather than a decline in religion, the secular age saw a proliferation of new options on a religious-secular spectrum. Although many Americans in this period undoubtedly perceived their world in this way, the question remains as to what extent these choices were ever really choices at all, and not ultimately conditioned by the inescapable laws of secularism's immanent frame. This is also, in ways large and small, a question that animates the work of Day and Phelps. Specifically, they recognized that the conventions that governed their media were themselves conditioned by certain ideas about the relationship between religion and science; between art and reality; between gender, sexuality, and the sacred. To make even "artistic" choices like these, when dealing with the representation of Christ, is to face this question rather directly. Both Day and Phelps framed their work as the rejection or at least critique of conventional mediations of the Christ story as conventional mediations between the artist and the divine. In doing so, they endeavored to imagine a way of figuring this mystical, historical character outside the array of "choices" presented to them as artists in the late nineteenth century. This argument does not posit the revolutionary success of either Day or Phelps in this regard, but it does suggest that both Day and Phelps were seeking—to various degrees—to render visible the invisible forces that conditioned the choices they made. Is it possible to escape the socially constructed boundaries of the medium in which one works, whether that medium is the photograph, the novel, or the immanent frame of secularism itself? To try to sort out these various contortions, one would need something like a media theory of secularism.

Mediation has been a galvanizing subject for scholars of secularism in the nineteenth century. John Lardas Modern, for instance, traces what he calls the "metaphysics of secularism" back to the importation and adaptation of Scottish Common Sense reasoning by various evangelical movements in the antebellum United States. For Modern, Common Sense spread based on its "promises of immediacy and transparency," as well as its emphasis on the self-reflective management of feeling.[8] Evangelicals who appropriated this system considered themselves able to accurately perceive the will of God—and, indeed, calibrate their own perceptions of that will—without external mediation. "Common Sense," Modern writes, "assumed that every human was endowed with the capacity for radical reflexivity and epistemic independence, that is, to become immediately aware of the process of awareness as the basis of objective knowledge."[9]

Even within this definition of *independence*, then, we see the foundational problem of secular agency. In the logic of Common Sense reasoning, there was no necessary mediation between the rational mind, the surrounding phenomenal world, and God. The "immediacy" of this style of reasoning thus led to the establishment of laws that were deemed "natural" precisely because they were presumed to have been arrived at freely and without outside influence.

Gregory Jackson argues that this theological emphasis on immediacy translated, in the nineteenth century, into what he calls "homiletic realism." In its scripting of the relationship between faith, knowledge, and sight, this uniquely pedagogical Protestant literary style ended up influencing many of the literary realisms that historians and critics would eventually identify in purely secular terms. At the heart of this style is what Jackson calls an "aesthetics of immediacy," which consists of "visual language, the personalization of religious narrative and doctrine, and the evocation of intense emotions, especially fear."[10] In essence, the aesthetics of immediacy constructed virtual experiences for the reader—particularly geared toward child and adolescent readers—who could both feel an identification with the sacred past and be instructed in the scripts of good religion.

Of course, even this "immediacy" was necessarily mediated. It was certainly productive of new forms of mediation, some of which became regimented through the development of hybrid scientific discourses that could speak to both faith and reason. Phrenology, for instance—the pseudoscientific analysis of the face and cranium—emerged in the mid-nineteenth century by joining the Common Sense desire for radical reflexivity with the scientific promise of total, unmediated objective knowledge and updating the centuries-old practice of physiognomy for a new age. Its popularity grew as it entered into a kind of amplifying feedback loop with the new liberal theologies of Unitarianism in New England, and its influence spread through the circulation of the *American Phrenological Journal*. Yet, the laws that governed this field of study bore the unmistakable marks of both the racism and the misogyny of their time, and, in turn, developed in order to shore up and police such racial, sexual, and gender-based hierarchies. What could be perceived through such examination was easily mapped out and circulated, too quickly limited and rigidified by an array of interpretive combinations and recombinations. This immediacy was enabled only by willful or unwitting blindness to the way one's perceptions of the world are always already mediated. "Immediacy," then, merely came to imply certain types of mediation, certain styles of influence, even certain perceiving subjects.[11]

However, the impulse—the promise, at least—was to achieve freedom from such external structures. Indeed, the emergence of Spiritualism provides a case study of the limits and possibilities of such liberation. In the early nineteenth

century, Spiritualism evolved alongside the general "democratizing" ferment of the second Great Awakening by presenting a counterintuitive, though compelling, option: to reject mediation in favor of becoming a medium oneself. Beginning in the 1830s, a growing number of women and men (mostly women) throughout the United States claimed that they were able to communicate with the dead. In this early period, these communications took place as spirit rappings, unexplained knocks emanating from walls or tables and made in response to direct questions; as the movement gained steam, the communications moved to the séance table. Believers would visit spirit mediums in the hopes of contacting—through haunting sounds, possessions, the expulsion of ectoplasm—their cherished, passed-on friends and relatives. Eventually, such communications became concretized through the evidentiary medium of the spirit photograph (about which more in chapter 4). Spiritualism never became institutionalized (no churches or official creeds), but it represented, for a moment, a popular negotiation of science and religion, the desire to achieve immediate communication with the divine through the possibilities of mediumship itself.

This phenomenon was virtually ignored by historians for much of the twentieth century, but, over the past few decades, Spiritualism's rise and fall has come to represent something like an exemplary counterhistory of secularization. In 1989, Ann Braude historicized the female spirit medium as a figure at the center of the movement for women's rights and suffrage; Catherine Albanese described Spiritualism as one of her "metaphysical religions" that offered a rejoinder to the largely male, largely conservative ferment of the early nineteenth century; and the "mechanics of transcendence" supposed by Spiritualist mediumship form part of a dynamic conversation about mediation and immediacy in John Lardas Modern's telling.[12] Spiritualism's countercultural position made it a uniquely helpful lens for scholars skeptical of the secularization thesis as it had been posed.

For Molly McGarry, the rise and fall of Spiritualism is something like a laboratory for the study of how the number of Taylor's "options between belief and unbelief" came to be artificially limited by an exclusionary politics of secularism. As both an early prod in the theological conversations that produced what Modern sees as antebellum secularism, as well as a belief system eventually understood to be a threat to "true religion" by the end of the century, Spiritualism ran the gamut from margin to mainstream and back to margin again. "The resilience of Spiritualism," McGarry writes, "brings into focus the historical specificities of the marginal and local forms by which dominant practices were resisted, deflected, or shown to be imperfectly constituted."[13] Spiritualism, in other words, remained non-normative even as the religious ideas that grew up around and

with it became institutionalized in American culture. To trace its fortunes was to trace the processes by which secularism became hegemonic.

By the twentieth century, Spiritualism was being portrayed by its detractors—and debunkers—as a false faith, a superstition, even a malady. But, despite these characterizations, the resistance Spiritualism represented was not characterized by a rejection of modernity, a fleeing into "premodern" mysticism to escape the present. Rather, Spiritualism is interesting to scholars in this postsecular moment precisely because it refused to choose. To be a scholar of Spiritualism is to be forced to contend with its contradictions, its desire to reconcile science and religion, skepticism and belief. The history of Spiritualism, McGarry writes, is "one which elucidates the ways in which both insides and outsides, cultures and subcultures, depend on stable demarcations at the same time that they refuse this opposition, each showing itself as containing the defining characteristics of the other."[14] Acknowledging the boundaries of the secular, even to step outside of them, is to reaffirm their existence. The Spiritualist embrace of mediumship, born from the same desire for immediacy as other antebellum religious movements, began to seem excessive as it stretched later into the century. As the virtues of radical reflexivity and self-awareness became naturalized in evangelical discourses to the point of disappearance, the hypervisible media of Spiritualism were left behind by mainstream Protestants and academic scholars alike. As McGarry provocatively asks, "Does magic decline, or does it just seem that way to academics?"[15]

What the case of Spiritualism suggests, for our present purposes, is the necessity of discussing the media through which secularism establishes itself at the same time that we acknowledge that secularism is itself a medium: the structuring medium of both belief and unbelief in this period, despite and perhaps because of the fact that it must inevitably disappear. In the seminal 2001 collection *Religion and Media*, the philosopher Hent de Vries suggested that, in the globally networked twenty-first century, there is a "virtual interchangeability" between religion and media. For instance, he argues that scholars would do well to take seriously the often casually proposed idea that the cinematic "special effect should be understood against the backdrop of the ... miracle." Theorizing cinema's supernatural charge in contemporary society alongside the idea that the miracle has, historically, been characterized by an emphasis on technique or technology, he claims, "would complicate matters, correcting a simplistic opposition between realms we only wish could be kept apart."[16] In light of this, the idea that there is some fluidity between religion as it is practiced and media as it is consumed or engaged with in the digital age has not only an attractive utility, but also a compelling resonance with discussions of nineteenth-century secularism.

The anthropological field of religion and media has come to be very interested in transposing the same questions of mediation and immediacy that vexed nineteenth-century evangelicals into a world of film, television, and online streaming. Much of this theorizing is indebted to scholars of visual culture such as W. J. T. Mitchell. As Mitchell writes, among his ten maxims for media theory, "There is always something outside a medium. . . . Every medium constructs a corresponding zone of immediacy, of the unmediated and transparent, which stands in contrast with the medium itself."[17] In other words, the construction of such a "zone of immediacy" is itself inevitably a process of mediation. To read, in the films and works of literature addressed in this book, found narratives—what Mitchell would call the "vernacular" theory—of secularism is to see media the way Mitchell describes them here. Mitchell variously refers to media as "both a system and an environment" and as "the invisible Matrix or the hypervisible spectacle, the hidden God or his incarnate living word."[18] Media, in these formulations, might as well be described as immanent frames. A photograph or film or novel can thus be a symbol of secularism, a microcosm of the secular age, and one of the main technologies or mechanisms of the secular itself. This is a theory of media and/as secularism.

From this theoretical perspective, the binary between immediacy (that which must be achieved) and mediation (that which prevents immediacy) that structured something like Common Sense reasoning is impossible to sustain. When does a medium disappear, and when is it impossible not to see? When does an artist, a theologian, a preacher, a filmmaker draw attention to the act of mediation, and when does that act slip out of the frame? As Birgit Meyer puts it, in the space of contemporary religious practice, "mediation and immediacy do not belong to two opposing realms but are intertwined."[19] This mutual imbrication, I argue, is as central to the relationship of religion and media at the turn of the twentieth century as it is at the turn of the twenty-first. Hence, to understand these practices, one must necessarily trace the shifting *performance* of mediation. At least in the practices Meyer studies, media tend either to become forcibly naturalized and thus invisible, or they become "hyper-apparent" as a part of the event or text. Mattijs van de Port makes a similar point. As he puts it, contemporary religious practices must always be concerned with "mediating immediacy," and so, like Meyer, he suggests that such practices toggle between two modes: "In the first mode the medium is 'naturalised' to the extent that it is no longer experienced as a medium. In the second mode, the mediation process is flauntingly revealed and highlighted for what it is."[20] Referring to the quite literal trend of constructing technological objects—telephones, calculators—out of transparent casing, Van de Port calls this second mode "plexiglass aesthetics."[21]

This is not a phenomenon unique to *new* media. These ideas are indeed reflective of very contemporary negotiations of religious experience and mediation in an age of viral media and ubiquitous technology, but I argue that they also provide a valuable framework for discussing the management of these same questions at a much earlier period in media history. Van de Port writes that "revealing the medium is not to opt for the real of mediation practices ('mediation is all we have'), it is to enhance the mystery of the immediate, to produce a sense of its superior power and truth."[22] To focus on mediation or, alternately, to endeavor to make it fully disappear, is a way of framing the promise of immediacy, while not necessarily denying its possibility. What Van de Port describes is not a phenomenon unique to the digital age. Indeed, it would not be inappropriate to apply such a characterization to the rhetorical acrobatics of antebellum adapters of Common Sense, and Modern even goes so far as to suggest that both literal and figurative "networks" were essential to the spread and stabilization of secularism at mid-century.[23]

To suggest, then, that Day and Phelps are both "mediating immediacy" in their work is not to suggest that they are fundamentally out of time, but rather that their work reveals the long history of such negotiations. Crucial to both Phelps's writing and Day's photographs is the performative stripping away of external apparatus in order to refocus on their own personal mediation of Christ. This process, even as it prioritizes immediacy as a goal, makes the medium itself central. Phelps loudly rejects the traditionally male mediation of the Christ narrative—thus spotlighting the fact of its mediation in any case—even as she strips away the body of biblical scholarship, the authorizing citations, the metanarrative flourishes that festoon the works of her peers. In the context of presenting herself as a new medium for the story of Jesus Christ, she produces a narrative in which mediation is made to disappear. Day, for his part, strives to make his acts of mediation hyperapparent. He makes aesthetic choices that deliberately work *against* what was perceived as the camera's evidentiary potential. He blurs images that might otherwise be precise; he positions the camera far enough away from his subjects to stymie physiognomic analysis but close enough to prevent informative geographical study; he frustrates the Christian searcher and the scientific diagnostician alike. He works against the naturalization of the camera by emphasizing the way in which every image bears the mark of its artist's hand. What Day and Phelps resist are the conventions that mark other texts with the imprimatur of good, rational, even "true" religiosity. These are not radical deviations from the normative spectrum of nineteenth-century secularism, but neither are their choices made wholly within the lines. Day and Phelps prompt us to look sideways at the practice of mediation itself and all of its social, spiritual, and even aesthetic valences.

A NEW MEDIUM: ELIZABETH STUART PHELPS

Elizabeth Stuart Phelps's 1868 novel *The Gates Ajar* tells the tale of Mary Cabot, a grief-stricken young woman who has lost her brother Roy. As the novel begins—it is told by way of Mary's journal entries—our narrator seems less grief-stricken by Roy's death than she is by the idea that she might never be reunited with him as they were on Earth. She has no doubt that her beloved brother has earned his place in Heaven, but, in the terms of her evangelical upbringing—the mouthpieces of which are the aptly named Dr. Bland and Deacon Quirk—Heaven is, as Mary conceives of it, a real drag. "Roy," she writes, "away in that dreadful Heaven, can have no thought of me, cannot remember how I loved him, how he left me all alone. The singing and the worshipping must take up all his time."[24] This "dreadful Heaven" is an ethereal, disembodied place, where all of the familiar structures, social networks, and even personalities of Earth are replaced by eternal (interminable) singing and praying and floating around. Mary's worry is not that her soul will never rest with Roy's but rather that she will never "really see him . . . as I saw him here."[25] In that place, as it had been described to Mary, we are no longer ourselves. Thus, even as Mary believes in the promise of eternal life, Roy's death represents the very real end of their relationship as she knew it.

Soon, though, Mary is taken under the wing of her Aunt Winifred, and Winifred has some different ideas about the afterlife. Throughout the course of *The Gates Ajar*, Winifred engages in a series of Socratic dialogues in which she ironically chastens literalist interpreters of the Bible by describing a materialist vision of the afterlife that not only serves as a continuation of life on Earth but the perfection of it. In Heaven, Aunt Winifred reassures her young auditor, Roy will be the same Roy he was when he sat in the parlor: he will have the opportunity to engage in meaningful work, and he will both remember and cheerfully greet his loved ones when they finally join him. Winifred's Heaven is wholly compatible with the ideal vision of earthly domestic harmony that Roy's untimely death disrupted. As the novel proceeds, Winifred's disquisitions on the subject take shape as something like a vernacular theory of Biblical hermeneutics, pitched against the ministers of the church, whose orthodox commitment to the literal interpretation of scripture—especially the symbolic infrastructures of the Book of Revelation—has led them to some nonsensical assumptions. To argue that the Bible confirms that there will be harps, but no pianos, to play in Heaven seems, to Winifred, the height of lunacy. Scholars who take such a position are both bad readers and bad communicators of God's truth.

The book and its two sequels were a massive success, but they were not necessarily warmly received by Protestant critics. Reviewers at the time were offended by Phelps's intensely materialist and pleasure-oriented interpretation of Christian eschatology—Winifred might be right about the pianos, but perhaps focusing on Heaven's mise-en-scene misses the theological point—and many contemporary scholars have been no less unkind. Phelps's novels have long been read as anti-intellectual, morally irresponsible, and grossly consumerist. She is, for instance, one of the targets of Ann Douglas's famous polemic against the "feminization of American culture," in which she argues that writers like Phelps represent the dissolution of what had formerly been a robust intellectual tradition.[26] Douglas characterized *The Gates Ajar* as a "bribe" to readers, a denial of reality, and a dumbed-down perversion of her father Austin Phelps's Calvinist conceptualization of Heaven "as a place."[27] "What in her father's strained but brilliant mind," Douglas writes, "was a concept borrowing the consoling indistinctness of fantasy, in the daughter's equally overwrought and sensitive consciousness became fantasy usurping the authoritative outline of the concept." In other words, Phelps's[28] work was not only wrong, it was corrosive.

But Phelps has been recovered somewhat since Douglas narrated her folly in this way. For many, the scholarly treatment of writers like Phelps has produced a "subtraction" narrative of its own.[29] In her defense of Phelps's exasperated approach to Biblical hermeneutics, for instance, Gail K. Smith suggests that readings like Douglas's strip writers like Phelps not only of their authority but also their potential nuance. "We have tended," she writes, "to portray evangelical women writers either as subversive heroines in an age bent on repressing them, or as agents of the degradation of formerly rigorous literary and theological standards."[30] Moreover, focusing on Phelps's management of theological argument distracts, as Nancy Schnog writes, from the way the *Gates* trilogy provides a fine-grained treatment of women's mourning in the aftermath of the Civil War. "What these depictions appear to reveal," she writes, "is Phelps's insight into the damaging emotional effects of a culture whose dominant forms of sympathy aimed to regulate and control the shape and expression of women's feelings."[31] In approaching Phelps, one must necessarily take into account the myriad ways in which the intellectual debates of American theology interacted with the lived experience of believers in a time of crisis. Phelps, I argue, improvised around the margins in this period, never fully rejecting, but never fully assenting to, either the theological framework or sexual politics of her youth or the scientific rationalism of her adulthood. Indeed, her work evinces many parallels with another marginal improvisation at the convergence of Christianity, sex, and science: the American Spiritualist movement.

Throughout her life, Phelps was fascinated with Spiritualism, but remained ambivalent about what role it ought to play for the Christian believer. While she would subtly renounce her father's and grandfather's Calvinism in her life and work, Phelps would never renounce her ancestral faith enough to claim that she was a Spiritualist. Still, the topic was never far from either her attention or the context of her reception. Indeed, her 1896 autobiography is even prefaced with an anecdotal disclaimer that the author is most assuredly *not* a Spiritualist.[32] The book begins with the somewhat well-known story of her grandfather, Eliakim Phelps, whose house was apparently possessed by spirits (one of whom allegedly communicated from the beyond the gates in order to request a piece of "squash pie") for a time in 1850. Phelps, perhaps facetiously, suggests that *this* is the reason why she is so often asked if she is herself a Spiritualist. (Certainly these inquisitors asked her the question because of an obscure anecdote associated with her grandfather and not, instead, because Phelps had been, for thirty years, one of America's foremost imaginative surveyors of the hazy space surrounding the gates between this world and the next.) Her answer is, "No; nor none of our folks!"[33] But she immediately expands this disavowal in a way that jibes more with our contemporary sense of her books as readers:

> That the phenomena were facts, and facts explicable by no known natural law, he was forced, like others in similar positions, to believe and admit. That he should study the subject of spiritualism carefully from then until the end of his life, was inevitable. But, as nearly as I can make it out, on the whole, he liked his Bible better.[34]

The implication is that Phelps, like her grandfather, does not count herself a skeptic in terms of the possibility of such supernatural occurrences on this side of the gates, but that such "facts" are not sufficient for her to reorient her belief system. One might even say she appropriated elements of Spiritualism and repurposed them. Nina Baym suggests as much when she says that the contours of Phelps's Heaven, though perhaps unfamiliar to the extraordinarily broad readership of *The Gates Ajar*, would have been very familiar to anyone who had read or heard descriptions of "Summerland," the Spiritualist afterlife.[35] The *Gates* trilogy is structured around the kind of porous boundary between life and death preached by Spiritualists, spirit mediums occur with some frequency in her stories, and Jesus himself occasionally appears as a spirit manifestation, but Phelps is always clear that her stories are meant to reaffirm the traditional values of Christian love and charity and Biblical study. In other words, as Roxanne Harde suggests, Phelps "validates spiritualism's phenomena, but undermines it as a spiritual tradition."[36]

Spiritualism was one of the many avenues Phelps pursued in rejecting the Calvinist doctrines that structured her adolescence, but it never replaced Christianity itself as the structuring force of her adult life.

All that said, *The Gates Ajar* is a story about mediumship. It is not so clearly focused on an avowed spirit medium, as some of Phelps's earlier tales were, but it is nevertheless centered around the idea of Winifred as a figurative medium: a means of communication between the facts of the afterlife and the facts of earthly existence. Winifred has read her Bible, she has read her Biblical scholarship, she has consulted the great theological minds of her generation, and she has come away with a belief—albeit one based on "analogy and conjecture"—about what Heaven is like. Her narration of that Heaven, however, is confident and detailed, and feels almost experiential at times. She has not seen Heaven herself, but she has perceived its reality and conveys that reality with authority. Like Phelps, who never saw the ghostly occurrences at her grandfather's home but nonetheless granted them the status of "facts," Winifred gives Mary access, a window, into another world. Phelps's two sequels to *Gates Ajar*—*The Gates Beyond* and *The Gates Between*—go far past this *figurative* mediumship to present the first-person narratives of deceased protagonists. If Winifred is analogous to a medium in *The Gates Ajar*, then the remaining two volumes make Phelps herself a medium, albeit to a fictional afterlife.

It's worth noting that, even given the somewhat heretical spirit of the *Gates* trilogy, it is difficult to position Phelps as a prophet of the postsecular. Phelps, in her writings and in her personal beliefs, fits squarely within the history of the "social gospel" as it emerges from liberal Protestantism in the late nineteenth century. As the metaphysical currents Modern outlines met with the circulation of European Biblical criticism, the evolutionary theory of Charles Darwin, and the chaotic aftermath of the Civil War, liberal theologies grew appropriative, absorbing apparently secular challenges as part of an impulse toward unity. This included the harmonization of liberal Protestantism and social reform movements which became popularly known as the Social Gospel. Phelps's work is part and parcel of these trends. Her 1880 essay "What Is a Fact?" reads like a manifesto on behalf of "mental science," a concept and keyword integral to the development of liberal secularism; her work was favorably reviewed by liberal Christian publications; and, as Tracy Fessenden has argued, her immortalizing of the domestic space of the home did much to popularize and solidify the exclusionary race and gender politics of the secular.[37] In short, Elizabeth Stuart Phelps played as much of a role—if not more so—than Lew Wallace did in establishing, circulating, and setting the terms for secularism's normative sociality in the postbellum period. Phelps's stylistic eccentricity masks, to some extent or another, the degree to which her work buttresses the liberal order.

Like Lew Wallace, Phelps also tried her hand at the Jesus novel. *Come Forth!* (1891), a historical romance in the vein of *Ben-Hur* that she co-authored with her husband Humphry Ward, was a flop. One suspects that it failed, in part, because it lacked the particular aesthetic of Phelps's other work on religious subjects. Fans who came to the novel expecting an unconventional take on the Christ narrative from the woman who had renovated Heaven in the style of the Victorian home must have been sorely disappointed with the paint-by-numbers portraiture of *Come Forth!* Here was yet another hapless Waverley or Judah Ben-Hur, coincidentally crossing paths with the Christ as he went about healing lepers and raising from the dead. It is, in Jefferson Gatrall's measure, a prototypical Jesus novel, even as it perhaps takes more liberties with Christ's surrounding incidents than others in the genre—and Phelps was not known as an author of "prototypical" novels.

Come Forth! is, for Gatrall, emblematic of what he calls the "sublime portrait" of Christ in the Jesus novel. As we have seen, how the authors of Jesus novels approach Christ's face—this unknowable but undeniable curiosity—defines the rest of their work. The sublime portrait was one popular device for avoiding the risks of specificity while not disappointing readers. This type of portrait occurs, generally, when some bystander—be it an Everyman protagonist or a random crowd—beholds Christ for the first time and is stunned into a mixture of rapture and inarticulateness. The resulting portrait, from that spectator's point of view, toes the line, as Gatrall describes it, "between a total image ban and a detailed descriptive sequence."[38] In the sublime portrait, the narrator's gaze works its way up to meet the gaze of Christ, but only rarely to describe it in concrete detail. "In the end," writes Gatrall, "the Nazarene's eyes are describable not in themselves but only in terms of their outsize effect on others."[39] The power of the gaze is enough to obscure anything but the sheer sublimity of seeing, and feeling seen in turn, by Jesus, the Christ.

Published five years after *Come Forth!*—and authored by Phelps alone—*The Story of Jesus Christ* affirms the sublime portrait's prioritization of the *feeling* of seeing Christ over the data extracted from such an encounter. It was disappointing to many readers for that reason. The reviewer for the *Phoenix Weekly Herald*, while praising Phelps's *Story of Jesus Christ*, expressed some disappointment that as iconoclastic an author as Phelps had produced such a tame tale.[40] "Contrary to expectations," they wrote, "it is purely orthodox and devoid of sensationalism."[41] At first blush, the book features hardly any of the catchy pop theology Phelps fashioned in the *Gates* trilogy, and though published at almost exactly the same time as Elizabeth Cady Stanton's *The Woman's Bible*, it contains none of that book's polemical feminist messaging. Admittedly, for both the reader in 1897

and the scholar in the present, the book comes as something of a minor letdown. Jesus is not a Spiritualist, he's not a Feminist, and he can't even play the piano. Phelps's "story" of Jesus Christ is a profoundly, almost defiantly, ordinary one, but that ordinariness conceals what I argue is its sustained focus on the way that various media—male scholars and theologians, even the novel form—throughout the nineteenth century had rendered *natural* a fiction of Jesus Christ.

The Story of Jesus Christ differs from its peers in three crucial ways. First, although *The Story* contains few concrete details of Christ's face—the book nowhere describes the color of his eyes, for instance, and describes his hair only as "dark brown"—[42]the descriptions it does provide are not particularly affected by the "sublimity" of his presence. In other words, because it is Phelps herself "seeing" Jesus on our behalf (rather than, for instance, a merchant who crosses paths with the messiah) her descriptions seem less hamstrung by awe than they are simply uninterested in the kinds of details common to other narrators of the Jesus novel. An exemplary description, from the middle of Christ's ministry, reads like this:

> He had grown pale, thin, shining. His eyes were larger than usual, and their hollows had darkened. His veined hands had shrunken a little, as the human hand does with certain temperature, giving the first signal of bodily change under suffering or sickness. What illuminated his patient smile? A sacred fire was in his eye. His disciples watched him in dull wonder.[43]

Compare this to one of the moments of sublime portraiture from *Come Forth!* as Gatrall identifies it: "Zahara raised her eyes, and looked into the Nazarene's. What a gaze fell upon her! . . . Those eyes,—what color had they? What form? No man knew, or knoweth to this day. Years afterward, Zahara used to say they were to her vision as the sun in mid-heaven, and of them she could tell no more."[44] The very powers of description that anchor the Jesus novel and give it its particular texture are unequal to the task of describing such a vision. The passage even manages to shoot forward in time to gauge the echoing impact of such a moment. The passage from *The Story of Jesus Christ*, however, is by no means rapturous to the point of inarticulateness, nor is it affected by the same kind of awestruck wordlessness that Phelps and her husband grant to Zahara. The narrator is calm: tinged with poetic musing, yes, but in full command of her descriptive toolkit. Yet it is not terribly specific, either. It would be difficult to draw an accurate likeness of the figure described by Phelps, and yet the detail is rich in its evocation of emotional import. He is "shining," his eyes are "larger than usual" and lit with a "sacred fire." This is something not fundamentally *unlike* a sublime portrait—a distillation of the impact, if not the minutiae of his

appearance—but it does not bring the narrative to crisis the way Zahara's vision does. This is not a moment of narrative transcendence; it is simply a different style of description. The passage even goes so far as to point to the disciples, watching in "dull wonder." Perhaps from their point of view, we might have received a sublime portrait—*What wondrous eyes! Such hands as we could never describe! A smile of which we couldn't speak and will never 'til the day we die!*—but Phelps deliberately gives us something else instead.

The sublime portrait may "pull back from the descriptive" at the wonder of Christ's face, but the copious details that surround it suggest that this figure is still knowable, still able to be agreed upon. The failure of description in view of Christ's face authorizes excessive description elsewhere: if there are things outside the limits of description, that means there are things *within* those limits as well. As was the case in *Ben-Hur*, the concretely described vision of Christ produces a normative idea of who he was, and thus who is like or unlike him. But even physical descriptions such as those just quoted are rare in Phelps's book. As I discuss later, Phelps pays special attention to the *action* of Christ's eyes—where and how they look—but very little to what he looks *like*, rendered in any style. Thus, although descriptions of Christ's physical features are scarce and vague, his psychological features are described with crisp, emotional clarity. In the sublime portrait, the efficacy of concrete description collapses, but it is not replaced by anything. Though Phelps's closeness to her protagonist does not bring extra physiological or physiognomic detail, it does bring an almost omniscient understanding of Christ's psyche, emotion, and affect.

Finally, there is the excessiveness of Phelps's portrait. The sublime portrait in the Jesus novel, as Gatrall describes it, is as defined by its style as it is by its brevity. In other words, this sort of portrait can only have the kind of spectacular impact Gatrall suggests because it is, to borrow Lew Wallace's phrase, such a rare and wonderful sight. Furthermore, as in any Jesus novel from before or after Wallace, while the portrait of Christ might be its stabilizing center, it nonetheless takes up a relatively small page count. Christ is only described twice, for instance, in *Come Forth! The Story of Christ*, in contrast, presents something like a book-length portrait, with a physical account of Jesus' life breathtakingly broad if not terribly deep. As we will see, Phelps's biography eschews many of the conventional descriptions that fill out other Jesus novels and biographies: there are precious few discussions of geography; rare and impressionistic accounts of landscape; only occasional characterizations of clothing and custom; and, aside from a short preface, almost none of the metanarrative discussion of historiography that is the hallmark of a novel such as *Ben-Hur* or a nonfictional Life such as Renan's. A majority of Phelps's book is occupied with describing Christ himself, not as a

body and not as an historical character, but as a mind and a heart. It is an almost uncomfortably *intimate* narrative portrait.

Nevertheless, a review for *The Outlook*, in praising the book, deemed it the exemplar of a new subgenre of the Life of Jesus: the "Pictorial Life." To contextualize this claim, the critic presented something like a taxonomy of the genre as it existed when Phelps entered the fray. There's the Dogmatic Life, the Rationalistic Life, the Apologetic Life, the Purely Historical Life, the Outline Life, the Scholastic Life, and the Romantic Life. Phelps's Pictorial Life, in contrast to these subgenres variously defined by their relationship to the scholarly controversy over the form itself, "might be described as a series of word-pictures of Gospel scenes. . . . Mrs. Ward's word-pictures have an individuality of their own. She makes no attempt to distinguish between the contribution which her imagination has made, and that which may have resulted from a closer and more careful study of the text."[45] For this reviewer, Phelps's book, which contains practically no precise physical description of Jesus, exemplifies a primarily visual or pictorial style. But this Christ portrait is pictorial not because it is densely detailed but because it is intimate, free of the always-visible citational line between scholarship and imagination. One of two anonymous reviewers in the *New York Times*—an allegedly renowned preacher whose scathing review was solicited for the Review of Books and Arts—described the narrative perspective in similar terms, albeit as a criticism of Phelps: "A tangle, like a tropical forest, in which fact and fancy, tradition and imagination, truth and conjecture, are inextricably confused."[46]

The collapsed boundary or "tangle" between what Phelps invents and what she has adapted from source material is productive, for these reviewers, of the *feeling* of the visual. Phelps's text is a written one, but its illusion is that of immediacy figured as visibility. I do not want to put too much weight on the surely undertheorized "word-picture" claim in the *Outlook* review, but it is a revealing and apparently common slippage even as it is, perhaps, an inaccurate one. In reading dozens of Lives from the Dogmatic to the Romantic, this reviewer would surely have read hundreds of words of physical description of Jesus—keys for visualizing this unknown figure—and yet it is *The Story of Jesus Christ*, a text from which almost all of these visualization aids are absent, that he deems "Pictorial." The physical descriptions we receive are sparse, not necessarily because Christ's features beggar description, but because we only encounter them as rare windows into his inner turmoil. This close to Christ, in other words, the color of his eyes is secondary to what else might be perceived.[47]

Just as in the sublime portrait Jesus novels, though, the eyes of Jesus play a crucial role in *The Story of Jesus Christ*, even if their particular features remain obscure. From early in the book, Christ's eyes are both a focus—when we are in

his presence, we almost always know what his eyes are *doing*—and a portal into description from his point of view. "The boy bent himself to his parents' wishes without protest," Phelps writes of the young Jesus in the temple, "but he had his own thoughts and views of things. These he neither obtruded nor avoided. His wide eyes, with distance in them, watched the rabbis in the country synagogue, and the neighbors at their theological gossip. Early he learned that it was unnecessary to say what one was thinking."[48] This passage is representative of a technique Phelps employs throughout. She begins with a banal observation easily extrapolated from the limited gospel accounts: that the boy Jesus was, generally, a well-behaved child. She then points to the unknown: "his own thoughts and views of things." This is the holy grail, so to speak, for the author of a Jesus novel, though novelists in this period rarely reach for it: *What was Jesus thinking?* For an answer, Phelps pivots to Christ's "wide eyes, with distance in them," imagines what they beheld, and follows something like a narrative eyeline match to the rabbis and neighbors. She does not provide a gratuitous amount of psychodrama here, but we then close the passage with her own invention: the *thought*. "It was unnecessary to say what one was thinking." Far from being unreadable, Christ's eyes are a kind of text, open for interpretation. Phelps does not describe them, not because they are indescribable, but because their color, size, shape, and setting are perhaps the least interesting things they reveal.

This passage continues to open out as Phelps continues to track Christ's eyeline: "Jesus stood at the bench and watched the shavings curl from the planes,—strong oak, or shining pine, yellow like the sun in the heavens; or cedar, red as flesh and blood; or olive, rich as the fibre of life,—his delicate imagination fastening itself on fancies or visions as he worked."[49] Our narrator works her way to this keen and evocative description, through Christ's eyes, of the various pieces of wood in his father's shop before introducing the idea of his "fancies or visions." Again, Phelps begins with banal detail only to introduce an object of Christ's vision that is ever so slightly outside the edges of what we might safely assume from a reading of the gospels—Christ as camera. And just as the reader may begin to imagine what those visions might be, Phelps interjects: "Who shall say what these were? whither they tended? what they portended? The youth himself knew not whence they came. Strange glimpses of that which he might not reach and did not understand broke through the fog of his daily task."[50] Phelps opens this paragraph with something akin to the metanarrative framing of Wallace, but she quickly moves toward something more speculative and less performative. Christ does "not understand" and sees his personality obscured as if through a "fog," but the reader, uniquely, knows what these strange visions are. Phelps does not describe them because we know the narrative they prophesy.

While the reader might have a sense of dramatic irony in this passage, knowing something the young Jesus himself does not know, Phelps ends the chapter with something like its thesis: "He had now come to recognize that he did not understand himself."[51] Throughout, Phelps's Christ is tortured, confused, uncertain of his destiny or his ability to achieve it. Phelps's narrator reaffirms this over and over, both by pointing to moments in which Christ is himself inarticulate about his feelings—whether by choice or by necessity—and by peppering her text with rapid-fire questions like those quoted earlier. Phelps's Christ, in many ways, is as dumbstruck by himself as are the ordinary people who behold him in the moment of the sublime portrait. Christ is an imperfect medium, but thus even more intimately human. Phelps, however, maintains clarity about her subject.

Throughout *The Story of Jesus Christ*, Phelps frequently maintains this closeness to Jesus and his psyche. She sparingly offers concrete details about what precisely he is thinking, but she offers copious details about the texture of Christ's thoughts, his state of mind. This is not so much a formal innovation, in Phelps's mind, as it is an innovation in perspective.[52] Indeed, the closest parallel one might find between *The Story of Jesus Christ* and Phelps's earlier Spiritualism-influenced work is that the Christ book is framed as a kind of mediation, structurally dependent on Phelps's own ability to zoom in on this or that crucial moment, revealing previously unseen aspects of its emotional impact on Christ himself. Neither reliant on the historical record, as in the scholarly Lives, nor on the limited perspective of a bystander, as in the Jesus novels, Phelps "interpreted" her character freely. There are any number of subtle invocations of this relationship in the book. The most prominent examples of a kind of textual mediumship are the moments when Phelps's narrator seems to drift so close to Christ that she begins to transcribe his exact, and noncanonical, thoughts. Witnessing a sacrifice in the temple, for instance, Phelps writes:

> Crowding about him, his people slew dumb things to pay Heaven a price for their sins. He sought for guilt in himself. What was it? What did it mean? How should a man sin? How could a child of God distress his Father? It was impossible to grasp the consciousness of it! He slaughtered no lamb to burn upon any altar,—he could not do it. But at that solemn Passover, the first of his sad, grand manhood, he offered and consumed himself. "I shall be the sacrifice," he thought. Filled with incommunicable emotion, he passed out of the inner Temple, and came suddenly upon a raving scene.[53]

Again, the passage begins with Phelps's questions which quickly become Christ's questions, her own imagination first ventriloquizing and then speaking on behalf

of his own thoughts. She exclaims, from Christ's point of view, the impossibility of grasping the scene. She then narrates imaginative details about the scene—no such moment occurs in the gospels—and quotes Christ's own thoughts before returning once again to invoke his "incommunicable emotion." Bookended by these two assertions that Christ's own consciousness was both impossible to grasp and incommunicable, Phelps nevertheless communicates to her reader. It is, perhaps, a vague communication because, as she repeatedly claims, Christ himself had only a vague awareness of its content. In moments like these, however, Phelps subtly but undoubtedly becomes Christ's medium.

This structural fact, however subtly performed, is important specifically because Phelps only ever asserts this role by implication. The word "medium" is used only three times in *The Story of Jesus Christ*, but each instance is telling. The first occurs in the "Presage" to the book, which deals primarily with the Nativity story. After describing Mary's vision of the angel—the annunciation—Phelps goes on: "Clearly but gently she was given to understand that she had not been made the subject of an inconsequent apparition, such as were frequent enough in Oriental experience or imagination; but that she was the medium of the most tremendous revelation which this planet has ever known."[54] Mary is the *medium* of this revelation. In literal terms, Phelps is suggesting a bodily mediumship: that Mary is the host of the child who will reveal these truths to the world. But Phelps quickly expands on this sense: "Chosen out of all the world, the Hebrew maiden whose qualifications for her solemn mission were the simple, womanly ones of a pure heart and a devout life received the message as she who could be chosen by it would be sure to do."[55] Mary is the medium for the revelation, not just because of her reproductive system, but because of her "womanly" "qualifications." This revelation could only be expressed through *her*. All three references to mediumship in this book are gendered, but, for reasons that will soon become clear, this is the only positive one.

A few pages later, Phelps describes a different type of mediumship:

> The story of the Gospels was written by men. Men have studied and expounded it for two thousand years. Men have been its commentators, its translators, its preachers. All the feminine element in it has come to us passed through the *medium* of masculine minds. Of the exquisite movements in the thought and feeling of Mary at this crisis in her history, what man could speak?[56]

Mary is a medium uniquely suited to her task; Phelps is a medium uniquely suited to *her* task; the men, from the apostles to the authors of Jesus novels, are not. Although here she writes specifically about accessing the experience

of the Virgin Mother, Phelps's gendering of mediumship is a common theme. The book begins with a note that includes the exquisite burn, "Men are many and scholars are few," in regard to her largely male peers in the business of writing the life of Jesus.[57] The apostles, too, are mediums: "The most eminent orator of history, [Jesus] preferred the *medium* of a few intelligent and controlling minds. He confided his system of faith to twelve unlettered men. Did he know that these would become the editors and authors of the greatest publication in the world?"[58] Phelps is praising Christ's decision here, but within that praise is a faint sense of displeasure, even ironic befuddlement. Aunt Winifred expressed her frustration with Biblical scholars; Phelps frequently expresses her frustration with the Bible itself, specifically its apocryphal authors. "They were not imaginative men," she frankly admits.[59] "Where were the senses of his friends? Dulled by trouble, blunted by love . . . They loved him according to their capacity," she condescends.[60] "His friends," she writes, "never any too sensitive to his moods, were blunt to his condition now."[61] Later: "Could they not have spared him, even then, this last reminder how weak they were, how full of undisciplined nature, how deaf to the real message of his life with them? . . . He looked at them with infinite sadness. They seemed to him like children."[62] To be a medium, in this book, is unmistakably to be the one responsible, not only for communicating, but also for understanding and, moreover, *sensing*. Christ, in Phelps's view, had been a victim of bad media. Specifically, he had been a victim of *male* media: insensitive, dulled, unimaginative, blunt. *The Story of Jesus Christ* is framed as a correction of that mistake by means of a new medium, more literally and affectively sensitive than those who had come before.

This female mediumship of *The Story of Jesus Christ* did not go unnoticed by critics. Indeed, an anonymous reviewer for the *New York Times*—the reviewer is unnamed, but advertised rather fatuously as "A Distinguished New York Theologian Eminent in His Own Communion and Widely Known Outside of it"—both understands the resonance of Phelps's invocation of mediumship and is practically apoplectic in his derision:

> Mrs. Ward's explanation of the great life is not our Lord's, and her interpretation of the faith which He founded is incomprehensible, because it differs so absolutely from His own. When she states as an objection that the story of the Gospel was written and has been studied, expounded, commented upon, translated, and preached only by men, and adds, "all the feminine element in it has come to us passed through the medium of masculine minds," we confess to a recognition in this fact of the wisdom of God's purpose in so ordering the communication of His revelation to us.[63]

For this "Distinguished New York Theologian," the male mediumship of Christ's narrative is one ordained by God. Although the reviewer finds plenty of other problems with Phelps's account, it seems here as if Phelps's gender is both the first and the last issue. The anonymous reviewer for *The Outlook* bypasses the idea of mediumship, but he comes to a similar conclusion,

> Her story has both the virtues and the defects of woman's work. We do not remember ever to have seen outside the Gospels the narrative of the annunciation and the birth more beautifully told than in this volume. It needed a woman to tell it. On the other hand, the picture of the temptation in the wilderness cannot be acquitted of the charge of being somewhat hysterical.[64]

The reviewer begins by agreeing with Phelps about the necessity of a female perspective for the pivotal annunciation scene. However, where Phelps extrapolates that such a perspective is necessary for the entirety of the story, the reviewer suggests that Phelps's womanhood is a virtue only for scenes that involve women. Characterizing the early section in which Phelps describes Christ's temptation in the wilderness, the reviewer calls Phelps "hysterical": a charge that, in 1898, might have boiled down to "excessively female." (The *Times* reviewer also singled out this section for his particular ire.) In one sense, the reviewer is not wrong to identify this section as exceptional. The wilderness chapter contains perhaps the most flamboyant display of Phelps's intimate style. So, what's so "hysterical" about the temptation in the wilderness?

The third chapter of Phelps's book, "The Wilderness," is the section that comes closest to Christ's point of view. It is the section in which Phelps takes the most liberty with her material: Satan, in this temptation, is the hallucinatory product of Christ's deteriorating mind as he is fasting. It is also the only section in which we spend almost the entire time close to Jesus' thoughts. *The Story of Jesus Christ* is a fascinating book if not always a gripping one, but the wilderness section is Phelps's wild set-piece. Early on, the section declares itself with a daring (perhaps hysterically so?) parallel construction litany:

> Night was coming on. Jesus climbed to the front of a high cliff, and looked about him. He saw the chalk of the midland hills sloping from three thousand feet yonder, near Hebron, to half that height at the valley of the Dead Sea. He saw a country of caves and gorges, of secrecy, of shadow, of unclean and venomous creatures, of skulking things and hiding men. For he remembered that there were men who chose the desert for their only home.[65]

This passage moves subtly from ordinary description to description of Christ's actions to description of his thoughts and memories. As she often does in the book, Phelps plays with the conventional expectations for such a scene. Certainly, it begins with the bold declaration, "He saw"—signaling that she would be narrating not only his world but also what he himself perceived of it—but it also begins with the type of topographical description that was common to such a narrative. The next sentence begins similarly—"He saw a country of caves and gorges"—but as the list continues, it becomes more personal, more individual. "Of secrecy, of shadow, of unclean and venomous creatures . . ." The description becomes evocative, but the implication is that it narrates what such scenery evokes for Jesus. Then, finally, breaking the "He saw" pattern, we have "He remembered." This, of course, is a qualitatively different action, one that, no matter how unimportant the observation, signals that this narrator has access to more than just the incident and detail that surrounds the inner life of Jesus.

Throughout the section, this access to Jesus' inner life becomes both deeper and more commonplace. Phelps continues to follow the gaze of his "strong eye," but she also continues to narrate his psychological state. She describes the anxiety of his dawning role from his perspective: "A threefold pressure crowded upon him and within him—the views of other men, the movements of his own soul, and the voice of God."[66] She casually describes what is or isn't on his mind at any given time ("it had not occurred to him"). Perhaps most notably, she narrates the visions that appear before him: "Visions of food swam before his eyes. Pictures of home, of friends, of long-needed sleep, of his own rug in his mother's house"[67] To some extent, suggesting that Jesus "sees" a readily observable landscape is a perspectival cheat. Especially given the common trope that visiting Palestine was to walk in Christ's footsteps, and that travel photography could give a rough estimate of what it had been like in the time of Christ, it would be uncontroversial to describe a landscape where he may have sat and suggest that that's what he saw as well. Describing visions is another matter, especially in this manner, as part of a spectrum of ordinary, earthly temptations that visit Jesus in this state.

Indeed, these visions lead to the deepest point of view Phelps seeks in this section. "Suddenly within him," Phelps writes, noting the precise location from which she sends this dispatch,

> Like the groping, griping hands of a strong man fighting in the dark, uprose the movement of something never felt before,—new forces in his soul; strange senses of the spirit, superinduced upon those of his fainting body; the shadows

of coming gifts, of advancing possibilities, of unknown facilities of action and unguessed powers of will. What were these? Whence did they come? What should he do with them?[68]

This type of passage is presumably the hysteria about which the *Outlook* reviewer writes. Fluid, rhythmic, building in momentum, Phelps describes the thoughts "within" Christ. She characterizes his mental state—a superinductive, supersensitive, fainting state that would certainly have provoked charges of feminization—and she asks *her* questions *as* him. Here Phelps's third person narration shifts, as it does elsewhere in the section, to speak as Christ, even for a fleeting moment. In literary fiction, this device—an almost free, indirect discourse—simply produces a sense of intimacy. Here, in this freighted genre, it gives Phelps a unique role. For Phelps, to be an author was to be a medium.

To grasp the strangeness of this style within the genre, compare it to Henry Ward Beecher's narration of Christ's temptations in the desert from his 1871 *The Life of Jesus, the Christ*. Though nearly thirty years separate the two volumes, the two are sometimes yoked, in terms of their authors' association with the tropes of sentimental fiction, their popularity, and their status as highly stylized accounts of the life of Jesus that are explicitly not "novels." Beecher wrote:

> In a parallel way, the apparition from the mountain-top, of all the glory of the nations, as a literal fact was impossible except by a miracle. And though a miracle is a fact wholly within the bounds of reason, yet we are not needlessly to convert common events into miracles. There is no such mountain, nor on a round globe can be. Besides, as a direct persuasion to worship Satan, it would be puerile. Far otherwise would it seem in a prophetic vision, where, as a symbol, it was to the real truth what letters and sentences are to the meaning which they express. The impression produced outruns the natural force of the symbol.
>
> There was a tremendous temptation to exhibit before men his real place and authority; to appear as great as he really was; to so use his energies that men should admit him to be greater than generals, higher than kings, more glorious than Temple or Palace. In that mountain vision he saw the line of temptations which would beat in upon the principle of self-esteem, that source and fountain of ambition among men.[69]

Where Phelps endeavors to telegraph no distance at all from Christ, and whose every move within the text sidles closer to her subject until she is narrating, surreptitiously, from his perspective, Beecher pushes away with both arms. There is a web of philosophical contortion about the natural or supernatural status of

miracles and semiotic qualifications about the symbolism of the vision before Beecher arrives at the same "he saw" that Phelps applies so freely. There is, in other words, a drastic stylistic difference between even two texts that are, broadly, similar in the type of character they portray and the audience they aimed to reach. Beecher tells this story at second or even third hand, constantly emphasizing the mediation of his imagination, whereas Phelps crafts a narrative perspective that erases such mediation almost entirely.

The reviewer for *The Outlook*, in observing the vanishing line between Phelps's imagination and her research, gestures toward this difference, and, even as he describes her book as "orthodox," the reviewer for the *Phoenix Weekly Herald* acknowledges that the work is "told in a new way," though both critics are at pains to say what precisely is "new" about it. For his part, the original reviewer for the *New York Times* seems primarily concerned about determining whether the work is controversial, suggesting that "the outlines are indelible and common to all, but the coloring has been so lovingly, so reverently, filled in that it is impossible to imagine how any susceptibilities can be hurt."[70] Only the scathing second *Times* review, by the aforementioned "Distinguished New York Theologian," pinpoints what precisely is unusual about Phelps's account. "Serious protest also needs to be made," he writes, "against the putting of words into the mouth of Him 'who spake as never man spake.'"[71] Still, even for that theologian, this is a minor concern. Phelps was not the first person to come so tantalizingly close to the first-person stance in her narration of Christ's life, and it would be an overstatement to suggest that this book commits anything other than mild—and not uncommon—heresies at the level of its theological interventions.[72] Nevertheless, taking measure of the book's deceptively critical formal politics, *The Story of Jesus Christ* becomes "an interpretation" with far more to say about mediation, immediacy, and the limiting scope of the secular imaginary.

Phelps's book performs a curious double duty. By articulating—both polemically and in terms of her critiques of the apostles—that a woman's perspective is necessary to access the truth of the gospel narrative, Phelps foregrounds the role of the author as medium. Her *Story* bears no framing pretense to be the direct, immediate communication of divine revelation, but rather is framed as the revelation of an exceptional medium. In contrast to nearly any comparable text, be it Henry Ward Beecher's, Lew Wallace's, or Elizabeth Cady Stanton's, *The Story of Jesus Christ* is strikingly unencumbered with the formal and stylistic markers of mediation.[73] There is none of Beecher's prevarication and preaching, neither Wallace's invocation of the act of research nor his romantic appeals directly to contemporary readers, and certainly none of the argumentative commentary of Stanton and her contributors. Both in tone and in structure and style, Phelps's

text is an intimate account, an account without need or recourse to the mediating conventions of her peers. Whereas other texts anxiously perform and affirm their adherence to standards of rationalism and scientific historicism, to a religiosity neither premodern and superstitious nor problematically skeptical—in other words, to the normative conventions of secularism—*The Story of Jesus Christ* does not. Her "Presage" testifies to the mediation of this text, but the text itself performs immediacy.

Thus, if Phelps's comments about mediumship conform to what Van de Port calls the "plexiglass aesthetic"—rendering the processes of mediation hypervisible—the remainder of her text operates through an aesthetic of naturalization, the illusion of freedom from mediation. For Van de Port, the important thing about such disappearing media is that they remain present even while their denial becomes something like a textual conceit. The "dream of immediacy," for Van de Port, reaches its apex in "acheiropoieta," or the idea that some sacred icons are believed to have been made by other than human hands, entering the world with no intermediary. The extremity of this example, he writes, is diluted but remains active in many popular forms, from the cinematic experience itself to the genre of reality television.[74] "Mediating immediacy," then, does not necessitate full, credulous disavowal of human handiwork, but rather plays with the suspension of disbelief. Secularism, as John Lardas Modern pointedly characterizes it, is expressed through "a public sphere whose legitimacy is founded upon an order that is both universal and rational, a space that insists upon its natural neutrality."[75] This "natural neutrality" is the basis by which the norms of such a secularism—in terms of political affiliation, gender, sexuality, race—are enforced. The "dream of immediacy" is coextensive, in many cases, with the regime of secularism.

It's ironic that, from phrenology manuals to accounts of spirit mediums to the so-called "liberal" lives of Jesus, the texts and discourses central to "naturalizing" secularism in this period are so didactic, self-conscious, and multiply mediated. The dream of immediacy was often expressed through highly mediated forms; Van de Port's "plexiglass aesthetic" is the style of secularism. At its most basic level, *The Story of Jesus Christ* is a generic rebuke to texts like these: it uses literary means to produce the feeling of immediacy in ways that had been relatively unconventional in religious texts. Phelps's aesthetic figures and performs "naturalization" in ways that, I argue, highlight the artifice of such socially scripted norms. The very occasion for Phelps's text, to begin with, is her sexist exclusion from the practice of scriptural exegesis. Although Phelps declined to contribute to Stanton's *Woman's Bible*, her own *Story of Jesus Christ* reveals a difference less of politics than of strategy. Rather than puncture her text with reminders of its authenticity, with guarantors of its "truth" in the form of citation,

or even with less subtle references to the inadequacy of male exegetes, Phelps produced an apparently seamless narrative constructed from a non-normative narrative point of view.

The Story of Jesus Christ is not fundamentally disruptive of the "normative sociality" of secularism. It is a critical text, but it is, ultimately, a text aimed at reforming rather than bringing down the regime. The text certainly takes occasional positions on theological and scriptural debates, but one does not get the sense that adjudicating such questions is the horizon of Phelps's ambition. The text shows rather than tells. It insists on unsettling the unexamined authority of male theologians and writers, grasping such authority for women by simply taking it. Indeed, while the undescribed Christ is, in some ways, a critical gesture, it is also one that merely flips the "readerly incorporation" of Wallace's novel. Rather than collaborate to flesh out the landscape or mise-en-scene, the reader must collaborate to generate an image of Jesus, thus weaving the norms of secularism into the text. *The Story of Jesus Christ* thus does little to disrupt what we now understand as the guiding principles of secularism in the nineteenth-century United States. Instead, Phelps's text speaks from the margin to the center. In delineating that marginal position, making it visible while performing feats of immediacy from its vantage, following the eyeline of an author as she gazes back at the secularism from which her perspective was excluded, the form of *The Story of Jesus Christ* gives us a view even its medium could not provide.

THE CHRIST SELFIE: F. HOLLAND DAY

Reviewers, even the unkind ones, went out of their way to frame Elizabeth Stuart Phelps's *The Story of Jesus Christ* as a visual text. Given that it lacks many of the visual descriptions that are the primary trope of the genre, this is an odd claim. But, as I've argued, "visual" in this sense is something like a euphemism for the bracing (and uncommon, in this mode) feeling of immediacy Phelps sought to provoke, absent the distancing mechanisms of her peers. To read a text unencumbered by the conspicuous mediations of other similar works is, counterintuitively, to realize how mediated those other experiences are. Still, as much as Phelps figured her text in terms of these mediations, it can only ever pretend to be *un*mediated. Its written form limits it in this way. A photograph, of course, can never be immediate either, never escape its form to offer the thing itself. All the same, it produces a whole different set of ontological uncertainties. Furthermore, though it might seem evident that a photograph of a subject is merely a representation,

the resilient concept of photographic indexicality in film and media studies suggests that there is a space, however slight, for materiality—even immediacy—on film. So, we turn from the literary "portraiture" of Elizabeth Stuart Phelps to the photographic portraiture of F. Holland Day, another medium from the margins.

Frederick Holland Day began experimenting with photographs of himself as Jesus Christ in 1896. The son of wealthy parents, he utilized his relative privilege to pursue his artistic passions. In addition to taking portraits in his Norwood, Massachusetts studio, Day co-founded a publishing company, Copeland and Day. That outfit put him in contact with many figures in the aestheticist and decadent movements, including Aubrey Beardsley and Oscar Wilde. Inspired by contacts such as these, he and his circle professed a desire to produce art-for-art's-sake and to rebel against the commonplace notion that photography was more a science than an art. Moreover, Day's work has been yoked in with the political as well as the aesthetic goals of decadence and aestheticism. "These writers," as Kristin Schwain writes, "celebrated male beauty and Greek love and sought to furnish cultural legitimacy for same-sex relationships through an amalgamation of paganism, Neoplatonism, and Christianity."[76] Day's portraits, especially his male nudes, served as convergence points for these same influences and have been read by many critics and historians as strikingly raw expressions of homoerotic desire at a time when homosexuals were being persecuted and prosecuted with terrifying frequency. For Day, photography, like the illustrations of Beardsley or the literary prose of Oscar Wilde, was a way of accessing the ideals of Truth and Beauty and articulating them through bodies that American society considered perverse and deviant, not a mechanism for producing realistic reproductions of the phenomenal world.

Indeed, many of the nearly 250 images in Day's Christ series mirror the theatrical, pageant-like aesthetic of his male nudes (which were often framed as historical figures). Day's first Christ photograph, from 1896, is entitled, "The Entombment" and features the photographer in profile, lying on a stone slab, nude but for a loincloth, and with an austere halo encircling his head. Two years later, in the summer of 1898, Day returned to this subject for a more elaborate shoot (figures 2.1 and 2.2). He had dramatically altered his diet in order to develop an emaciated frame and had grown a long beard to approximate the conventional iconography. Along with friends in period dress, he staged and photographed himself on the hills of Norwood in various tableaux from Christ's Passion. Day read widely, he selected historically accurate costumes, he imported textiles, and he chose locations based on their similarity to Palestinian landscapes he had seen in photographs.[77] In short, he accumulated the kind of research that could enable him to produce a modern vision of the historical Jesus in the same way that Lew Wallace did or that later filmmakers would try.

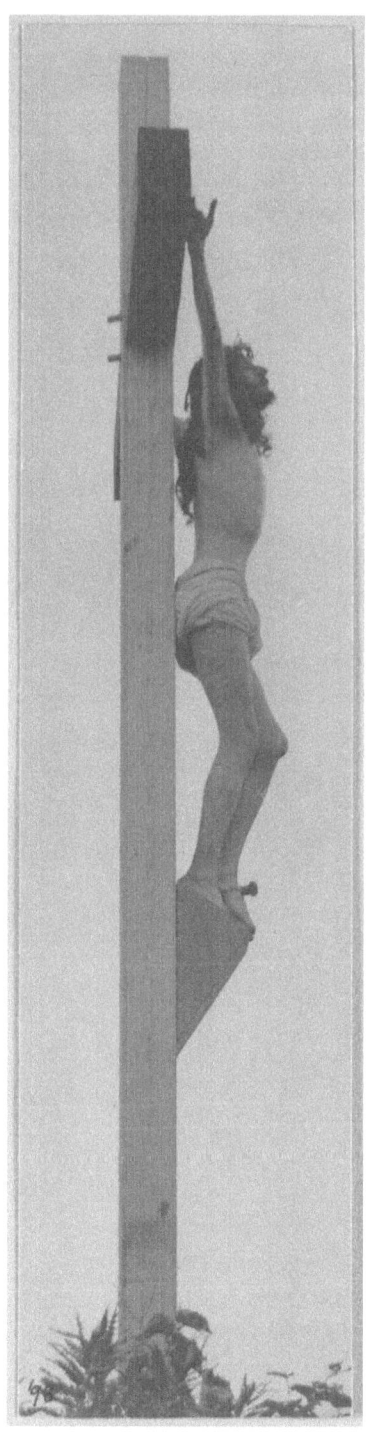

FIGURE 2.1 "Crucifixion, Profile, Right" (F. Holland Day, 1898)

Louise Imogen Guiney Collection, Library of Congress, Prints and Photographs Division

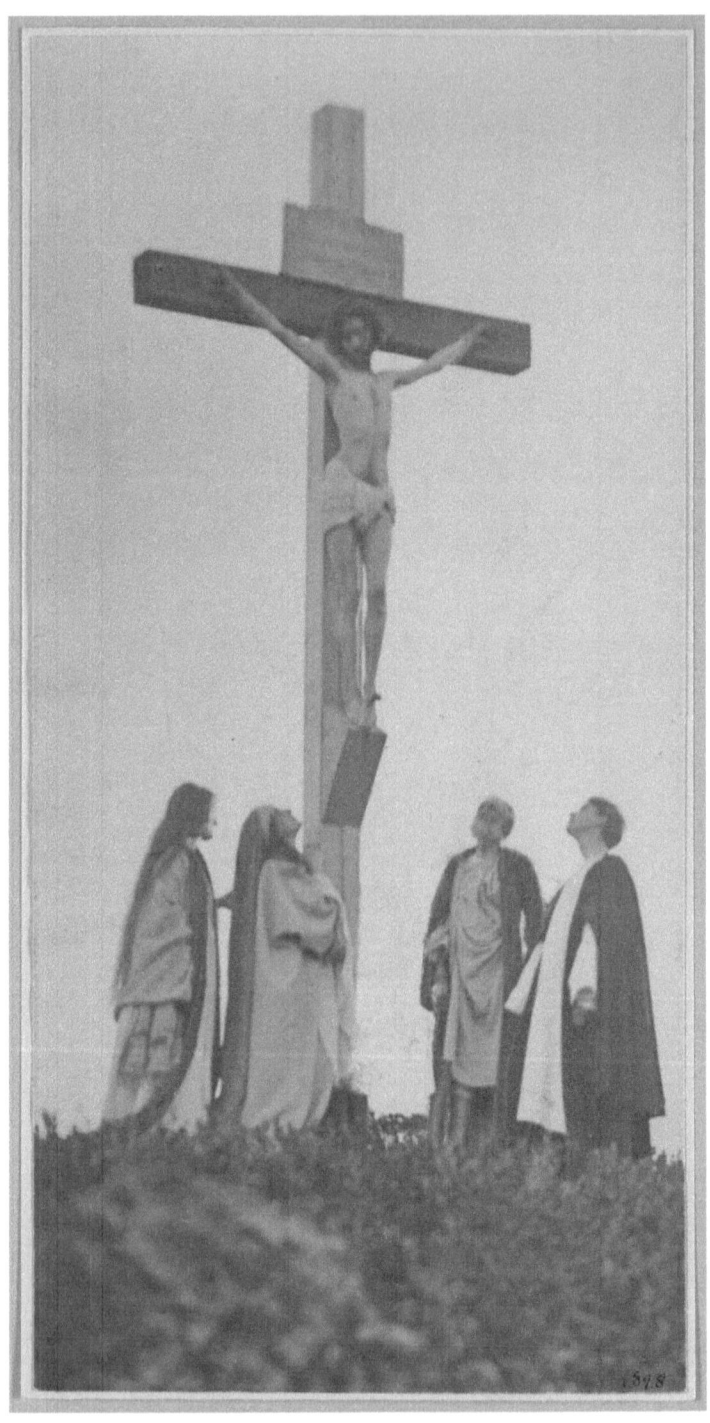

FIGURE 2.2 "Crucifixion, Frontal, w/Mary, Mary Magdalene, Joseph, and St. John" (F. Holland Day, 1898)

Louise Imogen Guiney Collection, Library of Congress, Prints and Photographs Division

The images, even those elaborately staged in this way, are strangely intimate. Especially compared to photographs of the kinds of *tableaux vivants* one would see at Oberammergau, or to the frames of early Passion Play films, these shots seem almost empty. Day was scrupulous in his preparations, and contemporary critics noted the elegance of some of the models' costumes, but, over and again, when the convention suggested that frames of these scenes ought to be filled with detail and incident, the evidence of Day's research tended to be cropped out.[78] This is quite literally true, for instance, in a print simply titled, "Crucifixion." Many of Day's crucifixion images show him suspended from the cross at different angles, with different spectators scattered about. As pictured in figure 2.2, long-shot images like these are about as busy as Day gets. All the same, that image is a stark contrast to another angle of the crucifixion that Day printed and exhibited.

The image is a low-angle profile of Day on the cross (figure 2.1), beginning with some assorted vegetation around the base of the crucifix and ending a few inches above its top. What's remarkable about the image is that Day is silhouetted to such an extent that very few small details of either his face or costume are apparently visible, and the print itself is considerably taller than it is wide—reaching to encompass the entire crucifix, but stretching only far enough outward on either side to fit Day in the frame. Moreover, despite Day's insistence on selecting Massachusetts's closest doppelganger landscapes to Palestine, we see no background but empty sky. As Trevor Fairbrother notes in an exhibition catalogue of Day's work that includes this print, "he took the photograph at a moment when he knew the sky would 'disappear' in the photograph he printed."[79] For a production so invested in historically authenticating detail, the Christ series not infrequently endeavors to make those details "disappear."

A similar dissolution of detail occurs in a print of Christ's resurrection from the tomb (figure 2.3). This image features more detail, but those details are almost entirely inaccessible to the viewer. The image is framed theatrically, in the manner of a *tableau vivant,* with Day at the center of the frame in a white robe, emerging from a tomb, perhaps gesturing toward the viewer. We see a sign above the tomb marking its inhabitant, and foliage above that. But the image is so blurry—so dappled, dark, and grainy—that Day virtually dissolves into the shadowy interior of the tomb: only indistinct daubs of white outline his face or draw our attention to his upraised fingers, and the sign above the tomb is rendered completely illegible. As Shawn Michelle Smith notes, these techniques—specifically the "obfuscation of detail in soft focus"—are markers of the pictorialist movement in photography.[80] Often "condemned as a refusal of the technological specificities of photography," Smith suggests that "we might see it as an aesthetic strategy that explores the limits of photographic representation."[81] Smith's reading

FIGURE 2.3 "Christ's Resurrection from the Tomb" (F. Holland Day, 1898)

Louise Imogen Guiney Collection, Library of Congress, Prints and Photographs Division

of the "politics of pictorialism" sets the stage for this chapter's contention that, beyond staking a claim in an internecine artistic squabble or even, more broadly, the social negotiation of sexual identity, Day's pictorialist Christ photographs rebuke a creeping secularism rooted in both the revelatory possibilities of technology and the policing of identity and faith alike. Even at their intimate scale,

these images foreground Day's mediating artistic consciousness. If Phelps conceived of the author as a medium, Day made so bold as to suggest that a photograph could have an "author" at all.

Nowhere, however, is this aesthetic activism more visible than in the photographs Day produced when he went into his studio that summer alone. For the series that would come to be known as *The Seven Last Words*, Day attached a mirror to his camera and produced seven close-up, soft-focus photographs of himself representing each of the seven phrases uttered by Jesus Christ on the cross in the four canonical gospels.[82] Many of the other photographs in this series involved Day managing a small cast, arranging figures, visualizing the composition of a scene from long- or middle-distance, but, as he sat in his studio to take the self-portraits that would make up *The Seven Last Words*, he looked at his own image in the mirror. As much as any photographs taken in the nineteenth century have a right to claim the description, *The Seven Last Words* were a series of selfies.

According to Marcy Dinius in her essay on "The Long History of the Selfie," the earliest daguerreotypists "understood all portraiture as self-portraiture," inasmuch as a portrait of any kind required such a degree of extended intervention and direction on the part of the photographer. More than that, because in the act of taking the picture, the daguerreotype's mirrored surface reflected both the subject and the photographer themselves, "the supposedly distinguishing narcissism of the selfie is, in fact, inherent in the origins of the medium."[83] Day shot *The Seven Last Words* using a platinum process and not a daguerreotype, but by affixing a mirror to his camera, he reached nostalgically back to the medium's earliest days at the same time that he groped toward its digital future. Like the contemporary selfie, these pictures were designed for intimate self-regard but destined for social circulation; they endeavored to represent a realistic and candid (if epoch-shifting) moment at the same time that they were elaborately staged; and they were born from the same unique scene of the photographer producing a public image by way of—literal—self-reflection.

Thus, Day's Christ selfies, perhaps unlike the outdoor tableaux he shot during this time, are rooted in a close-up intimacy that ought to be recognizable to us in the contemporary moment. According to Kristin Schwain, Day sought, to some extent, to render images that would seem familiar to his viewers at the turn of the century as well. The photographs in this series compositionally echo popularly circulated images of Christ from Bibles, picture cards, and lithograph prints, and whether or not Day intentionally evoked these new media, many scholars have noted the resonance between these sequential photographs, the motion studies of Eadweard Muybridge, and even the sequential images of early motion picture

film strips. These comparisons are certainly well-founded. To view, in Day's strip of sequential images, the raw material of animation is to see a life in them that Day certainly hoped to imbue. Slide lecturers had used similarly sequenced images with quick transitions to provide the illusion of movement in lectures about Oberammergau. Also, as Schwain notes, the "active" spectatorship that Day's images require resonates with many descriptions of early cinema.[84] Nevertheless, though the comparison with cinema or other animating and animated screen practices is tempting, it is also limiting. (As Fairbrother rightly points out, Day's pictorialist blurring renders his close-ups actually quite unlike the scientific precision of Muybridge's motion studies.[85]) The sequence of these images might suggest movement, but the images remain still, neither frozen documents of past movement nor images that would produce its illusion if fed into the right projection apparatus. That stillness generates meaning that the arrested movement of Muybridge or a film strip cannot.

Individually, the images are close-up portraits with soft-focus blurred edges. Together, however (as they were sometimes displayed), they create a wide frame. Their mounting and exhibition turn a series of vertically oriented images horizontal. This orientation, of course, along with the fact that the words printed overhead suggest a narrative, means that it is intuitive to read the images sequentially. Even the idea that the eponymous "words" imply a simple linear narrative is misleading, though. The words here are words that appear across all four gospels. They are arranged in rough sequence, but they are citations from four separate accounts of Christ's final moments. In this way, the "seven last words" can be both an orderly countdown and a jumbled compilation, an "eyewitness" record of the event as it happened and a synoptic digest of various accounts. I certainly don't want to stake a reading too far against the grain of conventional reception, as Day was by no means the first to harmonize these lines into a single narrative of Christ's last moments, and indeed there is liturgical precedent to do so. Nevertheless, the fact that the words, as cited from the gospels, can represent both linear time and the superimposition of multiple—occasionally conflicting—temporalities allows us to read Day's work in multiple ways as well.

What if we don't read Day's images as a sequence at all? In figure 2.4, we see the seven images exposed such that the edges blur to white, and they are separated only by white faux-columns. There is an almost panoramic sweep to this matting, with those blurred edges suggesting connection and even continuity between individual frames. Despite the columns that separate the individual images, there is still a sort of flow between them. Day's dark-outlined face appears as if an inkblot or a splash of paint from the base medium of white. Even as they individually limit the breadth of our view to the subject's face, the seven images

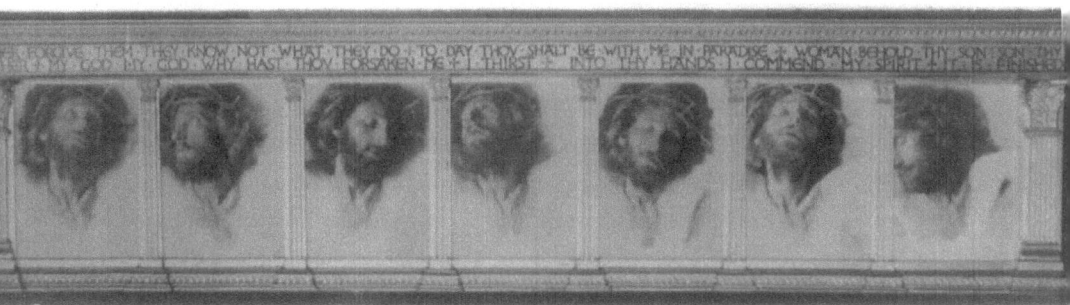

FIGURE 2.4 *The Seven Last Words* (F. Holland Day, 1898)

Louise Imogen Guiney Collection, Library of Congress, Prints and Photographs Division

together deepen it. What if we view this horizontal composite as a kind of landscape? If landscapes communicate breadth and width, what does this landscape communicate? If contemporary photographs of Middle Eastern landscapes communicate authenticity of detail, what does this landscape authenticate? Day's photographs are a landscape of pain, loss, grief, loneliness. This is affect in the shape of landscape, a panorama of anguish and passion. We don't see a variety of emotions here, but we do see variations on a theme. If we don't imagine *The Seven Last Words* as a sequence of moments but rather as an in-depth exploration—a detailed landscape—of *one* moment, we come to a different view. We are alone, here, not with the story of the gospels, but with Christ himself and F. Holland Day, his medium.

In the Christ series, Day tried to couple photography with the specific kind of spectatorship evoked by the tableau vivant (staged, living portrait). According to Schwain, "while tableaux were seen to assimilate the corporeal body with the ideal figure, photography coupled the specific and the type. It enabled the subject of representation to be himself or herself as well as the general subject depicted."[86] Thus, although Day's images were meant to mobilize common ways of seeing, they were also designed, in some way, to transcend those modes of spectatorship. That Day could be "himself" in these photographs, that he could become the medium for a representation of Christ, opened up a new possibility within the genre in the same way Phelps could be a new medium in hers.

Crucial to Day's art, as we saw initially in the crucifixion and resurrection scenes, was the ultimate disavowal of the idea of the camera as primarily a scientific apparatus. This ambition of Day's ran against the dominant trends of art

photography at the time, the "unmanipulated, sharp-focus, 'straight' image" of many of his contemporaries. As Smith characterizes it,

> As [Day] troubled the relation of photographic signifier to signified, he also unsettled the terms of scientific photographic evidence, remaking the image into a site of transfer and transportation rather than a fixed point. His images call into question the "scientific performance" of photography, challenging normative views of race and sexuality produced in scientific discourses of the time.[87]

Day's aesthetic choices, in other words, were not merely preferences, but rather polemics. As Kristin Schwain writes,

> Day's *Seven Last Words* was meant to represent the spiritual in material form and employed the photograph as a medium between the two realms. . . . Whereas other photographs aimed to substantiate the divine in visual form through the subject of the image, Day aimed to do so through the viewer's encounter with the work—through human experience rather than scientific verification.[88]

Day, like the Spiritualists, embraced technology while denying the mere earthliness of its possibilities.[89] Day was no Luddite. Rather, he believed that the camera was a transcendent device—"a site of transfer and transportation"—that did more than any other device to point to all that we could not articulate or that could not be said, rather than a device that reconciled, documented, and verified all that we already knew. Day objected to the concept that the photograph could *only* capture a material trace of the present moment.

This tension between what Siegfried Kracauer would later call photography's realist and formative tendencies—the ability to alternately capture or obscure reality—would continue to be a source of debate within photograph and film aesthetics throughout the century, even as Day's perspective was eclipsed by Stieglitz in the moment. Indeed, the film critic André Bazin, whose essay, "The Ontology of the Photographic Image," is an *ur*-text for mid-century cinematic realism, articulates something like Day's position even as he lays the groundwork for a film aesthetic that would move away from Day's artistic philosophy. Bazin writes that "photography does not create eternity, as art does, it embalms time, rescuing it simply from its proper corruption."[90] This is what Bazin calls the "mummy complex" of photography and film, the ability of this medium to serve as a material index of reality; to capture, through the interplay of light and chemicals, some physical trace of a moment in time. He continues:

> The aesthetic qualities of photography are to be sought in its power to lay bare the realities. . . . Only the impassive lens, stripping its object of all those ways of seeing it, those piled-up preconceptions, that spiritual dust and grime with which my eyes have covered it, is able to present it in all its virginal purity to my attention and consequently to my love. By the power of photography, the natural image of a world that we neither know nor can see, nature at last does more than imitate art: she imitates the artist.[91]

In Bazin's terms, the camera's mysticism lies in its potential for objectivity. The artists' hands are not visible because they make it so, but because it cannot help but be captured by the photograph's omniscient and omnivorous gaze.[92] Philip Rosen points out the productive contradiction in Bazin's theory: "A paradox of cinematic realism is that the mummy complex, whose desire for the everlasting should be so consonant with transcendence and with the spiritual, draws us back to the concrete world."[93] A lesson of postsecular critique is that there is no wiping away that "spiritual dust and grime": that any transcendence to be gotten through such authorizing of the camera and its dream of immediacy is made of nothing but concrete. Day's solution to this problem—to his distrust of indexicality as an end itself—may not have been a popular or viable one, but it provided the possibility of an alternate path. As Peter Coviello and Jared Hickman suggest, the postsecular "need not be taken as periodizing or prophesying eras of secularity or unsecularity. . . . Instead, *postsecular* refers to an epistemological and methodological reorientation from which history might look different."[94] In this sense, it is possible to imagine Day's photographs as constituting something like a postsecular approach to his medium: *Looking sideways* at photography.

However, the discourse on photographic realism, in this period, was not limited solely to abstract conversations about indexicality and the representation of the real. Indeed, the camera—the close-up in particular—had been positioned as a means of adjudicating character. As Tom Gunning puts it, at the turn of the century, the close-up had a "gnostic" mission. The scientific practice of physiognomy posited that the analysis of the face could produce knowledge, that facial features could be used to accurately categorize individuals based on "character" types. Although the practice had its roots in classical antiquity, it was reimagined in the United States as part of the similar, if more modern, pseudoscience of phrenology, and appropriated by the rationalist theologies of the antebellum period. These gnostic movements sought to secularize the promises of divine revelation through the language and methodology of science. Describing Duchenne, a photographer of mental patients, Gunning writes that "for Duchenne the face was an extremely flexible medium on which the spirit writes a translatable message

of emotions in a language created by God himself."[95] To calibrate the arch of the eyebrow, the slope of the forehead, the angle of the nose, was to know something measurable and actionable about the individual. Close-up photographs were used to assess criminality, to diagnose mental capacity, to judge goodness and badness. The scientific use-value of a photograph thus depended upon its precision, its clarity, its ability to transmit such "knowledge" to the analyst. Day's close-ups, in this sense, did not just deviate from a common style. Rather, in their blurring of edges, their pictorial dreaminess, they might be deemed failed portraits. They invoke the idea of the photograph as a diagnostic tool only to foil that use-value with something less certain and more intimate. Not just out of vogue, Day's photographs were, in a scientific sense, wrong.

For obvious reasons, this growing consensus about the camera's horizon of possibility, its drafting into service of the sciences rather than the arts, was of great concern to Day. As Day himself put it,

> The elder photography quibbles with details of petty import. It overlooks the esthetic scene, sole object of the eye, and the heart, and dwells at length upon a sprig, a straw.... Precise and dull as a statistician, it numbers the leaves of the trees, outlining them heavily against the sky, creating a sorry perfection wherein all that is mechanical is to be found, and from which all that is human is estranged."[96]

This passage might well be transposed as a critique of Lew Wallace's *Ben-Hur*. Photographers with the right approach, Day suggests, have chosen "not the sun-bright hours wherein all is to be seen, but hours neighbouring to twilight wherein something is to be guessed. They have found that the indefinite is the road to the infinite" This evocative scene can be read both literally—in terms of choice of natural light—and as a broader metaphor, not just for the artistic debate about photography, but for a general cultural debate (or lack thereof) about knowledge, representation, and faith: To be "seen" or to be "guessed." One model is about the exhibition, the presentation of available information. It relies on viewers' ability to understand and verify the validity of visual information based on their own intellect (something like what Neil Harris calls "the operational aesthetic"[97]). To guess, however, is to actively involve oneself, not just in the act of consuming as a viewer, but also in the creative process. It is to become a co-creator and also a part of the work itself.

This intellectual, bodily, even spiritual investment is at the heart of Day's Christ series. In *The Seven Last Words*, Day, not the camera, is the medium. In one sense, this is a deliberate attempt to reach back in time. The Oberammergau

Passion Play, that centuries-old ritual, had been abundantly photographed, but Day's "Modern Sacred Art Affair" sought to fully translate the dance of transhistorical embodiment into the specificities of the photographic apparatus. If an ordinary man *becomes* Jesus in the theatrical exhibition of the Passion Play, why must a photograph keep a theatrically mediated distance? Why not photograph—evoke—that *becoming* up close? John L. Stoddard's lecture on the Oberammergau play portrays the village as a kind of presecular, enchanted island in a sea of secular modernity. I discuss the implications of that for the controversy about the play's immigration to the United States in chapter 3, but for now it makes sense to associate Day less with those producers who sought to import the play than with the original performance itself, or at least its connotations in the United States. Despite being among the first artists to use the camera to capture a Christ image, Day's photographs endeavor to evoke an almost timeless union of player and role, which would be just as credible as a photograph of the Oberammergau play's first Christ in the wake of that infamous plague year.

Day, more than Phelps, presents a marginal view as an intent to stay marginal. He did not, of course, intend for his work to be lost in the way it was for the better part of a century; rather, his photographs endeavor to figure marginality—indeed, to truly recognize it by means other than scientific diagnostics. (During his heyday at the turn of the last century, he rivaled Stieglitz internationally and was lauded as the organizer of the controversial New School of American Photography exhibit in London and Paris in 1900.[98]) Day did not seek to reconcile his subject position to a mainstream secular imaginary intent on excluding it. Rather, he sought to sanctify his own marginality, to use the form and style of his photographs not only to draw attention to the artificial boundaries of secularism but also to imagine a politics outside them, transcendent.

Smith's recovery of Day's sexual and aesthetic politics enables such a postsecular reading. Smith writes that "[Day's] dreamy, soft-focused images transport bodies beyond the grasp of those scientists who used their own photographic techniques to deem them deviant and undesirable. In Day's erotic theater, homosexual and black male bodies become the idealized origins of beauty, truth, Christianity, and civilization."[99] In what she calls his "politics of pictorialism," Day leverages his deviant images to carve out space for deviant bodies. But the categorization of these bodies as deviant was not simply the result of commonplace cultural or even theological dictate; rather, the influence of phrenology, not just on popular culture but on liberal theology as well, had scientifically and spiritually marginalized figures like Day and the other subjects who entered his studio. Although phrenology was nominally the study of the cranium, the images reproduced in phrenological journals—at first, engraved illustrations, and then

daguerreotypes—were consistently close-ups of the face.[100] These faces, far from simply providing neutral, natural data points, served to limn the boundaries of acceptable or even legible moral character. "The increasing public visibility of racial and ethnic others," John Lardas Modern writes, "threatened the clean lines and smooth workings that lent support to the dense hierarchies of white privilege."[101] Phrenology tended to those lines and mechanics by way of exclusion. Modern points to the way specific racial and ethnic groups were placed outside of the norm by this practice, but, as Molly McGarry notes, phrenology additionally "offered no category for the homosexual."[102] While for many believers this practice, and these close-ups, reaffirmed an ideal of radical reflexivity, self-knowledge, and the immediacy of revelation, for many others the close-up was a means of enforced exclusion from the normative sociality of secularism. Looking at such scientific portraits, or even artistic portraits that shared their aesthetic points of view, Day did not—could not—see himself for the layers of spiritual dust and grime. Secularism did not disappear for F. Holland Day.

Day's Christ selfies are composed in counterpoint to the available aesthetic codes of rationalist faith. They present a Christ figure illegible to the scientific lenses of the nineteenth century; they embody Christ through a figure whose very existence is outside the normative sociality of secularism; and they strive for an intimate communion with the viewer that is less modern and progressive than nostalgic for the rapturous possibilities of an imagined presecular time. Day's mediations are hypervisible, in the terms of Meyer or Van de Port; his deviations from the aesthetic norm render his photographs formally polemical. Although a close-up portrait produced for scientific, or even spiritual, analysis must pretend to a naturalness, a neutral realism that mirrors its ideological rooting in the regime of secularism, Day's close-ups pretend no such naturalness. They are, as Smith suggests, "auratic" in a way Benjamin claimed the photograph could not be. Here, though, Benjamin's suggestion of a technical limitation of the photograph might be read as a conditioned spiritual limitation of the photograph. They make the hand of the artist visible, almost tactile. By figuring—queering—mediation in this way, they propose a "dream of immediacy" in excess.

Day's photographs are of interest to this book not because they foretell the cinematic adaptation of the Christ image, but rather because they proved to be not very influential at all in this regard. Day's approach is a lost path, only recently recovered by art historians and visual theorists. The artists of early cinema, as I discuss in chapter 3, went to the same Oberammergau play Day attended, but they came away with a vision of a Christian cinema that was as rooted in the metaphysics of secularism as Day's Christ selfies were leveraged against it. The Passion Play film sought after a scientific historical realism that

Day never embraced. Perhaps the truest way of gauging the way in which Phelps and Day both were able to resist the pull of their secular medium is that, though both artists engaged with the visual in intimate ways that could easily have been replicated within the aesthetic of early film, both seem to have been forgotten by the visual culture that grew up around them. Phelps and Day do not serve, then, as examples of how secularism became culturally institutionalized or formalized in this period. Rather, their cases put into relief just what an influential and overwhelming role cinema would play in that process. Day's *Seven Last Words* are the final utterances of an insurgence, ghostly images that dissolved into history the moment Christ moved onscreen.

3
Tricks and Actualities

The Passion Play Film and the Cinema of Attractions

In 1911, so the story goes, the Kalem Company director Sidney Olcott had set up his staff in a London hotel room to take auditions for a new motion picture of the life of Christ, to be titled *From the Manger to the Cross*. Midway through the audition process, a bearded man in a flowing blond wig, wearing long white robes and sandals, burst into the room, walked up to Olcott, and declared, "I am Jesus Christ. I will portray myself in your film." The man, it turned out, was the Shakespearean actor Robert Henderson Bland, who had begun what he would later call his "pilgrimage" into the character by engaging in this early instance of cinematic method acting. Moreover, he claimed that he had had a vision the night before, and that God had told him that Bland was his chosen son. With Bland already cast by the God of heaven and earth, he understandably felt confident going into the audition. Olcott duly hired him on the spot, but later recalled the incident in this way: "Frankly, we thought he was mad," he said. "But we didn't argue. He was obviously what we wanted."[1]

This incident, apocryphal though it might be, is indicative of a general mania surrounding the production and release of Olcott's film in 1912. Bland, who continued to wear his wig, robe, and sandals and refused to travel except on foot at nearly every stop of the promotional tour for the film, claimed that he had performed all of his scenes in an unconscious trance. And Gene Gauntier, the Kalem actress and screenwriter who wrote the film's scenario and portrayed the Virgin Mary in it, claimed that she came up with the idea for the film through some kind of mystical experience she achieved while bedridden in Egypt. The production and later reception of *From the Manger to the Cross*, one of the first feature-length films of the life of Christ and *the* first to be shot on location in Palestine, is suffused with this mixture of logistics and spirituality, materialism and mysticism. God comes to Robert Henderson Bland in a dream to prepare him for a job

interview. Gene Gauntier is visited by a spirit who gives her a profitable idea for a feature film. Although the resultant film is far less rapturous than all this would suggest, it is, in its aesthetic makeup, reflective at least of this dual allegiance on the part of the filmmakers. Gene Gauntier's vision was not just about any film idea: it was about an innovation in terms of location shooting. Gauntier's revelation was, in the end, a call to a greater, more conventional realism in service of a metaphysical, supernatural goal.

Between 1897 and 1912, the Passion Play was one of the most popular genres of world cinema. Films of Christ's life were produced, copied, and exhibited globally to great public acclaim, yet there remains curiously little scholarship on this archive. In this chapter, I discuss a number of these early life of Christ or Passion Play Films, from the late-nineteenth-century films of Edison and Lumière, to Alice Guy's *The Birth, The Life, and The Death of Christ* released by Gaumont in 1906, to Pathé's 1907 *The Life and Passion of Jesus Christ*, and finally, Kalem's 1912 *From the Manger to the Cross*. These films, I argue, mobilized an aesthetic of spectacular realism that thrived on the opposition and ultimate containment of trick and actuality. The Passion Play films, especially in their representations of Christ's miracles, freely superimposed signifiers of realism and fantasy, prodding viewers with the opportunity to discern and ultimately resolve their relationship in the space of the theater. That spectators could achieve this resolution in the theater—this situational equilibrium between reason and the supernatural—was an early demonstration of cinema's transcendent ability to serve as a disciplinary technology of secularism.

In this chapter, I first discuss the immediate prehistory of the Passion Play film as both a theatrical production and a popular subject for slide lectures in the late-nineteenth-century United States. To do this, I return to some of the sources of Charles Musser's pioneering archival work on the subject. However, this chapter specifically draws out the representational questions raised by the mixed reception of the Passion Play in the nineteenth century as a way of revealing the very specific narrative of secularization that undergirds both defenses and indictments of the popular performances. In the second section of this chapter, I suggest that this genre, in negotiating between the belief and skepticism of modern audiences, combined two modes of early cinema that are often characterized as oppositional: the trick and the actuality. I argue that these traditions, like the cultures of sacred and secular of which they are a part, are best studied as aesthetically intertwined and mutually stabilizing. To demonstrate this more fully, the final sections of this chapter turn to the aforementioned films by Edison, Lumière, Guy, Zecca, and Olcott. The Passion Play film is both an understudied genre of early cinema and a foundational example of how film emerged in this time as an expression of and training ground for belief in a secular age.

ST. JOHN IN SHIRTSLEEVES: THE PASSION PLAY BEFORE FILM

The Passion Play itself is a Christian tradition that stretches back to the medieval mystery plays. In a basic Passion Play—and there are as many historical and global variants as there are individual performances—the faithful perform the final hours of Christ's life, from the arrival in Jerusalem to the crucifixion, resurrection, and ascension. The plays, which continue to be presented today, are often community-based productions, more pageant than drama, and they are performed at ritual intervals: for example, every Easter season, as in many evangelical churches in the United States, or once every decade, as is the case with the famous Oberammergau Passion Play in Bavaria. That particular play had its first production in 1634, when villagers made a vow that if God spared them from the bubonic plague that was, at the time, rampant in Europe, they would perform Christ's passion every ten years. The town was spared, and so the play came to be performed every decade to growing global acclaim. The Oberammergau play is extraordinarily long—as many as seven hours—and includes a mixture of spoken dialogue, narration, music, and *tableaux vivants*. More remarkably, most members of the cast and crew are reported to be residents of the village, many of whom inherited their roles from parents or family members. The role of Simon the Cyrenian, for instance, may remain with one family for several generations. This tradition has continued to the present day, as cast member biographies in the press materials for the 2010 production list the day job of each actor and the role he or she played in previous productions.

This particular ritual performance and the circumstances of its production were the subject of a number of slide lectures in the late nineteenth century, most notably one by John L. Stoddard, the famous lecturer and writer, who toured the United States in 1880 with a magic-lantern show documenting the preparation for and performance of that summer's Oberammergau play. Stoddard's lecture, which he continued to deliver throughout the decade, and which he updated and revisited after traveling to see the 1890 production in Bavaria, was the most popular of many presentations of the Passion Play in this era. In his lecture, Stoddard would narrate the story of his travels to Bavaria and his subsequent attendance at the Passion Play itself, all the while cycling through a tremendous archive of photographs documenting both the play and the surrounding environs. His performances were notably focused not just on the life of Christ, but also on his own status as a spectator at this particular staging. In many ways, these lectures were re-enactments, not of the plays, but of an original act of spectatorship. One didn't just see the Oberammergau play; one saw *Stoddard* seeing the Oberammergau play.

For Stoddard, Oberammergau was a kind of untouched, presecular oasis, and the play itself functioned as a mode of time travel, bringing the presumed purity—and porousness—of an older time into the present. Indeed, in his 1897 *The Passion Play*—essentially an illustrated, narrativized transcript of his popular slide lecture—the idea of a transhistorical, semi-mystical connection between the villagers in Oberammergau and the Christ story is a central theme. It is not only that Oberammergau is somehow presecular, according to Stoddard, but also that the act in which the peasants are engaged is productive of a kind of bridge between an enchanted presecular age and the present. The entire first portion of the book is committed to Stoddard's travels among and conversations with the townspeople who play the characters in the Passion Play, and this "bridge" notion first makes its appearance in a long, didactic monologue given by Stoddard to his assistant and travel partner, who is shocked to find, among other things, that the horse that stands by the cross during the crucifixion works by day carrying lumber:

> The trouble with you . . . is that you have not yet adapted yourself to your environment. You secretly expect to see these actors of the Passion Play, clad in their Oriental robes, standing around the streets in picturesque positions. St. John in shirt-sleeves startles you. The Roman centurion's horse drawing a load of wood inspires you with horror; and Herod playing with his babies seems entirely out of place. You are experiencing in a higher degree the disenchantment that you feel in seeing on the street, in citizen's dress, the actor who an hour before had electrified you as Othello. Of course, one way to see the Passion Play would be to come here on Sunday morning, and leave directly after the performance. But in this way, one would see nothing of the village; and to view the Passion Play without the village would be like seeing a diamond without its setting. The great marvel of the Ober-Ammergau [*sic*] spectacle is to behold these pious mountaineers faithfully carrying out the vow of their forefathers, and under that great inspiration rising from the farm and workshop worthily to portray the historic characters connected with the life of Christ.[2]

The environment to which Stoddard insists his friend must adapt is one in which there is a strong, noncontradictory link between the present-day citizens of Oberammergau and the characters they portray. This same Orientalism—the notion that contemporary citizens in a place of great historical or spiritual significance share some transcendent bond with that past—animated many of the Holy Land travelogues that influenced Lew Wallace as well. The difference here is that, while the detritus of centuries of commerce and colonialism rendered the

Holy Land and its denizens "disappointing," Stoddard claimed Oberammergau to be free of these corrosive traces of the modern era.

Although the Oberammergau Passion Play itself and Stoddard's photographic lectures were met with tremendous critical acclaim in the United States and abroad, every attempt to produce a Passion Play in the United States during this period was met with nothing but hostility by American Protestant groups, many of whom were avid attendees of Stoddard's lectures and who cited the reverence and artfulness of Oberammergau in their criticisms. In 1879, in order to capitalize on the upcoming visibility of the Oberammergau play, Thomas Maguire, the manager of San Francisco's Grand Opera House, staged the first commercial U.S. performance of a theatrical Passion Play, based on playwright Salmi Morse's *The Passion: A Miracle Play in 10 Acts*. Protestant groups of all kinds tried to stop the production, and numerous bills were introduced in the city council, attempting, for instance, to make it a misdemeanor to exhibit "any play, performance and or representation, displaying or intending to display, the life and death of Jesus Christ, or tending to profane and degrade religion."[3] Indeed, despite garnering great reviews for the humanity and delicacy of his performance, in 1879, Joseph O'Neill was arrested and fined fifty dollars for "imitating" Christ in Morse's play in San Francisco.[4] One reverend, speaking for the influential Ministerial Union, condemned the play by saying, "For one dollar per head [Morse] would trample under foot the blood of the crucified, and present to the prurient gaze of an unhallowed throng the strange, deep, holy mysteries of our religion."[5]

Despite these particular protestations, it remains hard to imagine that these Protestants—no strangers to the commercialization and theatricalization of religion themselves—were genuinely offended by the union of commerce and reverence represented by Morse's play.[6] Indeed, it seems possible that what lay at the root of these criticisms is the idea that the plays were not modern *enough*. The markers of good religion in the late nineteenth century were often a mix of rationalism and faith, the appearance of empirical method applied to the search for Christian revelation. The style of this secularism was manifest in the scholarly affect of sacred geography, the scientific method of phrenology, and the historiographical philosophy of Lew Wallace. Whereas Stoddard's lecture and its elaborately performed documentary frame made audiences feel that they were joined with their narrator in an anthropological endeavor, the Morse play stripped all that away. The documentary frame constructed safe access to these fascinating, superstitious primitives, but the American play, absent these mediations, could perhaps easily turn the audience primitive, too.

Charles Musser, in attending to these controversies, suggests that this was not the only distance that could explain why Protestant groups were uncomfortable

with Salmi Morse's play but intrigued by both Stoddard and the inevitable films that would be produced. Musser argues that it is the fundamental "absence of presence" inherent in screen practice that made these slide lectures more palatable. In other words, screen representations signified both an "impoverishment and a liberation" for artists like Stoddard: because filmmakers could not presume to capture the authentic reality of Christ with the camera, according to critics, representing the figure onscreen neatly avoided the problems raised by the stage play. Screen projection produced a safe indexical distance between the divine Christ and the screen image meant to represent him.[7] Yet, as Stoddard's lectures paved the way for filmmakers to attempt Passion Plays of their own, and the "absence of presence" unique to screen practice made them legible and suitably reverent, the popular response to the Passion Play film in its earliest period was most remarkable for the fact that many reviewers found themselves transcending the distance between image and reality and testifying to something like a religious encounter enabled by the "realism" of the Passion Play film.

For Stoddard's slide lectures and the later Passion Play films, the screen paradoxically creates a representational distance—between the contemporary performers whose images are captured and the actual historical people they aim to represent—at the same time that it produces in spectators a sense of intimacy with the past.[8] In this way, Oberammergau, both as an imagined place and as a photograph in Stoddard's lecture, enables audiences to fix that image as one of what Vivian Sobchack might call "eternal timelessness," and, further, to allow the spectator to "possess" it visually.[9] For Sobchack, the act of looking at a photograph produces a particular kind of "subjective vision . . . literalized in an object that not only replicates and fixes the visual structure of having at a distance but also allows it to be brought nearer."[10] In other words, using Sobchack's formulation, though Stoddard's lectures might have created and then frozen a presecular moment, preserved respectful distances between the performer and the sacred character, and inoculated audiences against the feeling that their feelings about the play were too credulous, those lectures also allowed audiences to materialize, possess, and thus become closer to the image. Indeed, with the publication of Stoddard's book, these audiences could even purchase the images, possessing them quite literally. Motion pictures, taking their cue from Stoddard's popularity, immediately took advantage of that technology to access and ultimately modify this relationship. In cinema, "the space between the camera's (and the spectator's) gaze and the [figure onscreen]," Sobchack writes, "becomes suddenly habitable, informed with the real possibility of bodily movement and engagement, informed with lived temporality rather than eternal timelessness."[11] Sobchack's film phenomenology is structured around this notion of a habitable, dynamic

space between spectator and screen, lived life and projected life. Early cinema, especially in its own Passion Plays, would do a great deal to construct and codify the rules for that space and its inhabitants.

SPECTACULAR REALISM: BETWEEN TRICKS AND ACTUALITIES

The commonplace default narrative of early cinema separates films into two distinct, foundational orientations. In the beginning, there were two forms: the trick and the actuality, the fake and the real, the fantasy and the truth. The trick begat this, and the actuality begat that. Early cinema, we know, was no sort of orderly procession from mode to mode. Nevertheless, historically, we have often been asked to recognize a model of cinema's formal evolution that is based on a binary between the trick and the actuality. Indebted most directly to Siegfried Kracauer's distinction, in *Theory of Film,* between the "realistic" and "formative" tendencies of early cinema, the binary model of film history is as pervasive as it is ultimately misleading.[12]

What is a trick film? The trick is the moon's grimace, the floating head, the disappearing lady. It's the puff of smoke, the flying bed, the electric hotel and its animate inanimate inhabitants. The trick film—by Georges Méliès, by Alice Guy, by Segundo de Chomón—is a film with a trick in it in the era of attractions. It is defined by the spectacle, the attraction, that it contains. It is, by way of shorthand, the ancestor of the special-effects epic, the sci-fi blockbuster, the horror film. Whether we understand the trick to smother and render obsolete any narrative architecture, or whether we think about the trick as part of a stuttering marionette's dance with the threads of plot that enable it, the trick takes over. This is not the movie about what the people on earth do while the astronomers fly to the moon.

The actuality film, the *actualité,* is that film. Trains arrive in stations, workers leave factories, soldiers assemble and fight. Babies eat breakfast, proud parents look into the camera, leaves rustle behind them in extraordinary displays of spectacular contingency. The actuality film—by the Lumière brothers, by Thomas Edison, by Charles Urban—is a film with an actuality in it in the era of attractions. It is, by way of shorthand, the ancestor of the documentary, the romantic comedy, Italian neorealism. The actuality—the real event, reenacted or captured in the moment—names both the spectacular attraction and the aesthetic of which it is a part. There is no trick except for the trick of reality itself.

As attractive as these descriptions are, they are historically conditioned. The separation of these modes has always been an oversimplification, a way of thinking about film's aesthetic history as an almost genetic combination of two parents. But when we really look at them, early films reveal themselves to be pastiche, palimpsestic assemblages combining not only oppositional orientations but even foreign bits of film, points of convergence within busy networks of global circulation. Méliès made tricks, and he made actualities, and he made narratives for both. Seemingly pure actualities like the Lumière train and seemingly pure tricks like the vanishing lady are ends of a spectrum, not wholly contained opposites, and even they are leavened with other elements. To insist on a hard-and-fast distinction between the trick and the actuality is to erect boundaries where there are none, or, more accurately, to mistake contact zones for rigid borders.[13]

This is not news, but it is a point worth articulating when endeavoring to analyze the actual relationship between these orientations in the era of early film. In an essay entitled "The Life and Death of Superimposition" (1946), André Bazin described the historical separation as largely artificial:

> The opposition that some like to see between a cinema inclined toward the almost documentary representation of reality and a cinema inclined, through reliance on technique, toward escape from reality into fantasy and the world of dreams, is essentially forced.... The one is inconceivable without the other.[14]

Bazin argues that this is a false dichotomy. More than that, he suggests that the cooperation between the two, or at least their bristling contact, is something like the point of film as a medium. The real potential of cinema, for Bazin, does not lie solely in its capacity for realism, nor does it rest completely in film's ability to imagine new, fantastical worlds. Instead, the potential of cinema lies in its simultaneous management of these orientations. Here, resisting the binary of trick and actuality is not a hollow act of courage against a straw man. Rather, this false narrative provides an opportunity to leverage a description of cinema's ambivalent, confounding, lived aesthetic heritage. André Gaudreault, writing specifically about this dilemma in relation to the Passion Play film, suggests a somewhat cheeky resolution:

> The question remains: is a Passion Play film documentary or fiction? It is neither one nor the other. In fact the question is misguided. Someday we will have to stop placing these two entities back to back like this (rather than being disconnected wholes unto themselves, they overlap considerably).... It may be that we need a new word to express this crucible relationship between documentary and fiction. Unfortunately "cruci-fiction" doesn't seem suitable.[15]

What Gaudreault calls the "crucible relationship between documentary and fiction" in the Passion Play film is a foundational element of film's emergence as a medium. "Cruci-fiction" may be, in almost every way, an inappropriate coinage, but at least it captures the centrality of this dynamic to film's origin story.

I call this "crucible relationship" *spectacular realism*, and I argue that it is an aesthetic of the secular age. As both Bazin and Gaudreault demonstrate, and as the alternately scandalized and seduced critics of the Passion Play perform, the question that film as a medium is set up to answer is a question about the relationship between observable reality and what William James would later call the "reality of the unseen."[16] In this way, regardless of a film's subject or the filmmaker's personal faith, film as a medium is inescapably animated by questions of belief and often bound to particular answers. Every frame of every film from 1895 to the present, whether it contains a baby's breakfast or a vanishing lady, is occupied with visually adjudicating this relationship. And it is precisely this relationship, difficult as it is to parse, that a binary model of early film history sidesteps. If we eschew such ahistorical separations, what we see is an aesthetic spectrum in which realism and fantasy are superimposed, in which the signifiers of documentary and the signifiers of fiction are mutually authenticating.

It is this feedback loop between the real and the fantastic that renders film such a perfect refraction of secularism in this period. Adam Lowenstein, in his reading of Bazin's realist theory, suggests that what's really at stake for Bazin in "The Ontology of the Photographic Image"—his foundational essay on realism—is the camera's perceived power to "*combine* rational fact with irrational belief." Bazin's theorization of cinematic realism, he writes, is an account of the "complicated collaboration between the mechanical objectivity of the photographic medium and the affective subjectivity of the viewer's response to, and belief in, the photographic image . . . an irrational dream coextensive with rational reality."[17] For Lowenstein, this means that the endpoint of Bazinian realism is actually a species of *surrealism*. For our purposes, however, this reading is enough to suggest that cinema is not just a free space in which realism and fantasy, reason and irrationality bump up against each other—it is not, in other words, Taylor's "middle realm"—but rather a space in which these orientations are forcibly combined, in which a vision of reality is presented to authorize a particular fantasy and vice versa. Surrealism takes this aesthetic foundation to its extreme, but such a possibility is part of the frame regardless.

This echoes John Lardas Modern's influential characterization of what he calls the "normative sociality" of secularism: "Under the sign of a nonspecific Protestantism there occurred a mutual imbrication between the religious and the secular. To be clear, I am not making the familiar case for the collaboration of

the religious and the secular. Instead, I wish to attend to the strange processes by which the religious and the secular were *made compatible*" (emphasis mine).[18] As decades of critiques of the secularization thesis have made clear, there is no clean dividing line between the religious and the secular; moreover, the two orientations—like the trick and the actuality—counterbalance and enable each other. The process of secularization was, in some ways, a process of retrofitting the two so that they could accomplish mutual stabilization. Reading Bazin by way of Lowenstein by way of Modern, we can imagine that the camera's potential lies in its ability to make an *irrational dream* and *rational reality* compatible. Early filmmakers, between trick and actuality, set the terms for this compatibility, and in so doing made cinema both a theater and a training ground for belief in a secular age.

It is in the era of attractions—film's earliest period, from 1895 to on or about 1906—that this dynamic is most visible, if only because it is so near the surface. Although the concept of the cinema of attractions is nearly thirty years old now, it remains the strongest argument for the formal continuity of these otherwise divergent modes. This aesthetic is rooted in exhibitionism, the transubstantiation of the theater onto the screen, and the reliance on shock over narrative, as it has traditionally been defined in Hollywood cinema. As Tom Gunning described it in 1989,

> the aesthetic of attraction addresses the audience directly, sometimes . . . exaggerating this confrontation in an experience of assault. Rather than being an involvement with narrative action or empathy with character psychology, the cinema of attractions solicits highly conscious awareness of the film image engaging the viewer's curiosity. The spectator does not get lost in a fictional world and its drama, but remains aware of the act of looking, the excitement of curiosity and its fulfillment.[19]

This is as true for the trick as it is for the actuality. The viewer is called to both experience and reflect upon that experience, to find pleasure in the intellectual and emotional management of these stimuli rather than be fully carried away by them. A disappearing lady accomplishes this goal just the same as a train speeding toward the camera. What I'm describing as spectacular realism is part and parcel of this aesthetic. If attractions are designed to keep spectators "aware of the act of looking," spectacular realism names the moment at which viewers become aware of the crucible at work: the thin, peripheral margin of the viewer's gaze that tethers the viewer to the phenomenal world. The ghostly figure superimposed over travelogue footage, the appearing and disappearing angel in front of

an historical landmark, the trick intruding upon the actuality and vice versa: this is the moment at which film's function as a medium of belief is laid bare. But it also describes the role of the spectator in this scripted negotiation between rationality and irrationality.

The separation between the sacred and the secular, like that between the trick and the actuality, is a narrative expedient. This is not to diminish the tangible differences between the two orientations, but rather to point to the notion that difference does not imply estrangement in this era. The sacred partakes of the secular, the secular partakes of the sacred, and the movies you see when you peer into the Kinetoscope are neither fully magic nor fully real. What's more, the opposition between trick and actuality—and the viewer's ability to consciously sort them out—is baked into the aesthetic. Realism and fantasy support each other, are *compatible* with each other, by way of their opposition. To figure the trick and the actuality as separate orientations is indeed "forced," as Bazin says, and "misguided," as Gaudreault says, but this does not dull the impact of their perceived dialectical relationship. To see early cinema through its spectacular realism is neither to melt down realism and fantasy into an undifferentiated mass nor to imagine a free and improvisatory exchange between the two; rather, it is to see their opposition as fundamental to the secular mechanics of cinema. The history of the Passion Play film is the history of a realist medium's relationship with special effects, the history of how cinema was born secular.

THE RICKETY PLATFORM AND THE ELEGANT DISSOLVE: TRICKS AND THE PASSION PLAY

The first Passion Play films claimed to consist of actual footage of plays produced in Horitz, Bohemia, and Oberammergau, Bavaria, respectively. Although the Horitz film was indeed shot in Bohemia, produced by Klaw and Erlanger, and distributed in the states by Edison, the Oberammergau film, also distributed by Edison, was actually shot on the roof of the Grand Central Palace theater in Manhattan.[20] These films were incredibly popular, mobilizing both the attractions of the documentary—a film of a play of the gospels—and the trick. The pretense of documentary was meant both to capitalize on the success of lectures like Stoddard's and also to inoculate the films against the kind of critiques (about actors being paid to portray Christ) that nearly brought down Salmi Morse's play. Indeed, the taglines on Edison's promotional posters read, "All Moving Pictures. True to Life." The second of these lines—*True to Life*—is a distinct and

deliberate claim for the authenticity of the film as actuality or documentary and not, pointedly, a commercial, theatrical spectacle, but it is also usefully ambiguous about its referent. What exactly about this film was meant to be "true to life": the villagers in Oberammergau performing a play, or the historical and divine characters they represent?

This was an active question in early reviews of the films, and it was a question most often resolved by reference to film's dual fantastical and realist capacities. A reviewer of the Horitz film, for instance, claimed that the picture's realism came as a "surprise to people unacquainted with the thaumaturgy of the cinematograph." Again, we have reference to the camera as magical. And what is the result of cinema's prestidigitation here?

> At first, the spectator thinks of the pictures only as a representation of a representation—regards them in the light of an effort to show how the peasants at Horitz acted their "passion play".... But when the play begins there is a new mental attitude toward the representation. The thought that one is gazing at a mere pictorial representation seems to pass away, and in its place comes, somehow or other, the notion that the people seen are real people, and that on the screen there are moving the very men and women who acted the "Passion Play" last summer in the Bohemian forest to the delight of thousands of foreigners.[21]

This is a common description of the early cinematic experience. This is not to give in to the myth of the credulous spectator, but rather to draw attention to the fact that the phenomenological collapse of distance between spectator and screen—detailed earlier by Vivian Sobchack—was still understood, at this time, to be something of a remarkable occurrence. Thus, the act of "thaumaturgy" or magic here is performed in service of a species of cinematic realism.

This review becomes especially extraordinary in its final argument:

> Then the players begin to depict the birth and life of Christ, and with this change of the subject, there comes a new change of mental attitude. So absorbing becomes the interest in the pictures that the onlooker, from merely regarding the figures as figures of the real, live people who acted the play in Bohemia, begins to forget all about what was done in Bohemia and henceforth is lost in the thought that the faces and forms before him are the real people who lived in Palestine 2000 years ago, and with their own eyes witnessed the crucifixion of Christ.[22]

Here, the reviewer moves from marveling at a convention of the cinema experience to marveling at something that transcends the material potential of the

apparatus. The reviewer claims that the images are so "absorbing" that the viewers "forget" the material circumstances of both the film *and* the performance that is being filmed, and thus become "lost" in the idea that they are watching actual history unfold onscreen. This language of absorption might seem to run counter to an understanding of attractions as largely non-narrative works invested in producing and utilizing the distance between spectator and screen. But, as Gunning describes it, such investment is a crucial part of the aesthetic: "[F]ar from being placed outside a suspension of disbelief, the presentation acts out the contradictory stages of involvement with the image, unfolding, like other nineteenth-century visual entertainments, a vacillation between belief and incredulity."[23] Attractions are structured around the opposition between two modes and two ways of seeing.

Even though these films were produced squarely within the era of attractions—visible in their theatricality, their exhibitionism, their direct address to the audience—they still constitute something of a special case, particularly in their relationship to narrative. Passion Play films were built around a kind of back-door narrative buttress. On a formal level, the early Passion Play films were structured to provoke the kind of audience absorption just described, and thus to engender the communion between spectator and image described by Sobchack, through audience participation. Many scholars of early Passion Play films note that these films—particularly the Edison and 1903 Zecca films—despite existing before the emergence and establishment of conventions for narrative continuity, were nevertheless able to be experienced by spectators as narrative films. Gunning reports that even by 1903, Passion Play films could be ordered by exhibitors with varying numbers of scenes and thus varying lengths, but that, regardless of what elements of Christ's life were shown—the miracles, the crucifixion—audiences familiar with the story were able to fill in the blanks, to collaborate with the film in the construction of a narrative address. "This familiarity," Gunning writes,

> is assumed by the elliptical narrative structure of the films of the Passion which Burch describes as having no narrative sense for anyone ignorant of the Christian tradition. The very possibility of films of the Passion with varying numbers of scenes depends on such foreknowledge. The knowledgeable viewer could always fill in the gaps if certain key scenes were provided and thus the series could be either compressed or expanded.[24]

Not only as a feature of cinema as a medium but also as a feature of these films specifically, the audience was asked to transcend the space of the theater to take part in the experience of the story. This, presumably, is the kind of intersubjectivity

and interaction described in the Horitz review. The Passion Play film requires audience investment in order to make sense at all.

There are echoes of *Ben-Hur* in this interactivity: the implicit or explicit request that readers or spectators contribute to a story in order that it may be told. What's more, just as was the case in Lew Wallace's novel, this participatory element is crucial to the way these films formally replicate and amplify the logic of secularism. If the style of secularism is something like an inevitability that feels like a choice, then this mode of involvement—the film *needing*, calling out for the imaginative collaboration and knowledge of the spectator—is a workshop in liberal agency. However, supplying plot synopses of the New Testament is neither the only nor the most central mode of spectator involvement in the Passion Play film. Instead, there is another source of "absorption" that gives these films their power of world-making beyond even the interaction of the spectator.

In the Passion Play film, viewers can surrender themselves without surrendering their rationality. Indeed, even the *Horitz* reviewer, who testified to his absorption, suggested that viewers are "lost *in the thought*" that these scenes are real. By providing their own collaborative commentary and marveling *intellectually* about the "thaumaturgy of the cinematograph," viewers provide what Gunning calls the "rationalist context" necessary for attractions to work. To approach these films critically but remain open to their ability to fool the senses, to become momentarily lost but find one's way back: these are pleasures of the cinema of attractions that are coextensive with the way the film medium begins to function as a laboratory for belief in the secular age. The myth of the credulous spectator is wrong not only because it is historically inaccurate, but also because it misstates the kind of belief that cinema helped to produce in this early period. Film did not seek to return skeptical moderns to a mythical premodern sense of wonderment; instead, it sought to produce a new form of wonderment calibrated with modern skepticism in mind. It was, indeed, the movement *away* from naïve belief, the step *back* to rationality, that constituted the magic of secularism here, naturalizing a style of belief rooted in a structuring opposition between rational skepticism and the idea of transcendence. This cinematic style provided audiences with a fleeting escape from their reality and its temporality, but audiences returned to their own worlds just as quickly, just as shockingly. According to Gunning, attractions produced "an intense interaction between an astonished spectator and the cinematic smack of the instant, the flicker of presence and absence."[25] The cinema of attractions—the smack and the recovery—thus constructed a frame for secular belief.

Whereas the Edison films accomplish this primarily through their suggestion of tableaux *come to life*, another 1898 film, this one produced by the Lumière company and directed by Alexandre Promio, provides a far more spectacular example

of this experimental framing that's so simple as to be almost moving. The Lumière film is notable here for its integration of special effects—and thus mobilization of the "trick" aesthetic—in both expected and unexpected places. The frames are wide with painted stage sets and the action taking place low in the frame: this is the theatrical exhibitionism by which we identify the cinema of attractions. The film, like most of its contemporaries, consists of a series of moving tableaux: the Nativity, the Flight into Egypt, the Raising of Lazarus, the Last Supper, Gethsemane, the Trial Before Pilate. There are two miracles. In the first, the Raising of Lazarus, Christ commands the man beneath the sheet to rise, and the man beneath the sheet complies. There's a striking suddenness to this action, but it's accomplished conventionally, without any of the dissolves or double exposures that would become common in later Passion Play films. Rather, it's the Last Supper where the filmmakers manipulate the camera to great effect (figure 3.1).

In the gospels, the miracle of the Last Supper is essentially an offscreen one. Christ's body and blood are manifest materially but invisibly as bread and wine. In the Lumière production, though, the miraculous aspect of this event is visualized (if relocated). After the intertitle, we see a table stretching nearly the width of the frame, men pouring wine and passing bread on either side of a conspicuous space in the center. After a few seconds, Jesus suddenly appears in that empty space, and the apostles react with shock and delight, throwing their hands in the air—perhaps as if they'd just seen a train hurtling toward them from a movie screen. To sustain this grace note a bit longer, Jesus then produces two loaves of bread from beneath his robes (big illusions, close-up magic, he does it all). This is the most basic trick edit, the substitution splice that enabled Méliès to destroy moon aliens with his umbrella. The fact that this cut appears in this film in order to produce an event that isn't even a part of the gospel narrative seems extraordinarily significant. Moreover, it's a perfect illustration of the spectacular realist understanding of cinematic process. For Jesus here—the physical manifestation of the camera's possibility—the act of appearing from nowhere is a matter of fact. For the spectator—whose onscreen proxies are the stunned apostles—this is a work of seeming magic. The diegetic world of this film is one in which the boundaries between the miraculous and the real appear to be porous.

This simple edit in the Lumière film turned out to be a seed that would grow into perhaps the most recognizable—if counterintuitive—tropes of the genre: the Passion Play film is a special-effects film. The porousness of this scene of the Last Supper indeed became the visual aesthetic, and perhaps even theological prerogative, of this film genre as it developed throughout the silent era. And although the Lumière edit is subtle, even understated, such edits would not be so for long. Alice Guy's 1906 film, *The Birth, the Life, and the Death of Christ* is

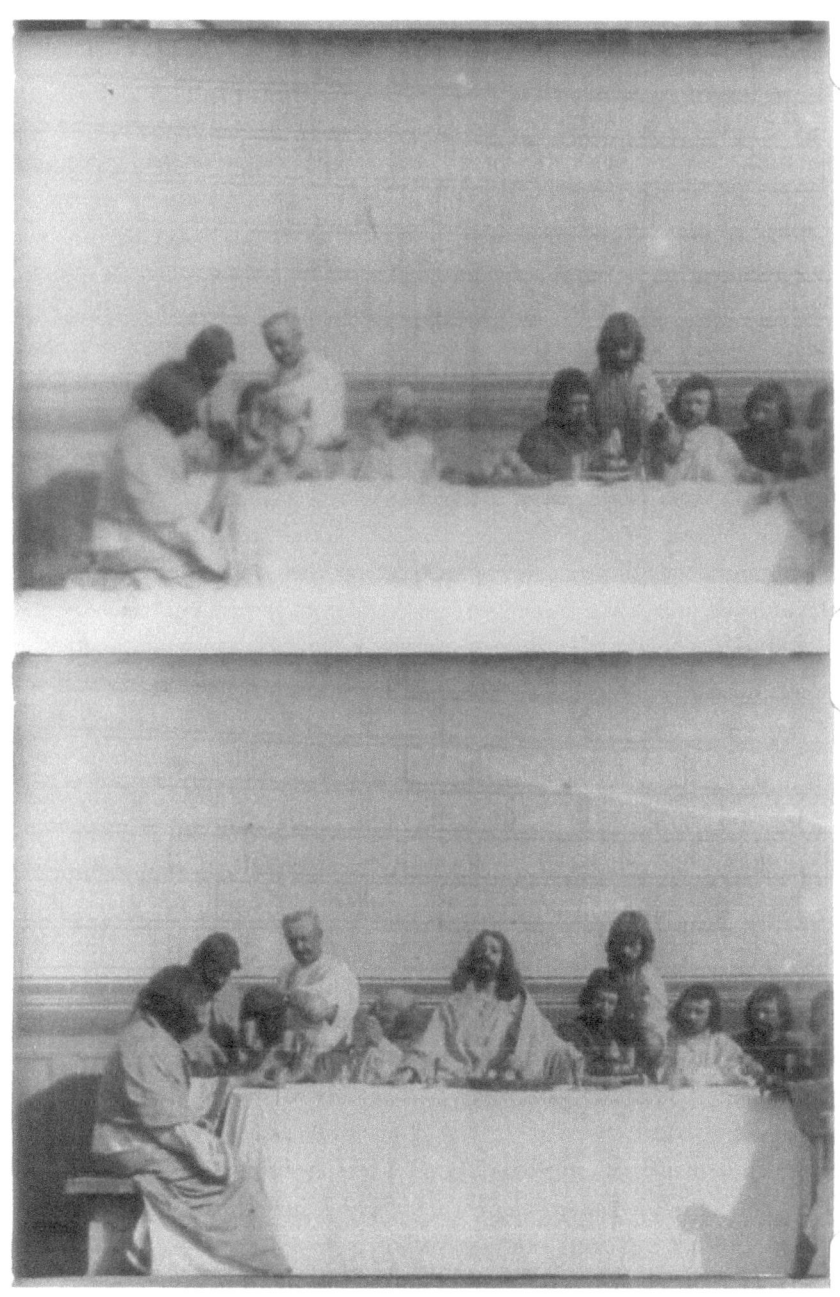

FIGURE 3.1 *The Passion Play* (Alexandre Promio, 1898) Library of Congress

a Passion Play film that elaborately expands upon the possibilities inherent in the medium. Guy began her career as a secretary for the French camera and photography supply company that eventually became the Gaumont Film Company. She began making short films in the mid-1890s, and, by 1896, she was named head of the studio. For much of the twentieth century, Guy was overlooked in histories of this period in favor of her contemporary and competitor Georges Méliès, but Guy had as much to do with the early evolution of cinema as did her rival, and her career continued well into the era of narrative integration, when she directed many films for Solax in the United States. She was a pioneer of cinematic special effects—making reference to Guy's Catholicism, Alison McMahan calls these films Guy's "miracle films"[26]—and the ambition and length of her films has led many scholars to consider her one of the earliest "narrative" filmmakers. In both its spectacular set-pieces and its investment in storytelling, *The Birth, the Life, and the Death of Christ* is perhaps her representative masterpiece.

In Guy's film, there are abundant theatrical sets as well as natural locations, in addition to wild theatrical histrionics. Though the actors portraying the main characters do not address the audience as they did in earlier films indebted to the conceit of the Passion *Play*, the angels that appear often do, bowing and gesticulating toward the camera. Indeed, Christ and his female angels materialize and dematerialize with stunning frequency. These scenes call to mind the tradition of the vanishing lady film, most famously produced in this period by Georges Méliès. In his *Vanishing Lady* (1896), we find the figure of the magician, whose presence is stable, or at least controlled within the frame, as well as the figure of the vanishing woman, whose presence is notably unstable and contingent on the powers of the magician. While always in service of Christ, Guy's film features female angels who appear and disappear at will. As David Shepherd has noted, this emphasis on women (both the angels and Mary, who plays an enormous role in the film) was virtually unprecedented in the Passion Play film to this point.[27] Guy's angels thus function as a kind of inversion of the gender dynamic of Méliès's film. When Méliès makes the female assistant vanish, there is an uncertainty as to her whereabouts, a kind of anxiety about the absence of this woman as she slips between existence and nonexistence. When she first returns, she is a charred skeleton, restored to fleshiness only by the further intercession of the magician. Understandably, the figure of the vanishing lady, and the controlling violence of the magician, has long been a central one in feminist film theory. Karen Redrobe (formerly Beckman), focusing on the trope in early film, suggests that such "magic tries to convince us that 'surplus' bodies can be evaporated harmlessly and without trace,"[28] and excavates a genealogy of films that sought to trouble the ease of such vanishings. Guy's film, at least in this aspect, fits that countercultural

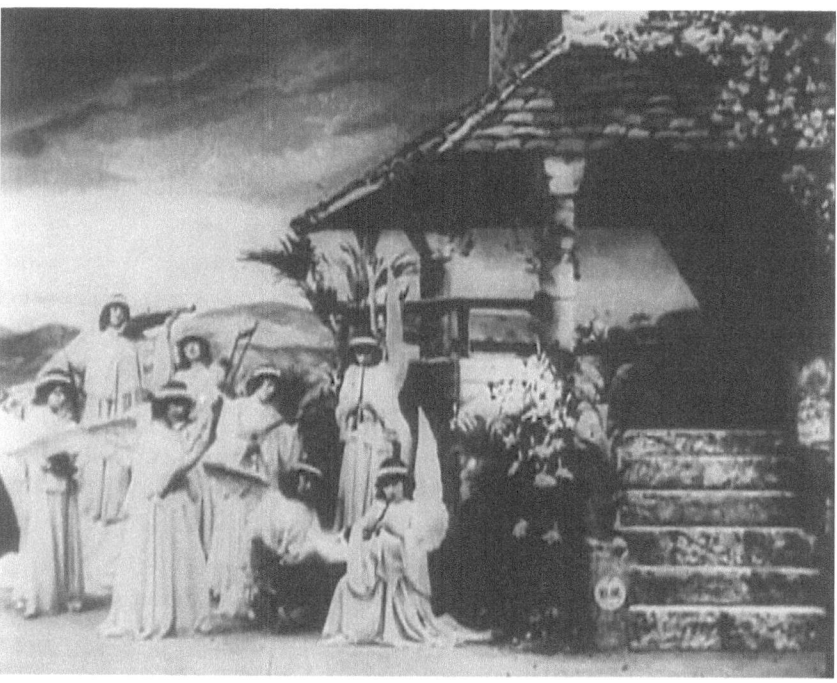

FIGURE 3.2 *The Birth, the Life, and the Death of Christ* (Alice Guy, 1906)

lineage. The angels in her Christ film may disappear, but their presence—their power—is always felt. So, Guy's angels were not only an innovation in terms of the genre's spectacular effects, they were an innovation in terms of its assumed, if unstated, politics.

The constant appearance and disappearance of the angels in Guy's film reinforces the idea of a filmic space that always contains two layers: the visible, and the invisible ready to reappear at any time. An early sequence, entitled "The Sleep of Jesus," reveals this to be a priority (figure 3.2). We see a wide frame with a two-story home on the right and a staircase in the center with a crib at its base. To the left are palm trees and mountains in the distance, but otherwise just an empty—visually charged—space. Joseph wanders down the staircase to check on the slumbering infant. He is soon joined by Mary, and, as they move variously up and down the stairs, peering at their son from the ground and from an elevated deck, it's clear we're meant to understand that Joseph is telling his wife that their son is safe and that they can retire inside. (Regardless of the child's divinity, this is some pretty hands-off parenting.) As soon as they go offscreen, a band of angels

dissolve into the frame, virtually filling that empty space to the left, and crowding so closely as to obscure the sleeping child. The angels play instruments—presumably a lullaby—but they also form a kind of protective wall around the child. These are the literal manifestations of the "safety" Joseph tried to impress upon Mary, but they are also shown to be materially affecting the Christ child. They are a supernatural supplement to this child's young life, but, in the world of the film, they are not so much unreal as normally unseen.

The film's resurrection scene is similarly crowded with angels. Where earlier films had dealt with this event by implication (the tomb is found empty, for instance), Guy saw a squandered opportunity. Gaumont staged the resurrection right in front of the audience's eyes, fully revealing the reality of the unseen, so to speak.[29] Angels dissolve in, lift the heavy stone, and surround the tomb to pray. Guards awaken and flee in terror as Christ dissolves in, spreads his burial cloth to reveal his bared torso, and rises into the air (figure 3.3). Again, Christ disappears as the angels remain in prayer. Guy then cuts to Christ's followers rushing to the exterior of the tomb, where they are greeted by another angel. Upon entering, the followers crowd around the empty tomb and kneel with the angels who still

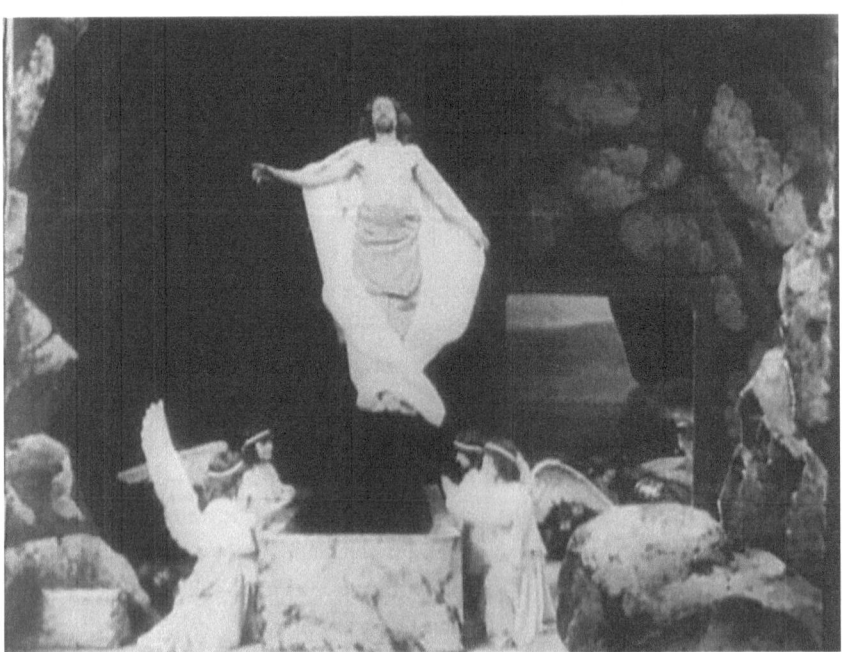

FIGURE 3.3 *The Birth, the Life, and the Death of Christ* (Alice Guy, 1906)

remain from earlier. Christ's absence is the evidence here—it is itself the miracle, which was visible only to the eyes of the supernatural angels—and yet all the remaining figures kneel and pray at the miracle that has occurred. Guy's film represents a world that can be traversed freely by Christ and his angels, but these tricks do not imply a kind of chaotic instability. Rather, they reveal the invisible to be a structural element of the visible. The ordinary people moving through these frames have no choice but to acknowledge and bow down before such spectacular evidence.

Guy called *The Birth, the Life, and the Death of Christ* "one of the first big spectacle films," and it was such a success that it attracted both misattribution—the French cinema writer Georges Sadoul maddeningly credited it to somebody else—and mimicry.[30] The 1907 French film *The Life and Passion of Jesus Christ*, produced by Pathé and directed by Ferdinand Zecca with effects by Segundo de Chomón, is both an admiring and a critical response to Guy. Zecca began his career at Pathé, but, after a falling out, he was reduced to selling soap door-to-door. Guy found him in this state in 1904 and hired him as her assistant at Gaumont. Within a few years, he had returned to Pathé, where he was quickly appointed managing director.[31] His 1907 film was at least the third Passion Play film produced by the company, and it is the best known and most readily available version today. Despite the fact that it is ostensibly a remake of Pathé's 1899 and 1902 versions, as Dwight Friesen convincingly argues, its clearest debt is to Guy's film.[32] Indeed, many of the scenes echo Guy's staging, and the film's conspicuous de-emphasizing of female characters seems to be a pointed response to her film. It is also, not incidentally, even more heavily laden with effects, most of which were created by Chomón, a pioneering Spanish special-effects artist. Spectacular embellishments cover this Pathé film. Whereas Guy's film relied on an investment in character development paired with effects to distinguish it from earlier films, the Zecca production leans considerably harder on flash. Lightning bolts burst into the picture, and the Pathé color stenciling process—not uncommon in this period—gives many scenes a feeling of animation missing from the more staid Edison and Lumière productions (figure 3.4).

At the center of Zecca's film, just as it was for Guy, is the idea of traversable boundaries between the seen and the unseen. Particularly striking is the scene "Christ Walks on the Waters," an event from the gospels, rendered eerily and masterfully by Chomón (figure 3.5). Double exposure, as we see often in the work of Guy and Méliès, is a convention of the trick film, but here it is exposed over a natural landscape, as in a travelogue. Because of the stillness of the frame, viewers could approach these scenes through a practice of what Noël Burch has called "topographical reading": "a reading that could gather signs from all corners of the

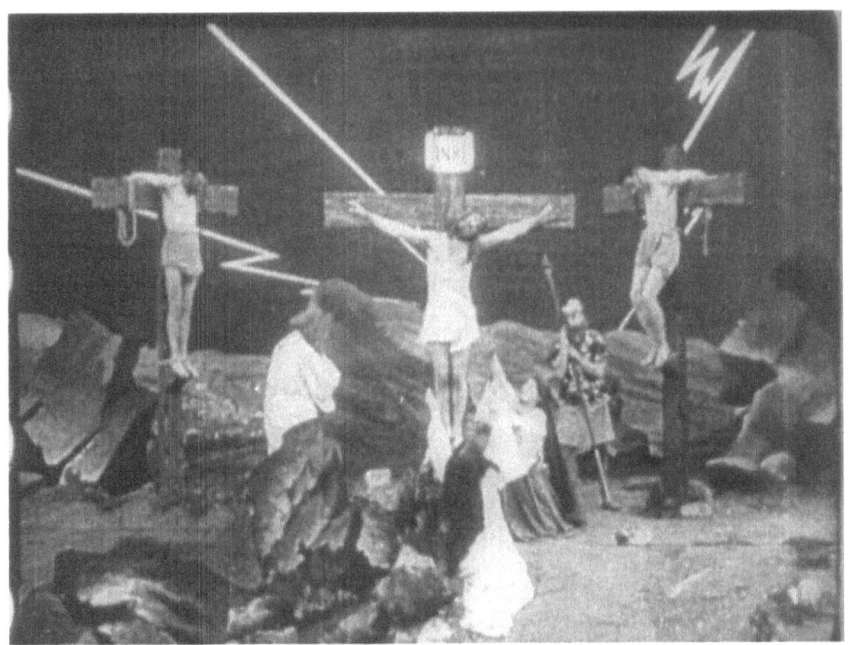

FIGURE 3.4 *The Life and Passion of Jesus Christ* (Ferdinand Zecca, 1907)
Library of Congress

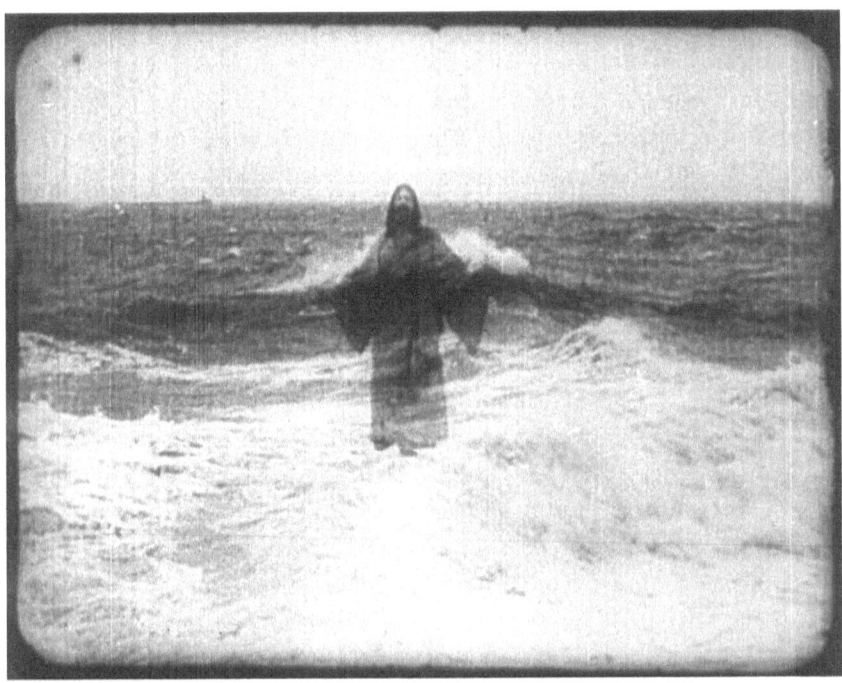

FIGURE 3.5 *The Life and Passion of Jesus Christ* (Ferdinand Zecca, 1907)
Library of Congress

screen in their quasi-simultaneity, often without very clear or distinctive indices immediately appearing to hierarchise them, to bring to the fore 'what counts.'"[33] Christ's transparency gives the figure an almost ghostly effect, and it also creates a dilemma for the audience. Reading topographically, how does one reconcile the ghost of Jesus Christ and the sea? To represent Christ as an apparition—formally echoing the spirit photographs of the late nineteenth century—is to ask viewers to consider the status of such an apparition as evidence, even as they might reflexively grant the roiling sea that status. In this way, topographical reading becomes emblematic of the kind of limited "choices" through which early spectators could become involved in film. To dismiss this trick or that illusion might simultaneously be to lend credence to some other part of the frame; to choose one element over another is to assent to the economy, the sociality, of the frame itself.

Zecca's resurrection, like Guy's, is a showpiece of the film (figure 3.6). In this sequence, we see the angels fading into the shot. They raise the stone, and Christ, on what seems to be a rather rickety device—a black mechanical platform meant

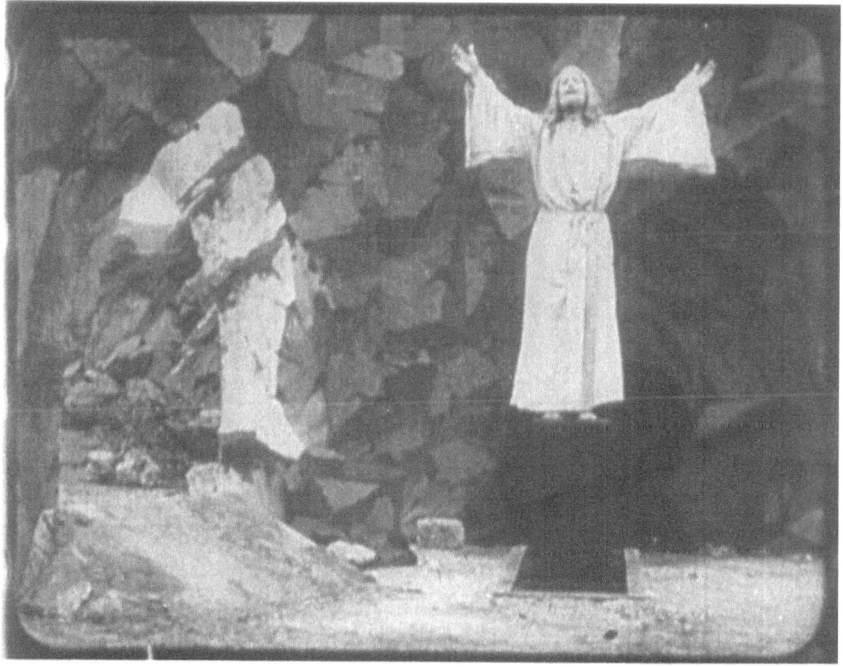

FIGURE 3.6 *The Life and Passion of Jesus Christ* (Ferdinand Zecca, 1907)

Library of Congress

to blend into the background—rises from the grave. (For all their differences, Zecca's resurrection is a pale imitation of Guy's elegant dissolve.) As a guardian warrior angel appears to the left, Christ himself disappears. This disappearance is made almost more impactful by the technological mismatch between the fairly seamless dissolve and the clear visibility of the apparatus that raises him into the air. That that apparatus itself disappears along with Jesus makes this seem, counterintuitively, more miraculous. The herky-jerky platform is a reminder of the boundaries of this world; the dissolve is a reminder that those boundaries might be transcended. Again, we have the suggestion of porous boundaries between the seen and the unseen. These invisible creatures appear from thin air, but they are still able to lift an enormous object. The unseen layer of reality is no less effectual than the one we ordinarily see.

Indeed, the representation of the filmic world as one consisting of invisible layers is literalized in the film's final scene, the ascension. After walking his apostles to a bluff, over which can be seen painted cumulus clouds layered atop each other, Christ steps into the center of the frame to address his followers. The followers kneel with their backs to the camera, Christ raises his arms, and a hand-painted golden sunburst—similar to those one might see in a stained-glass window—appears to frame him. The figure is lifted by the clouds farther back in the frame, as if rising to heaven. (The clouds surrounding the actor seem to be suspended by ropes attached to a track on the ceiling of the studio.) Finally, the entire top half of the frame fades into a scene with Christ surrounded by angels of all sizes, as the adoring apostles rise from their genuflection and lift their arms toward the scene.

With his arms gesturing in the air at each point in this scene, Christ takes the audience on a tour of the layers of reality. First, he reveals the sunburst that enrobes him in light. This is the light of his divinity, the second layer of his own physical person (figure 3.7). Then we see the clouds that convey him to the sky: nature, the already visible world, bending to his will. Finally, we see the gallery of heavenly beings—angels and the souls of the departed—who reside in the sky (figure 3.8). As the Christ figure is drawn back into the soundstage, with still layers of clouds behind him, spectators perceive the illusion of a depth of field, but, along with this, Zecca also seeks to establish a depth of reality. Not only do we perceive distance, we also perceive unseen layers of experience. And so, as Jesus gestures, the spectator is invited to move deeper into the natural world of the frame, then the supernatural world of the frame, and simultaneously to consciously contemplate both movements. Recall Prescott constructing an eyewitness point of view and then calling attention to the impossible marvel of such a perspective, or Lew Wallace imploring the reader to "travel" with him to the past.

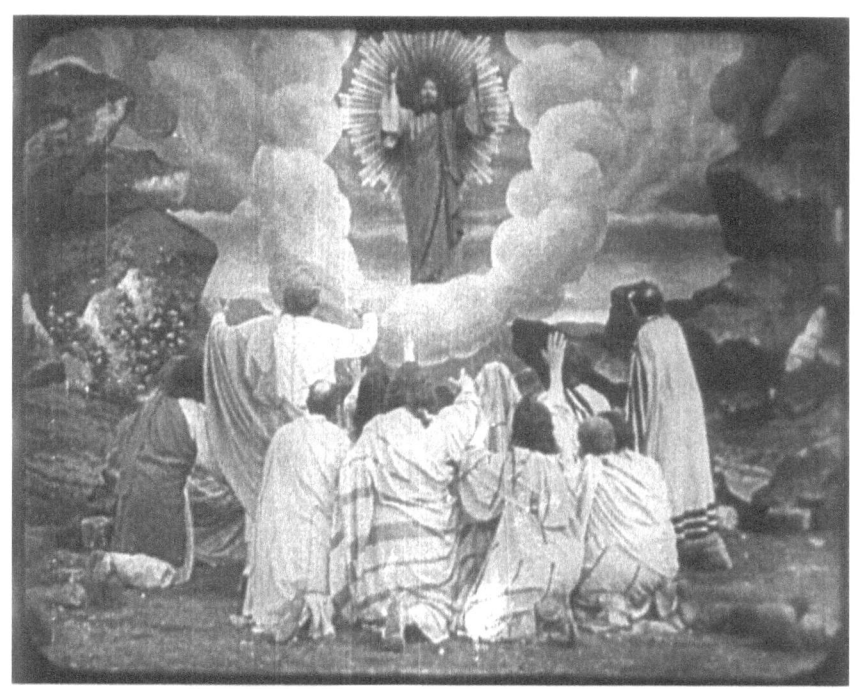

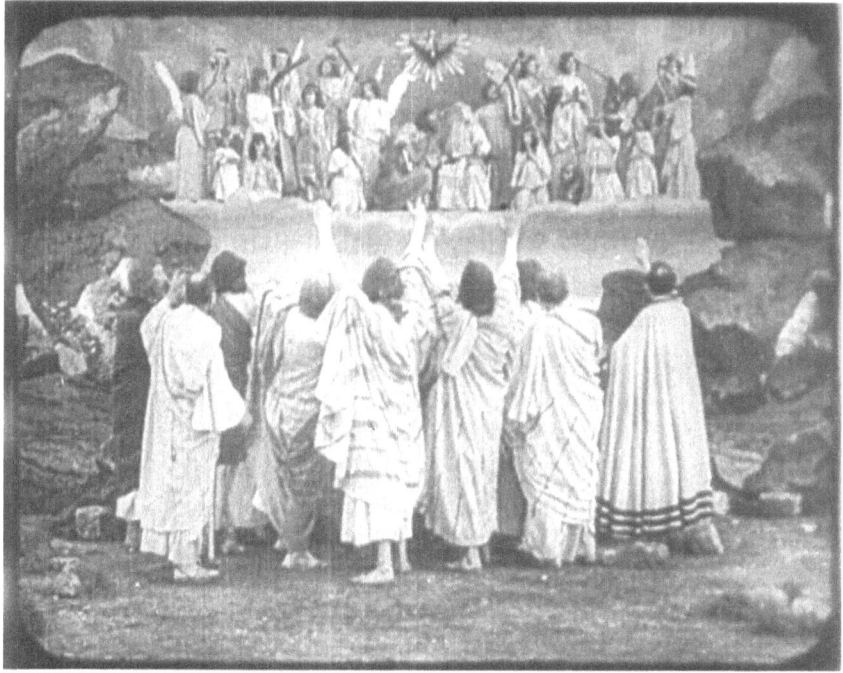

FIGURES 3.7 & 3.8 *The Life and Passion of Jesus Christ* (Ferdinand Zecca, 1907)
Library of Congress

Each special effect is an opportunity to be absorbed and an opportunity to reflect on that absorption. It is a moment when film renders visible the stabilizing, architectural elements of reality, even in their construction.

THE PASSION OF GENE GAUNTIER: ACTUALITIES AND THE PASSION PLAY

In 1912, with the era of attractions firmly "underground" (in Gunning's famous phrase), it's fitting that a Passion Play film would be the genre to insist upon rolling away the stone. Indeed, the film scholar Charles Keil, writing about 1912's *From the Manger to the Cross*, has suggested that the Passion Play film, as a genre, suffered from what he calls "stylistic retardation."[34] What Keil means by this is that Passion Play films do not, until well after the alleged end of the era of attractions, fully adopt the stylistic hallmarks of contemporary film style: moving cameras, close-ups, parallel editing. Such films, in other words, despite still being produced during a time of rapid change and transition in filmmaking, remain stylistically frozen in the age of attractions. This is another way of characterizing the betwixt-and-betweenness of this film genre, both innovative and outmoded, radical and conservative in style. To say that *From the Manger to the Cross* suffers from "stylistic retardation" in relation to the broader world of cinema at the time, however, overlooks the extent to which it serves as the apotheosis of the early period of spectacular realism as an aesthetic. The "real" landscape of this film brought to final fulfillment many of the genre's inherent claims to true-to-life authenticity.

The Passion Play film, I have argued, wants viewers to entertain the notion of tricks *as* actualities, and thus a patina of authenticity and even geographical accuracy attaches even to the earliest of these films in the form of the travelogue aesthetic. In this genre, viewers were simultaneously given access to both the attractions of the travelogue film and the attractions of the magic film. As we saw in *Ben-Hur*, this interest in the reality of place, the visibility of geography, was not new. The mid-nineteenth century saw the emergence of a number of innovations in Biblical historiography that reoriented belief around place, from the sacred geography of the 1830s to Renan's description of contemporary Palestine as "the fifth gospel." Utilizing archival research in the Holy Land, and extensive studies in sacred geography, historians and theologians historicized the Bible for the first time during this period, rooting mythical actions in concrete locales. At once unsettling the authority of the gospel accounts by casting doubt on the

eyewitness authorship of the four evangelists who wrote them, *and* deepening the detail with which contemporary readers could imagine the time of Christ, these scholars inaugurated a new way of visualizing the gospels—based especially in the locations, geography, and costumes of first-century Palestine—that early filmmakers were more than eager to exploit. As such, even though the first Passion Play film shot on location did not appear until 1912, all of the films are awash in the signifiers of geographical, cultural, and historical authenticity.

Even as the special effect characterizes the genre, it works in tandem with the everpresent aesthetic of the travelogue, perhaps the purest signal of an actuality aesthetic. Utilizing any and all technological means of reproducing and embellishing the miracle scenes detailed in the gospel narratives, the Passion Play films sought to take advantage of the slippage that the *Boston Herald* reviewer noted in the Horitz film: to create, on film, a kind of visual evidence of the miraculous. But these emphases are not necessarily exclusive to this genre. Realist cinema practice as a whole emerged, in part, out of the discourse of evidentialism that was so crucial to American theology, photography, literary realism, popular entertainment, and scientific discourse in the late nineteenth century. As Vivian Sobchack puts it, "Although the cultural logic of realism has been seen as represented primarily by literature . . . it is perhaps even more intimately bound to the mechanically achieved, empirical, and representational 'evidence' of the world constituted—and expanded—by photography."[35] In literature and theology of the nineteenth century, the presentation of evidence, or the framing of narrative as a form of evidence itself, became conventional and central to the development of both. With the emergence of photography and later cinema, there came the opportunity to visualize this evidence. Therefore, the inherent realism of film as an evidentiary medium—a medium based in the recording of reality—made it a perfect medium through which to visualize the evidentiary claims of theology. Film was always in dialogue with this impulse, and the Passion Play film functions as a point of convergence for cinematic, theological, and cultural expressions of it.

These competing priorities—geographical authenticity and elaborate miracle scenes—are made compatible by being presented as natural. Reading topographically, the goal seems to be a frame in which no one image—trick or actuality—comes to the fore more than another. The easiest place to locate this testing ground in the Passion Play film is at the foot of the Pyramids at Giza. As I have already addressed, one of the primary challenges and opportunities of the Christ film, in conceiving of a spectacular realism adequate to the miraculous narratives of the gospels, lies in representing not just a messiah who performs miracles, but a human for whom the boundaries between heaven and earth, seen and unseen, do not apply. In both Guy's and Zecca's films, the angel provides a kind of marker of

these boundaries, and both films also feature an extended set-piece based on the "flight into Egypt" portion of the Gospel according to Matthew. In this recognizable space, we have an extended encounter with the angelic. According to gospel accounts, Joseph, the father of Christ, was told in a dream to flee Bethlehem and hide in Egypt shortly after the nativity to avoid the murder of the innocents ordered by Herod. Because the story is, in essence, a story of Christ being protected from Herod through supernatural intervention, the various filmmakers saw it as an opportunity to demonstrate the blurred boundaries between natural and supernatural. Moreover, they sought to accomplish this in a location—Egypt—whose monuments and landscapes would be recognizable to a Victorian public fascinated by Egyptology. This is one of the first scenes in which a spectacular realist aesthetic—the miraculous rescue of the Christ child in a historically authenticating locale—might not only be possible but also necessary.

An early scene in Zecca's flight into Egypt section establishes this conceit (figure 3.9). After the intertitle, we have a still shot of the baby Jesus with small

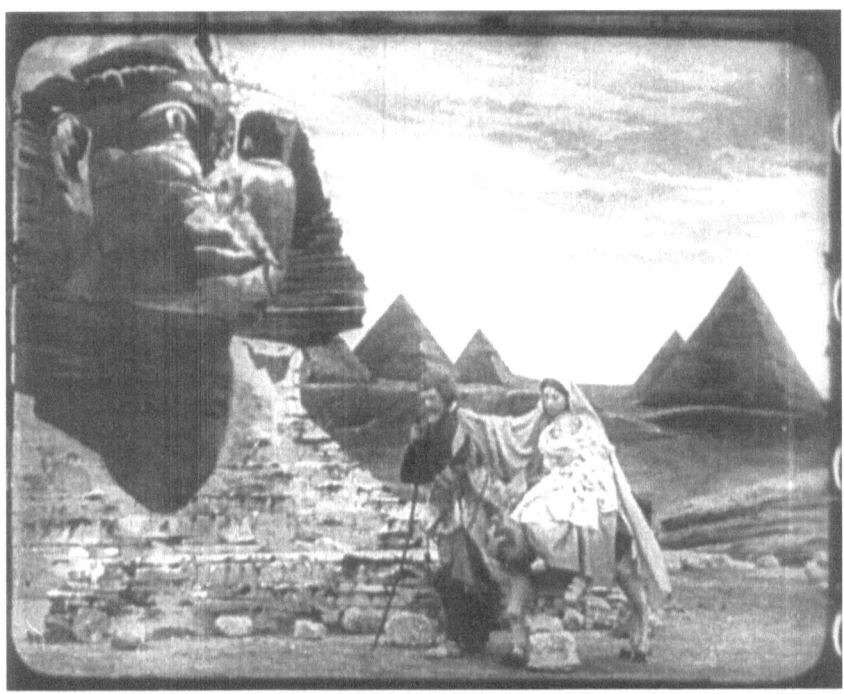

FIGURE 3.9 *The Life and Passion of Jesus Christ* (Ferdinand Zecca, 1907)

Library of Congress

angels floating above him, presumably serenading him. As Joseph enters the scene, the angels promptly vanish from view. He does not see them—indeed, can't see them—but the Christ child is implied to be in a kind of conversation with their presence. A few shots later, once the Holy Family has begun the journey to Egypt, Joseph stops to pray, and in a flash the entire family disappears, replaced in the shot by an armored angel. This angel, wielding a flaming sword, does battle with a band of encroaching soldiers. Once this threat is disposed of, the angel disappears and the Holy Family reappears, seemingly not aware that they had just vanished into thin air. These angels are not vapors or ghosts. Instead, they are again presented as a material force in the world, protecting, comforting, and signaling the Christ child's divinity for us. What's more, the sequence ends with an image that anchors the action with the specificity of place: a backdrop of the Sphinx. While it is certainly a long way from an actuality, it is most certainly a reference to popular Middle Eastern travelogues, and this—the appearance of the Sphinx specifically—is indeed a holdover from the Edison plays, which themselves featured backdrops of this image. The Holy Family, in the midst of all of this miraculousness, now becomes a vehicle for the audience's sightseeing. Though it may seem to be incidental, this is a part of the genre's actuality impulse that continues through these films and eventually motivates the move to real location shooting.

Although the appearance of the Sphinx is meant to authenticate the scene geographically, the precise manner of the Sphinx's appearance adds to the curious temporality and historicity of the Passion Play films. In Zecca's film, as well as in Olcott's 1912 film, the Sphinx appears as a ruin, a noseless monolith recognizable to anyone with even a passing familiarity with the imagery and symbology of ancient Egyptian culture. According to archaeological consensus, however, the Sphinx, despite being built thousands of years before Christ's birth, would almost certainly still have had a nose (well into the fourteenth century AD at least).[36] Moreover, this is a fact that would have been known during the making of this film. Indeed, a common myth at the time was that Napoleon's army had shot it off. This is not to quibble with the historical accuracy of Zecca's or Olcott's films. It is, however, to point out a way in which these films sought to bridge the gap between Christ's time and the time of the contemporary. The noseless Sphinx is an anachronism in this shot, but it is also an aesthetic echo of any number of travelogue films from the time that would have shown a Sphinx that looked exactly this way. (The illustrated plates in the Garfield Edition of *Ben-Hur* that I discussed in chapter 1 feature a similar juxtaposition: images of contemporary Palestine used to illustrate a tale of the first century.) In Zecca's film, the Christ child's flight into Egypt, despite the pretense of historical authenticity, is a flight through a contemporary travelogue scene. Thus, while the image

might not actually authenticate the scene as historically accurate, it associated the image with another genre of film that held a considerably less fraught aura of authenticity. Like Buster Keaton's projectionist in *Sherlock Jr.*, walking into the space of the films he projects, Christ here makes a brief, anachronistic cameo in a turn-of-the-century travelogue film.

Although these earlier films did much to establish the conventional representation of the visibility/invisibility dialectic in the Passion Play film genre, and worked at the integration of trick and actuality, it is not until 1912's *From the Manger to the Cross* that we see the full synthesis.[37] *From the Manger to the Cross* is significantly less miraculous, in terms of special effects, than either Zecca's or Guy's films, likely because, by this time, special effects of the kind that could reproduce miracles were no longer huge selling points with audiences that had seen them all before. Where Zecca's film ends with Christ carried to heaven by twin cherubs, and Guy's ends with Christ levitating and disappearing out of the tomb, Olcott's ends with the iconic image of the crucifixion. Christ heals the lepers and raises Lazarus from the dead, but with no attendant special effects. However, angels do fade into the frame during the annunciation to Mary at the beginning of the film, and a transparent Christ later does walk on water (figure 3.10).

These choices demonstrate the top priority of this production: authenticity. Where Zecca and Guy presented their films with titles only to describe the events—in the traditional tableau style—Olcott's film prefaced each action with a corresponding scripture passage. As an opening intertitle states, the film was meant to be an accurate and faithful representation of the gospels. What this means is that only miracles explicitly described in the text are reproduced—and we are given the text to prove it, as in the intertitle that precedes an angel materializing before Joseph.

The key to the perceived authenticity of the resurrectionless *From the Manger to the Cross*, however, is its advertised status as the first Christ film shot in the Middle East. It was Gene Gauntier, the scenarist for this film, who came up with the idea to shoot the film on location. Indeed, she retells the story as a kind of divine inspiration: "I lay semi-delirious in bed. Alice Hollister sat with me. Suddenly, I sat up exclaiming, 'We're going to Cairo and take the Flight into Egypt at the Pyramids. Then, the Life of Christ in Palestine!'"[38]

So, in a film devoid of most of the miracles common to previous productions, what does "authentic" scenery do? As Tom Gunning states, in the travelogue films of the turn of the century, "image becomes our way of structuring a journey, and even provides a substitute for it. Travel becomes a means of appropriating the world through images."[39] Travel films, in this sense, function fairly transparently as documents of an imperial gaze. In the Christ film, however, this imperialism is

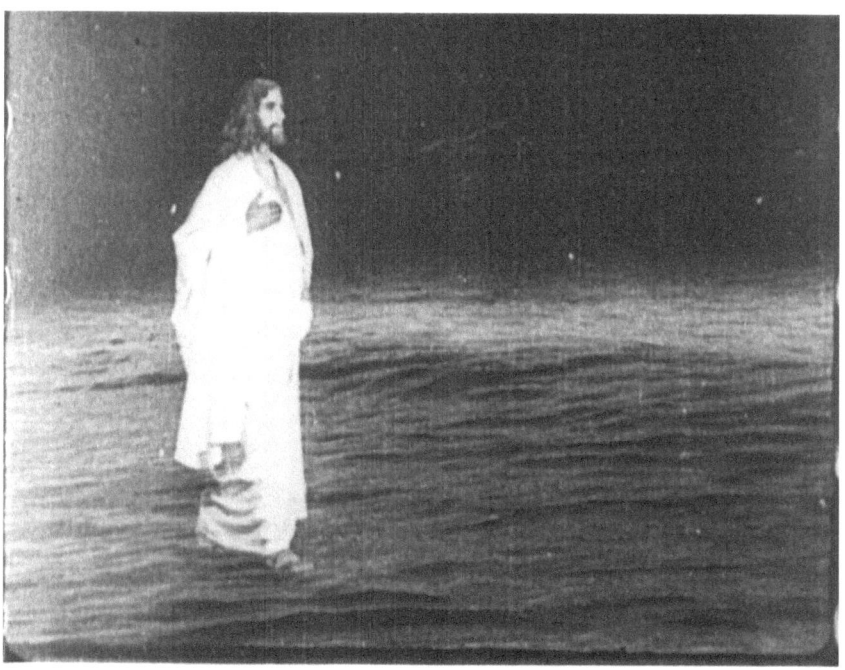

FIGURE 3.10 *From the Manger to the Cross* (Sidney Olcott, 1912)
George Eastman Museum

marshaled toward an additional end. Just as with *Ben-Hur*'s obsession with landscape, the Passion Play film sought to mobilize the imagination of the touristic pilgrim, a pilgrim animated by the idea that the holy landscape might provoke a transcendent spiritual awakening, seeing through the layers of rock and dirt into the sacred past. Whether ultimately enraptured or disappointed by the sight, thousands of Americans sailed across the ocean to see if they could behold a landscape that would fill them with faith. *From the Manger to the Cross*, through the virtual medium of film, attempted to make good on the Holy Land's promise in the same way Lew Wallace attempted to fulfill his readers. Thus, though Olcott's and Gauntier's film may not have as many spectacular special effects, those effects are rendered even more remarkable because they are revealed to be an unseen layer of reality within the actual Palestinian landscape. When Robert Henderson Bland's Christ walks on water, the waves are those of the Sea of Galilee.

From the Manger to the Cross advertised this aspect of its production with aplomb in its opening titles (figures 3.11–3.14). The intertitles make sure to point

FIGURES 3.11, 3.12, 3.13, 3.14 *From the Manger to the Cross* (Sidney Olcott, 1912)

Library of Congress

FIGURES 3.13, 3.14 (*Continued*)

out that the film is a "history," not a tale or a story, and that the scene of this history is, in fact, the scene *of* history.[40] This echoes comments about the Passion Play film all the way back to the reviewer of the Horitz film. The medium enables the contemporary to slip away like an outer shell, revealing the *scene of history* beneath all of the scenes conjured to represent it. Moreover, the conflation of cinematic imagery with historical accoutrements (the map) helps also to authorize the film. The precise geography of Palestine was central to the perceived realism of works of sacred geography like Robinson's, biographies like Renan's, and novels like Wallace's, and this sketch is one of many ways Olcott's film attempts to seek a claim to this evidential legacy. This sense of historicity is further emphasized by the specification that the film was shot in "authentic" locations and told "according to the gospel narrative." This, like Griffith's later films, is presented not only as a film, but also as a historical document, bolstered by citations of sacred and secular histories and supplemented by accurate knowledge and actual motion-picture photography of the land itself.

Like Zecca's film before it, *From the Manger to the Cross* featured a flight into Egypt section (figure 3.15). As I noted earlier, this section boasts far fewer special effects than its predecessor, but to some extent Olcott and Gauntier position the Sphinx itself as the special effect in the frame. Though these scenes are without miraculous content, their very geographical authenticity actually provides the spectacle for this display of spectacular realism. Mary Ann Doane suggests that film "exists nowhere but in its screening for a spectator in the present," and so the "tense" of even historical films is the present tense.[41] Here, the ruined Sphinx has the same effect as Zecca's, but amplified. Here, *From the Manger to the Cross* actually becomes a travelogue film. By collapsing the past of Christ's life with the inaccessible present of the Holy Land within the present tense of film—being trick, travelogue, and spectacular realist evidence of the camera's magic power—*From the Manger to the Cross* attempts to conjure a life of Jesus accurate in terms of its geography, its history, and even the temporality of the religious experience it elicits.

THE PASSION PLAY FILM IN TRANSITION

The porousness I have ascribed to these films as an aesthetic ideal is, of course, indebted to Taylor's description of the premodern world as uniquely sensitive and vulnerable to the supernatural, to the influence of gods and angels. In his account, secularization effectively "buffers" the world, and that porousness is lost.

FIGURE 3.15 *From the Manger to the Cross* (Sidney Olcott, 1912)

George Eastman Museum

It would be easy, then, to see the Passion Play film as nostalgia for a presecular age, a virtual escape from a buffered modernity. Indeed, part of the premise of this book is that, despite being emblems of modernity and easy material evidences of secular progress, early films like these simply *look* so much like the sort of enchanted premodernity Taylor describes. The porous/buffered dialectic, however, has been widely challenged, and so too must any conception of early cinema as purely escapist in this way. As Gunning, Musser, and others have shown, viewers in this era took a fundamentally rationalist approach to the sensations of the cinema, taking pleasure not purely in the experience of being carried away to an enchanted time, but in experiencing the thrill of images that momentarily challenged the laws of reality. Cinema spectatorship, then, could be a kind of double-sided absorption: being first absorbed by the image, and then reabsorbing that image's irrational provocation into a rational view of the world. Cinema could test the spectators, revealing their intellectual blindnesses,

susceptibilities, and hidden desires. To experience the gospel narratives in this medium was to consider the possibilities for belief in a moment characterized by this sort of liberal rationality: to experience the sensation of credulity without relinquishing the skepticism and evidential demand that grounded everything from theology to pop culture in this period. In the Passion Play film, the cinema of attractions was not a mechanism for the freewheeling indulgence of irrationality, superstition, or even faith, but rather a mechanism for the containment and management of those impulses.

The Passion Play films of Guy, Zecca, and Olcott occupy what Charles Keil calls the "transitional period" between the era of attractions and the era of narrative integration. According to Keil, in this period of overlap, "transitional style entails both flaunting the exoticism of attractions and aiding in the comprehension of narrative."[42] The Passion Play film, endeavoring to shock audiences with spectacles of the miraculous and the real while at the same time mobilizing the viewer's already-existing familiarity with its plot points, is exemplary of this transitional style. By the time Olcott, Gauntier, and Bland began their promotional tour in 1912, Lois Weber and D. W. Griffith were already producing the films that would eventually be recognized as the foundational texts of a cinema of narrative integration. In such a cinema, viewers would not need to supply their own narrative; instead, they would have it expressed to them via the narrative discourse of film. This is the shift Gunning, Hansen, and others describe as cinema's transition from exhibitionism to voyeurism. The spectator is explicitly invited to behold a spectacle, or the spectator is implicitly invited to enter the diegetic world of the film.

The role of the attraction in this era of narrative integration has been somewhat contested. By and large, in this period, the attraction became submerged and subordinated to a new narrative discourse that privileged seamlessness over productive opposition, immersion over shock. But this earlier cinema did not die, and there are various accounts of the life of the attraction after its style was effectively eclipsed. Gunning famously states that the attraction "goes underground," to be resurrected in the antinarrative avant-garde; Donald Crafton argues that, in slapstick comedy, the attraction (in the form of the gag) constitutes a "calculated rupture" in the otherwise integrated narrative, producing pleasure through its irreconcilability within the narrative system; Scott Bukatman identifies an understanding of "the disruptive power of cinematic spectacle" at the heart of feminist film theory; and others have pointed to the life of the attraction in the Hollywood musical, the special-effects blockbuster, the horror film, and the new-media aesthetics of YouTube, GIF, and Vine.[43] The cinema of attractions did not initially emerge as antagonistic to narrative—indeed, from even the earliest

moments, this aesthetic incorporated its own narrative forms, albeit to different ends—but this cinema's constitutive ambivalence toward narrative became radicalized in the postattractions era. In the years after these Passion Play films, the attraction survived in various guises, but nearly all of them represented some overt challenge to the increasingly hegemonic order of narrative film.

Though it would be decades until the Hays Code institutionalized and policed the style of narrative integration—and its implied moral system—this new discourse quickly became de rigeur. As I have argued, the cinema of attractions, as we can track it in the Passion Play films of this transitional era, modeled both a style of cinema and a style of secularism. These films challenged a rationalist understanding of the world in order that spectators could collaboratively reaffirm it. The cinema of narrative integration represented less a progression from this style than a different way in. If the early cinema spectator was meant to be actively involved in the creation of the cinematic experience (even if that agency was also an illusion), the spectator after 1912 was certainly meant to submit to the world-making possibilities of cinema.[44] This world-making, which we will begin to see in Griffith and again with DeMille and Gibson, is the realization of cinema as a secular medium. Miriam Hansen marks this transition as a transition from a cinema of attractions to "a notion of cinema as a moral institution."[45] In other words, if the cinema of attractions allowed spectators the ability to exercise a pantomime of liberal agency by discerning the sense or nonsense of cinema's various sensational provocations, then the cinema of narrative integration ushered in an era in which film could simply *represent* the order and unity of this sort of liberalism. Film went from training ground of the secular to propaganda of the secular. It would take later generations of filmmakers to recognize the disruptive power of the early cinema aesthetics—Gunning, indeed, takes the term "attraction" from Sergei Eisenstein—and to weaponize it against classical Hollywood and the cultures and exclusions it represented. In chapter 4, however, I turn to the unlikely figure of W. E. B. Du Bois as one of the first artists to see this potentiality in attractions.

4

The Double Life of Superimposition

W. E. B. Du Bois's Black Christ Cycle

In the 1916 Christmas edition of the NAACP magazine *The Crisis*, editor W. E. B. Du Bois published a striking drawing. The image, created by frequent contributor Lorenzo Harris, is a cartoon panorama of a lynching. In a two-page spread, we see a chaotically sketched pen-and-ink drawing of an angry white mob wielding clubs and guns and hoisting a figure, in the far right corner, from a tree (figure 4.1). The figure itself is of a dead black man, head slumped down, eyes slashes of dark ink, hanging from a rope. That figure, however, is embraced by a glorified, living, white Christ—complete with a halo—looking straight ahead at the lynch mob with the same slashed eyes. The vertical pen strokes, evoking torrential rain, create a kind of base medium from which both figures emerge and upon which the members of the lynch mob, in dark black suits and vests, are stamped. Both the lynched man and Christ, in white, blend into the rain, threatening to dematerialize within it. However, the lines also serve to blur the figures together, such that they become one compound entity within the drawing. To the right of these figures, cut out of the scene and printed in type over a white background, is a slight adaptation of Matthew 25:40: "Inasmuch as ye did it unto the least of these, My brethren, ye did it unto me." The line serves as a caption, a call to conscience for Southern whites who perpetrated racial violence (and who, in their safety, were compositionally separated from the Christ in whose name many of these violent acts occurred), but it also calls attention to the blurring of the figure. To lynch a black man is to lynch Christ himself. The title of the image is "Christmas in Georgia, A.D. 1916."

This is an extraordinary image on its own—one of the most powerful of the numerous similar images Du Bois commissioned for *The Crisis* during his long editorship thereof—and yet the illustration gains an added dimension when we place it beside a very different image—a moving image—that appeared only a

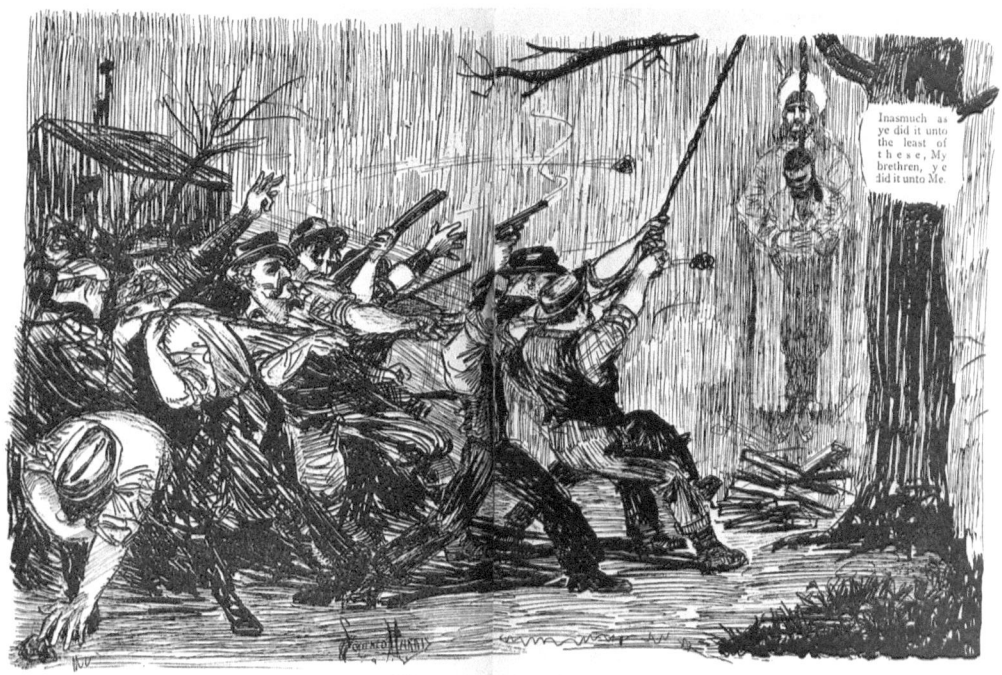

FIGURE 4.1 "Christmas in Georgia, A.D. 1916" (Lorenzo Harris, 1916)

The Modernist Journals Project, Brown and Tulsa Universities

year earlier. At the end of D. W. Griffith's 1915 film *The Birth of a Nation*, two pairs of honeymooning lovers sit atop a tall bluff and gaze wistfully upon the apocalypse. At this genesis moment of a new nation, when North and South have symbolically realized Griffith's ideal of a social, political, and ethnic unity through the intermarriage of the Stoneman and Cameron clans, none other than Jesus Christ appears to show us a view of its glorious end (figure 4.2). As they peer into the horizon, Ben Cameron, the Southern founder of the Ku Klux Klan as depicted earlier in the film, and his new Northern bride see a vision of the final judgment. First, they (and we) behold the terrifying and terrified masses of sinners, cowering under the whip of an enormous mounted beast: the "God of War," an intertitle explains. Though his whip stings the writhing damned below him, this beast is transparent, superimposed upon the scene. Soon, though, this chaos gives way to the savior and his saved. A giant and transparent Christ is superimposed upon a bustling multitude of white Christian souls. The figure raises his arms in welcome and oscillates briefly before disappearing to leave his newly ascended flock to their heavenly business. The film ends with the lovers gazing

FIGURE 4.2 *The Birth of a Nation* (D. W. Griffith, 1915)
Library of Congress

still at the horizon, but this time upon what appears to be a palatial Middle Eastern cityscape: the New Jerusalem. The final intertitle reproduces the words of Daniel Webster, shown earlier in the film: "Liberty and union, one and inseparable, now and forever!" It is the original moment of Griffith's nation, a compressed apocalyptic history of this *new* new republic, now and forever.

One year apart, two Christs, both transparent. One opens his arms to welcome his believers, the descendants of those who founded an "Invisible Empire" to purify the white race at the cost of black lives, and to offer divine sanction for the brutality of the Jim Crow era. One closes his arms to embrace the body of one of those lives lost, a victim of the same *all-but*-invisible empire, offering himself up as brother to the suffering black men and women of the Jim Crow era. One is an avatar of white supremacy, the other an avatar of black dignity in the face of racial violence. Du Bois was a loud and prominent voice in the antiracist fight against *The Birth of a Nation* during and after its theatrical release, and so it might be tempting to ascribe a direct connection here, to identify a shot fired from the pages of *The Crisis* directly at Griffith's film. There is, however, no evidence to suggest that Harris drew this image, or that Du Bois printed it, for that reason specifically. Indeed, as I detail in this chapter, Du Bois had already been

publishing stories and illustrations of a black, lynched Jesus in *The Crisis*—one of which pointedly uses superimposition as a figurative device—for several years before Griffith's film. But the use of superimposition as a compositional technique in both—the mirroring of Christ figures, the masses of Southern whites—these visual echoes bear notice, and they point to something that I argue is central to understanding Du Bois's aesthetic politics in this period.

I return to these images in greater depth later in this chapter, but here I want to push a bit further into their fundamental contrasts. Griffith tried to electrify his vision of race in America through this superimposition; Du Bois sought to uncover the messiness of that sleight of hand. Griffith sought to produce a seamless theological and social narrative to bolster a white supremacist order; Du Bois resisted not only Griffith's ideology but also the seamlessness with which he sought to present it. Griffith's image is one of union (false, of course, because of those excluded from its frame); Du Bois's is one of jolting separation and shocking juxtaposition. "Christmas in Georgia, A.D. 1916" demonstrates the confusion, the ambivalence, and the violence of its scene. It advocates for spectators to be conscious of this layering and its method rather than insensible to it. Du Bois sought not to captivate his viewer or reader with a disappearing realism, but rather to awaken them with shock and to reveal the complicity of the spectator in the raising of the cross rather than to welcome them into the jubilant company of the saved.

Presented in this way, Du Bois's aesthetic aims ought to sound familiar. In this chapter, I argue that we can read W. E. B. Du Bois's work in the early twentieth century—particularly what I call his "Black Christ Cycle" of stories and illustrations in which Jesus is represented as a contemporary person of color, lynched in the Jim Crow South—as productively engaged with the aesthetic of attractions, as it circulated and then, famously, went "underground" in this era. Du Bois never made a movie, nor did he so much as write a piece of film criticism, but by situating his work in the context of early cinema we can see numerous echoes and adaptations that not only illuminate the life of this confrontational aesthetic into the twentieth century but also reveal its political potential. In particular, I argue that this aesthetic was useful to Du Bois precisely because of its opposition to the cinematic style represented by Griffith: narrative integration. It is not a stretch to suggest that W. E. B. Du Bois, in these years, and throughout his career, was engaged in a multiplatform quest to destabilize the faulty, biased, hateful narratives of white supremacy that made heroes of whites and villains of their black victims. Situating his work in context of the media that surrounded him historically, this chapter argues that there was a cinematic vector to this quest. In other words, Du Bois's resistance to these narratives shares something foundational with cinema's early resistance to narrative itself.

To do this, I first turn to a moment of historical convergence: W. E. B. Du Bois's theory of double consciousness took shape in the era of attractions. I argue that this is more than a coincidence: this media context provides insight into the evolution of Du Bois's political aesthetics in the early twentieth century. To trace the contours of Du Bois's engagement with the cinema of attractions, I return to the sources of Tom Gunning's original argument about this aesthetic. Specifically, by looking to Soviet filmmaker Sergei Eisenstein's revolutionary appropriation of the style in his mid-century writings, I argue that attractions provide a road map for resisting hegemonic secular narratives of political progress, a route Du Bois pioneered decades before Eisenstein did. I then turn to the particular narrative against which Du Bois focused much of his work in this mode: the narrative of Reconstruction as a legislative chaos caused by the biological and social inferiority of enfranchised black people. The Black Christ Cycle emerged, I argue, as a way to disrupt the secular narratives of this school of historians, overlaying images of Christ on the Jim Crow South in order to reveal the conflict between Christian social ethics and the Christianized white supremacy of the Dunning School. The chapter finally turns to the Black Christ Cycle itself. I read Du Bois's Black Christ Cycle as an artistic dismantling of the Dunning School narrative of the postbellum period, animated by an aesthetic of attractions that interrupts and reveals the secular deceptions of the Jim Crow era. This is, in some ways, a reading of Du Bois's approach to the visual, but it is, perhaps more importantly, about his approach to narrative and the way he positioned his work as a disruptive force in the history of the contemporary United States as it was being written, and rewritten, in the early twentieth century.

DOUBLE CONSCIOUSNESS AND THE CINEMA OF ATTRACTIONS

Thomas Edison commercially projected his first motion pictures in the United States on April 23, 1896. A little more than a year later, in the August 1897 issue of the *Atlantic Monthly*, W. E. B. Du Bois published his now-famous passage about a different kind of vision:

> The "shades of the prison-house" closed round about us all: walls strait and stubborn to the whitest, but relentlessly narrow, tall, and unscalable to sons of night who must plod darkly against the stone, or steadily, half hopelessly watch the streak of blue above.... The Negro is a sort of seventh son, born with a veil, and gifted

with second-sight in this American world,—a world which yields him no self-consciousness, but only lets him see himself through the revelation of the other world. It is a peculiar sensation, this double-consciousness, this sense of always looking at one's self through the eyes of others, of measuring one's soul by the tape of a world that looks on in amused contempt and pity. One feels his two-ness,—an American, a Negro; two souls, two thoughts, two unreconciled strivings; two warring ideals in one dark body, whose dogged strength alone keeps it from being torn asunder.[1]

Nowhere in his archives is there any evidence that Du Bois was particularly inspired by the nascent medium of film when he articulated his experience as a black man in America at the turn of the twentieth century. Most of the words Du Bois expounded regarding film were dedicated to opposing the release of *The Birth of a Nation* on behalf of the NAACP nearly twenty years later, and, in his later life, penning polite letters of complaint to local theaters about the artistic quality of the films they screened. Nevertheless, it's hard not to see how Du Bois's metaphors evoke the apparatus and phenomenological experience of the cinema. The shadow play in this passage, the plunging of the "sons of night" into darkness, the subject's resignation to the role of spectator watching "the streak of blue above," the "revelation of the other world": these figures call to mind the cinematic experience at a level beyond the canny deployment of theatrical mise-en-scène. More than that, this is a passage that figures "second-sight" as a type of mediation, seeing a simulacrum of the world projected outside of oneself, reconciling one's experience of the world with the moving image of another's. In both its material symbols and its discourse, this initial articulation of double consciousness echoes and amplifies the rhetoric of spectatorship that had begun to grow up around the new medium of film.

The scholarship on W. E. B. Du Bois and visual cultures of the early twentieth century is rich and deep. In *Photography on the Color Line*, Shawn Michelle Smith even goes so far as to argue that double consciousness itself is ultimately a theory of "the color line *as* visual culture," that Du Bois advances his argument about double consciousness through an explicitly and deliberately visual frame.[2] The veil is a screen upon which white conceptions and misconceptions are projected. Works by Jane Gaines, Farah Jasmine Griffin, Saidiya Hartman, and others have suggested that double consciousness could be read as a kind of film theory that approaches looking relations in a way that presages advances in feminist film theory and critical race theory later in the century.[3] Spectators of early cinema did not believe the representations of human figures onscreen to be real, but the apparent reality, or its reproduction, prompted them to examine their own relation to the world—or so the story has been told. Both the film experience and double consciousness, in other words, were modes of

revealing and thinking through the constructedness of the social world. The film screen, like the veil itself, was thus a medium for the production of a kind of self-consciousness, and race manages to transform the ordinary world into something like the uncanny shadow world of the cinema. Double consciousness might be a theory of the visual, but it is also a theory of spectatorship.

Indeed, while Du Bois's prose might allude to the material components of the film experience—the evocation of second-sight, the walls and the veils that serve as screens, the streaks of blue that mimic the moving image—it is the way that Du Bois's analysis toggles between the promise of revelation and the sting of alienation that draws the closest comparison to early cinema. By suggesting that the veil, rather than rendering its inhabitants blind to the world, gives them "second-sight," Du Bois begins to imagine the recuperative power of such a perspective. As Smith writes,

> Du Bois's prison-house connotes both a failure to be perceived, an invisibility, and a heightened insight. *Seeing* the Veil also *rends* the Veil for Du Bois; it is a moment of transformed awareness, of enlightenment.[4]

Smith reads double consciousness in this way to demonstrate Du Bois's engagement with visual culture, to show how this theory signified the color line as a sinister distortion of the visual ordering of the world. To gain "second-sight," then, was to see this distortion for what it was. For Du Bois, this is both a burden and a gift. It is a burden to be forced to hold these two perspectives and manage them for one's own survival, but it is also a gift of clarity. The conflict between two images of the world is productive of an almost transcendent insight about the way that world really works. This analysis provides a strong parallel to early cinema spectatorship, where viewers were engaged, at least in part, by the visibility of the apparatus and the dawning realization of their relation to it. Inasmuch as double consciousness as a point of view and a practice "transforms awareness" in this manner, it performs the work of the cinema of attractions.

This chapter does not make any claims regarding the inherent politics of early film, nor does it offer a naïve conflation of the precarious position of African Americans in the Jim Crow South with the leisurely position of the spectator in early cinema. Indeed, as Allyson Nadia Field suggests, while "double consciousness is an apt metaphor for the cinematic experience," it is not a theory that can be abstracted from race. "The idea of always looking at oneself through the eyes of others," she writes, implies "an 'other' that is necessarily racially posited."[5] Reading double consciousness as film theory, then, requires attention to the deeply ingrained racial politics of the film medium itself. And so, this chapter

identifies points of convergence between an emerging model of cinematic spectatorship and the political art of W. E. B. Du Bois in order to articulate the ways in which Du Bois's aesthetic resistance to narratives of white supremacy mirrored the address of early cinema.[6] In this chapter, I flesh out Du Bois's cinematic aesthetic in relation to both his theory of double consciousness and also to his two decades of work on what I call the Black Christ Cycle, a series of stories and illustrations featuring a black, lynched Christ in the post-Reconstruction South. The Black Christ Cycle reappropriates attractions in order to disrupt the cinematic secularism of D. W. Griffith's *Birth of a Nation* in the same way that it disrupts the secular logic of white supremacy that structures the film.

Echoing and refracting the methodology of attractions, the Black Christ Cycle emerged, I argue, as a way to disrupt the secular narratives that so shaped Du Bois's world, overlaying images of Christ on the Jim Crow South so as to reveal the conflict between this secular progress narrative and the lived experience of black people in America. For Du Bois, narratives like these used the power of art and storytelling fundamentally to deceive readers, to circulate "lies-agreed-upon" under the cover of fudged facts, pseudoscience, and other suspiciously thin evidences transfigured by the aesthetic of realism—the style of secularism as it has been manifested in everything from Lew Wallace's historiography to the Passion Play film. Narrative in this mode can be a kind of trickery; realism is a kind of soft propaganda. We now colloquially describe the work of narrative as captivation, but, as we know and must remind ourselves every day, this kind of narration of social history is a dangerous thing to be captivated by. Du Bois, in his disruptive re-envisioning of the aesthetic of attractions, refused to be held captive in this way.

Reading Du Bois in and through early cinema, it's important to remember that Tom Gunning's initial theorization of the aesthetic of attractions (explored in greater detail in chapter 3) was not merely an exercise in historical formalism; rather, it was a historicization of the politicized cinema of Sergei Eisenstein and other early- to mid-century avant-garde artists. Gunning's 1986 essay, "The Cinema of Attraction[s]: Early Film, Its Spectator, and the Avant-Garde," is as much an attempt to locate the origin of Eisenstein's "montage of attractions" in early cinema as it is to describe the shape of screen practice before 1906. Returning, for a moment, to this essay and its sources, we can see the way that Du Bois developed a theory of spectatorship—and eventually a political aesthetic—that has much in common with Eisenstein's theory of art-as-conflict and can be just as convincingly situated in the milieu of early cinema.

As we have seen, the aesthetic components of the cinema of attractions are its exhibitionism, its theatrical direct address, and its reliance on spectacle and shock over narrative. It is an aesthetic that not only predates but also actively

resists the cinema of narrative integration that began to emerge in the early twentieth century. Gunning's association of this aesthetic with the period of early cinema proved to be the essay's most portable insight, providing a strong counterargument to the then-accepted conception of these films as an unformed, unsophisticated "primitive cinema," groping unsuccessfully toward narrative. Gunning introduced this reading of attractions not just to legitimate these films on their own, but to make visible a direct line from the earliest motion pictures to the spectacular propaganda of Soviet montage.

Indeed, although the aesthetic components of the cinema of attractions appear conspicuously in the most obvious of its more contemporary afterlives—the Hollywood musical, the blockbuster action film, the CGI epic, the animated GIF and Vine video—the afterlife of most concern to Gunning was its political one. In a slightly later essay on the cinema of attractions, he writes, "The spectator does not get lost in a fictional world and its drama, but remains aware of the act of looking, the excitement of curiosity and its fulfillment."[7] This *awareness* is the effect of the aesthetic of attractions, and it is the element that Eisenstein seized upon more than any one element of the style. A cinema that guides its viewer to find pleasure, insight, or even discomfort through active intellectual engagement with the screen is a powerful kind of cinema, and one that would have been out of fashion for a number of years by the time Eisenstein began making films. But this aesthetic does not just positively define its approach to spectators. Rather, it does so in opposition to another cinematic method of representing reality. The aesthetic of attractions is notable not merely for its potential, but for the fact that it was, after 1906, effectively replaced by the rise of narrative integration in cinema. This style is anchored by one key innovation: *continuity editing*. This technique, also known as *invisible editing*, arranges images in order to create a coherent sense of space and time. Its rudiments are the shot-reverse-shot, the 180-degree rule, and the parallel edit. Continuity editing is the means by which films began to construct a coherent filmic world in which spectators might become absorbed, lost, held captive—and through which a narrative can emerge. It is the innovation that, in essence, created cinema as *we* know it. Attractions operate against this style and its ambitions, and Eisenstein appropriated their spirit to resist what he identified as the deceptions of narrative integration. Gunning writes elsewhere, "Attractions are a response to an experience of alienation, and . . . cinema's value lay in exposing a fundamental loss of coherence and authenticity. Cinema's deadly temptation lay in trying to attain the aesthetic coherence of traditional art and culture."[8] Thus, this is an aesthetic that is *constitutively* against "coherence" in visual and narrative contexts, against a plot that progresses from frame to frame, or a frame itself that erects a clear boundary between the filmic and extrafilmic

world. In chapter 3, I argued that this aesthetic, and its pushpull approach to credulity, was central to the development of cinema as a secular medium. All the same, in the years after its submersion underground, it isn't a stretch to imagine such an aesthetic mobilized to combat other types of coherence (the coherent ideology of capitalism, the false "authenticity" of bourgeois realism, even the normative sociality of secularism itself). The aesthetic of attractions, then, is not solely a way of dissecting the entertainments of the turn of the twentieth century; it offered a mode for figuring and awakening consciousness.

This was Eisenstein's goal. In a passage that Gunning cites in his original essay on attractions, Eisenstein wrote, "The way of completely freeing the theatre from the weight of the 'illusory imitativeness' and 'representationality,' which up until now has been definitive, inevitable, and solely possible, is through a transition to montage of 'workable edifices.' "[9] "Illusory imitativeness" and "representationality" are the hallmarks of narrative integration, and Soviet montage—despite deploying a formal innovation that was unavailable to early filmmakers and that, in its classical American version, did much to contribute to narrative integration—represents a way of mobilizing the aesthetic of attractions to new ends. Eisenstein further railed against narrative integration in his 1949 polemic, "A Dialectic Approach to Film Form." He wrote,

The foundation for this philosophy is a dynamic concept of things:

Being—as a constant evolution from the interaction of two contradictory opposites.

Synthesis—arising from the opposition between thesis and antithesis.

A dynamic comprehension of things is also basic to the same degree, for a correct understanding of art and of all art-forms, In the realm of art this dialectic principle of dynamics is embodied in

CONFLICT

as the fundamental principle for the existence of every art-work and every art-form.

For art is always conflict[10]

Narrative integration requires that spectators' experience of film not conflict with reality as they already perceive it. It is a style of film that seeks to minimize all cinematic elements that might take the viewer out of the diegetic world

of the film by prompting *awareness* of the apparatus or technique. In exchange, the cinema of narrative integration requires a kind of submission to the screen image, and thus to the (invisible) manipulator of that image. Because of this, Eisenstein believed that conflict must be at the "nerve" of cinema—not as an aesthetic choice, but as a political one. Art, for Eisenstein, *is* conflict, and to mask it—to render its dynamism "invisible"—is to deceive. Thus, rather than create spatial continuity to let spectators lose themselves in the film experience, Eisenstein sought to work against continuity, to push viewers in different directions. "It is art's task to make manifest the contradictions of Being," he wrote, "to form equitable views by stirring up contradictions within the spectator's mind, and to forge accurate intellectual concepts from the dynamic clash of opposing passions."[11] The aesthetic that, in its early period, called out to cinema's theatrical ancestors at the same time as it taught spectators about the new medium, was now appropriated to reveal to them the nature of the social and political world.

Eisenstein's greatest critique of narrative integration in this vein—especially as practiced in the United States—ironically came via his praise of Griffith as a master of parallel editing and montage. Although he wrote, in his famous essay on Charles Dickens and Griffith, that the latter was a "revelation" to young Soviet filmmakers, he drew a clear distinction between American and Soviet montage principles. "The structure that is reflected in the concept of Griffith montage," he wrote, "is the structure of bourgeois society." After suggesting that Griffith's true genius lay in his facility with tempo and rhythm, Eisenstein continued:

> True rhythm presupposes above all organic *unity*. . . . And naturally, the montage concept of Griffith, as a primarily parallel montage, appears to be a copy of his dualistic picture of the world, running in two parallel lines of poor and rich towards some hypothetical "reconciliation" where . . . the parallel lines would cross, that is, in that infinity, just as inaccessible as that "reconciliation." Thus it was to be expected that our [Soviet] concept of montage had to be born from an entirely different "image" of an understanding of phenomena, which was opened to us by a world-view both monistic and dialectic.[12]

Eisenstein credits Griffith with an innovation—an innovation Eisenstein and the other Soviets enthusiastically employed in their own montage films—but he keeps his focus on the damning fault of Griffith's cinema: his assumption of organic unity. Griffith's cinema, his montage, thus leads not to truth but to a recycling of its own ideology.[13]

That ideology, for Du Bois, is the secular naturalization of white supremacy, Christianity, and sacred violence manifest in the "organic" formal unity of

The Birth of a Nation. Du Bois's theorization of double consciousness—inasmuch as it describes the gaze of the black subject as inherently dialectical, perceptive of contradiction, aware constantly of the material effects of racial hierarchy, "clairvoyant," as Du Bois would later phrase it, about the hypocrisies of whiteness—is in dialogue with the confrontational aesthetics of the cinema of attractions as Eisenstein adapted it and Gunning described it. But while Eisenstein was describing a theory of filmmaking practice—an aesthetic toolkit that could be *used* to shock spectators out of complacency, out of their acceptance of a constructed social and political order—Du Bois was describing a perspective that already existed: an inescapable and constant experience of self-conscious spectatorship. For Du Bois, double consciousness means that there is no other way of seeing the world than in its conflict, contradiction, and constructedness. Du Bois's spectators did not have the privilege of choosing one or the other; his spectator is trapped in a prison-house that is shaped by a logic very similar to the logic of attractions. Du Bois can't help but see the incoherence and inauthenticity of a world organized and imagined in and through white supremacy. The viewers Gunning describes indulged in the aesthetic of shock and confrontation as a means of recognizing their own alienation from work and technology and industrialization; Du Bois's were never unaware of this conflict.

FABLES OF THE RECONSTRUCTION: THE DUNNING SCHOOL

From Edison to Eisenstein to Gunning, the aesthetic of attractions has been defined in relation to its management of narrative. Du Bois set this aesthetic to work on the narratives of history. If double consciousness is a theory of spectatorship Du Bois used to describe the way African Americans see the world of the Jim Crow era, it also made the historical narratives that enabled this oppression uniquely visible. By the time Du Bois began his work, the renarration of the Civil War and Reconstruction by white supremacist historians had already begun. William Dunning—the namesake of the so-called Dunning School of historians—published his collected essays on the topic the same year Du Bois published his first words on double consciousness. Dunning and his followers called upon whites in the North and South to *strengthen* their mythologies, to construct and inhabit an airtight narrative of biological superiority and Christian messianism. Du Bois, from that early essay in *The Atlantic*, all the way to his publication of *Black Reconstruction* nearly forty years later, used his own

variation of the aesthetic of attractions to wage a campaign of disruption against the secular narratives of white supremacy. He called upon African Americans to use their alienation from American culture, to deploy the gift of second sight that allowed them to keep hold of both reality and its mythologies at the same time.

This might sound like an abstract claim, but this was no narrative of wisps and suggestions. The Jim Crow laws that disenfranchised black Americans and shielded white terrorists were built and strengthened through a feedback loop with this new school of historical writing. As Peter Novick has demonstrated, the very creation of American historical study as a profession in the late nineteenth century—the American Historical Association (AHA) was founded in 1884—was catalyzed in part by a drive for historians to promote national "reconciliation" in their work after of the Civil War. Specifically, the AHA, and many of its members, sought to smooth over the "sectional conflicts" of the Civil War, streamlining a singular history of the United States as a nation rather than the pluralistic history of the United States in conflict with each other. However, to smooth over such conflicts, or even really to describe them as "sectional" rather than ideological or ethical, was to recast the role of slavery in this history. This reconciliation wouldn't just be American; it would be *Anglo*-American. Thus, bolstered by "scientific racism"—pseudoscientific theories of black inferiority based on eugenics and biased demography that were becoming more and more accepted by mainstream white readers—"a nationalist and racist historiographical consensus, which demonstrated historians' impartiality and objectivity, was achieved on the 'middle period' of the nineteenth century."[14] Historians, typified by the Northerner Dunning, sought to overcorrect, to "show their fairness and impartiality by bending over backward to appease the southerners."[15] For Dunning, the Civil War highlighted an ugly crime of American history—the *practice* of slavery—but it did nothing to alter, and in fact did much to reveal, the natural inferiority of black Americans (and thus the superiority of Anglo-Saxon whites). Freeing the slaves was not a mistake, because slavery itself is immoral, but (so the logic went) giving black people the vote and the opportunity to represent themselves in the legislature was. In his blistering 1935 "The Propaganda of History," Du Bois summed up the tenets of the Dunning School as follows: "1. All Negroes were ignorant ... 2. All Negroes were lazy, dishonest and extravagant ... 3. Negroes were responsible for bad government during Reconstruction."[16] Dunning's followers and students were many, and, in the years after his initial seminars, a historical narrative of the Civil War and Reconstruction founded on this basic assumption became common in scholarly monographs, university classrooms, and popular culture.

The central crux of this narrative, and its most materially significant plot point, was that while freeing slaves was a laudable achievement, black suffrage

was a mistake and a disaster. Ill-equipped to govern themselves, enfranchised black people—and their Radical Republican supporters in the South—began, during the Reconstruction period, to oppress and persecute white Southerners. Reconstruction's progress at integrating African Americans into the political process was recast as tyrannical overreach. Efforts to protect the newly acquired civil rights of African Americans were recast as violations of the civil rights of white former slave owners. Black votes and political initiatives during Reconstruction were recast as ignorant, if not malicious, abuses of misplaced power. "To be injured," writes Robyn Wiegman, "by the economic transformations of Emancipation, by the perceived loss of all-white social spaces, by the seeming dissolution of whiteness as the condition of citizen subjectivity—provides the bases of white supremacist collective self-fashioning."[17] These narratives emerged to retroactively justify and buttress a new, reactionary order in the South. As the Reconstruction historian Eric Foner stated, "the Dunning School of Reconstruction was not just an interpretation of history. It was part of the edifice of the Jim Crow system."[18] The historiography that described Reconstruction as a topsy-turvy dystopia and a government-sanctioned program of discrimination against Southern whites lent the imprimatur of "science" and impartiality to the laws that would disenfranchise black voters and give legal cover to the lynch mobs that would terrorize black Americans for decades.

Central to the narratives of the Dunning School, the narratives of scientific racists, and the narratives that justified violence and disenfranchisement on the ground in the South at the turn of the century were the rhetorical and symbolic union of Christianity and white supremacy. "Hovering over and sanctifying the religious violence," writes Edward Blum, "stood the image of a white Jesus and a white God."[19] Orlando Patterson has argued that lynchings functioned, for their white Christian perpetrators, as a kind of ritual sacrifice, performances that gained power through their visual evocation of Christ's suffering on the cross. Racial violence, in other words, was a kind of a devotional act.[20] W. Scott Poole has argued that, rather than endeavoring to ritually reenact the crucifixion, lynch mobs in the post-Reconstruction era saw themselves as soldiers in an apocalyptic battle to save Christianity from the satanic meddling of African Americans. Lynchings were thereby justified as holy war:

> In the battle against the Antichrist, moral scruples could be shunted aside. White Southern Christians, armed with shotguns, bowie knives, and lynching ropes, saw themselves at the heart of a theological drama—not the bloody drama of Calvary, but instead the final battle, the apocalypse.[21]

What these historians describe is a kind of interactive, secular logic. Either the lynch mob recreates the crucifixion as a ritual of atonement, or the lynch mob wages guerrilla war against the hordes of the Antichrist; in both cases, a narrative of the sacred linkage between Christianity and the politics of white supremacy is the necessary precondition. It's a style of live-action role-play rooted in Democratic politics, scientific racism, and a very selective reading of the Bible that requires players to buy in to the scenario so fully that they're willing to commit atrocities. Racial violence in the post-Reconstruction South needed white Southerners to immerse themselves so totally in this narrative that they could justify acts that might otherwise have been deemed heinous and even anti-Christian. The horrors of Jim Crow were motivated by politics and racism, but they were thus enabled by widespread belief in a narrative that told a very particular story about what Jesus Christ required of his allegedly chosen race. The secular narrative of divinely sanctioned white supremacist violence offered a *coherence* for white Southerners endeavoring to rebuild their lives after the Civil War. For the theologian James H. Cone, in the Jim Crow Arkansas of his youth, "the violent crosses of the Ku Klux Klan were a familiar reality, and white racists preached a dehumanizing segregated gospel in the name of Jesus' cross every Sunday."[22] The ideology that allowed for these atrocities was inseparable from the Christianity appropriated to justify it.

While it might seem transparently contradictory, this imbrication of Christianity and racist ideology was a feature, not an aberration, of white supremacy in this period and place. White and black Christians were certainly pivotal in many of the antiracist battles against Jim Crow, and the black church has long been a cradle of the civil rights movement, but Jesus, as we know, could be subject to "special interpretations and uses," as Warren Susman put it. Indeed, as Kelly J. Baker has demonstrated, the members of the Ku Klux Klan perceived themselves, first and foremost, to be members of a *religious* organization. More than that, it was a Protestant organization with very familiar, secular outlines. "Klan conceptions of Protestantism," Baker writes, "contained values like religious freedom and individualism while simultaneously drawing boundaries of exclusion." This embrace of individual liberty had a very specific goal: the (re)union of all Protestant denominations and sects against Catholicism, Judaism, and the prophets of racial equality. These antagonists were portrayed not as valid points of view in their secular order, but as agents of religious tyranny and compulsion seeking to force their views on the unwilling. The KKK was an organization structured around perceived threats against whiteness and Protestantism, and thus against God's chosen nation.[23] As George Shulman has written, the ideology of white supremacy alone is enough to suggest the faultiness of the secularization thesis.

"Secularization," he writes, "is one face of a biopolitical project seeking to immunize the enfranchised against the infection and impurity signified by racially marked others but carried internally, incipiently, by everyone." White supremacy, in other words, even and especially because of its appropriation of Protestant Christianity, is secular.[24]

As Shulman also notes, however, forms of black insurgency against white supremacy have similarly "confounded the religious-secular dichotomy." Forms of black insurgency like the genre of black prophecy, he argues, constitute a "countertheology that takes exception to sovereign states of exception, the dark side of a sanitizing secularization."[25] Du Bois's mobilization of the aesthetic of attractions in his Black Christ Cycle is a part of this insurgent tradition. These stories and illustrations were designed to counteract the sway of white supremacist narratives, to interrupt their ability to captivate and mesmerize their adherents, to destroy the coherence that made them appealing. He wrote,

> It is propaganda like this that has led men in the past to insist that history is 'lies agreed upon,' and to point out the danger in such misinformation. . . . Nations reel and stagger on their way; they make hideous mistakes; they commit frightful wrongs; they do great and beautiful things. And shall we not best guide humanity by telling the truth about all this, so far as the truth is ascertainable?[26]

If the secular narrative of white supremacy constituted the "lie-agreed-upon" in the Jim Crow South, Du Bois would use his Black Christ Cycle to reveal this deception, to make spectators *aware* of the constructedness of this world.

D. W. GRIFFITH'S ALTERNATIVE FACTS

D. W. Griffith's *The Birth of a Nation* was the ideal vessel for this narrative. *The Birth of a Nation* revealed the convergence between the aesthetic aims of narrative cinema and the ideological aims of Dunning School revisionism. Its continuity edits conspired not just to produce an immersive filmic world, but also to craft that world along the lines of a specific kind of ethno-nationalist narrative of history. The everpresent dilemma of teaching *Birth* in a classroom is that it is both the best illustration of cinema's early, enthusiastic embrace of nineteenth-century racist popular cultural forms *and* the most famously cited example of the emergence of large-scale narrative integration. In screening the iconic scene in which Gus (the villainous freed slave played by a white actor in blackface) chases the

innocent white Flora off a cliff, both of these superlatives are unavoidable. Especially when invoking Griffith's place as a pioneer of this style in film history, though, his case is sometimes presented with a conspicuous "*but*" in the middle: *Griffith was an early innovator of cinematic narrative realism* but *he is also responsible for perhaps the most racist film in history.* Reading Griffith through the Dunning School, however, the extent to which these two aspects of Griffith's film are inextricably linked, even mutually dependent, becomes exceedingly clear. To separate the two approaches to the film is to avoid an uncomfortable assertion: that the cinema of narrative integration itself is complicit in Griffith's deformation of history. *The Birth of a Nation* used the film medium's technological possibilities to produce a seamless, captivating narrative realism based largely on a set of bigoted hallucinations. *The Birth of a Nation*'s racism is not so corrosive *despite* the film's formal unity and narrative dexterity; it is so corrosive precisely *because* of it. The film's final image—the transparent, oscillating Christ—might invoke the spectacular exhibitionism of attractions, but I argue that this patently unbelievable figure serves only to reinforce a narrative realism rooted in white supremacy.

Despite the film's obvious bias, Griffith proudly trumpeted the meticulousness of his film, citing "the research of scholars, archaeologists, and academic printers for precision and accuracy."[27] Many reviewers agreed that the film projected a convincing aura of historical authenticity. An advertising program seeks to bolster this particular angle, quoting critics who proclaim that "the realism of this work is amazing," and even that watching the battle scenes "is like real war."[28] In reviews, the film was credited with an "uncanny realism" and a "terrible realism," and Dorothy Dix went so far as to suggest that the film's perspective is "just as the angels looking down from heaven must have seen."[29] Even Woodrow Wilson's apocryphal comment that "It is like writing history with lightning. And my only regret is that it is all so terribly true" belongs in this camp.[30] (Wilson himself was a devotee and, indeed, purveyor of Dunningite revisionism.) These reviewers all shared their praise of the film's accuracy, authenticity, and faithfulness to the record, even though this record was often the one produced (and doctored) by Dunning and his followers.

Over and over again, reviewers of *The Birth of a Nation* showed themselves to be preoccupied by the film's success as realist art. The Rev. Thomas Gregory, to take an especially rich example, reviewing the film in *The New York American*, made a hyperbolic but not unusual proclamation:

> I am prepared to say that not one of the more than five thousand pictures that go to make up the wonderful drama is in any essential way an exaggeration.

They are one and all faithful to historic fact, so that looking upon them, you may feel that you are beholding that which actually happened ... no one who sees it can be the least bit sceptical [sic].[31]

This is a common reaction to the film from a sympathetic critic. The film is praised for its ability to represent history as it "actually" was: Gregory used the word "actually" or its variants no less than three times in this short review. In other words, Gregory rated the film's success on its ability to offer a credible representation of reality.

What makes Gregory's review remarkable and instructive, however, is not his placing of *The Birth of a Nation* in a realist tradition, but the manner in which he describes that realism. Shortly after suggesting that, in the film, Griffith comes "pretty near working a miracle," Gregory offered a reading similar to the one above, but in a distinctly different register:

"[S]eeing is believing"—and in this wonderful photo play, we actually see the birth, growth, and coronation of this King of Nations, this giant of the Powers of the earth.... As if by the waving of some magician's wand the great scenes are, one after another, unrolled before us.[32]

This is an articulation of spectacular realism. Here Griffith's ability to produce credible realist cinema is likened to the work of a magician; moreover, spectatorship is linked to belief—seeing to believing—even as what is being praised is the film's near-documentary accuracy. To "feel that you are beholding that which actually happened," then, is less a reaction to a remarkable feat of re-creation than it is a testimony to film's miraculous and transcendental power. For Gregory, Griffith's realism was based in an act that was previously thought to be impossible: the construction of a filmic reality that rivals, if not supplants, historical reality for the viewer.

Though Griffith allowed his film's promotion machine to make claims for the film's "realism" as such—a souvenir card for the film describes it as "the very acme of art and realism"—he was notoriously outspoken on the future of cinematic historiography and his own role in its development. In a widely circulated interview from 1915, Griffith set forth a utopian dream of cinema's future:

The time will come, in less than ten years, when the children in the public schools will be taught practically everything by moving pictures. Certainly they will never be obliged to read history again Imagine a public library of the near future, for instance. There will be long rows of boxes or pillars, properly

classified, of course. At each box a push button and before each box a seat. Suppose you wish to "read up" on a certain episode in Napoleon's life. Instead of consulting all the authorities, wading laboriously through a host of books, and ending bewildered, without a clear idea of exactly what did happen and confused at every point by conflicting opinions about what did happen, you will merely seat yourself at a properly adjusted window, in a scientifically prepared room, press the button, and actually see what happened.... You will merely be present at the making of history.[33]

In passages like this one, we get a Griffith who is more than just idealistic about the future of cinema. Indeed, his preposterous bluster makes it tempting to take his comments with a grain of salt, or to suppose that he is exaggerating for effect. But imagine, for a moment, that we take seriously the notion that Griffith saw the emerging medium as one that could ideally replace written history, that could turn consumers of historical work into eyewitnesses of a sort. At the root of this idea was the confidence that film could produce such an immersive replication of reality, even past reality, that the resulting film could rival even the actual events themselves (and, as is demonstrably the case in *The Birth of a Nation*, pass off racist fantasies as fact). As Michael Rogin puts it in "The Sword Became a Flashing Vision," Griffith imagined his film as "not an avenue to history but its replacement."[34] If we indulge the fantastical components of this vision, it seems patently ridiculous. But if we read this as a kind of hyperbolic theory of narrative integration—of the ability film has to turn what's true within its diegesis into what's perceived to be true in the world—then we have to read this passage as one of shudder-inducing insight. For decades after *The Birth of a Nation* was released, it would have been hard to say Griffith was wrong.

Yet, the seams of this apparently seamless historical film are visible, perhaps nowhere more so than in the scenes Griffith saw fit to single out and label "historical facsimile," citing, as in a work of academic historiography, the source material from which the images were drawn. This, as we know, is one of the tropes of the style of secularism that this book tracks from the nineteenth century: the hypervisibility of mediation. There are three such "historical facsimiles" in the film: the Lincoln assassination, the surrender of Lee to Grant at Appomattox, and the South Carolina Reconstruction legislative session. The Lincoln assassination set-piece, even today, is lauded for its painstaking staging. The intertitles framing this sequence report that what follows is, point by point, an accurate and faithful representation of the actual historical event (figure 4.3). Indeed, even beyond the unusual gesture of providing scholarly citation, the

FIGURE 4.3 *The Birth of a Nation* (D. W. Griffith, 1915)

intertitles go so far as to note the exact time as well as scene in the play during which Lincoln is shot:

> AN HISTORICAL FACSIMILE of Ford's theatre as on that night, exact in size and detail, with the recorded incidents, after Nicolay and Hay, in "Lincoln, a History."

As the camera peers up at the dead president from deep in the midst of the rustling chaos that ensues after the shot is fired, Griffith's film audience witnesses this event from the perspective of the audience at Ford's theater that night. But in that audience is also one of the young couples complicit in the foundation of the Ku Klux Klan and eventual witnesses of Griffith's apocalyptic vision on their honeymoon. Griffith's set-piece stays faithful to accounts of the evening, but, by including his characters, he situates this event within a different, alternate history.

The second sequence in this grouping is the surrender at Appomattox. It carries the same authorizing citation in its intertitle, but rather than mobilizing the tools of narrative cinema, it functions primarily as a brief *tableau vivant*. Aside from the fact that it is one of the sequences in the film that most keenly recalls the cinema of attractions, it is most interesting to us here as a scene that reinforces the trustworthiness of the "historical facsimile" within the film. The final "historical facsimile," however, retains the Lincoln assassination's performative politics of citation, but rather than taking a (mostly) accurately depicted event and placing it within the warping context of a white supremacist renarration of history, this facsimile doctors the (source) image itself. The intertitle suggests that what we see transpire onscreen is drawn from a photograph of a "riotous" South Carolina legislative session after the end of the Civil War (figure 4.4). The scene opens on an empty chamber, but it quickly dissolves into a series of racial caricatures—shoeless black congressmen, eating fried chicken, dancing in minstrel style—occupying the chamber, along with reaction shots from a horrified white gallery, gasping in revulsion at this apparent miscarriage of law and justice.

FIGURE 4.4 *The Birth of a Nation* (D. W. Griffith, 1915)

As noted earlier, this is a narrative common to the Dunning School, though it has rarely received such sharp and direct representation onscreen. The scene is obviously a false one, but it is anchored by the same claim of authenticity as the Lincoln assassination and Lee's surrender. The key difference here is a sleight of hand: the photograph Griffith cites in the intertitle is a photograph of the *empty* chamber. The caricatures that populate it after the dissolve are entirely the director's invention. It is the Lincoln assassination's meticulous detail that allows Griffith the leeway to blur these particular details, to imply that a bigoted fever dream has the weight of the historical record behind it.[35]

Griffith's apocalypse, though not labeled as such, shares something with these scenes of "historical facsimile." It is as filled with imaginary incident and personae as the scene in South Carolina, but it is as anchored to a textual referent—albeit scriptural—as the Lincoln assassination. The final image of *Birth of a Nation*, after the apocalypse, is a single intertitle describing the honeymoon scene: "Liberty and union, one and inseparable, now and forever!" Traditionally, we might imagine these words, ascribed earlier in the film to Daniel Webster, to evoke the triumph of Lincoln, a figure recuperated rather than villainized by the Dunning School. But the liberator and the uniter here is the Christ of Revelation, and the "now and forever" of Webster's exclamation can be read as the time signature of this scene: the "now" of the Stonemans and Camerons, post-Reconstruction, and the "forever" of the Last Judgment. Griffith's scenes of the Last Judgment, appropriately situated on the horizon, form the horizon of American history as it begins again with the honeymooners. Having successfully foiled what Griffith depicts as Reconstruction's efforts to destroy white America, these lovers gaze upon a future in which they will perpetuate their pure race, strengthened rather than diminished by the new union of North and South. The Last Judgment validates this project, showing the honeymooners a vision of the New Jerusalem as, literally, a city on a hill—the culmination of the American experiment as it is reconceived in *Birth of a Nation*.[36]

This is obviously a scene of fantasy and phantasm. Regardless of the spectator's beliefs, no audience member would have perceived Griffith's apparitional Christ as real. Indeed, aesthetically it is easy to see this scene as fitting neatly within the cinema of attractions, a clear aesthetic break from what transpires before it. Contemporary critics have tended either to dodge or to dismiss this scene—Melvyn Stokes's otherwise authoritative history of *The Birth of a Nation*'s production and reception, for instance, scarcely mentions the two minutes that end the film, precisely because of their dissonance with the rest of Griffith's film. Russell Merritt calls the scene "an incredible and unconvincing tour de force [relating] the restoration of the old South to contemporary

dreams of peace and isolation."[37] For Helmut Färber, the scene is an unambiguous aesthetic failure. The superimposed Christ is indicative, for him, of Griffith's own inability to provide a satisfactory conclusion to his film, and the end of the picture is thus a placeholder for what would ideally have been a more literal continuation of the primary narrative of reconciliation, "showing, for instance, Ben Cameron and Phil Stoneman taking political office, working on new legislation, and collaborating in Lynch's former office."[38] Still others read a kind of desperation in the scene's spectacular transubstantiation of white supremacist logic. Robert Lang calls the ending a "tremendous, hysterical effort to assert that, though a great deal has been lost, something even greater has been gained."[39] Finally, Philip Rosen labels the scene a "visual allegory" meant to serve as a vehicle by which "truths" about history can be "bluntly and directly given to the audience."[40]

What these assessments share is the sense of an ending that is somehow excessive, outside the bounds of the narratively coherent Dunning School romance that precedes it. This perspective (especially as articulated by Rosen) squares with the idea that Griffith's Christ is a throwback to the Passion Play films of the era of attractions. However, where most of these critics see an aesthetic failure—a scene that viewers must bracket in order to understand the demonstrated success of the film's ideological message—I suggest that this final moment of supernatural flourish is, in fact, integral to Griffith's project. Cedric J. Robinson gestures toward this ideological centrality in his description of the sequence: "The abrupt juxtaposition of these visual constructions fuses whiteness and race theodicy, patriarchy and filiopiety, historical destiny and Christian civilization on the mass consciousness."[41] Although the scene's contrivance would have been unavoidably clear to viewers, it is so excessive—such a sundering of the film's realist ambitions—that it counterintuitively authorizes what came before it. It serves as fantastical leverage. This scene goes to great lengths to signal its unreality, whereas the scenes preceding it do the opposite; we disbelieve this scene in order to take the scenes before it for granted. Viewers may not *believe* in this spectral Christ, in other words, but they may well use this image to believe in the divine mandate of the spectral (if not transparent) riders of the Ku Klux Klan who haunt the rest of the film. Griffith produces scenes of seamless realism under the sign of faithfulness and scenes of outrageous racist vitriol under the sign of accuracy. These scenes proudly bear the title of "historical facsimile" while the concluding scenes of apocalyptic terror and revelry—no less unreal than that legislative session—are signaled as fantasy. These are Griffith's alternative facts, brought to their apotheosis in Christ's authenticating return.

ON SUPERIMPOSITION

What, then, do we make of the convergence between Griffith's final image and Lorenzo Harris's "Christmas in Georgia, A.D. 1916"? Although I began this chapter with a litany of their differences, in this one context—a debt to the aesthetic of attractions—they bear an undeniable similarity. The history of superimposition itself can provide some nuance to the comparison.

In photography, a superimposed image is an image produced through two separate exposures, two images sedimented upon each other. It is literally two photographic images in one, whether created as a trick or a trip-up. The first photographic superimpositions, or "ghost photographs" as they were colloquially known, began to appear in the 1850s. There is little evidence to suggest that these superimposed photographs were circulated as anything other than novelty photographic tricks for much of their first decade. However, in 1861, when William Mumler began offering portraits of living individuals with deceased loved ones in the background in his Boston engraver's studio, these images took on a new life. The novelty "ghost photographs" became "spirit photographs" that promised sitters communion with their lost companions and suggested scientific proof of an afterlife. More specifically, these photographs were adopted, circulated, and given the heft of both religion and rationalism by the transatlantic Spiritualist movement.[42]

Superimposition, then, has always been a technique and an aesthetic charged with transcendent possibility as well as the possibility of deception. Within only a few years of its discovery, viewers were eager to believe the layered image and its fantasy of union and transit between living and dead, seen and unseen. At least, they were eager to experiment with that belief, to tease themselves with it even if they knew or believed better. An object of technological progress, scientific process, and popular consumption that, at the same time, can serve as a vessel for belief, this photograph is a perfect figure for the time. It is a double image in the most literal way: the way its technical composition could be mobilized to communicate an ethereal truth, evocative of the push-and-pull ambivalences of the secular age.[43]

However, by the time the technique and technology of superimposition made it to motion pictures at the end of the nineteenth century, something was different. It's easy to see the compositional echoes of the spirit photograph, for instance, in the multiple scenes of Christ walking on the water (discussed in chapter 3). Yet, the reappearance of the spirit photograph as a visual echo in the

era of attractions is not the same thing as its resurrection as a truth claim. What was haunting becomes hokey. What served as a symbol of the secular union of science and the sacred becomes, by turns, almost too literal. "Despite cinema's uncanny qualities," Matthew Solomon writes,

> despite its continuities with phantasmagoria shows, and despite vigorous popular and scientific interest in spiritualism continuing well into the twentieth century, there was never a spirit-cinema to parallel the practices of spirit photography.... The incipient cinema's cultural associations with magic ... worked to repress and displace the medium's phenomenological affinities with apparent spirit phenomena, helping disavow the spectrality of cinema.[44]

In other words, although the compositional conventions and practical techniques of spirit photography were appropriated by filmmakers in the early twentieth century, the "phenomenological affinities with apparent spirit phenomena" could not possibly travel with them. By the time superimposition reached the cinema, it had been disenchanted, leaving only a formal echo of a lost belief.

This disenchantment is not just a historical coincidence. According to André Bazin, superimposition was simply a poor fit for cinema. In his essay "The Life and Death of Superimposition," Bazin suggests that the aesthetic of the superimposed can never be anything but glaringly fake. He writes, "Superimposition on the screen signals: 'Attention: unreal world, imaginary characters'; it doesn't portray in any way what hallucinations or dreams are really like, or, for that matter, how a ghost would look."[45] Bazin objects in particular to the way that ghostly superimposed figures move not as figures in a space but as images on an image, obeying photographic rather than physical laws. (He particularly hates, for instance, when a ghost walks over a table as if it's not there.) The superimposition is thus, for him, always a didactic effect, a device that calls attention to artifice rather than subsuming it.

So, it is not surprising that superimposition would be a central technique of the cinema of attractions (as well as its underground inheritors of the mid-century avant garde). Indeed, Bazin's critique of the superimposed image brings to light an aspect of spectacular realism that we have not yet explored: the fact that spectacular realism is not a sustainable realism. Christ superimposed upon the Sea of Galilee in *From the Manger to the Cross* is designed to leverage the medium's realist capacity, not to disappear within it. Just because the miracles of the Passion Play films are layered upon actualities does not mean that they are not also tricks, moments of shock and spectacle and alienation.

Spectators are not meant to believe the image but to have the image calibrate their internal struggles with belief. As Gunning writes, "our senses of vision and perception are brought to crisis" by ghostly images such as these, but that crisis need not necessarily resolve into belief.[46] Thus the space is opened for something like the spirit photograph—oriented by the ontology of the photographic image but not determined by it—to produce this kind of ambivalence.[47] Spectacular realism is meant to stretch the capacity of film's realism, to demonstrate what the medium can do—but also to acknowledge what is beyond its reach.

There is one lineage of superimposition that ends up in the era of attractions: a didactic, spectacular approach highlighting and undercutting cinema's nascent ability to create aesthetic and narrative coherence. Then there's the lineage of superimposition that stalls out in spiritualism and asks its spectators to believe in the unity of these images. Harris's image, especially because it's an illustration rather than a photograph, holds no pretense of belief. It gains depth through its reference to the photographic technique, but it cannot make any of that medium's truth claims, however contested those claims are otherwise. Griffith's image is no more able to do so, but it would be a mistake to suggest that the end of *The Birth of a Nation* owes nothing to the spirit photograph. Griffith's Christ reaches through the cinema of attractions back to the impossible realism of spirit photography. Perhaps the scene knowingly leverages its attractions in order to authorize the film that precedes it, as I have suggested, but the idea of a medium that could transcend (and manipulate) the seen and the unseen as easily as it could transcend (and manipulate) the present and past seems like an idea Griffith might have embraced. Griffith references the spirit photograph here as he helps to cement cinema as the new medium of belief.

SPECTATORS AT A CRUCIFIXION: THE BLACK CHRIST CYCLE

Du Bois never had a great deal of faith in the medium of film to produce an adequate response to the Dunning School or to *The Birth of a Nation*. He dedicated many pages in *The Crisis* to semi-regular digests of negative reviews that *The Birth of a Nation* received in newspapers across the United States, but also freely acknowledged the skill with which the film was produced. Indeed, it was the wild success of the film's noxious message that seemed to bother Du Bois

most, because of what it showed about the medium of film and its audiences. In *Dusk of Dawn*, his autobiography, Du Bois wrote,

> This method of popular entertainment suddenly became great when David Griffith made the film "The Birth of a Nation." He set the pace for a new art and method: the thundering horses, the masked riders, the suspense of plot and the defense of innocent womanhood; all this was thrilling even if dramatic and overdrawn. This would have been a great step in the development of a motion-picture art, if it had not happened that the director deliberately used as the vehicle of his picture one of the least defensible attacks upon the Negro race.... There was fed to the youth of the nation and to the unthinking masses as well as to the world a story which twisted the emancipation and enfranchisement of the slave in a great effort toward universal democracy, into an orgy of theft and degradation and wide rape of white women.[48]

Earlier I wrote about the necessity of historicizing the emergence of narrative integration alongside the urgency of Griffith's proselytization of the Dunning School. Du Bois was able to make this observation in the moment. The "great" step Griffith made in developing film formally was immediately tainted, for Du Bois, by the story the director chose to tell. Furthermore, it's hard not to equate the rapturously captivated reviewers quoted earlier with the "unthinking masses" Du Bois cites here. Certainly, he is not claiming that film is lost to the cause of antiracism, but the essay does serve as somewhat of an explanation as to why he never seriously pursued film as a weapon against Jim Crow.

As early as 1915, the NAACP had begun exploring the possibility of producing a cinematic response to *The Birth of a Nation*. When the organization formed a "Scenario Committee" to begin work, however, Du Bois refused to serve.[49] In place of cinema he turned to the pageant, a form that was popular among African American uplift media at the time. In 1911, Du Bois wrote *The Star of Ethiopia*, a historical pageant in five parts that would perform, in spectacular fashion, the centrality of Africans and African Americans to the history of the world. Du Bois was not the first to unearth this nostalgic form—indeed, pageantry had become almost trendy in the early twentieth-century United States—but he was the first to suggest using it to trumpet the achievements of people of color. *The Star of Ethiopia*, through its several performances between 1913 and 1920, staged a celebration of African American history designed specifically to counteract the narratives of white supremacy and black inferiority so vividly presented by Dunning, Griffith, and others. In 1915, Du Bois called the pageant a "new and rising form of art expression."[50] In 1916, he suggested that the pageant could serve as

the vehicle for a "new folk drama built around the actual experience of Negro American Life" that could specifically rival the motion-picture theaters that had begun to spread in Harlem.[51] Later that year, he wrote, "The Pageant is the thing. This is what people want and long for. This is the gown and paraphernalia in which the message of education and reasonable race pride can deck itself."[52] Du Bois's preferred medium would eventually be overshadowed by Griffith's, but the theatrical turn to the pageant still illuminates the relationship between Du Bois's work and the aesthetic of attractions in this period. All the same, I argue that it was his work in *The Crisis* that most clearly expressed this aesthetic debt.

Du Bois edited *The Crisis*—the NAACP's official publication—from its founding in 1910 until he stepped down in 1934, and during that time the magazine published what it called its "Christmas Number" every December. These special issues largely follow the format of an ordinary *Crisis*—a section entitled "Along the Color Line," followed, in various orders, by the "Opinion," "Editorial," and "Men of the Month" columns, as well as assorted features about contemporary issues in African American life—with the one exception that nearly every Christmas issue prominently featured a story, poem, illustration, or editorial essay in which Jesus Christ is either portrayed as black or resurrected amid the contemporary black community. Covers drew attention to the theme with photographs of black women in modern dress titled "Annunciation" (figure 4.5) or "Madonna and Child" (figure 4.6), representations of the Christ child himself as a dark-skinned infant, and explicitly contemporary scenes of the rural South with Biblical captions such as "The Flight into Egypt" (figure 4.7). However, while the cover images stuck to portraits of women, children, and families—as covers of *The Crisis* often did—the stories and illustrations within the pages of the Christmas number were less occupied with celebratory yuletide nativity scenes. Generally written by Du Bois himself, the centerpiece text of many Christmas numbers featured the narrative of a black man in the twentieth-century American South who preached the gospel of Christ, was often persecuted, murdered and buried, sometimes to rise again. These are tales of violence, nearly gothic horror, and often acute anger, and, throughout Du Bois's twenty-four-year editorship of *The Crisis*, they were told again and again, from different perspectives and in different styles, nearly every Christmas.[53]

The Black Christ Cycle consists of a long series of adaptations of the Christ narrative rooted in a contemporary analogy between Christ's crucifixion and the lynchings that terrorized the Jim Crow South. The Black Christ Cycle is thus, in one light, a meditation on this mode of modern, racial violence. However, in its annual emphasis on the variance of these stories and in the focus of the stories themselves on the different angles from which one might view these events,

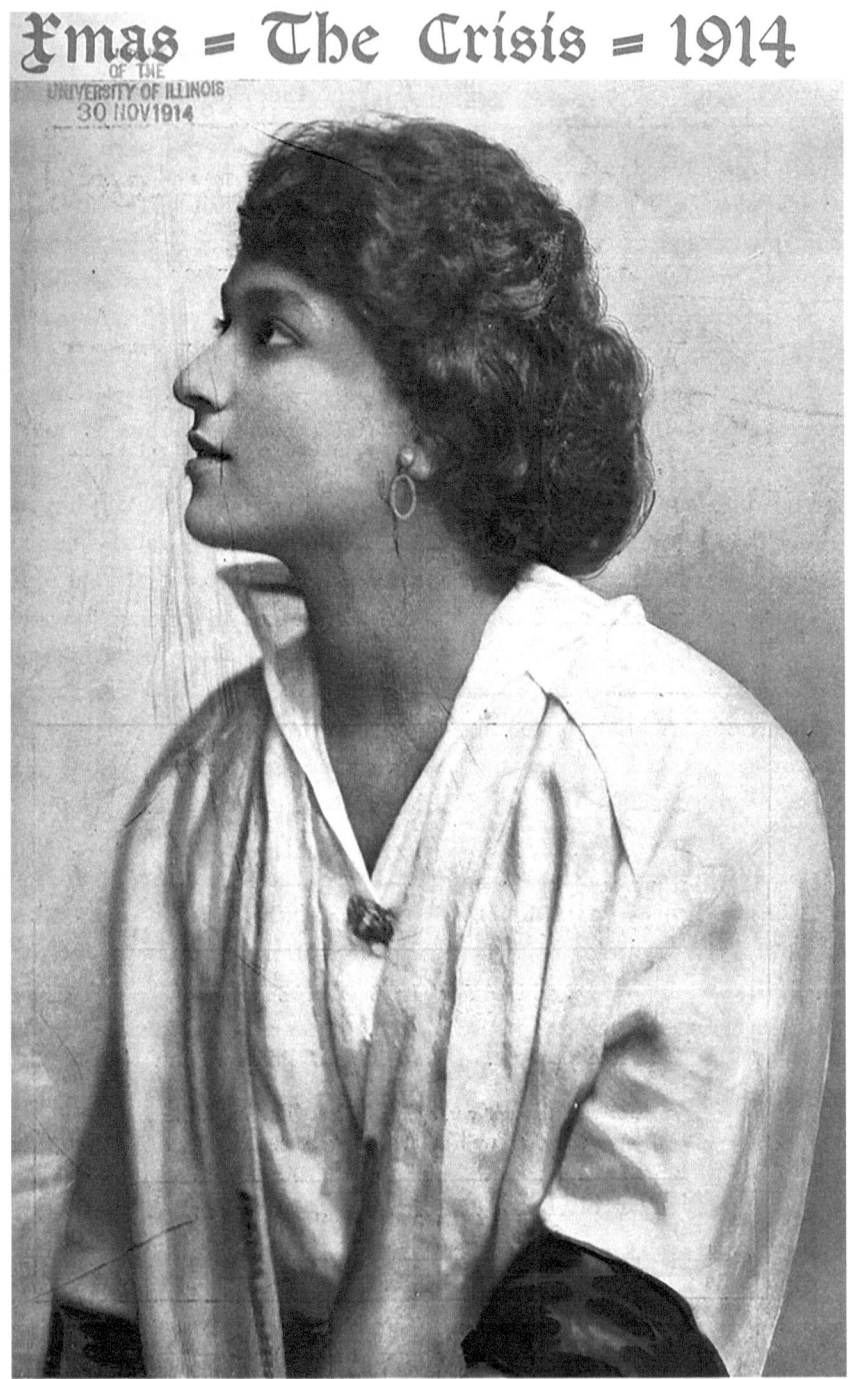

FIGURE 4.5 "Annunciation" (C. M. Battey, 1914)

The Modernist Journals Project, Brown and Tulsa Universities

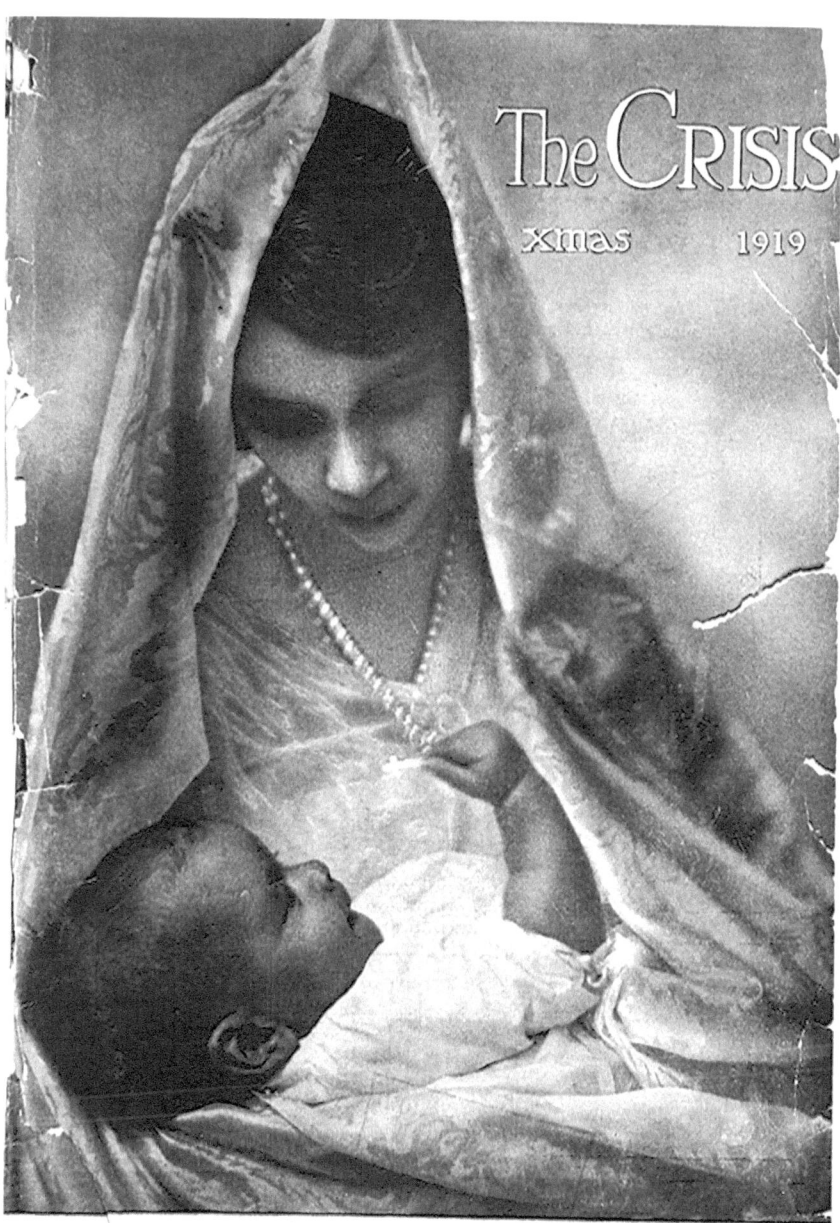

FIGURE 4.6 "Madonna" (C. M. Battey, 1919)

The Modernist Journals Project, Brown and Tulsa Universities

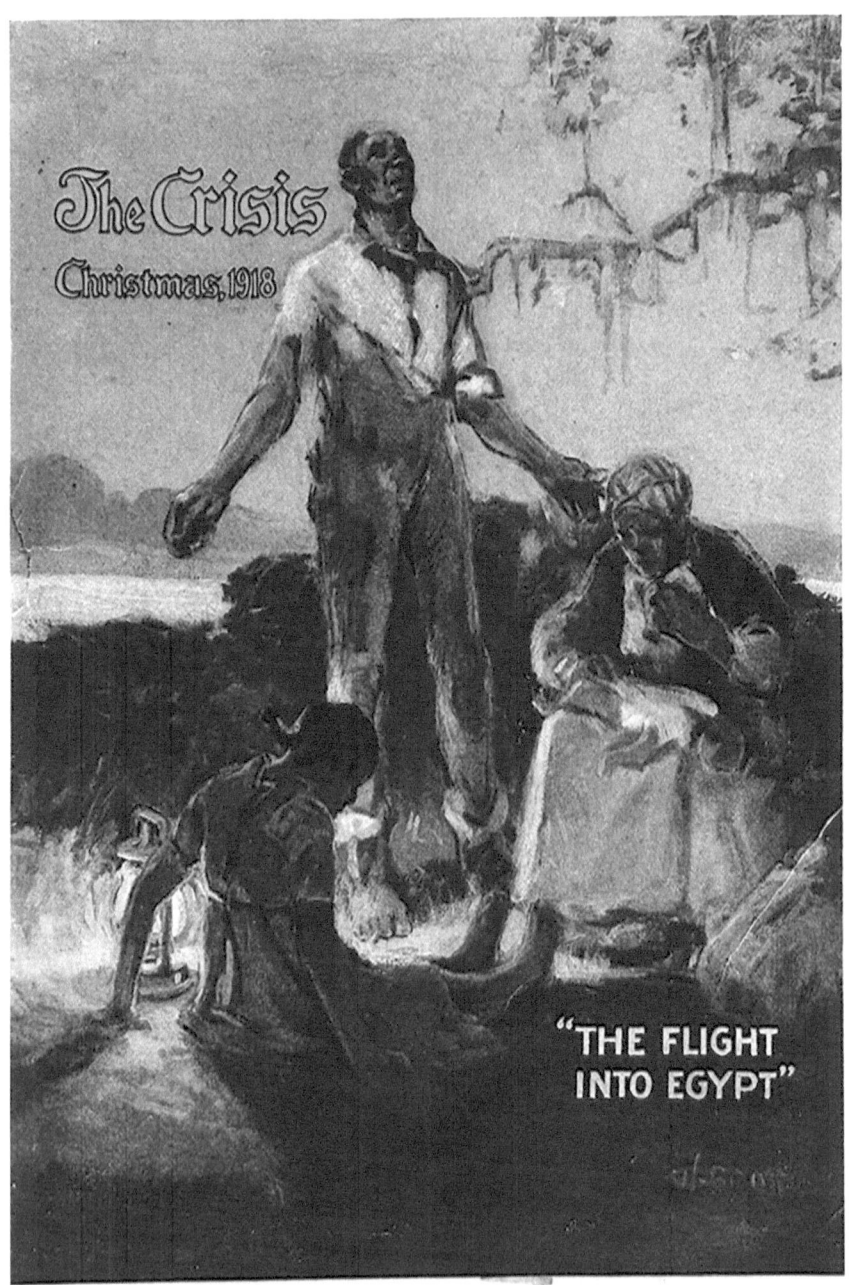

FIGURE 4.7 "The Flight into Egypt" (William E. Scott, 1918)

The Modernist Journals Project, Brown and Tulsa Universities

the Black Christ Cycle is also fundamentally about spectatorship, both white and black. This cycle explores the hypocrisies of Christianized racial violence through a complex series of juxtapositions and superimpositions (both literary and visual). If double consciousness and early cinema resonate by way of their shared impulse toward the visibility of conflict and their shared goal of spectator awareness, the Black Christ Cycle provides a rich example of this convergence.

Despite Du Bois's centrality to the history of African American art in the twentieth century, his Black Christ is rarely addressed at length.[54] Even the religious historian Richard Wightman Fox, in his massive volume *Jesus in America: Personal Savior, Cultural Hero, National Obsession* (2004), saw fit to limit his attention to Du Bois's work on the Black Christ to a single story that he brands "eminently forgettable."[55] Indeed, Du Bois's interest in adapting and appropriating the Christian myth system alone is "forgettable" only if we ignore how frequently Du Bois sought to remind his readers of it. Eric Sundquist has argued that these stories form the core of Du Bois's Pan-African messianism, depicting the black liberator that the Ethiopian movement saw prophesied in Psalm 68. Recent attention to Du Bois's religious life by Edward Blum and Jonathon Kahn (among others) has fleshed out the rich political and theological symbolism of the Black Christ figure as these scholars counter traditional assumptions about Du Bois's perceived "irreligiosity." Even so, scholars have yet to approach the Black Christ narratives together as a work of literary and artistic production, a revolving story-*cycle*. By attending primarily to the *figure* of the Black Christ in these texts, rather than to the manner in which Du Bois chose to present that figure and the relation these stories and images bear to each other aesthetically and ideologically, these scholars show a tendency to harmonize Du Bois's accounts, to articulate a coherent character with a particular political or religious message. Without attention to the often-dynamic visual character of these stories and illustrations in their original contexts and the drastic differences in their structures and perspectives, the Black Christ stories appear in the scholarly literature either as flights of fancy or as a series of stories with the same protagonist. The Black Christ that appeared annually in *The Crisis* is anything but consistent, and Du Bois's commitment to the annual reimagination—including a variety of divergent, often overlooked, illustrations—of this story suggests that this project was more than a series of occasional parables for the author. Du Bois's protagonist is manifest in a spectrum of racial types (from light-skinned men able to pass as white to dark-skinned men); he speaks in everything from King James English to thick regional dialect, and Du Bois freely moves from resituating the gospel narratives in modern times to tales of a contemporary second coming. By attending to the multivocality, the variations in perspective, and the unstable sense of

place and time in these tales as a whole, we come away with a less totalizing picture. The Black Christ Cycle is best understood as something like an epic work rooted in conflict and resistance, designed not to produce a single, unified "Black Christ" to redeem the oppressed of the Jim Crow South, but rather to assail the very narratives that enabled that oppression.

One constant throughout most of the cycle, and the point at which its particular aesthetic of attractions is most visible, is the centrality of the spectacle of lynching. This is the central "attraction" of the Black Christ Cycle, the spectacular shock that disrupts and transforms everything around it. One of Du Bois's editorial mandates at *The Crisis*, from the very beginning, was unsparing reportage and comment about the epidemic of racial violence throughout the United States, especially in the South. This included investigative journalism, fiction, poetry, and, most importantly, photography. This policy had profound implications for the magazine's political tone. As Russ Castronovo has shown, *The Crisis*'s "ghastly" attention to lynchings alongside its other reportage interrupted any easy narrative of racial uplift that might have been drawn from the pages of the magazine.[56] Castronovo sees this as an innovative, pedagogical impulse to critique categories of aesthetic formalism, and, indeed, the shock of these printed images fits in with an Eisensteinian model of attractions. In the context of the Black Christ cycle, *The Crisis*'s policy of focusing attention on the lynched body disrupts the formation of an optimistic uplift theology. The Black Christ was not employed primarily, or even at all, to encourage African American readers to put their trust in Christ so that they might be redeemed, like him, through the violence done to him. Instead, the Black Christ served to emphasize the harsh physical realities of crucifixion and lynching both, to deromanticize this image of holy transcendence, and to offer a stark, unmissable contrast between Christ's gospel of social equality and the Southern Christian white gospel of racial terror. The cycle doesn't deny familiar parallels—to be Christ-like is to be beaten, persecuted, and murdered before all else—but it focuses as much on discontinuity, alienation, and the spectacle of lynching itself as it does on any communion that might result therefrom.

The Black Christ Cycle is thus animated by an aesthetic of conflict, juxtaposition, and shock. Each story and each illustration surrounds lynching with an aesthetic that is itself made up of discontinuity and disruption, prophesying this inevitable violence at the level of form. According to Amy Louise Wood, *The Crisis*'s insistence on reprinting lynching photographs—images that were themselves mostly produced by white supremacists seeking to further dominate black Americans through media circulation—was itself a revolutionary gesture of reappropriation. Throughout this period, as Wood reports, lynching was understood to be both a public spectacle and a mechanically reproducible form of culture.[57]

From postcards to newspaper images, lynching was an extraordinarily visible, if geographically localized, element of American culture. These images, produced by the perpetrators of the lynch mobs, formed part of the event itself. "It was the spectacle of lynching," Wood writes, "rather than the violence itself, that wrought psychological damage, that enforced black acquiescence to white domination."[58] In other words, by making these images available publicly and controlling their circulation, white supremacists could extend the physical violence of the scene of lynching into a psychological violence directed at black Americans who saw such images. The very realism of these images was annexed and tainted as it was pressed into the service of white supremacist ideology.

In this context, the Black Christ Cycle employed the imagery of lynching to shift the locus of control and the message communicated. If the circumstance of the photograph was a part of the violence, then *The Crisis* would recontextualize the images and scenes so that they "no longer served as visual testimonies of white unity and superiority but instead as graphic and indisputable symbols of white brutality and injustice."[59] Du Bois's central mechanism for this recontextualization was the visual and rhetorical superimposition of lynching and crucifixion, the visual juxtaposition of Christ and the violence committed in his name: the joint presence and structured opposition of the thesis and antithesis.

The Black Christ Cycle was not powered just by the conflict of ideologies; on a descriptive level, it sought to tease out the temporal conflict inherent in lynching. According to Jacqueline Goldsby, the American reading public in the early twentieth century was "flummoxed" by the historical temporality of photographs and depictions of lynching. Observers labeled lynching spectacles "'new' and 'savage,' 'old' and 'strange,' an 'invention' and a 'tradition' all at once."[60] In other words, these images on their own constituted something like an irreducible conflict, the intertwining of almost medieval modes of violence with distinctly contemporary structures of racial animosity, of rural Southern rituals of punishment with modern techniques of mechanical reproduction. The act of lynching, then, was already a temporally ambivalent act, a space in which history and modernity interact; rather than unifying these disparate temporalities in the figure of Christ, Du Bois's stories and illustrations foreground their disunity. The Black Christ Cycle identifies and amplifies this temporal friction to make readers *see* lynching for what it is.

Perhaps naturally, this friction becomes most visible in the illustrations that are a part of the Black Christ Cycle. In the 1919 Christmas number, for instance, printed across a full page, is a photograph of a white mob posing around a silhouetted figure burning on a pile of kindling. The photograph is captioned—and listed in this way in the table of contents—"The Crucifixion at Omaha" (figure 4.8).

THE CRUCIFIXION AT OMAHA

FIGURE 4.8 "The Crucifixion at Omaha" (uncredited photographer, 1919)

The Modernist Journals Project, Brown and Tulsa Universities

The photograph is indeed aesthetically striking, as the black figure in the center is rendered featureless by the light of the flames, which emerge around his head. The image, though suggestive of Christ (or at least of divinity), is in no way reminiscent of a crucifixion. It lacks even the natural parallel that a hanging body draws to the suspended figure of the crucified body. Also, it is accompanied, on the following page, with a straight reported piece—with no rhetorical flourish or Christ imagery—on lynching in Omaha. This is a crucifixion in spirit, Du Bois seems to suggest, and the matter-of-fact description of its violence unites it with lynching in its material reality rather than its redemptive potential. Not an elaborately drawn story of the Black Christ, what this striking photograph of the aftermath of a lynching shows *is* a crucifixion. The key here, and in all of these illustrations, is not that Christ is a metaphor for the situation of the

contemporary African American. It is that the time periods of each are mixed and that the figure of Christ and the figure of the lynched body begin to exist in dynamic friction: figures from the past are juxtaposed against figures of the present, lynching and crucifixion are employed interchangeably, and the ordinary aesthetic of *The Crisis*—which regularly featured depictions like this—is thrust out of its stable rooting in the present into a transhistorical space where new and old exist together. This mislabeling or visual disconnect shocks the reader or viewer by making a flat statement that's factually untrue—this is a lynching, not a crucifixion—only to prompt the question of just exactly how untrue it is.

Du Bois's stories, for their part, likewise endeavor to fabricate this sense of temporal discontinuity, to sustain the friction between the contemporary and the sacred past at every turn. Each of the stories in the cycle, for instance, takes a different perspective on the use of scriptural citation. Some, like "The Gospel of Mary Brown" (1919)—which parallels the gospel account from Mary's annunciation to Christ's death—insist that the Christ character speak only in direct quotations from the gospel, while all those around him, including his family, speak in a thick Southern dialect. Discovering her son (named Joshua here) at church, lecturing the deacons, Mary Brown asks, "Son, why did you do me this-a-way?" The young savior answers, as if from a different scene entirely, "Wist ye not, that I must be about my father's business?"[61] Here, we have a simple adaptation of the story of the young Jesus at the temple, but the dramatic difference in speech patterns keeps our attention constantly on the act of adaptation itself. The disconnect ensures that we, as readers, constantly remember the artifice, constantly keep in mind the theatrical conceit.

In addition to attempts like these to contrast temporalities through anachronistic language, Du Bois also utilized typography to create juxtaposition. His most common technique in this regard was to interject italicized scriptural quotation into his stories as a kind of running annotation. The 1924 piece called "The Temptation in the Wilderness," for instance, consists of two discrete narratives—one quoted directly from scripture, and the other which follows it allegorically—both spliced together and differentiated by the scriptural text printed in italics. An opinion column in the 1923 Christmas number, entitled "The Gospel According to John Chapter 12," is also structured this way. In it, Du Bois retells the story of Martha and Mary featuring a black *female* Christ referred to as the "President of the State Federation of Colored Women's Clubs" and described as "a woman, tall, fat and brown, heavy-faced with thin grey hair with tired lines beneath her eyes."[62] Between every few paragraphs, the line "*And Martha served*" appears, drawing attention to the story's premise of an equivalence between the service of contemporary black women, the service of these Biblical

women, and the service of Christ. As the argument between the President and this story's Judas—"Madam Treasurer"—escalates, the quotations serve as captions to the action until this metatextual commentary and the diegesis merge. As Martha anoints her feet, the President speaks, in lines from the New Testament, "*Let her alone. Against the day of my burying hath she kept this. For the poor always ye have with you, but me, ye have not always.*"[63] In this story, titled simply as the chapter from which the scriptural lines are drawn, we have three levels of discourse—the metatextual quotations, the remembered story from scripture, and the contemporary story that echoes it—that are freely intertwined and contrasted. Such conspicuous juggling of texts, temporalities, and points of view again draws attention to the conceit. The Black Christ Cycle is as invested in proposing the comparison between Christ and contemporary black Americans as it is invested in considering the strangeness of that comparison. These stories are not animated by a sense of fate or historical circularity; they are animated by the uncanniness of the Jim Crow South, expressed in sweeping scenes of violence and small anachronistic details alike.

I've argued that the connection between Du Bois and Griffith's images is forged through the split legacy of superimposition, and I've suggested that the Black Christ Cycle aimed to disrupt the narratives of white supremacy by building its aesthetic through juxtaposition and conflict. Inasmuch as these stories and illustrations constitute a portrait of the Jim Crow South, the picture is one of hypocrisy and profound disconnect between truth and fiction, history and myth. However, Du Bois's most substantial engagements with the aesthetic of attractions and his most direct attacks on the logic of Jim Crow are his depictions of the Black Christ's lynching. Du Bois emphasizes lynching as performance, shifts his point of view from the victim to the mob to the gathered onlookers, and retells stories of white complicity and violence as parables of spectatorship, making a hegemonic point of view strange. Indeed, the temptation is to imagine this cycle as a series of stories and illustrations about Jesus Christ; yet, throughout, it is the spectator whom Du Bois finds most compelling, most worth our attention.[64]

There are many types of spectators in these stories, from contemporary African Americans who do not immediately recognize the Christ to whites who track his movements and gossip from afar. Still, it is the lynch mob itself that most interests Du Bois. In Du Bois's stories, and in some of the illustrations accompanying them, these communities represent some refraction of the contemporary spectator. As Wood writes, spectatorship—whether in person or through photographs and films—was absolutely central to lynching's communicative power: "To see an event was to understand its truth."[65] The coherent truth

presented by a lynching—as scripted by its perpetrators—was white supremacy: the physical, political, and cultural power of one race over another. Lynchings were thus a medium of communication, the pure performance of a deceptive and malicious narrative. Du Bois's stories are spectacles of revelation, moments when the narratives that undergird the Jim Crow South are toppled, and some of their most impactful moments occur when the scales fall from the eyes of white spectators. Du Bois, utilizing the aesthetic of shock and spectacle, deconstructs this performance and its scripted reaction.

With few exceptions, Du Bois presents conversion narratives based around the lynching. "The act of witnessing a lynching, even in photography and film," Wood writes, "[could lend] the authority of both divine truth and irrefutable proof to white supremacist ideology and help produce a sense of superiority and solidarity among otherwise different white southerners," but in reappropriating and recontextualizing those images, antilynching activists "hoped that visual images of lynching would impel Americans to bear witness, to take moral and social responsibility for the brutal injustice of lynching."[66] Many of Du Bois's Black Christ stories work through the implications of this act of witnessing. In many ways, they resonate with what Courtney R. Baker calls "humane insight," or a "kind of looking . . . in which the onlooker's ethics are addressed by the spectacle of others' embodied suffering . . . a look that turns a benevolent eye, recognizes violations of human dignity, and bestows or articulates the desire for actual protection." The miracle of these stories would not be the incarnation of a black messiah so much as the conversion of those complicit in his lynching/crucifixion, the provocation of "humane insight."[67] Du Bois sought to wrest "divine truth" from the white supremacists in order to activate the sense of "moral responsibility" that might result from witnessing Christ crucified or the Black Christ lynched.

The 1911 "Jesus Christ in Georgia"—reprinted years later in *Darkwater* as "Jesus Christ in Texas"—builds up to just such a spectacular scene of spectatorship. This story (Du Bois's first in this mode) does not actually feature a lynched Christ. Instead there are two figures in this story: a black man falsely accused of a crime and then lynched, and a mysterious stranger. The story follows the "stranger," who travels to different places in the contemporary South, passing as white, and often speaking in the actual words of Christ. At each stop, the people he meets "discover" the stranger's race while they ignore his divine identity, and he moves on. The story ends with the stranger encountering the other man shortly before he is lynched; the closing supernatural image is that of a crucified Christ superimposed on the convict's murder. What's most remarkable, however, is that it is a white woman who finally recognizes

the identity of the stranger they've all encountered, and through whose eyes we see the final image:

> [The convict] stretched out his arms like a cross, looking upward.... Behind the swaying body, and down where the little, half-ruined cabin lay, a single flame flashed up amid the far-off shout and cry of the mob. A fierce joy sobbed up through the terror in her soul and then sank abashed as she watched the flame rise. Suddenly whirling into one great crimson column it shot to the top of the sky and threw great arms athwart the gloom until above the world and behind the roped and swaying form hung quivering and burning a great crimson cross.... There, heaven-tall, earth-wide, hung the stranger on the crimson cross, riven and blood-stained with thorn-crowned head and pierced hands. She stretched her arms and shrieked.[68]

This is, then, a story about shock and recognition. The layering of images here—the body of the lynched man superimposed upon the body of the crucified stranger—serves a didactic purpose. Thereby the woman is shown, via a kind of screen projection, the parallel between Christ's suffering and the suffering of the man lynched in her name. This white woman—as if in a horror film—receives a revelation of her own culpability in the death of Christ through a revelation of her complicity in racial violence. Moreover, it provides an ironic parable about the way that the Christianized racism of Southern whites quite literally prevents them from beholding their savior. They see only the constructed racial identity, which obscures the holy truth. If the aesthetic of attractions is about using spectacle, using the uncanny friction between reality and unreality to bring the spectator to a new kind of awareness, here we see Du Bois employing it as stinging ethical critique.

This reading is available simply through attention to the story itself and the way it unfolds its narrative to this crescendo in a scene of spectatorship. When it first appeared in *The Crisis* in 1911, however, "Jesus Christ in Georgia" featured a striking half-page illustration that makes the above reading almost unavoidable. (The illustration is absent from *Darkwater*.) The page shows a wooden cross with pointed edges, resembling flames, with a drawing of a traditional, white head of Christ in the center—complete with crown of thorns and blood—looking dejectedly down to his left. In this figure's eyeline is what appears to be a newspaper photograph, unretouched, of a black man hanging from a tree with white members of his lynch mob posing below (figure 4.9). Prominent in the photograph is the hanging tree, limbs stretching to either side, echoing Christ's cross. Below this illustration, the text of the story begins.

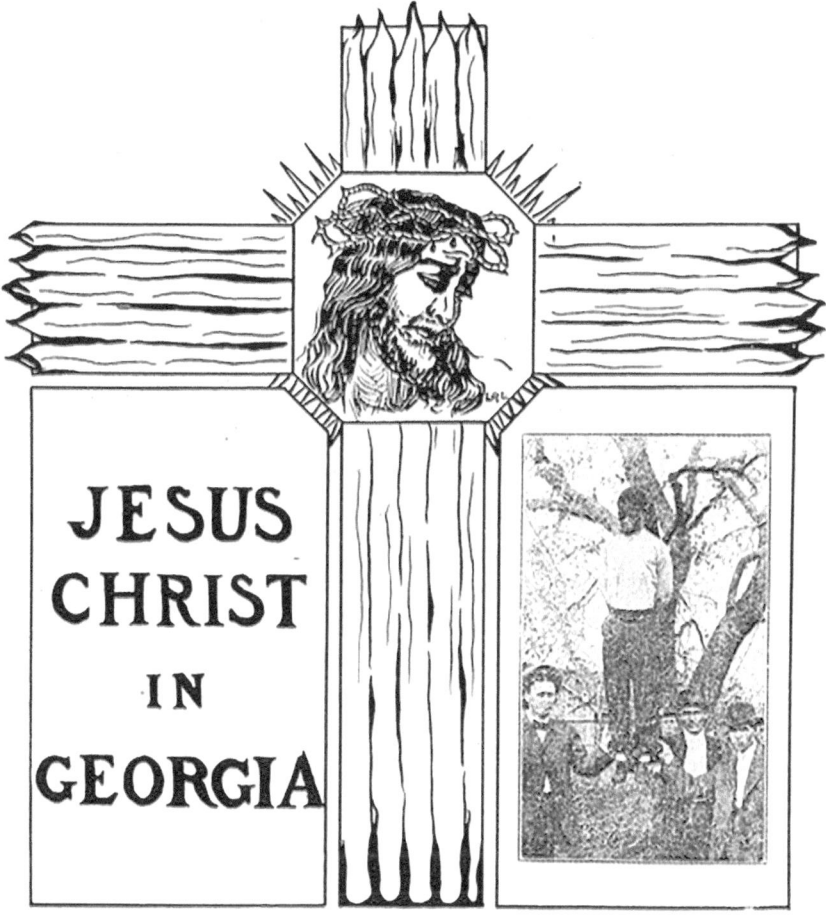

FIGURE 4.9 "Jesus Christ in Georgia" (uncredited artist, 1911)

The Modernist Journals Project, Brown and Tulsa Universities

Here, we see an empathetic Christ, himself in agony at the moment of his crucifixion, gazing across time to the present, in which this actual figure is murdered. But Christ's face might also be seen to express dejection and disappointment at the white figures posed in the frame. Their actively evil obliviousness is the target of this gaze as well.

Notably, this extraordinary image is *not* the image that is so graphically described in the story itself. It does not illustrate the story's action; rather, it is emblematic of the story's call to attention. Here, the lynched figure is not visually

altered. The victim of this crime remains in the frame of his original photograph, with several white members of the lynch mob at the bottom, staring at the camera. The story itself is a representation and critique of spectatorship, yet the lynching image that illustrates it is a posed portrait—and the only eyes that meet the reader's are those of the lynch mob.

There is, however, another spectator, one within the image: Jesus himself. Centered in the illustration, Christ's head tilts down to his left, and his eyes fall upon the photographic image. His mournful face is recognizable from any number of classical representations of the crucifixion, but in this picture it is recontextualized as empathy for the lynched man. In a twist even on the story it accompanies, this Christ figure provides an image of the identity of lynching and crucifixion, but he also, perhaps more crucially, provides a model of viewing. The men in the photograph, like the mob in the story, are blasé at best about their action. Jesus, in contrast, offers a reaction appropriate to the scene, with shock and horror of the kind that finally grips the white woman at the end of the story. This illustration is shorthand for the story itself. To become lost in the contrived ordinariness of such an act is to forfeit morality. One must always remain aghast, like Jesus Christ himself, in the face of such spectacle.

Du Bois's final story in the Black Christ Cycle returns to this scene of spectacular witnessing, but it is otherwise unique among its peers. "The Son of God" (1933) revisits this jarring realization for readers by first endeavoring to immerse them in a coherent story world that the finale will ultimately render strange. Whereas earlier stories in the cycle, as described earlier, used internal juxtapositions between the dialogue of Christ and the dialogue of his followers, "Son of God" features no such juxtapositions. The story, written in a kind of realist, regionalist style, is full of modernizing detail about a Christ—named Joshua—alive in the contemporary South: the man Joshua raises from the dead, for instance, is named Laz Simmons, and Joshua gets in tangles with Methodists instead of Pharisees. The list of charges that condemn Joshua to death mix and match between Christ's alleged misdeeds and the kinds of crimes for which black men were often lynched: "The charge against him wasn't clear: 'Worshipping a new God' 'Living with white women!' 'Getting up a revolution.' 'Stealing or blasphemy,' the neighbors muttered."[69] Most strikingly, though, the language is fully written in dialect. In an impressive digest of the Sermon on the Mount, the Beatitudes, and the Golden Rule, Du Bois's Joshua declares:

> Heaven is going to be filled with people who are down-hearted and you that are mourning will get a lot of comfort some day.... Sit down and rest and sing sometimes. Everything's all right. Give God time ... you know how folks use to

think they must get even with their enemies? Well, I'll tell you what: you just love your enemies. And if anybody hits you, don't hit 'em back. Just let them go on beating you.[70]

There is certainly an uncanniness to scenes like this, but the story's reliance on the recognizable conventions of a certain style of realist prose conjures a level of familiarity, and even comfort, that briefly and impactfully distracts from the conspicuous act of contemporization at work.

Nevertheless, the story's final scene jolts the reader out of any sense of comfort. Joshua's ultimate lynching produces a spectacular supernatural display that reveals the true identity of the victim to his white attackers. After the lynching, Joshua's mother Mary exclaims, in Biblical diction that jolts out of the dialect that had characterized her speech throughout: "Behold the Sign of Salvation—a noosed rope."[71] Here Du Bois trades the cross for the noose, but he does not do so only rhetorically in the story. Instead, the image is described as actually appearing to the whole assembled crowd, thus blurring even the lines between the relatively realistic depiction of a lynching—recognizable to readers of *The Crisis* used to reading such journalistic accounts in the magazine—and the supernatural appearance of an enormous noose, strangling the world. Joshua's father Joe, drunk and furious, looks up only to see "the shadow of the Noose across the world."[72] The visibility of the "noosed rope" is the moment of conflict, productive of what Eisenstein would have called "revolutionary synthesis." Rather than endeavoring to camouflage his Christ in the modern world—to make him disappear within a realistically rendered, coherent present—Du Bois's figure is there to reveal the shuddering conflict between the Christian social ethics represented by the gospel and the racial violence in the contemporary South. These are the hypocrisies that double consciousness makes visible. It is the art of Du Bois's stories, through spectacular displays like this, to make them visible to any reader. It is thus no coincidence that what the "shadow of a noosed rope across the world" describes is itself a superimposition.

Coda

Resurrectionists: Toward a Post-Cinematic Postsecular

This book ends, appropriately, with a pair of resurrections. One occurs at the end of the silent era; the other occurs at the alleged "end" of cinema itself in the twenty-first century digital age. (As Thomas Elsaesser writes, "every film theory may be a funeral as much as a birth announcement.")[1] One Jesus steps from the black-and-white silents into the candy-colored light of classical Hollywood; the other steps into the pixellated radiation of the uncanny valley. In one of these films, Jesus Christ, played by H. B. Warner, is resurrected in Technicolor; in the other film, Jesus Christ, played by Jim Caviezel, is beaten to a bloody pulp but emerges clean, undeterred, and conspicuously dusted with the miraculous manipulations of computer-generated imagery (CGI). These resurrections are very different, yet they echo each other in revealing ways. Most obviously, they share a common lineage from the early Passion Play films produced during the era of attractions, and they revive this stylistic toolkit in moments of crisis for their medium. They are spectacles, marvels of technology and technique devised by resurrectionists—Cecil B. DeMille and Mel Gibson, respectively—raising an old aesthetic from the dead to the applause of an astonished audience. This mobilization and management of attractions—the positioning of this oppositional aesthetic in relation to the frame of seamlessly integrated narrative cinema—reveals a great deal about cinema and/as secularism. These resurrections betray the optimism that technological advances might enable new ways of seeing even as they show how easily these technologies are made to conform with tradition. New media sometimes replace, but cannot escape, the old.

Part of the argument of this book is that cinema, as it developed out of the literary and visual cultures of the late nineteenth century, became a technology

of secularism. We have seen this unfold in the way that an aesthetic of spectacular realism trained viewers into a certain type of liberal rationalist belief and in the way that Jesus himself became a medium of this belief. We have seen how this figure of mystical power, miraculous action, and outrageous devotion became, in this period, a somewhat predictable figure, anticipating, modeling, and visually representing the bounds of secularism's normative perspective. In the precinematic theories of Elizabeth Stuart Phelps and F. Holland Day, as well as the blistering silent-era critiques of W. E. B. Du Bois, we have seen the teasing possibility of a cinema that could acknowledge and question the scripts of secularism, even if it could not escape them. But we have also witnessed the near-impossibility of sustaining this critique, especially within the frame of films about Jesus Christ's life and death. If cinema is secular, and spectacular realism is the aesthetic of secularism, then the Passion Play film might very well be secularism's perfect genre.

If cinema is secular, though, could there be such a thing as a cinematic *postsecular*? In this brief, final chapter, I first turn to the resurrections of DeMille and Gibson, which are themselves resurrections of the cinema of attractions. For these filmmakers, like D. W. Griffith before them, the film medium's greatest possibility is not its realism alone, but the possibility of captivating spectators with that realism. To make a film that not only keeps its audience's attention but alters the way they perceive their own world is the ultimate goal. As S. Brent Plate has argued, this makes film a lot like religion, in that "both function by recreating the known world and then presenting that alternative version of the world to their viewers/worshippers."[2] Central to this world-making is the emergence of what is broadly known as *classical Hollywood style*. David Bordwell, Janet Staiger, and Kristin Thompson famously defined this cinema as a set of unwritten rules that characterized the dominant style of Hollywood film from about 1917 to 1960. Classical Hollywood style is rooted in formal unity and realism, and, most importantly, in the impulse to "conceal . . . artifice."[3] It is this "natural" style, and its authoritative world-making, that I suggest any postsecular cinema must endeavor to disrupt.

What DeMille and Gibson both explicitly seek is the limit case of such world-making: the apocryphal Grand Café scenario made real, the moment when the filmic world holding you captive becomes the world in which you live and cinema's concealment of artifice becomes complete. The ultimate, spectacular failure of this task—the dissonant resurrection that awakens viewers from their enthrallment—only serves to mask its subtle success. Indeed, part of how cinema's captivating secularism functions is by allowing or even prompting the sensation of *snapping out of it* when the cinematic experience is over. Film, then, is a lot like secularism, too. The conceit of suspending disbelief presumes that

disbelief itself is not a species of faith. We live in the world cinema has helped secularism re-create for us.

Yet, Gibson's resurrection, with its uncanny digital punctum, raises the possibility of a new perspective. Perhaps the solution to a postsecular cinema is an embrace of the much-ballyhooed post-*cinematic* moment. In the final sections of this chapter, I turn first to the question of whether or not the fraught discourse of post-cinema—which assesses both the rhetoric of the "death of film" in the digital age and accounts for the profusion of "cinematic" content across nonfilmic media and platforms—implies or even produces a postsecular approach to cinema. The chapter, and book, then ends by turning away from the Passion Play film and recognizing resurrection in the defiantly uncaptivating cinema of Abbas Kiarostami.

THE RESURRECTION IS IN TECHNICOLOR: CECIL B. DEMILLE

After the release of his epic Christ biopic *The King of Kings* in 1927, Cecil B. DeMille sent an autographed photo to his friend and recent collaborator Bruce Barton. It read, "If nobody knows Him when we are through, it will be because they are blind and deaf."[4] The note is, first of all, a cute piece of wordplay on the title of Barton's best-selling book, *The Man Nobody Knows: A Discovery of the Real Jesus*, which was published in 1925 and which had, in part, inspired DeMille to film his own take on the biography of Christ. *The Man Nobody Knows* is notorious for being the book in which Jesus Christ is portrayed as the "founder of modern business." It's a juxtaposition—of scriptural exegesis and the cliches of contemporary business-speak—that's as remarkable for its vulgar directness as it was for its popularity. Barton's text is a series of situated rereadings of the gospels, each of which falls under one of the book's major themes: Jesus' masculinity, his commitment to service, his sociability, his skill as a leader of men, and so on. It is a gripping, sometimes exasperating, locomotive of creative anachronism. Aside from naming Christ the founder of modern business, Barton stated, "He picked up twelve men from the bottom ranks of business and forged them into an organization that conquered the world." But its quips can easily obscure how its form—"threading," as Barton writes, back and forth in time throughout modern history, Great Man to Great Man, false equivalence to false equivalence—sanctifies Barton's eccentric prosperity gospel.[5] It's as funny as it is terrifying. Almost immediately, *The Man Nobody Knows* became a cultural sensation, a touchstone for middle-class Americans. The book outsold

The Great Gatsby in the year both were published, it spawned two sequels, and it made Bruce Barton a national celebrity.[6]

DeMille saw great potential in the spectacle surrounding Barton's book. After scrapping plans to adapt it to film in earnest (DeMille's Businessman Jesus is, alongside Dreyer's Christ and Orson Welles's cowboy Christ, among the great unrealized saviors of cinema), DeMille decided that he would instead try to capture Barton's anachronistic energy by making a historical parallel film. (He retained Barton as a creative advisor on the film.) As Father Daniel Lord, DeMille's Jesuit advisor for *King of Kings*—and eventual contributor to the Production Code—reported, the filmmaker and his screenwriter Jeanie Macpherson originally envisioned the film as a "two-part story," beginning with the narrative of Christ's ministry, death, and resurrection, and ending with a narrative set in the present day.[7] In this version, *The King of Kings* would have featured the story of the gospels as a prologue to the story of a contemporary man struggling to follow in Christ's footsteps. This film would have echoed the basic premise of much social gospel fiction, such as Charles Sheldon's best-selling 1896 novel *In His Steps*, but it would have used a somewhat didactic narrative structure very familiar to DeMille, who had played with the historical parallel device in his films *Male and Female* (1919), *Manslaughter* (1922), and *The Ten Commandments* (1923), which takes almost exactly the same form as his proposed Christ epic. Writing about this device in D. W. Griffith's *Intolerance* (1916)—which features *four* separate timelines, including the story of Christ—Miriam Bratu Hansen suggests that such a structure imparted moral lessons by emphasizing the "eternal recurrence" of history, the cyclical reemergence of the same themes, crises, and even characters.[8] The historical parallel device granted a spectacular strangeness to these films even as it naturalized their moral and ideological messages, though its potential power could never really overcome the awkwardness of its construction. Sumiko Higashi suggests that such films, especially in DeMille's hands, were "Janus-faced," and that they implied "progress that reinforced the status quo and militated against social change."[9] Despite its radical form, the historical parallel, in the hands of Barton, DeMille, or Griffith, betrays a fundamentally conservative impulse.

In the light of these early concepts, the film DeMille ultimately made, *The King of Kings*, might seem a bit bland. It is neither a historical parallel film juxtaposing two superficially unrelated histories, nor does it activate any of the heretical frisson Barton had appropriated from the social gospel movement. Still, even within DeMille's highly conventional epic—a film that would serve as a model for the Golden Age of Biblical epics that unfolded at midcentury—the impulse to shock survives. Rather than any sort of narrative or historical gymnastics,

DeMille used technology to access the contemporary. The most remarkable feature of *The King of Kings* is that it is a black-and-white narrative film bookended by two spectacular color sequences, filmed using the then-cutting-edge two-strip Technicolor process. At the time, the use of two-strip Technicolor was both a bold choice and an expensive one. Despite the fact that Technicolor—a process that "naturalized" color into the cinematographic process rather than applying it in postproduction via stencil or dye—was available and used before *The King of Kings*, it was rare. Moreover, because practically no one had yet ventured to apply the process to an entire feature, there were not yet standard conventions for how it ought to be deployed. Thus, in 1927, Technicolor would have been presented as more "natural" than black and white in that it reflected the living colors of the images captured rather than those superimposed upon it (as in something like the Pathé color-stenciling process). For all that naturalness, though, it was also more jarring in practice in that it was, by virtue of its rarity, always unexpected.[10] These twin features—natural and unnatural, so to speak—made two-strip Technicolor in 1927 both a sign of the times and a throwback to the aesthetic friction that did so much to charge the era of attractions.

The King of Kings opens with a Technicolor sequence in the prostitute Mary Magdalene's splendid abode that is bonkers even by contemporary standards. DeMille meant the scene—which features a rogue's gallery of johns bedecked in colorful Orientalist costume, dozens of exotic animals hoofing and prowling about on the marble floors, and ends with the Magdalene shouting, "Harness the zebras!"—to shock audiences into a new understanding of what a religious film might be. In a letter to a production advisor after the film had wrapped, DeMille described the intended effect as such: "Everyone in the audience has come with a set idea that they are going to see something very Biblical and are in for a sanctimonious evening. . . . The first sequence gives everyone in the audience—no matter what their preconceived idea—a surprise." Echoing the 1898 review of *The Horitz Passion Play* which claimed that the film allowed spectators to "forget the present," DeMille suggested, "They forget the viewpoint with which they arrived at the theater—their idea of a religious play is all upset—and then as we gradually work into the appearance of the Christ, they are surprised into a satisfactory mental attitude toward the figure as we presented it."[11] Audiences would be "surprised," and their ideas "upset," by this display (and indeed they were: Mordaunt Hall in the *New York Times* called the sequence "startling and strange").[12] Whether DeMille meant to refer to the comedy of the scene, the skimpy attire worn by the Magdalene, the impressive assortment of wild beasts, or the rainbow of color that greets the viewer, it remains hard to say, but the intention is clear: Barton had changed his readers' frame of reference for the Christ story, and

DeMille wanted to do the same for his viewers. Even "if you printed 75 million Bibles," he later wrote, "the viewer's idea of the life of Jesus Christ is [still] going to be formed by what we give them. The next generation will get its idea of Jesus Christ from this picture."[13] And that picture was in Technicolor.

Yet as soon as Mary Magdalene boards her zebra-drawn chariot and rides off to find this Jesus of Nazareth fellow, the film switches back to the standard black and white. The remaining film is filled with visual flair—in the next sequence alone, we first see Christ's face from the first-person point of view of a blind child regaining sight, and Magdalene's exorcism features seven different superimposed figures representing the Deadly Sins—but it is not until the resurrection that the film returns to color (figures 5.1 and 5.2). That scene begins with a glorious sunset, which functions almost like a color bar screen, marking the transition and demonstrating the gradients and nuances viewers are about to behold. This momentary pause signals a different tone from the visual frenzy at the Magdalene's: both scenes are theatrical showpieces, but DeMille is endeavoring to demonstrate the ability of this versatile technology to inspire responses from shock to awe. We then cut to the stone on Christ's tomb, practically alive with glowing mosses and patches of soil. From this stone, which we are watching carefully for its luminosity, we cut to the soldiers guarding the tomb, villains in the narrative but our surrogates in this scene. Just like us, they are spectators, and their faces of terror and wonder are cues for us in the theater. After all the soldiers have fled the scene, the stone rolls away, and the resplendent Christ emerges. Ironically, once Jesus is resurrected, there's not a lot for DeMille to work with, given the figure's white robe and the drab, brownish-gray stone surrounding him, so the beams of light that radiate outward and fill the frame flash pink and yellow and purple. Christ then beholds that sunrise himself, bookending this miracle with another reminder that this is a scene about color and light, about new marvels, about the dawning of a new age.

It's important, here, to realize that the soldiers—the spectators—are separated from the resurrection itself. The tomb and the soldiers occupy wholly different frames, linked only by the rhythm and logic of the editing. If the miracles are special effects, then the resurrection becomes a staging of the cinematic experience.[14] The soldiers are shocked by this man rising from the dead; we are shocked by the spectacular realism of two-strip Technicolor. (We are also, potentially, comforted by its return after it had disappeared.) Like the apocryphal spectators in the Grand Café in Paris, they cower before this new spectacular refraction of their own reality. In DeMille's framing—with its pulsating glow and the soldiers shielding their eyes—the resurrection is as defined by its unique and miraculous play of light as it is by the actual thing happening in the frame. What, then, if we

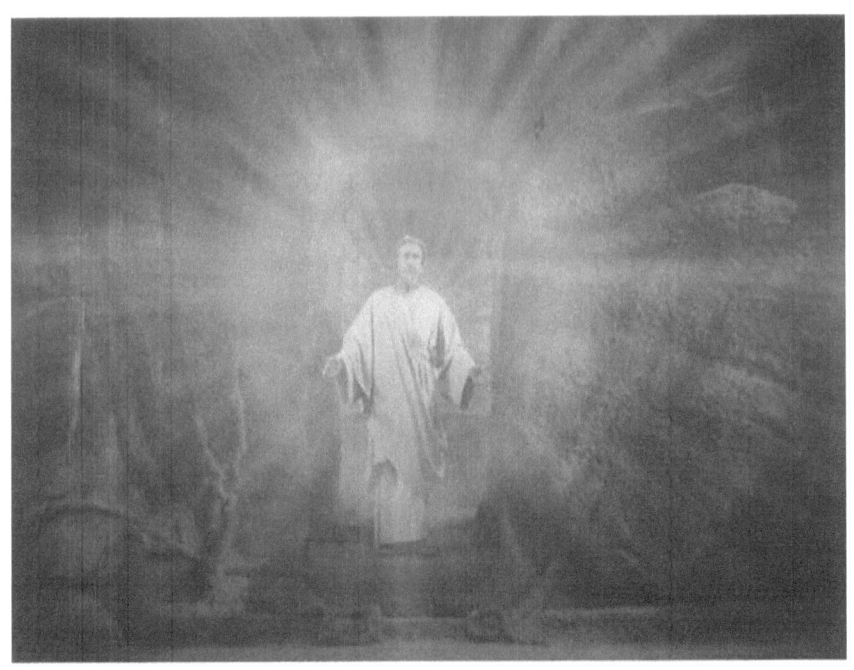

FIGURE 5.1 *The King of Kings* (Cecil B. DeMille, 1927)

FIGURE 5.2 *The King of Kings* (Cecil B. DeMille, 1927)

imagine that the soldiers are not illuminated but *blinded* by this light? (Warner's Jesus is, after all, introduced through the eyes of the blind.) What if this act—the Technicolor Resurrection—forces their senses to crisis? The soldiers figure the way DeMille wants his audience to "forget the viewpoint with which they arrived at the theater," and they demonstrate the way he accomplishes this by brute force. This Technicolor is not just the conspicuous placement of a new technology; it's a prompt for viewers to reorder and reimagine their world around a new reality.

After the stunning Technicolor resurrection set-piece, the film briefly shifts back to black and white again, further emphasizing the *difference* of that scene. We see Christ among his apostles, returning for a final curtain call, but the effect is not one of returning to the familiar. The viewer does not have time to settle back into the black and white. Indeed, the film quickly ends with an even more didactic and shocking image: a black-and-white shot of Warner's Christ superimposed over a modern city scene. There are smokestacks, skyscrapers, and bridges, all of which denote a contemporary vista, an amalgam of recognizable city landmarks in silhouette. Transcripts of DeMille's narration of the film to his crew before shooting confirm that he had an even more spectacular conclusion in mind:

> This figure of Jesus grows greater and greater and greater ... and the skyline of Judea and the outline of the people at His feet grows dimmer and dimmer. As the figure grows larger, then through the skyline of Judea comes the hazy outline of the steel mills of Pittsburgh, the Eiffel Tower of Paris, the Washington Arch, the skyline of London, the skyline of New York, of Paris ... we see the Taj Mahal of India. We see a great bronze Buddha against a background of a huge Chinese pagoda. We see a suggestion of the modern world and above it all, this great figure with his arms outstretched embracing it. He has not moved, His arms have been outstretched since they were outstretched to the ancient world, and, as it all starts to fade and grows dimmer and dimmer, through it all, in great letters we read the words, "Lo, I am with thee always."[15]

Although the scene that was eventually produced does not take quite as elaborate a journey, we still see the composite city scene, and we see Christ above it. We still see the stark juxtaposition we might remember from the final image of D. W. Griffith's *Birth of a Nation:* a transparent Christ superimposed on a bustling multitude. The words at the end of the film, modernized ever so slightly, read, "Lo I am with you always." Jesus, of course, is referring to himself, but he might as well be talking about the early film aesthetic that both Griffith and DeMille recall here at the ends of their monuments to the cinematic future.

DeMille makes this break from the dominant aesthetic of his film in much the same way Griffith did more than a decade earlier. Just as Griffith leveraged the spectral superimposition at the end of *Birth of a Nation* to authenticate the "historical facsimiles" that came before, DeMille's film ends with a sundering of his film's otherwise seamless, epic narrative. Still, it's hard not to imagine that DeMille's ambition is for something slightly less prankish than Griffith's at the end of *Birth of a Nation*. DeMille's Technicolor resurrection attempts to do the reverse of what Griffith had done: to make the mundane, black-and-white *remainder* of the film seem unreal, to allow audiences to feel at home, natural, as spectators to a resurrection that *looks like* the colorful world around them. From this perspective, the opening Magdalene scene might serve to desensitize viewers to the shock of Technicolor: by the time they see it in the big finale, it is still remarkable but no longer new. The final image of Christ on the skyline in black and white thus serves as the jarring moment which naturalizes all that came before. The narrative content at the end of *Birth of a Nation* and the end of *King of Kings* clearly echo each other— "... now and forever ...," " ... with you always ..."—but formally DeMille is making a penultimate move, endeavoring to plunge his viewers further into the filmic world before pulling them out again. Perhaps after those soldier-spectators were struck blind, the scales fell from their eyes.

THE RESURRECTION IS CGI: MEL GIBSON

If we travel now to the turn of the twenty-*first* century, we find another filmmaker looking to access reality through special effects, a filmmaker who manages a transition—and a callback to the cinema of attractions—that's arguably more jarring than either Griffith's or DeMille's. Mel Gibson's 2004 *The Passion of the Christ* is nothing if not an absorbing spectacle. Aside from a few cursory flashbacks and some early scene-setting, most of the film's run-time is occupied with capturing, in excruciating detail, the entirety of Jesus Christ's torture and death. Its violence, in fact, was so all-consuming that upon release many viewers were reported to have left the theater to escape the film's unceasing intensity. But this was about more than mere violence; it was about the way the film sought to interpolate the viewer into the scene as a "virtual witness" to these acts. Alison Griffiths, tracking such witnessing back to medieval religious rituals, calls this the "revered gaze," naming the way the film immerses the viewer in a kind of brutalizing, totalizing realism rooted in emotion and sensation.[16] *The Passion of the Christ* aims to make the viewer *feel* its realism in every spectacular moment of suffering.

For these reasons, *The Passion of the Christ* was a terribly effective evangelical film; in fact, buoyed in part by viral promotion from churches, went on to become the most profitable independent film of all time. Though many critics pilloried the film for its over-the-top violence (David Edelstein, for instance, called it a "snuff movie") and its anti-Semitism, millions of Christian viewers who might otherwise have objected to graphic violence onscreen raved about the film's power.[17] Specifically, they testified to the film's realism and authenticity; even Pope John Paul II was reported to have said, after his Vatican screening, "It is as it was."[18] Stephen Prince, who catalogued many reactions to the film in the Christian media and blogosphere, writes, "Among viewers who supported the film, particularly Christians receptive to this very graphic modern rendition of a passion play, the judgment was that Gibson had gotten it right, that the film was truthful and was the most accurate and realistic film depiction of the physical torments inflicted on Jesus after his arrest."[19] Crucial to that realism, from a phenomenological standpoint, is that the film had the physical effect on viewers that Griffiths describes. Much of what's so brutal and absorbing about the film—Roger Ebert, in his rave review, described it as "inescapable"—is the close, unrelenting realism of its torture scenes.[20] Vivian Sobchack argued that these scenes represented "sadomasochistic immersion in the materiality of *one's own* flesh."[21] The particular realism of Gibson's film, its insistent physicality, transformed the spectator into what Sobchack calls the "cinesthetic subject," producing "sense and affect as meaning on and for lived body subjects."[22] To see this film was to transcend the distance of the cinema experience and feel this imaginary violence on one's own skin.

Such a viewing was acknowledged and encouraged by publicity circulating around the film that posited a kind of continuity between the suffering of Jesus for mankind and the suffering of Caviezel for his art. Gibson's Jesus claimed he'd been struck by lightning during the production, and reports from the set testified to his actual broken ribs and scratched corneas. J. Hoberman cites this focus on bodies and brutality when he dubs *The Passion of the Christ* the masterpiece of what he calls the "New Realness" in twenty-first-century cinema. Responding to both the televised violent trauma of the 9/11 attacks and the simultaneous "death of film" prophesied by writers like Susan Sontag (more on this to come), some filmmakers, according to Hoberman, turned to a "compensatory 'real-ness' emphasizing film as object (if only an object in decay)."[23] The aesthetic of this "New Realness" is brutality, anti-entertainment, long takes, tight shots, blood and dirt spattering the camera lens, audiences immersed in inescapable, verisimilar, real-time horror. This cinema is meant to feel as awful as it does real.

No one would suggest that Mel Gibson's *Passion of the Christ* was a model of cinematic subtlety, yet that unsubtlety is an illusion. Although the tales of Caviezel being beaten to a pulp suggest otherwise, much of the goriest rending of flesh was accomplished with CGI in postproduction. The film features 135 digital effects shots.[24] When you see a chunk of Christ's eye gouged or the white of bone beneath his flayed back, you're likely seeing digital manipulation at work, the inheritors of Guy and Chomón turning their attention to blood and guts rather than materializing angels. But these effects, unlike those of Gibson's ancestors, disappear, and are meant to do so. As Prince notes, the role of postproduction effects in producing this battered savior was deliberately hidden, "like a family secret that stays closeted." Unlike the apocryphal stories of Caviezel as a lightning rod, digital effects were rarely discussed in any of the film's marketing, and, despite a tremendous appetite for paratextual material, there is not even a standard behind-the-scenes effects documentary for the film. As Prince writes,

> Given the often subliminal presence of digital effects in modern cinema, it was inevitable that eventually [viewers] would confuse judgments about accuracy and realism. So, among its other significant attributes, *The Passion of the Christ* gives us perhaps the first really striking demonstration of digital wizardry used to create images that viewers deem truthful and authentic rather than evidently fantastic.[25]

This is the digital apotheosis of spectacular realism, a kind of spectator experience Griffith and DeMille could have imagined only in their wildest, most unboundedly narcissistic dreams. *The Passion* is such a terrifying and potentially moving cinematic experience because it is full of confrontational spectacle, but its ultimate aesthetic realism—and the seamless integration of its effects—keeps viewers from being thrown out of the film.

That is, until bloody Jim Caviezel is resurrected. Gibson's resurrection is just as bolstered by digital effects as the scenes of scourging and crucifixion that precede it, but these effects, for reasons that will soon become obvious, are considerably less hidden. They disappear less readily. Like DeMille's resurrection, this scene is also an extended play of light, as we watch a shadow that initially appears to be the shadow of the tombstone roll across the interior of the tomb. The camera tracks, and it appears more and more that this shadow is untethered to that physical reality. It is, as it was in the Zecca and Guy films, the unseen making itself visible. Just as the shrouded body is revealed—the camera and the shadow move with unified motion, again yoking the cinematic apparatus with the work of the miraculous—it collapses in upon itself. This sequence is, in nearly every formal

way possible, a classical trick film. As the camera continues to track back, we see a hale and hearty Christ, kneeling in profile, his wounds healed, his outlook surprisingly sunny. We dissolve to a close-up; he looks upward in prayer, in gratitude. But then he closes his eyes, and, cued to the thundering action music, we see a different look in those eyes, a look of stern purpose (figure 5.3). He stands, and then we see it: the wound in his hand (figure 5.4). This is the spectacle, the trick we are meant to behold. It's an uncanny sight no matter what—a massive hole in a person's hand—but it's made more so because of the gritty realism of the wounds that preceded it. The camera lets us linger on this bit of CGI in order to punctuate the miraculous occurrence, to nod to the faithful, and to clearly emphasize Gibson's own faith in both the physical and divine reality of Christ; most significantly, though, this sustained attention asks us to *notice* the effect.

FIGURE 5.3 *The Passion of the Christ* (Mel Gibson, 2004)

FIGURE 5.4 *The Passion of the Christ* (Mel Gibson, 2004)

FIGURE 5.5 *Terminator 2: Judgment Day* (James Cameron, 1991)

It is the last image of the film, before Christ steps offscreen, and, ever so briefly, it recalls another landmark of cinematic violence: James Cameron's Terminator franchise.[26] The comparison is hard to un-see—a muscular, nude man kneeling in profile on the cold ground, standing up and going forth with stern purpose—and, intentional or not, Gibson certainly appropriates the iconography, using its shorthand. Prince suggests that *The Passion* is the first film to use CGI to emphasize realism rather than fantasy, but the film ends with a reference to an *ur*-text of the digital fantastic, in particular, the CGI wizardry of *Terminator 2: Judgment Day* (1991) (figure 5.5). This resurrection, from its conspicuous CGI to its intertextuality, is striking, not because it batters us into shared consciousness with the film but because it reminds us, in ways elaborately avoided for more than two hours, that this *is* a film.

In a film coated in blood and CGI, it is somehow this calm scene that is excessive. Like Griffith before him, in more ways than one, Gibson uses this final jarring moment to draw a line between the optimistic imagining of the resurrected Christ and the historical, physical—verisimilar—brutalization of Jesus. Alison Griffiths writes that in Gibson's *Passion*, like the medieval passion play, "awareness of the performance as staged, while simultaneously real, defines the experience as one of constant oscillation between two states of being."[27] The immersive physicality of *The Passion* brings this constitutive element of the cinematic experience to crisis—Sobchack's "cinesthetic subject" struggles to suspend disbelief when every blow seems to register on her own body—and the resurrection blithely ends its thrall. The viewer is absorbed, physically triggered, by the brutality of the passion itself, but, in the moment of the resurrection, when

viewers catch their breath, they can think back and marvel at how it was all made to seem so real. They can understand, even explicitly praise, the sorcery, even as they were only just taken in by it. It returns the audience to an ordinary—even familiar, if you're conversant with the *Terminator* franchise—scene of spectatorship. Yet, in its exhibitionism, its direct address, its contextual shock, it further transports the audience to an even earlier scene of spectatorship in the era of attractions. *The Passion of the Christ* accomplished something akin to what Griffith dreamed cinema might one day accomplish: "you will merely seat yourself at a properly adjusted window, in a scientifically prepared room, press the button, and actually see what happened. . . . You will merely be present at the making of history."[28] *The Passion of the Christ* is a historical facsimile for the digital age, and the resurrection at its end awakens the viewer into a world somehow different than it was before.

POST-CINEMATIC/POSTSECULAR

The history of the Passion Play film, from Edison to Gibson, is the history of a realist medium's relationship with special effects. Indeed, spectacular realism, as the secular aesthetic of cinema, needs special effects in order to exist; the toggling between credulity and incredulity that marks it is the product of two seemingly competing orientations joining together to script the way spectators perceive both. In DeMille, we see a canny negotiation between new and old technologies of realism, but in 1927, the task of transubstantiating the film medium's belief-function into something life-changing, something that might spectacularly reorient the viewer's point of view, could only be accomplished through the trick of juxtaposition. DeMille, like Griffith before him, could only jury-rig his revelations. Of course, these tricks only serve to remind us of the actuality: film's belief-function operates best when it operates in secret, when it is the *unseen something* of a continuity edit or a point-of-view shot or lacerations lovingly painted by digital craftsmen. In the digital era, these functions have become both more and less visible. Gibson nods to the cinema of attractions and its herky-jerky synthesis of realism and fantasy with his performative CGI resurrection, but his film works the way it does not because of this leverage, but because of the invisibility of its artifice, the disappearing hands of its hundreds of makers. His final trick film is a punctuation mark, not a structural element. *The Passion of the Christ* is a compulsory, captivating film: its moves are invisible and hypervisible at the same time.

The Passion of the Christ is thus a canonical text of the contemporary secular age. This bullying evocation of religious experience, this torture to transcendence, became, in its moment, something like the shared vocabulary of "good" religion. Indeed, despite the fact that Gibson's traditionalist Catholicism infuses every moment onscreen, Protestant evangelicals broadly embraced the film. Gibson's resurrection reminds us how profoundly the Overton window of secularism was changed by his violent devotional, how this shockingly excessive text could travel so quickly from the margin to the center of Christian discourse in America. In describing cinema as secular, I have focused primarily on form rather than content, on the ways in which filmmakers' balancing of the signifiers of realism and fantasy expresses a certain style of belief or unbelief. Gibson, too, is more concerned with form—*how* Christ suffered, died, and was buried—than any particular content of his ministry, and perhaps this disinterest in interpretation allowed space for a broader range of Christian viewers. In 1898, the Passion Play film could be expressive, reflective of the style of secular belief; in 2004, Gibson's film set the terms of that belief in a style so simple and communal that it felt natural. If the style of secularism is an inevitability that feels like a choice, *The Passion of the Christ* presents a vision of Christianity that is almost irresistible. Yet, if cinema is the medium of secularism, how could it die at just this moment of triumph?

Over the past few decades, film studies has been gripped by its own narrative of decline. Around the turn of the twenty-first century, many critics and scholars declared that cinema was dead. Digital cameras, digital projection, CGI effects, the phasing-out of celluloid, the failure to preserve the material traces of film history, and, of course, the unholy scene of people watching *Ben-Hur* on their iPhones: these have been the harbingers of cinema's demise. The death of cinema, then, was more specifically the death, or "decay," as Susan Sontag evocatively put it, of the medium's material base.[29] As Lev Manovich wrote around this time, "cinema is the art of the index; it is an attempt to make art out of the footprint."[30] Thus, when cinema is no longer rooted in that footprint, when it becomes detached from the photochemical process that allowed an object in the world to leave a material trace on a strip of film, it is no longer cinema. This loss persists even when such a footprint is projected digitally. D. N. Rodowick writes:

> My working hypothesis remains that when reproduced on an electronic or digital screen, 35mm original may never fully realize the phenomenological density of time, pastness, and causality of the projected film experience. More poignantly for film studies, this experience has been lost for at least a generation for the great majority of motion-picture audiences.[31]

Perhaps hastened by the shifting profit motives of major studios and the exponential spread (or dissolution) of media across platforms, it was this shift that ultimately broke cinema. This is the subtraction story of digitization.

This tale of decline, however, has generated its own nova effect narrative. Manovich even declares that, in the digital age, cinematic realism, like belief in Charles Taylor's formulation, becomes "only one option among many." The decay of film—the material base—as a constitutive element has opened, not closed, the possibilities of cinema; formerly marginal approaches to the reproduction of reality have become central.[32] In this line of argument, we see not necessarily a decline, but a diffusion of cinema across new screens, platforms, and materials. At the root of this point, we encounter the argument that cinema does not require indexicality in order to be itself. Watching the past twenty years of cultural production, seeing the way that the cinema of attractions found new life in Vine video and terrifying poignancy in the viral footage of police violence from the era of Black Lives Matter; the way video games have come to boast increasingly complex narratives and shades of what Alexander Galloway calls "social realism"; the way television has become a space for the kind of midbudget drama that seemingly went extinct in Hollywood after the 1970s; the way a degradation in image quality has been counterbalanced by the spread of independent films on digital subscription platforms: in these ways we see what Francesco Casetti refers to as the "persistence" and "relocation" of cinema in the digital era.[33]

This view is fairly representative of the discourse of "post-cinema," a set of critiques, rooted in both the deep historicization of cinema and theoretical speculation about its future, that endeavors to understand cinema's continued life in the context of announcements of its death. This discourse acknowledges the crisis of digitization, but it also acknowledges that nearly every generation has believed they were living through cinema's end times. As André Gaudreault and Philippe Marion put it, "The fact is that *cinema just keeps on dying.*"[34] Shane Denson and Julia Leyda editors of a mammoth, indispensable, and miraculously open-access anthology of writing on the subject—describe post-cinema in this way:

> Post-cinema would mark not a caesura but a transformation that alternately abjures, emulates, prolongs, mourns, or pays homage to cinema. Thus, post-cinema asks us to think about new media not only in terms of novelty but in terms of an ongoing, uneven, and indeterminate historical transition. The post-cinematic perspective challenges us to think about the affordances (and limitations) of the emerging media regime not simply in terms of radical and

unprecedented change, but in terms of the ways that post-cinematic media are in conversation with and are engaged in actively re-shaping our inherited cultural forms, our established forms of subjectivity, and our embodied sensibilities.[35]

The discourse of post-cinema, as articulated by Leyda and Denson, is not a discourse of utopian potentiality. The persistence of cinema's aesthetic and narrative norms, even as its material bases give way to a dizzying array of seemingly immaterial and ephemeral new forms, seems to suggest that "death" is not necessarily the end. Post-cinema tempts us with the possibility of more, and better, resurrections to come.

Given this attentiveness to cinema's survival as both a discourse and a way of seeing in the aftermath of its own death, it seems worth asking: Is the post-cinematic also postsecular? If cinema, as I have argued, is a born-secular form—that its various innovations and appropriations and evolutions represent different ways of looking at the same thing—then does the era of post-cinema promise the medium's escape from the immanent frame? Reading through the growing literature on post-cinema, it's easy to get discouraged. The alleged dissolution of cinema after the digital takeover of the medium and its much-ballyhooed dissolution across multiple other new media and platforms may have the liberatory charge of a nova effect, the opening of new aesthetic and spectatorial options between film and not-film. But, as Leyda and Denson note, regardless of how one approaches the archives and practices of this era, "post-cinema is . . . bound up in the neoliberal motor of perpetual capitalist expansion and subsumption."[36] Steven Shaviro describes post-cinema as a kind of collaboration in which "digital technologies, together with neoliberal economic relations, have given birth to radically new ways of manufacturing and articulating lived experience."[37] Scholars such as Dudley Andrew have noted that, even as it is clear that cinema neither died after digital nor was really born with celluloid, the moment of post-cinema has opened up as many new avenues for manipulation as it has for reclamation of lost purity.[38] In other words, there is little presumption that the post-cinematic offers anything like a way outside of the social and institutional norms through which cinema has evolved since 1895; if anything, by moving away from a singular discourse of cinema tethered to the materiality of film, post-cinema allows us to see just how portable and medium-agnostic those norms are. The expansion of cinema to include forms such as the massively multiplayer online role-playing game or even the neo-attractions trick filmmaking of Vine does not reduce mediation; rather, it threads those mediations together so densely that they hardly seem to be there at all.

A uniquely appropriate example of this fraught space between materialism and mourning that characterizes the post-cinematic is Bill Morrison's 2012 experimental film *Just Ancient Loops*. There is perhaps no filmmaker so invested in exploring the push and pull between cinema's ethereal magic and its material disintegration. Morrison is best known for his work built around digital scans of the Library of Congress's invaluable but irreversibly degraded paper prints collection. His films use those scans to produce hypnotic, lushly orchestrated film montages that transform the visibly decaying nitrate into a kind of animated character. *Just Ancient Loops* is a three-part exploration of cinematic visualizations of "heaven." It begins with archival footage of a turn-of-the-century lunar eclipse, scarred by time but largely crisp in its images of the moon and its spectators. The film then moves to a gorgeous digital animation of Jupiter and its moons, over which is eventually layered musical staff notation, visibly illustrating a contemporized version of the music of the spheres. It ends, however, with a bubbling, blistering reproduction of the resurrection and ascension sequences that conclude Ferdinand Zecca's 1907 *The Life and Passion of Jesus Christ*.

It is tempting to fault Morrison's work for its God's-eye view, its distant formalism. Indeed, as Darragh O'Donaghue writes, the film, especially its climactic resurrection, "fuses the human and superhuman, natural and supernatural, earthly and celestial realms in one overpowering image that at once generates, incarnates and obliterates thought."[39] O'Donaghue's critique sounds almost like a postsecular one: the film medium is used to lend an affective charge to an ultimately normative spiritual vision. The film's equal fascination with science and religion, and its investment in superimposing the two, is indeed consistent with the visual cultures of secularism. Nevertheless, I think that Morrison's work is a little more aware of this problem than O'Donaghue credits him with: if not resolving it, then at least drawing our attention to it.

Morrison's is a film about mediation. Its opening images of the eclipse are just as much images of filmmakers filming and viewers viewing the event, and even of the moon—whose craggy surface appears in close-up to visually echo the decaying nitrate itself—as mediating object. The middle section's long, smooth tracking shot of Jupiter's digitally rendered moons threatens to immerse us in the illusory environment of space, until Morrison superimposes a musical staff on the paths of the orbits, reminding us of the film's artifice even as it seeks to argue for an almost supernatural, celestial harmony. Of course, the excessive corruption of Passion Play film serves as its own mediation. In earlier moments in the film, the decay could be seen as ornamental, a kind of decoration on the screen image, but by the time we get to Zecca's film, the decay almost fully obscures much of the

FIGURE 5.6 *Just Ancient Loops* (Bill Morrison, 2012)

image, warping the Pathé color-stenciling process that renders the film's distinctive pinks and yellows (figure 5.6).

Eva Hoffman writes that, in this film, "celluloid is haunted by instability and is susceptible to a continual process of entropy."[40] The miraculousness of Zecca's resurrection, its challenging and reinscription of belief in a secular age, is quite literally erased by this "process of entropy." Affectively, paired with the swelling, pulsating music, the effect is one of awe, but it is awe mediated by a reminder of film's deterioration, of time's passage, of the apparatus's fallibility and the ultimate physical incoherence of these otherwise coherent images. Morrison's film replaces one mode of self-interrogation (the attractions-era model of spectatorship) with another (that of post-cinematic spectatorship). It doesn't critique cinema's process of secularization; rather, it loops it until we see its edges, its bubbling boundaries. It is, in this sense, a throwback to the era of attractions, but it is also a transfiguration of that style. By making each frame quite literally about the invisible ways belief is conjured in film, the medium/format that produces the illusion, Morrison ensures that even our raptures are self-conscious. Ultimately,

though, O'Donaghue's critique of the film holds. To lose oneself in the annihilation of these previously miraculous images is to recommit to cinema's secular magic. Still, the sheer improbability of this film's success at captivating its audience, the uncanny procedural efficiency of Morrison's manipulations, points, for those who wish to follow, to the question that must be at the heart of any postsecular approach to cinema.

Whereas Morrison reframes the material decay of film, digitally illuminating a post-cinematic nova effect, other filmmakers have turned the other way, from spectacular realism to defiantly *un*spectacular realism. A corollary to Hoberman's "new realness"—which, in many ways, aims to compensate for the lost gravity of materiality by flooding the zone with material signifiers—is what Nicholas Rombes points to in his book *10/40/70: Constraint as Liberation in the Era of Digital Film Theory*. "The easy ability to select," he writes, "with will and intent and the force of an interpretive idea—images and scenes from films to weave together arguments about what or how they mean comes with a loss, the loss of risk, of chaos, of the sort of randomness that makes it possible for the argument to *choose us* rather than the other way around."[41] To imagine that risk, chaos, and randomness were an actual part of the film experience in an earlier pre-post-cinema era is perhaps to afford cinema too much credit, but the idea of interpretation as a critical aesthetic (rather than desire for creation or nostalgia for lost magical intersubjectivity between spectator and screen) is a promising one. As Mel Gibson so strikingly demonstrates, such a captivating phenomenological experience is still more than possible after the death of film. So what if we turn to a cinema that is not invested in the romance of captivation in the first place?

Rombes points out the irony that, even as the digital apparatus makes spectacular realism as accessible as it has ever been—the seamless blending of reality and fantasy is both cheaper and more convincingly verisimilar than at any other point in film history—international art cinema has seen a return to long-take formalist realism. We see this, for instance, in the digital minimalism of Abbas Kiarostami, the endless take of Alesandr Sokurov's *Russian Ark* (2002), and Dogme 95's polemic "Vow of Chastity," which insists on handheld video and eschews special effects and postproduction modification. In other words, at a time when immersing the spectator in spectacle is perhaps easier than ever, we've seen a simultaneous rejection of that style. It's not a coincidence that scholars working now in "postsecular cinema" have identified filmmakers like Lars von Trier (a founder of Dogme 95) and Chantal Akerman as patron saints, realists invested in constraint as a path to critical consciousness.[42] "Those nostalgic for the golden age of celluloid," Rombes writes, "must recognize in digital cinema the revenge of the real upon classical cinematic practices that mutilated reality."[43] The era of post-cinema

is filled with filmmakers who have followed Gibson's path to accelerated spectacular realism (and Hoberman even lumps Gibson and Von Trier together under the umbrella of "New Realness"). The center holds, cinema is not dead, the immanent frame is not in danger of collapse. But this landscape is also littered with filmmakers enlivened by a renewed critical impulse toward classical cinema and a resurgence of interest in Bazin's theorizations of cinematic realism. A. O. Scott has termed some of these films "neo-neo-realism," and the resonance is merited.[44]

The digital resistance to a classical, historical realism that "mutilated reality" takes form in ways that are resonant with postsecular critique. If cinema's belief-function is circumscribed by the logic of spectacular realism, if it is in the business of training secular believers, the digital realism Rombes describes asks viewers to see the invisible ways in which their belief is constructed or circumscribed within that frame. If it is not a wholly new or wholly effective mode of resistance, it is still a way of prompting us to look sideways at secularism itself. Like Phelps's Christ or Day's selfies or Du Bois's Black Christ, it constitutes a critical aesthetic politics of the postsecular. There has not yet been a Passion Play film for this mode of cinema. Perhaps the genre is too associated with secular aesthetics, or perhaps it is too out of time to ever really be timely, but there has been no Jesus for this cinema, no direct engagement on the part of these filmmakers with the crisis of materiality and miracle that has called all of the texts in this book to life. There have, however, been resurrections.

THE RESURRECTION IS STRAIGHT TO VIDEO: ABBAS KIAROSTAMI

"I don't know how necessary it is to take the viewer hostage," said the Iranian auteur Abbas Kiarostami in 2004 (in his documentary, *10 on Ten*), the very same year *The Passion of the Christ* was released. It would be hard to think of a filmmaker less like Mel Gibson than Kiarostami, whose slow, delicate, uneventful films about identity and existence were lauded at film festivals throughout the 1990s and 2000s. Kiarostami was not talking about anything so drastically assaultive as Gibson's film—he was merely describing the effect of Dolby Surround Sound in theaters—but it's easy to imagine *The Passion* as an exemplary subject of his cinematic critique. Kiarostami continues:

> Cinema is really a wonderful thing. Any viewer sitting in a seat in a dark movie theatre is turned into an innocent child. And there's nothing quite as magical as

light and darkness. It can send viewers into raptures. Under the circumstances, I suppose this is akin to picking pockets in the dark. By captivating the viewer, we rob him of his reason, which is even worse than emptying his pocket.

Like the earliest film theorists, Kiarostami describes the cinematic experience as "magical" and "wonderful," but that magic and wonder, for him, are often mobilized in order to "rob," to take something from viewers that they don't intend to give. Yes, cinema can be magical, Kiarostami argues, but do we really want to put anyone under a spell?

The cinematic robbery is a sly metaphor, no less so for its subtle invocation of the 1951 film *Pickpocket* by Robert Bresson. Kiarostami cited Bresson as an influence throughout his career, and his films demonstrate a clear debt to what Susan Sontag called Bresson's "spiritual style" and what Paul Schrader called his "transcendental style." For Sontag, Bresson exemplified a formalism that was primarily "reflective," eschewing the traditional "involvement" of narrative cinema in order to provoke rather than proscribe the viewer's self-reflection. "The emotional distance typical of Bresson's films seems to exist," Sontag writes, "because all identification with characters, deeply conceived, is an impertinence—an affront to the mystery that is human action and the human heart."[45] Schrader's "transcendental style" functions similarly. It is a method of ascetic, austere, almost iconographic formalism that prompts contemplation rather than captivation: "Bresson's everyday stylization consists of elimination rather than addition or assimilation. Bresson ruthlessly strips action of its significance; he regards a scene in terms of its fewest possibilities."[46] Kiarostami echoes this point, citing Bresson in the documentary *10 on Ten*, "I believe we can make the viewer experience mental effort by using omission. He can become involved in the making of the film through his imagination." In Bresson's style—which resurfaces in Kiarostami's style and is theorized in the digital age by Rombes—an almost rigid formalism becomes liberatory for filmmakers and spectators alike.

However, this type of liberation, in a secular context, can seem a lot like the myth of liberal agency. Rather than be captivated, viewers become "involved in the making of the film." They are allowed to retain their "reason," and thus to engage, perhaps, in the sort of rationalist belief scripted by the early Passion Play films. How is this different from Lew Wallace compelling his readers to fill in details in *Ben-Hur* or a viewer supplying the interstitial narrative of Edison's *Passion Play*? Does this "transcendental" or "spiritual" collaboration not exist on a spectrum with Griffith's interpolation of the viewer when an intertitle after a scene of the KKK's "liberation" of the Reconstruction-era South asks, "Dare we dream of a golden day when bestial War shall rule no more"? Like many of the

critiques in this book—from Day and Phelps to Du Bois—Kiarostami's postsecularism is not and cannot be complete. Like the postsecular turn in cultural study as described by Fessenden and Coviello and Hickman, it is suffused in the framing and terminology of the secular even as it resists its impulses. Crucial to postsecular critique is what Coviello and Hickman describe as the "epistemological and methodological self-interrogation" that might eventually lead to a way of thinking about modernity without recourse to the concept of the secular.[47] If not fully imagining a discourse beyond secularism, Kiarostami (along with many of the other formalists Rombes cites) seems firmly engaged in the kind of "self-interrogation" that is a convention of postsecular critique. He does this, I argue, by confronting cinema's own subtraction story.

Kiarostami's most famous and influential mobilization of the digital is his 2002 film *Ten*. The film consists of ten improvised vignettes of a female cab driver in Tehran speaking with her passengers, each filmed by two digital cameras mounted on either side of the dashboard. Although *Ten* served as Kiarostami's loudly declared entry into digital cinema, it was not his first experiment with video. Indeed, looking back a few years to 1996's *Taste of Cherry*, we find a structural forerunner to *Ten*, one that was shot on film but that includes a provocative digital epilogue. *Taste of Cherry* does not fully belong to the post-cinematic moment, but it occupies a space in the 1990s when filmmakers—particularly, in this case, Steven Soderbergh, Jane Campion, and Sally Potter—began to provocatively imagine the transition.[48]

The film follows Mr. Badii as he drives around Tehran, picking up passengers, engaging them in long conversations, and then asking if they will bury him after he commits suicide. He will dig the hole, he will get inside of it, and all they need to do is show up to the spot and shovel dirt over his lifeless body. Most of the film consists of three long set-pieces in Badii's car, shot on 35mm, but using the same long-take, stationary style Kiarostami would later employ for *Ten*. The film ends inconclusively—the final passenger seems willing to do this favor, though we are unsure if he actually will—with Badii admiring the sunset on the hill where he wishes to be buried (figure 5.7). We then cut to a close-up of his face, eyes open, alive, lying in his shallow grave. He is lit by the moon, which soon vanishes behind a cloud. After a few moments, there is a flash of lightning to show us Badii's conscious face, but after that we stay for nearly a minute in darkness, with only the sound of rain to remind us that the film is not yet over. Suddenly, however, we hear the sound of soldiers marching, and the film fades in on grainy digital video of the procession, in daylight, on the same hill. The video then cuts to a tracking shot of a man carrying a film camera. After a few moments, the frame begins to track the other way, following none other than Homayoun Ershadi—the

FIGURE 5.7 *Taste of Cherry* (Abbas Kiarostami, 1996)

actor who played Badii—lighting a cigarette, taking a puff, and handing it to Kiarostami himself, who appears to be supervising sound recording for the film (figures 5.8 and 5.9). The first nondiegetic music in the film then fades in—Louis Armstrong's instrumental "St. James Infirmary," with its mournful trumpet—as we see various shots of the soldiers (extras) waiting between takes. We then see a long take of Badii's car, without Badii, driving offscreen, and the film fades to black. This is Abbas Kiarostami's digital resurrection.

To be clear, this last resurrection is neither the resurrection of Jesus nor the resurrection of a Christ figure. Diegetically, it's not even a resurrection at all. Throughout this book, one of my guiding constraints has been that I have only considered films, novels, and works of visual culture in which Jesus appears as a character. He may look different from the way he is ordinarily portrayed, but it is not a figure *like* Jesus that draws our interest: it is Jesus himself, live and in person. This restriction forces us to consider what aesthetic forms do in response to the crisis of Christ's dual identity as historical man and divine being. In the laboratory of the Passion Play film, we see something like the rawest and most utilitarian embodiment of spectacular realism. What does a miracle look like in the real world? But this aesthetic, and these questions of representation and ontology, are not limited to the Passion Play film: we simply encounter their most extreme articulation there. Perhaps because of its subject matter, perhaps because of how

FIGURE 5.8 *Taste of Cherry* (Abbas Kiarostami, 1996)

FIGURE 5.9 *Taste of Cherry* (Abbas Kiarostami, 1996)

firm the trappings of its genre are and how unwilling filmmakers might be to run variations on them, we have also seen the way that the Passion Play film is not necessarily the space for building anything resembling postsecular critique.

Thus we turn to this film about a driver trying desperately to kill himself, made by a Shiite Muslim who chose to make films in Iran under the extreme constraint of theocratic state censorship. As I have noted earlier, secularism in cinema is a style: a style of belief, of unbelief, a set of conventions that govern the way spectators see and understand the world onscreen and the world around them. Stylistically, then, *Taste of Cherry* is as direct a critique of this style as could be imagined, and, looking at its resurrection, if only as a structural rhyme with all of these cinematic passions, can perhaps suggest some ways in which this postsecular reading of cinema extends beyond the case studies in this book.[49]

In an interview after *Taste of Cherry* won the Palme d'Or at the Cannes Film Festival, Kiarostami characterized the film's provocations much the same way one might frame a critique of secularism's normative sociality. Describing the three long dialogues on the subject of suicide that structure the film, Kiarostami said, "The opportunity to talk about these taboos, explore what they are and why they exist, has given me a new outlook. It is the role of art to discover, question, and expose these taboos for what they are and what they are worth—what we are told as a child not to do and what we consequently do not do as an adult."[50] In context of the director's statements about taking viewers "hostage"—which he repeated in this interview as well—we can see that Kiarostami views cinema as a medium that can be put to the task of reinforcing "taboos" or questioning them, upholding norms or refusing to grant their natural neutrality. Inasmuch as he suggests that the film is about "Islamic Culture," this is the substance of its critique of the secular; the taboos one inherits from childhood fables are as influential, if not more so, than the restrictive dictates of the theocracy. In its form as well as its content, though, *Taste of Cherry* is resistant to the way such soft, inevitable-seeming norms, brought to the theater by the viewer, might impose upon his film an unintended moral structure. "I didn't want spectators emotionally involved in this film," Kiarostami said.[51] Badii's resurrection is the ultimate rejection of that involvement: a post-cinematic postsecular rebuke.

Part of the way that the traditional Passion Play film trains believers is by playing a kind of pushpull game with credulity. What a viewer will or won't believe onscreen has changed over the history of cinema, of course, and we who felt physically ill at screenings of *The Passion of the Christ* might scoff at the idea of a spectator even able to suspend disbelief at a screening of *From the Manger to the Cross*. However, as I have argued, it is the movement away from this naïve belief—the step *back* to rationality—that is constitutive of secularism in cinema.

Taste of Cherry, in its formal distancing, in its structural refusal to generate empathy for Mr. Badii, does not have many moments from which to step away, and yet it ends with an almost Brechtian distancing maneuver. It not only short-circuits any possibility that we might have begun to feel sadness for Badii, to *believe* that he is a person, but also calls into question our tacit belief that film—and its material base—reflects even the reality of its subjects. It endeavors to radicalize our distance, to transcend boredom or indifference and become something genuinely new. The cut to video does not leverage the audience's relationship to one reality over another, in the spectacular manner of Griffith, DeMille, Gibson, or even Morrison; rather, it suggests that there is no one reality at all.

As if to take a kind of joy in that shattering, Kiarostami plays us "St. James Infirmary," a funeral song, over this resurrection. As Michael Price has pointed out, Armstrong's recording obviously evokes the traditional New Orleans jazz funeral that shifts from mourning to celebration, but it also echoes the Islamic funeral processions at Behesht-é Zahra that feature brass instruments, as well as the trumpet blown by the angel of resurrection in Iranian folklore.[52] It's a complex sound cue, and, even short of these intertextual references, it has the effect of turning this drastic act of cinematic alienation itself into a kind of triumphant ritual. This disappointment is itself worthy of praise, of celebration, of applause. This is only a film, we are alive, and no film or culture or material ought to be able to tell us what or how that means.

"St. James Infirmary" is a soundtrack to the miraculous absences in *Taste of Cherry*, the mournful or prophetic sound of a possibility beyond this one film's economy. The whole point of classical Hollywood cinema is the idea that viewers forget they are watching a film. For whatever length of time you show up in the darkened theater, you are held captive by the image, "forgetting the present," as that Horitz reviewer said; forgetting your "viewpoint," as DeMille said; held "hostage," as Kiarostami said. It is in this sense that cinema is most recognizable as the organ of secularism, the ground you walk upon but cannot perceive, the unseen something, the immanent frame. To view in this way is to see elements of each text that are there, that are essential, but that are hidden in plain sight. It is to refuse captivity. To look sideways is to see all that is good, all that is marvelous in the world and in its reproduction onscreen, but it is also to be alive to the things film might ask us to accept if we are too ensorcelled by that marvelousness. It can be a mode of critical viewing, and it can be a mode of understanding, but it can also be a demand. In many ways, this impulse blends with the impulse illuminating avant-garde movements throughout film history, from Eisenstein to the New Wave to those films called postsecular in the contemporary moment. It is to find a cinema experience that challenges rather than reaffirms, that reveals

mediation rather than knitting its own mediations so tight as to be opaque, that confronts rather than flatters the audience. It is to live in a kind of discomfort, to be troubled by those things that it might be easier to overlook. It is never complete, and it is never wholly possible—it is built around impossibility and failure. The images name where they are and they name *what* they are. A man's face nearly disappears in the blurred frame; a stranger on a cross stretches *heaven-tall* and *earth-wide* before the shrieking crowd below; a man awakens from death, lights a cigarette, and hands it to a film director. And, then, out of nowhere, the trumpets sound.

Notes

INTRODUCTION

1. While in keeping with the representational tradition of *Ben-Hur*, as S. Brent Plate points out, the relative absence of Jesus in Wyler's film was likely also a result of the looming shadow of the Production Code. S. Brent Plate, *Religion and Film: Cinema and the Re-creation of the World*, 2nd ed.(New York: Columbia University Press, 2017), 133.
2. George Wales, "MGM Planning Ben-Hur Remake," *Total Film*, January 15, 2013, http://www.imdb.com/news/ni44959587.
3. Peter Coviello and Jared Hickman, "Introduction: After the Postsecular," *American Literature* 86, no. 4 (December 2014): 645.
4. Tracy Fessenden, "The Problem of the Postsecular," *American Literary History*, 26, no. 1 (Spring 2014): 156.
5. Elaine Scarry, *Dreaming by the Book* (Princeton, NJ: Princeton University Press, 2001), 6.
6. The literature on the historical Jesus is, of course, broad and deep. The most pithy and accessible single account of this movement and the variations between different nineteenth-century biographies of Christ, though, is still Albert Schweitzer's 1906 *The Quest of the Historical Jesus* (New York: Dover, 2005).
7. For an overview of the European response and its contexts, see the outstanding annotated version of *Essays and Reviews: The 1860 Text and Its Readings*, ed. John William Parker (Charlottesville: University of Virginia Press, 2000).
8. Warren Susman, "History and the American Intellectual: Uses of a Usable Past," in *Locating American Studies,* ed. Lucy Maddox (Baltimore, MD: Johns Hopkins University Press, 1999), 21.
9. Richard Wightman Fox, *Jesus in America: Personal Savior, Cultural Hero, National Obsession* (New York: HarperOne, 2004); Stephen Prothero, *American Jesus: How the Son of God Became a National Icon* (New York: Farrar, Straus, and Giroux, 2004). In addition to the work of Fox and Prothero, Edward Blum and Paul Harvey's *The Color of Christ* provides a more targeted argument about the "whiteness" of Christ in an American context, albeit with a similar broad scope.
10. Horace Bushnell, *Nature and the Supernatural as Together Constituting the One System of God* (New York: Scribner, Armstrong, 1872), 16–20.
11. Ralph Waldo Emerson, *Essays and Lectures* (New York: Library of America, 1983), 82.

12. Andrews Norton, *Internal Evidences of the Genuineness of the Gospels* (Boston: Little, Brown, 1855), 127.
13. Henry Ward Beecher, *The Life of Jesus, The Christ*, vol. I (New York: J. B. Ford, 1871), iii.
14. See Fox, *Jesus in America;* Prothero, *American Jesus.*
15. Ernest DeWitt Burton and Shailer Mathews, *The Life of Christ: An Aid to Historical Study and a Condensed Commentary on the Gospels* (Chicago: The University of Chicago Press, 1900).
16. William T. Stead, *If Christ Came to Chicago: A Plea for the Union of All Who Love in the Service of All Who Suffer* (Chicago: Laird and Lee, 1894).
17. W. D. P. Bliss, ed., *The New Encyclopedia of Social Reform* (New York: Funk and Wagnalls, 1908), 111.
18. See Gary Dorrien, *The Making of American Liberal Theology: Imagining Progressive Religion, 1805–1900* (Louisville, KY: Westminster John Knox Press, 2001).
19. W. E. B. Du Bois, "The Church and the Negro," in *Du Bois on Religion*, ed. Phil Zuckerman (Lanham, MD: Altamira Press, 2000), 99–100.
20. Jenny Franchot, *Roads to Rome: The Antebellum Protestant Encounter with Catholicism* (Berkeley: University of California Press, 1994).
21. Gregory Jackson, *The Word and its Witness: The Spiritualization of American Realism* (Chicago: University of Chicago Press, 2009), 3.
22. Norton, *Internal Evidences*, 4.
23. E. Brooks Holifield, *Theology in America* (New Haven, CT: Yale, 2003), 173–97.
24. It was not solely writers in the religious sphere who privileged the eyewitness or who played with the changing dynamic between seeing and believing. Popular culture in the nineteenth-century United States was obsessed with questions of method, credibility, and evidence. Consumers were alternately thrilled and frustrated by works that forced them to assess their own reliability as eyewitnesses—what Neil Harris called, in relation to P. T. Barnum, "the operational aesthetic." Jonathan Crary notes that between 1810 and 1840, there occurred a "new valuation of visual experience" based in the revelation that vision was a subjective rather than objective process. Newly "mobile and exchangeable[e], abstracted from any founding site or referent," visual experience became something observers felt they could no longer fully trust. Scientists, as a result began to seek out the physiological basis of visual perception, and the devices they created to test vision—things like the phenakistoscope and stereoscope, which were technological precursors to cinematic projection—eventually migrated into popular culture, teaching audiences both about the limits and new possibilities of their own senses. Likewise, this was accompanied by a new anxiety about subjective vision. As Lorraine Daston and Peter Galison put it, "The subjective self was prone to prettify, idealize, and in the worst case, regularize observations to fit theoretical expectations: to see what it hoped to see." And so, audiences aspired toward objectivity as "a desire, a passionate commitment to suppress the will, a drive to let the visible world emerge . . . without intervention." As audiences tried to regain or approximate what they perceived to be the lost objectivity of vision, many of those same people sought proof of Christian revelation from their religion. See Neil Harris, *Humbug: The Art of P. T. Barnum* (Chicago: University of Chicago Press, 1973); Jonathan Crary, *Techniques of the Observer: On Vision and Modernity in the Nineteenth Century* (Cambridge, MA: MIT Press, 1990), 14; Michael Leja, *Looking Askance: Skepticism and American Art from Eakins to Duchamp* (Berkeley: University of California Press, 2004); Lorraine Daston and Peter Galison, *Objectivity* (New York: Zone Books, 2005), 34, 143.
25. R. Laurence Moore, *Selling God: American Religion in the Marketplace of Culture* (New York: Oxford University Press, 1994), 10; T. Jackson Lears, *No Place of Grace: Antimodernism and the Transformation of American Culture, 1880–1920* (New York: Pantheon, 1981); Ann Douglas, *The Feminization of American Culture* (New York: Farrar, Straus, and Giroux, 1977).
26. Charles Taylor, *A Secular Age* (Cambridge, MA: Belknap Press, 2007).

INTRODUCTION 207

27. Talal Asad, *Formations of the Secular: Christianity, Islam, Modernity* (Stanford, CA: Stanford University Press, 2003).
28. Janet Jakobsen and Ann Pellegrini, "Times Like These," in *Secularisms*, ed. Janet Jakobsen and Ann Pellegrini (Durham, NC: Duke University Press, 2008), 4.
29. Beyond this investment in narrative, many key works of the postsecular turn in American studies specifically have been focused on the literary. The question of the secular has been a key focus among Medievalists and Renaissance scholars as well as the many nineteenth-century Americanists with whom this introduction engages. And, beyond that, several of the most prominent works on this subject to come out of religious studies in recent years—Tracy Fessenden's *Culture and Redemption*, John Lardas Modern's *Secularism in Antebellum America*, and Josef Sorett's *Spirit in the Dark*—have zeroed in on literary texts as well. See Tracy Fessenden, *Culture and Redemption: Religion, the Secular, and American Literature* (Princeton, NJ: Princeton University Press, 2007); Jordy Rosenberg, *Critical Enthusiasm: Capital Accumulation and the Transformation of Religious Passion* (New York: Oxford University Press, 2011); John Lardas Modern, *Secularism in Antebellum America* (Chicago: University of Chicago Press, 2011); Jordan Alexander Stein, "Secular Aesthetics: Form, Theme, and Method in the Study of American Literature," *Comparative Literature* 65, no. 3 (2013): 325–44; and Josef Sorett, *Spirit in the Dark: A Religious History of Racial Aesthetics* (New York: Oxford University Press, 2016).
30. Jakobsen and Pellegrini, "Times Like These," 12.
31. Coviello and Hickman, "After the Postsecular," 647.
32. Asad, *Formations of the Secular*, 26. See also Jakobsen and Pellegrini, "Times Like These," 12.
33. Taylor, *A Secular Age*, 3.
34. Taylor, *A Secular Age*, 11.
35. Taylor, *A Secular Age*, 392.
36. Taylor, *A Secular Age*, 351.
37. For more in-depth consideration of the historical role of religion in literary study, see "Methods for the Study of Religion in Early American Literature," a special issue of *Early American Literature* edited by Jordan Alexander Stein and Justine Murison, 45, no. 1 (2010); and "American Literatures/American Religions," a special issue of *American Literary History* edited by Jonathan Ebel and Justine Murison, 26, no. 1 (Spring 2014).
38. Nathan O. Hatch, *The Democratization of American Christianity* (New Haven, CT: Yale University Press, 1989); Mark Noll, *America's God: From Jonathan Edwards to Abraham Lincoln* (Oxford: Oxford University Press, 2002).
39. John Lardas Modern, *Secularism in Antebellum America* (Chicago: University of Chicago Press, 2013), 7. See also *Varieties of Secularism in a Secular Age*, ed. Jonathan VanAntwerpen, Michael Warner, and Craig Calhoun (Cambridge, MA: Harvard University Press, 2010); and the online forum about Taylor's book on *The Immanent Frame* (https://tif.ssrc.org/category/secular_age/).
40. Saba Mahmood, "Secularism, Hermeneutics, and Empire: The Politics of Islamic Reformation," *Public Culture* 18, no. 2 (2006): 328.
41. Fessenden, *Culture and Redemption*, 61; Modern, *Secularism in Antebellum America*, 11.
42. Fessenden, *Culture and Redemption*, 3.
43. Molly McGarry, *Ghosts of Futures Past: Spiritualism and the Cultural Politics of Nineteenth-Century America* (Berkeley: University of California Press, 2008), 5.
44. Vincent Lloyd, "Introduction: Managing Race, Managing Religion," in *Race and Secularism in America*, ed. Jonathon Kahn and Vincent Lloyd (New York: Columbia University Press, 2016), 5. See also Jared Hickman, *Black Prometheus: Race and Radicalism in the Age of Atlantic Slavery* (New York: Oxford University Press, 2017).
45. Asad, *Formations of the Secular*, 5.

46. Ben Singer uses the phrase "spectacular diegetic realism" to contrast turn-of-the-century melodramatic theater's emphasis on "verisimilar mise-en-scene and the use of real objects on the stage—real horses, real fire engines, real pile drivers, real water, etc." with a naturalist orientation toward character psychology. The phrases both draw attention to the same thing—the idea of realistic images as itself shocking—but our usages diverge there. *Melodrama and Modernity* (New York: Columbia University Press, 2001), 51.
47. Lindsay Vail Reckson's monograph *Realist Ecstasy: Religion, Race, and Performance in American Literature* (New York: New York University Press, 2019), in particular her chapter on cinematic documentaries of the Sioux Ghost Dance, does valuable work in this regard.
48. Miriam Bratu Hansen, *Babel and Babylon: Spectatorship in American Silent Film* (Cambridge, MA: Harvard University Press, 1991); Charles Musser, *The Emergence of Cinema* (Berkeley: University of California Press, 1994); and many of the key short essays from this era of scholarship are collected in Thomas Elsaesser's essential *Early Cinema: Space, Frame, Narrative* (London: British Film Institute, 1990).
49. Tom Gunning, "An Aesthetic of Astonishment: Early Film and the (In)credulous Spectator," in *Film and Theory*, ed. Robert Stam and Toby Miller (New York: Blackwell, 2000), 114–33.
50. Rachel O. Moore, *Savage Theory: Cinema as Modern Magic* (Durham, NC: Duke University Press, 2000), 3.
51. Gunning, "Aesthetic of Astonishment," 115.
52. Gunning, "Aesthetic of Astonishment," 117.
53. Gunning, "Aesthetic of Astonishment," 119.
54. Vachel Lindsay, *The Art of the Moving Picture* (New York: Liveright, 1970), 305.
55. Lindsay, *Art of the Moving Picture*, 290. For more on this strain in early film theory, see Moore's *Savage Theory* and Malcolm Turvey, *Doubting Vision: Film and the Revelationist Tradition* (Oxford: Oxford University Press, 2008).
56. Hugo Münsterberg, *The Photoplay* (New York: Dover, 1970), 11.
57. Gunning, "Aesthetic of Astonishment," 125.
58. Moore, *Savage Theory*, 14.
59. Miriam Bratu Hansen, "Early Silent Cinema: Whose Public Sphere?" *New German Critique* no. 29 (Spring/Summer 1983): 151.
60. Wendy Hui Kyong Chun, "Race and/as Technology; or How to Do Things to Race," *Camera Obscura 70* 24, no. 1 (May 2009): 7.
61. Roland Cosandey, André Gaudreault, Tom Gunning, eds., *An Invention of the Devil?* (Sainte-Foy, Quebec, Canada: Presses de l'Université Laval, 1992). The most substantial scholarship in religion and early cinema since this moment is collected in two volumes: David J. Shepherd, *The Bible on Silent Film: Spectacle, Story and Scripture* (Cambridge, MA: Cambridge University Press, 2013); and Shepherd's edited collection, *The Silents of Jesus in the Cinema (1897–1927)* (New York: Routledge, 2016).
62. Mark Cauchi and John Caruana, eds., *Immanent Frames: Postsecular Cinema Between Malick and von Trier* (Buffalo: SUNY Press, 2018), 1–2; Costica Bradatan and Camil Ungureanu, eds., *Religion in Contemporary European Cinema: The Postsecular Constellation* (New York: Routledge, 2017).
63. Priya Kumar, *Limiting Secularism: The Ethics of Coexistence in Indian Literature and Film* (Minneapolis: University of Minnesota Press, 2008), 179; Cara Caddoo, *Envisioning Freedom: Cinema and the Building of Modern Black Life* (Cambridge, MA: Harvard University Press, 2014); Terry Lindvall, *Sanctuary Cinema* (New York: New York University Press, 2011); Plate, *Religion and Film*, xviii; Judith Weisenfeld, *Hollywood Be Thy Name: African American Religion in American Film, 1929–1949* (Berkeley: University of California Press, 2007). See also, for instance, Terry Lindvall, *The Silents of God: Selected Issues and Documents in Silent American Film and Religion, 1908–1925* (Lanham, MD: Scarecrow Press, 2001); John Lyden, *Film as Religion: Myths, Morals, and Rituals* (New York:

New York University Press, 2003); Robert K. Johnston, *Reel Spirituality: Theology and Film in Dialogue* (New York: Baker, 2006); *The Religion and Film Reader*, ed. Jolyon Mitchell and S. Brent Plate (New York: Routledge, 2007), which contains excerpts from a variety of monographs in the field; and Sarah Cooper, *The Soul of Film Theory* (New York: Palgrave Macmillan, 2013).

64. For this suggestion, I am indebted to Anu Thapa, and her brilliant paper on D. G. Phalke presented at the UW-Milwaukee Center for Twenty-First Century Studies "Ends of Cinema" conference.
65. For an exhaustive critique of the modernity thesis, see Singer, *Melodrama and Modernity*.

1. A RARE AND WONDERFUL SIGHT: *BEN-HUR*'S HISTORICISM

1. Lew Wallace, *Autobiography* (New York: Harper and Brothers, 1906), 632.
2. Lew Wallace, *Ben-Hur: A Tale of the Christ* (New York: Signet, 2003), 533.
3. In many ways, *Ben-Hur* is a classic example of the nineteenth-century "Jesus novel," as painstakingly catalogued and anatomized by Jefferson J. A. Gatrall in his *The Real and the Sacred: Picturing Jesus in Nineteenth-Century Fiction* (Ann Arbor: University of Michigan Press, 2014). Of all these novels, *Ben-Hur* is of specific interest for this book because of the way its legacy dovetails with the emergence of early cinema out of late-nineteenth-century American visual culture (in which adaptations of *Ben-Hur* were central), but Gatrall's description of the genre's place in negotiations of sacred and secular in this period is resonant for both my discussion of *Ben-Hur* and its later cinematic inheritors: "The emergence of the Jesus novel over the second quarter of the nineteenth century represented a daring expansion of the secular into the realm of the sacred. In terms of formal realism, the influence of the secular is most evident in the novelist's twin strategies of pictorialism and perspectivalism; even where ostensibly miraculous figures and events arise in the Jesus novel, the narrator either pictures them for the reader's discerning eye or filters them through the disparate perspectives of other characters. In this sense, the rhetorical strategies of the Jesus novel conform to what Charles Taylor terms the 'conditions of belief' in the secular age, namely that belief in God has become an option, not a given" (30).
4. Gregory Jackson, "A Game Theory of Evangelical Fiction," *Critical Inquiry* 39, no. 3 (Spring 2013): 483–84.
5. Wallace, *Autobiography*, 936. Wallace was, at the time that he finished the manuscript of *Ben-Hur*, the governor of the territory of New Mexico. The "gloomy harborage" to which he refers is the governor's mansion, where Wallace was frequently kept under armed guard to protect him—quite seriously—from being assassinated by William Bonney, a/k/a Billy the Kid. Wallace's wife, in a journal entry, quotes Billy the Kid as saying, "I mean to ride into the plaza at Santa Fe, hitch my horse in front of the palace, and put a bullet through Lew Wallace" (921).
6. This phrasing is also, notably, a reference to Revelation 1:19, "Write the things which thou hast seen, and the things which are, and the things which shall be hereafter."
7. William Hickling Prescott, *The Papers of William Hickling Prescott*, ed. C. Harvey Gardiner (Urbana: University of Illinois Press, 1964), 186.
8. Eric Wertheimer, "Noctography: Representing Race in William Prescott's History of the Conquest of Mexico," *American Literature* 67, no. 2 (June 1995): 303–27.
9. William Hickling Prescott, *History of the Conquest of Peru*, ed. Mary Powlesland Commager (New York: Barnes and Noble, 2004), xi.
10. Prescott, *Conquest of Peru*, 186.
11. Peter Novick, *That Noble Dream: The "Objectivity Question" and the American Historical Profession* (Cambridge, UK: Cambridge University Press, 1988), 44–46.

12. Eileen Ka-May Cheng, *The Plain and Noble Garb of Truth: Nationalism and Impartiality in American Historical Writing* (Athens: Georgia University Press, 2008), 66.
13. Cheng, *Plain and Noble Garb*, 66–67.
14. Wertheimer, "Noctography," 304.
15. John Ernest, "Reading the Romantic Past: William H. Prescott's History of the Conquest of Mexico," *American Literary History* 5, no. 2 (Summer 1993): 238.
16. Irving McKee, *"Ben-Hur" Wallace: The Life of General Lew Wallace* (Berkeley: University of California Press, 1947), 10.
17. William Hickling Prescott, *The History of the Conquest of Peru* (Philadelphia: J. B. Lippincott, 1874), 308.
18. William Hickling Prescott, *The Conquest of Mexico* (New York: Henry Holt, 1922), 233.
19. Prescott, *Conquest of Mexico*, 362–64.
20. Hilton Obenzinger, *American Palestine: Melville, Twain, and the Holy Land Mania* (Princeton, NJ: Princeton University Press, 1999).
21. Edward Robinson, *Biblical Researches in the Palestine and the Adjacent Regions: A Journal of Travels in the Years 1838 and 1852* (London: John Murray, 1867), vii.
22. Melani McAlister, *Epic Encounters: Culture, Media, and U.S. Interests in the Middle East, 1945–2000* (Berkeley: University of California Press, 2001), 13.
23. E. Brooks Holifield, *Theology in America* (New Haven, CT: Yale, 2003), 188.
24. Robinson, *Biblical Researches*, 220.
25. Robinson, *Biblical Researches*, 418–19.
26. McAlister, *Epic Encounters*, 16–17.
27. Obenzinger, *American Palestine*, 49.
28. John Lloyd Stephens, *Incidents of Travel in Egypt, Arabia Petraea, and the Holy Land* (Norman: University of Oklahoma Press, 1970), 4.
29. Stephens, *Incidents of Travel*, 329.
30. Stephens, *Incidents of Travel*, 340.
31. Stephens, *Incidents of Travel*, 354.
32. Herman Melville, *Journals*, ed. Howard Horsford with Lynn Worth (Evanston, IL: Northwestern University Press, 1989), 88.
33. Melville, *Journals*, 91.
34. Herman Melville, *Clarel: A Poem and Pilgrimage in the Holy Land* (Evanston, IL: Northwestern University Press, 2008), 1.28.65.
35. Melville, *Clarel*, 1.22.40–1.22.47.
36. For more on mesmerism and secularism, see Emily Ogden, *Credulity: A Cultural History of U.S. Mesmerism* (Chicago: University of Chicago Press, 2018).
37. See Gatrall, *The Real and the Sacred*.
38. Ernest Renan, *The Life of Jesus* (New York: Modern Library, 1927), 13.
39. Renan, *The Life of Jesus*, 38.
40. Renan, *The Life of Jesus*, 39.
41. Renan, *The Life of Jesus*, 130.
42. Wallace, *Ben-Hur*, 5.
43. Wallace, *Ben-Hur*, 31.
44. Wallace, *Ben-Hur*, 32.
45. For more on descriptive detail as a convention of the Jesus novel, see Gatrall, *The Real and the Sacred*; for more on description as part of the history of the English novel in general, see Cynthia Wall, *The Prose of Things: Transformations of Description in the Eighteenth Century* (Chicago: University of Chicago Press, 2006).
46. Gatrall, *The Real and the Sacred*, 79.

47. Gatrall, *The Real and the Sacred*, 533.
48. See also Jackson, "A Game Theory of Evangelical Fiction."
49. Jackson, "A Game Theory of Evangelical Fiction," 32.
50. Jackson, "A Game Theory of Evangelical Fiction," 32.
51. Jackson, "A Game Theory of Evangelical Fiction," 83.
52. Gregory Jackson, *The Word and Its Witness: The Spiritualization of American Realism* (Chicago: University of Chicago Press, 2009), 68.
53. Wallace, *Ben-Hur*, 265.
54. "Ben-Hur," *Los Angeles Times*, April 29, 1888.
55. Gatrall, *The Real and the Sacred*, 136.
56. Wallace, *Ben-Hur*, 467.
57. Wallace, *Ben-Hur*, 48.
58. Wallace, *Ben-Hur*, 53–54.
59. Wallace, *Ben-Hur*, 70.
60. Wallace, *Ben-Hur*, 485.
61. Wallace, *Ben-Hur*, 500.
62. Wallace, *Ben-Hur*, 500.
63. Wallace, *Ben-Hur*, 501.
64. Wallace, *Ben-Hur*, 503.
65. Wallace, *Ben-Hur*, 468–69.
66. Wallace, *Ben-Hur*, 469.
67. Theodore Hovet, *Realism and Spectacle in* Ben-Hur (Ann Arbor: University of Michigan, 2013), 262.

2. LOOKING SIDEWAYS: MEDIA THEORIES OF JESUS CHRIST

1. David Morgan, *Protestants and Pictures: Religion, Visual Culture, and the Age of American Mass Production* (New York: Oxford University Press, 1999), 292. See also Sally Promey, "Visible Liberalism: Liberal Protestant Taste Evangelism, 1850 and 1950," in *American Religious Liberalism*, ed. Leigh E. Schmidt and Sally Promey, 76–96 (Bloomington: Indiana University Press, 2012).
2. See Rachel McBride Lindsey, *A Communion of Shadows: Religion and Photography in Nineteenth-Century America* (Chapel Hill: University of North Carolina Press, 2017).
3. Jefferson J. A. Gatrall, *The Real and the Sacred: Picturing Jesus in Nineteenth-Century Fiction* (Ann Arbor: University of Michigan Press, 2014), 30.
4. Shawn Michelle Smith, *At the Edge of Sight: Photography and the Unseen* (Durham, NC: Duke University Press, 2013), 44.
5. Albert Schweitzer, *The Quest of the Historical Jesus* (New York: Dover, 2005), 4.
6. Charles Taylor, *A Secular Age* (Cambridge, MA: Belknap Press, 2007), 11.
7. Kathryn Bond Stockton, *The Queer Child, or Growing Sideways in the Twentieth Century* (Durham, NC: Duke University Press, 2009), 52.
8. John Lardas Modern, *Secularism in Antebellum America* (Chicago: University of Chicago Press, 2011), 23.
9. Modern, *Secularism in Antebellum America*, 22.
10. Gregory Jackson, *The Word and Its Witness: The Spiritualization of American Realism* (Chicago: University of Chicago Press, 2009), 16–17.
11. See Morgan, *Protestants and Pictures*, 275–85; Modern, *Secularism in Antebellum America*, 147–57.

12. Ann Braude, *Radical Spirits: Spiritualism and Women's Rights in Nineteenth-Century America* (Boston: Beacon Press, 1989); Catherine Albanese, *A Republic of Mind and Spirit: A Cultural History of American Metaphysical Religion* (New Haven, CT: Yale University Press, 2007).
13. Molly McGarry, *Ghosts of Futures Past: Spiritualism and the Cultural Politics of Nineteenth-Century America* (Berkeley: University of California Press, 2008), 12.
14. McGarry, *Ghosts of Futures Past*, 6.
15. McGarry, *Ghosts of Futures Past*, 13. Among other, countercultural evocations of immediacy in this period is the idea of ecstatic experience, explored in Ann Taves, *Fits, Trances, and Visions: Experiencing Religion and Explaining Experience from Wesley to James* (Princeton, NJ: Princeton University Press), 199; Ashon Crawley, *Blackpentecostal Breath: The Aesthetics of Possibility* (New York: Fordham University Press, 2017); and Lindsay Vail Reckson, *Realist Ecstasy: Religion, Race, and Performance in American Literature* (New York: New York University Press, 2019).
16. Hent de Vries, "In Media Res: Global Religion, Public Spheres, and the Task of Contemporary Comparative Religious Studies," in *Religion and Media*, ed. Hent de Vries and Samuel Weber (Redwood City, CA: Stanford University Press, 2001), 19, 28. See also a special dossier on "The Spirit of Media," *Critical Inquiry* 42, no. 4 (Summer 2016).
17. W. J. T. Mitchell, *What Do Pictures Want? The Lives and Loves of Images* (Chicago: University of Chicago Press, 2005), 214.
18. Mitchell, *Pictures*, 217.
19. Birgit Meyer, "Mediation and Immediacy: Sensational Forms, Semiotic Ideologies and the Question of the Medium," *Social Anthropology* 19, no. 1 (2011): 26–27.
20. Mattijs Van de Port, "(Not) Made by the Human Hand: Media Consciousness and Immediacy in the Production of the Real," *Social Anthropology* 19, no. 1 (2011): 76.
21. Van de Port, "(Not) Made by the Human Hand," 84.
22. Van de Port, "(Not) Made by the Human Hand," 85.
23. Modern, *Secularism in Antebellum America*, 32.
24. Elizabeth Stuart Phelps, *Three Spiritualist Novels* (Urbana: University of Illinois Press, 2000), 13–14.
25. Phelps, *Spiritualist Novels*, 31.
26. "The tragedy of nineteenth-century northeastern society is not the demise of Calvinist patriarchal structures," Douglas writes, "but rather the failure of a viable, sexually diversified culture to replace them. 'Feminization' inevitably guaranteed, not simply the loss of the finest values contained in Calvinism, but the constitution of male hegemony in different guises." Her advancement of a wildly unorthodox eschatology was thus blunted by the fact that this eschatology simply reproduced the same structures of gendered labor, consumption, and morality against which Phelps had had to struggle in order to become a professional writer in the first place. Ann Douglas, *The Feminization of American Culture* (New York: Farrar, Straus, and Giroux, 1977), 13.
27. Douglas, *Feminization*, 223.
28. Douglas, *Feminization*, 88.
29. The apparent lack of rigor in Phelps's theological imaginary, according to Smith at least, testifies to a more, not less, complicated relationship to theology. Specifically, Smith argues that *The Gates Ajar* represents a nimble engagement with contemporary Biblical hermeneutics and, rather than providing evidence of the watering-down of intellectual life in the "overwrought and sensitive" hands of a minister's daughter, Phelps's novel indicates "the surprisingly permeable boundaries between the nineteenth-century academy and popular cultural forms" (101–2). Phelps's unusual reading of Biblical criticism, then, should not be understood as a willful failure to understand it, but rather a substantive endeavor to disagree with both its assumptions and the culture surrounding it. As her biographer Lori Duin Kelly writes, *The Gates Ajar* is more an expression of Phelps's "real impatience with Biblical scholarship" than her ignorance of it. *The Life and Works of Elizabeth Stuart Phelps, Victorian Feminist Writer* (Troy, NY: Whitston, 1983), 34. Indeed, Smith carefully tracks the way

that many of the most famous passages of supposed "anti-intellectual" polemic against Biblical criticism—voiced by Winifred in the text—actually display learned engagement with the field. Winifred's seeming dismissal of intellectual debate is instead a dismissal of the "elitism and sexism" of male intellectuals themselves. Kelly, *Life and Works*, 104.

30. Gail K. Smith, "From the Seminary to the Parlor: The Popularization of Hermeneutics in *The Gates Ajar*," *Arizona Quarterly* 54, no. 2 (Summer 1998): 99.
31. Nancy Schnog, "The Comfort of My Fancying: Loss and Recuperation in *The Gates Ajar*," *Arizona Quarterly* 49, no. 3 (Autumn 1993): 132.
32. The *Gates* trilogy is sometimes referred to as the "Spiritualist Novels," but this is a contemporary coinage. The three novels were collected by the University of Illinois Press in 2000, and the appellation of "Spiritualist" was drawn from Nina Baym's introductory essay in which she draws parallels between Phelps and the Spiritualists' visions of Heaven. According to John Kucich, *The Gates Ajar* was warmly received by Spiritualist readers, and because of the novel's popularity in this demographic, the subsequent volumes were advertised in Spiritualist periodicals; the final volume bears a butterfly on its cover, which would have been recognizable as a nod to Spiritualism. The books, however, were not described as "Spiritualist Novels" until the twenty-first century. I am grateful to John Kucich and Claudia Stokes as well as the vibrant C19 Listserv community for the information in this footnote!
33. Elizabeth Stuart Phelps, *Chapters from a Life* (Boston: Houghton Mifflin, 1896), 8.
34. Phelps, *Chapters*, 8.
35. Phelps, *Three Spiritualist Novels*, ix.
36. Roxanne Harde, "'God or Something Like That': Elizabeth Stuart Phelps's Christian Spiritualism," *Women's Writing* 15, no. 3 (December 2008): 355.
37. Elizabeth Stuart Phelps, *Selected Tales, Essays, and Poems*, ed. Elizabeth Duquette and Cheryl Tevlin (Lincoln: University of Nebraska Press, 2014); Tracy Fessenden, *Culture and Redemption: Religion, the Secular, and American Literature* (Princeton, NJ: Princeton University Press, 2007), 132.
38. Gatrall, *The Real and the Sacred*, 93.
39. Gatrall, *The Real and the Sacred*, 97.
40. A critic for the *New York Herald* (in the years after *The Gates Ajar*) had written that Phelps was "by no means an orthodox Christian. Indeed, after due consideration, we have come to the conclusion that she has quite a little religion of her own." Review of *Men, Women, and Ghosts*, *New York Herald* (May 24, 1869).
41. "Story of Jesus Christ," *Phoenix Weekly Herald* 23, no. 47 (November 25, 1897).
42. Elizabeth Stuart Phelps, *The Story of Jesus Christ: An Interpretation* (New York: Houghton Mifflin, 1897), 384.
43. Phelps, *Jesus Christ*, 265.
44. Elizabeth Stuart Phelps and Herbert D. Ward, *Come Forth!* (New York: Houghton Mifflin, 1891), 313.
45. "The Story of Jesus Christ," *The Outlook* (December 11, 1897): 915.
46. "Impossible Lives of Christ," *New York Times* (January 22, 1898): 49–50.
47. The second anonymous reviewer for the *Times* makes a similar point: "Now and then, among the great religious painters in the golden age of art, there is a suggestion, eked out by the imagination of the eye, which, in a faint and far-away degree, approached what we may imagine to have been the face of the God-Man. But the illustrations in this book are sufficient evidence of the utter inability of the artists of our modern schools and times to represent the features of One who is described in Holy Scripture under two contradictory expressions as 'the One who is altogether lovely' and 'the One who hath no form nor comeliness nor beauty.'"
48. Phelps, *Jesus Christ*, 59.
49. Phelps, *Jesus Christ*, 59.

50. Phelps, *Jesus Christ*, 59.
51. Phelps, *Jesus Christ*, 61.
52. As Gatrall describes in his book, there had been other Jesus novels that endeavored to narrate Christ's thoughts in similar third-person omniscient style, particularly the works of the French writer Harriet Martineau and the German writer Franz Delitzsch. Even so, these cases were rare; in an American context, they were almost unheard of. Phelps was likely the first U.S. writer to occupy such a point of view. That said, these examples all pale in comparison to the unusual first-person *Autobiography by Jesus of Nazareth*, written by the spirit medium Olive G. Pettis in 1870, and excerpted by Laurie Maffly-Kipp in her edited volume *American Scriptures: An Anthology of Sacred Writings* (New York: Penguin, 2010).
53. Phelps, *Jesus Christ*, 107.
54. Phelps, *Jesus Christ*, 9.
55. Phelps, *Jesus Christ*, 9.
56. Phelps, *Jesus Christ*, 11.
57. Phelps, *Jesus Christ*, x.
58. Phelps, *Jesus Christ*, 272.
59. Phelps, *Jesus Christ*, 269.
60. Phelps, *Jesus Christ*, 297.
61. Phelps, *Jesus Christ*, 330.
62. Phelps, *Jesus Christ*, 339–40.
63. "Impossible Lives of Christ," *New York Times*.
64. "Story of Jesus Christ," *The Outlook*.
65. Phelps, *Jesus Christ*, 79.
66. Phelps, *Jesus Christ*, 83–84.
67. Phelps, *Jesus Christ*, 85.
68. Phelps, *Jesus Christ*, 87.
69. Henry Ward Beecher, *The Life of Jesus, The Christ* (New York: J.B. Ford, 1871), 99.
70. "Story of Jesus Christ," *Phoenix Weekly Herald;* "Mrs. Ward's Story of Christ," *The New York Times* (November 13, 1897).
71. "Impossible Lives of Christ," *New York Times*.
72. In the rare cases when *The Story of Jesus Christ* has been mentioned in scholarly literature, the common take is that, in focusing on Jesus Christ's emotionality, Phelps produces a feminized Christ. To some extent, this is true. Many of the tropes that have come to be associated with "feminization" in this period are indeed tropes about emotionality, about Christ as a model of motherly care, about the delicate and "beautiful" features bestowed upon him in lithographs of the time. Indeed, in the broader sense in which Douglas identifies feminization with the "loss of theology," Phelps's *Story* is as prime a suspect as her *Gates* trilogy. Both turn-of-the-twentieth-century critics and turn-of-the-twenty-first-century scholars emphasize the ways in which *The Story of Jesus Christ* was unremarkable, more or less orthodox in some way, good or bad.
73. Phelps was a vocal feminist activist in this period, and yet she was not involved in Elizabeth Cady Stanton's collaborative anthology of feminist Biblical criticism, *The Woman's Bible*, which was released the year after Phelps's Christ biography. Reportedly, Phelps turned down the opportunity to contribute.
74. Van de Port, "(Not) Made by the Human Hand," 76.
75. Modern, *Secularism in Antebellum America*, 19.
76. Kristin Schwain, *Signs of Grace: Religion and American Art in the Gilded Age* (Ithaca, NY: Cornell University Press, 2008), 94. The status of Day's lived sexuality is somewhat vague from an historical perspective. For more, see Jay Hatheway, *The Gilded Age Roots of Modern American Homophobia* (New York: Palgrave-McMillan, 2003), 57; Smith, *At the Edge of Sight*, 44.

77. Schwain, *Signs of Grace*, 82.
78. Day's paradoxical attention to decorative detail and compositional disinterest with it was noted by numerous critics at the time, specifically Robert Demachy, Marmaduke Humphrey, L. M. McCormick, and Sadakichi Hartmann. All four of their reviews are included in *F. Holland Day: Selected Texts and Bibliography*, ed. Verna Posever Curtis and Jane Van Nimmen (Oxford: Clio Press, 1995).
79. Trevor Fairbrother, *Making a Presence: F. Holland Day in Artistic Photography* (New Haven, CT: Yale University Press, 2012), 63.
80. Smith, *At the Edge of Sight*, 41.
81. Smith, *At the Edge of Sight*, 45.
82. Patricia Fanning, *Through an Uncommon Lens: The Life and Photography of F. Holland Day* (Amherst: University of Massachusetts Press, 2008), 107.
83. Marcy Dinius, "The Long History of the Selfie," *J19: The Journal of Nineteenth-Century Americanists* 3, no. 2 (Fall 2015): 446–48.
84. Schwain, *Signs of Grace*, 78.
85. Fairbrother, *Making a Presence*, 63.
86. Schwain, *Signs of Grace*, 80.
87. Smith, *At the Edge of Sight*, 44.
88. Smith, *At the Edge of Sight*, 88.
89. Although Tom Gunning, in his essay on the early cinematic close-up, does not mention Day, he makes an argument that jibes with the claims of both Smith and Schwain. Although photographic close-ups in the late nineteenth century were primarily associated with the professional and recreational practice of physiognomic study, close-ups in early cinema took advantage of technological advancements in order to produce an almost utopian play of "familiar yet uncanny images." In other words, early cinema also utilized the close-up to move beyond the technical limitations of film in order to access something outside its representational boundaries. Ironically, the Passion Play film as a genre was a late adopter of the close-up. Tom Gunning, "In Your Face: Physiognomy, Photography, and the Gnostic Mission of Early Film," *Modernism/modernity* 4, no. 1 (January 1997): 24.
90. André Bazin, *What Is Cinema*, vol. 1 (Berkeley: University of California Press, 2004), 14.
91. Bazin, *What Is Cinema*, 15.
92. Dudley Andrew argues that Bazin, despite his association with the idea of objectivity in film, was a great critic of cinema's absences, especially in this essay. "Our imaginations," he writes, paraphrasing Bazin, "can grasp at the reality that the photograph hints at." *What Cinema Is! Bazin's Quest and Its Charge* (New York: Wiley-Blackwell, 2010), eBook ed., 13.
93. Philip Rosen, "Belief in Bazin," in *Opening Bazin: Postwar Film Theory and Its Afterlife* ed. Dudley Andrew (New York: Oxford University Press, 2011), 111.
94. Peter Coviello and Jared Hickman, "Introduction: After the Postsecular," *American Literature* 86, no. 4 (December 2014): 646.
95. Gunning, "In Your Face," 10.
96. F. Holland Day, "Is Photography an Art?" in *F. Holland Day: Selected Texts and Bibliography*, ed. Verna Posever Curtis and Jane Van Nimmen (Oxford: Clio Press, 1995), 79–80.
97. Neil Harris, *Humbug: The Art of P. T. Barnum* (Chicago: University of Chicago Press, 1974).
98. Fanning, *Through an Uncommon Lens*, 111–33.
99. Smith, *At the Edge of Sight*, 71.
100. Morgan, *Protestants and Pictures*, 280.
101. Modern, *Secularism in Antebellum America*, 157.
102. McGarry, *Ghosts of Futures Past*, 169.

3. TRICKS AND ACTUALITIES: THE PASSION PLAY FILM AND THE CINEMA OF ATTRACTIONS

1. Charles Foster, *Stardust and Shadows: Canadians in Early Hollywood* (Toronto, Canada: Dundurn, 2000), 929. As I discuss in this chapter, Olcott's narration of this meeting constitutes a useful bit of mythology for the film, but it's very possibly inaccurate. Bland himself, in his 1922 memoir, *From the Manger to the Cross: The Story About the World-Famous Film of the Life of Jesus*, tells a very different story, one in which he specifically does not self-identify as Jesus. In his version, Bland was hesitant, and Olcott had to convince him to take the part.
2. John L. Stoddard, *The Passion Play* (Chicago: Belford, Middlebrook, 1897), 18–19.
3. Charles Musser, "Passions and the Passion Play: Theatre, Film, and Religion in America, 1880–1900," *Film History* 5, no. 4 (December 1993): 422. Musser's work, along with the essays collected in *An Invention of the Devil?* and in Shepherd's *Silents of Jesus* anthology, constitute the most thorough sources on the early Passion Play film. See Roland Cosandey, André Gaudreault, and Tom Gunning, eds., *An Invention of the Devil?* (Sainte-Foy, Quebec, Canada: Presses de l'Université Laval, 1992) and David J. Shepherd, ed., *The Silents of Jesus in the Cinema (1897–1927)* (New York: Routledge, 2016). Later Jesus films have received much more attention. For monographs on the depiction of Jesus in film, see, for instance, Richard Walsh, *Reading the Gospels in the Dark* (New York: Bloomsbury, 2003); Adele Reinhartz, *Jesus of Hollywood* (New York: Oxford University Press, 2007); W. Barnes Tatum, *Jesus at the Movies*, 3rd ed. (Farmington, MN: Polebridge, 2012).
4. Doris Alexander, "The Passion Play in America," *American Quarterly* 11, no. 3 (Autumn 1959): 365–66.
5. Alexander, "The Passion Play in America," 353.
6. For more on the deep, already-existing commercialization of Protestantism in this period, see R. Laurence Moore, *Selling God: American Religion in the Marketplace of Culture* (New York: Oxford University Press, 1994) and Colleen McDannell, *Material Christianity: Religion and Popular Culture in America* (New Haven, CT: Yale University Press, 1995).
7. Musser, "Passions and the Passion Play," 420.
8. Writing about later filmed Passion Plays, André Gaudreault further suggests that it was the documentary frame itself that helped ease the transition from stage play to screen: "What better way to be cleared of all responsibility than to create, or pretend to create, a filmic document of a theatrical fiction, by filming in a 'documentary' manner a Passion Play performed as a 'fiction' on the stage of one theater or another?" André Gaudreault, "The Passion of Christ: A Form, a Genre, a Discourse," in Shepherd, *The Silents of Jesus*, eBook.
9. Vivian Sobchack, *Carnal Thoughts: Embodiment and Moving Image Culture* (Berkeley: University of California Press, 2004), 143.
10. Sobchack, *Carnal Thoughts*, 143.
11. Sobchack, *Carnal Thoughts*, 146.
12. Siegfried Kracauer, *Theory of Film: The Redemption of Physical Reality* (Princeton, NJ: Princeton University Press, 1997), 30.
13. There is a separate, concurrent conversation to be traced in early theories of the cinema of attractions between attractions themselves and narrative. Aside from Gunning's essay to which they both respond, the crucial essays in this debate include Donald Crafton's 1987 "Pie and Chase: Gag, Spectacle, and Narrative in Slapstick Comedy," and Charles Musser's 1994 "Rethinking Early Cinema: Cinema of Attractions and Narrativity." These essays are all helpfully collected in *The Cinema of Attractions Reloaded*, ed. Wanda Strauven (Amsterdam: Amsterdam University Press, 2006). I return to this particular strain of the attractions debate in chapter 4.
14. André Bazin, *Bazin at Work* (New York: Routledge, 1997), 73.
15. Gaudreault, "The Passion of Christ," eBook.

16. William James, *The Varieties of Religious Experience* (Cambridge, MA: Riverside, 1902).
17. Adam Lowenstein, *Dreaming of Cinema: Spectatorship, Surrealism, and the Age of Digital Media* (New York: Columbia University Press, 2015), 15–16.
18. John Lardas Modern, *Secularism in Antebellum America* (Chicago: University of Chicago Press, 2013), 20–21.
19. Tom Gunning, "An Aesthetic of Astonishment: Early Film and the (In)credulous Spectator," in *Film and Theory*, ed. Robert Stam and Toby Miller (New York: Blackwell, 2000), 121.
20. Charles Musser, *Edison Motion Pictures: An Annotated Filmography, 1890–1900* (Washington, DC: Smithsonian Institution Press, 1997), 370.
21. Musser, *Edison Motion Pictures*, 370.
22. Musser, *Edison Motion Pictures*, 370.
23. Musser, *Edison Motion Pictures*, 119.
24. Tom Gunning, "Passion Play as Palimpsest: The Nature of the Text in the History of Early Cinema," in *An Invention of the Devil? Religion and Early Cinema*, ed. Roland Cosandey, André Gaudreault, and Tom Gunning (Sainte-Foy, Quebec, Canada: Les Presses de l'Université Laval, 1992), 106.
25. Tom Gunning, "Now You See It, Now You Don't: The Temporality of the Cinema of Attractions," in *The Silent Cinema Reader*, ed. Lee Grieveson and Peter Kramer (New York: Routledge, 2004), 49.
26. Alison McMahan, *Alice Guy-Blache: Lost Visionary of Cinema* (New York: Bloomsbury Academic, 2003), 98.
27. Shepherd, *The Silents of Jesus*, eBook.
28. Karen Beckman, *Vanishing Women: Magic, Film, Feminism* (Durham, NC: Duke University Press, 2003), 8.
29. Ironically, the resurrection is consistently understood by filmmakers as underserved by previous filmmakers. Even Cecil B. DeMille, in 1927, insisted on spending an extraordinarily large amount of his film's budget and resources on making the resurrection the technical marvel of the film.
30. Alice Guy-Blache, *The Memoirs of Alice Guy-Blache*, ed. Anthony Slide, trans. Roberta and Simone Blache (New York: Scarecrow, 1986), 46.
31. McMahan, *Lost Visionary*, 89.
32. The production history of the various Pathé Passion Play films of this era (1899, 1902–1905, 1907, 1913) is complex and, in many ways, inscrutable. It is, for reasons common to historical work in early cinema, difficult to positively trace the origin of many of the scenes that comprise the various versions. That said, the heroic detective work of Alain Boillat, Valentine Robert, Dwight Friesen, and Jo-Ann Brant—collected in David Shepherd's indispensable collection *The Silents of Jesus in the Cinema (1897–1927)* (New York: Routledge, 2016)—is the best starting point for sorting this mystery. This book refers solely to the 1907 version as it has been made commercially available by Image Entertainment—though, somewhat hilariously, the Image Entertainment DVD mislabels the 1907 version as the 1902 version in its copy. For more on the popularity of the 1907 film in the United States, see Richard Abel, *Americanizing the Movies and Movie Mad Audiences, 1910–1914* (Berkeley: University of California Press, 2006), 22–24; and for a brief, yet detailed, analysis of the incremental stylistic alterations of both the Guy and Zecca films, see Richard Abel, *The Cine Goes to Town: French Cinema, 1896–1914* (Berkeley: University of California Press, 1994), 164–66.
33. Noel Burch, *Life to Those Shadows* (Berkeley: University of California Press, 1990), 154.
34. Charles Keil, "*From the Manger to the Cross*: The New Testament Narrative and the Question of Stylistic Retardation," in Cosandey, Gaudreault, and Gunning, *An Invention of the Devil*, 112.
35. Sobchack, *Carnal Thoughts*, 141.
36. Willis Goth Regier, *Book of the Sphinx* (Lincoln: University of Nebraska Press, 2004), 104.
37. Despite not being shot on location in the Holy Land, both the Zecca and Guy films far outstrip earlier Passion Play films in their use of outdoor locations.
38. Gene Gauntier, "Blazing the Trail," *Woman's Home Companion* 56 (January 1929): 21.

39. Tom Gunning, "'The Whole World Within Reach': Travel Images Without Borders," in *Virtual Voyages: Cinema and Travel*, ed. Jeffrey Ruoff (Durham, NC: Duke University Press, 2006), 27.
40. For more on the centrality of "historical" vision in the Passion Play film, and its advantages and disadvantages, see Reinhartz, *Jesus of Hollywood*.
41. Mary Ann Doane, *The Emergence of Cinematic Time: Modernity, Contingency, the Archive* (Cambridge, MA: Harvard University Press, 2002), 23.
42. Charles Keil, "Integrated Attractions: Style and Spectatorship in Transitional Cinema," in *The Cinema of Attractions Reloaded*, ed. Wanda Strauven (Amsterdam: Amsterdam University Press, 2006), 199. See also Charlie Keil and Shelley Stamp, eds., *American Cinema's Transitional Era: Audiences, Institutions, Practices* (Berkeley: University of California Press, 2004).
43. See Gunning, "The Cinema of Attraction[s]: Early Film, Its Spectator, and the Avant-Garde," 382; Crafton, "Pie and Chase: Gag, Spectacle and Narrative in Slapstick Comedy," 356; Bukatman, "Spectacle, Attractions and Visual Pleasure," 71; Pierre-Emmanuel Jaques, "The Associational Attractions of the Musical"; and Dick Tomasovic, "The Hollywood Cobweb: New Laws of Attraction," all in Strauven, *Cinema of Attractions Reloaded*. See also Adam Lowenstein, *Shocking Representation: Historical Trauma, National Cinema, and the Modern Horror Film* (New York: Columbia University Press, 2005); Kristen Whissel, *Spectacular Digital Effects: CGI and Contemporary Cinema* (New York: Columbia University Press, 2014); Jane Hu, "GIF Typologies and the Heritage of the Moving Image," *Hyperallergic* (September 28, 2012) (online); Phillip Maciak, "Is Beyoncé the Future of Digital Cinema?" *Slate Magazine* (November 24, 2014) (online); Amanda Hess, "The Silent Film Returns—on Social Media," *New York Times*, September 13, 2017.
44. Critiques of narrative cinema often take form as calls to active viewing over passive viewing. I see the life of attractions in the era of narrative integration as part of the same lineage as something like bell hooks's "oppositional gaze," in this way.
45. Miriam Bratu Hansen, *Babel and Babylon: Spectatorship in American Silent Film* (Cambridge, MA: Harvard University Press, 1991), 56.

4. THE DOUBLE LIFE OF SUPERIMPOSITION: W. E. B. DU BOIS'S BLACK CHRIST CYCLE

1. W. E. B Du Bois, "Strivings of the Negro People," *Atlantic Monthly* 80, no. 478 (August 1897), 194.
2. Shawn Michelle Smith, *Photography on the Color Line: W. E. B. Du Bois, Race, and Visual Culture* (Durham, NC: Duke University Press, 2004), 25.
3. Saidiya Hartman and Farah Jasmine Griffin, "Are You as Colored as That Negro? The Politics of Being Seen in Julie Dash's Illusions," *Black American Literature Forum* 25, no. 2 (Summer 1991): 361–72; Jane Gaines, *Fire and Desire: Mixed-Race Movies in the Silent Era* (Chicago: University of Chicago Press, 2001).
4. Smith, *Photography on the Color Line*, 41.
5. Allyson Nadia Field, *Uplift Cinema: The Emergence of African American Film and the Possibility of Black Modernity* (Durham, NC: Duke University Press, 2015), 21.
6. For an account of how Du Bois's writings on race influenced the development of black film criticism in this moment, see Anna Everett, *Returning the Gaze: Genealogies of Black Film Criticism, 1909–1949* (Durham, NC: Duke University Press, 2001).
7. Tom Gunning, "An Aesthetic of Astonishment: Early Film and the (In)credulous Spectator" in *Film and Theory*, edited by Robert Stam and Toby Miller (New York: Blackwell, 2000), 121.
8. Gunning, "An Aesthetic of Astonishment," 128. See also Adorno on the "phantasmagoric" in cinema: Theodor Adorno, *In Search of Wagner* (New York: Verso, 2005).

9. Sergei Eisenstein, "Montage of Attractions," trans. Daniel Gerould, *Drama Review* 18, no. 1 (March 1974): 78–79.
10. Sergei Eisenstein, *Film Form*, trans. Jay Leyda (New York: Meridian, 1957), 45–46.
11. Eisenstein, *Film Form*, 46.
12. Sergei Eisenstein, "Dickens, Griffith, and the Film Today," in *Film Form*, 234–35.
13. James Chandler argues that, in this essay, Eisenstein objects to a "practice of montage grounded in *alternation* of viewpoint rather than the *alteration* of viewpoint." The former technique, Chandler suggests, Eisenstein yoked together with liberalism. *An Archaeology of Sympathy: The Sentimental Mode in Literature and Cinema* (Chicago: University of Chicago Press, 2013), 32. See also Yuri Tsivian, "Talking to Miriam: Soviet Americanitis and the Vernacular Modernism Thesis," *New German Critique* 21, no. 2 (2014): 47–65.
14. Peter Novick, *That Noble Dream: The Objectivity Question and the American Historical Profession* (Cambridge: Cambridge University Press, 1988), 77.
15. Novick, *That Noble Dream*, 80.
16. W. E. B. Du Bois, *Black Reconstruction in America, 1860–1880* (New York: Simon and Schuster, 1999), 711–12.
17. Robyn Wiegman, *Object Lessons* (Durham, NC: Duke University Press, 2012), 146. See also Eric Lott, *Love and Theft: Blackface Minstrelsy and the American Working Class* (New York: Oxford University Press, 1995); David Roediger, *The Wages of Whiteness* (New York: Verso, 2007); and Carol Anderson, *White Rage: The Unspoken Truth of Our Racial Divide* (New York: Bloomsbury, 2017).
18. Quoted in Mike Konczal, "How Radical Change Occurs," *The Nation*, February 3, 2015.
19. Edward Blum, *W. E. B. Du Bois: American Prophet* (Philadelphia: University of Pennsylvania Press, 2007), 145.
20. Orlando Patterson, *Rituals of Blood: The Consequences of Slavery in Two American Centuries* (New York: Civitas Books, 1999).
21. W. Scott Poole, "Confederate Apocalypse: Theology and Violence in the White Reconstruction South," in *Vale of Tears*, ed. Edward Blum and W. Scott Poole (Macon: University of Georgia Press, 2005), 40.
22. James H. Cone, *The Cross and the Lynching Tree* (New York: Orbis Books, 2011), xv.
23. Kelly J. Baker, *Gospel According to the Ku Klux Klan: The KKK's Appeal to Protestant America, 1915–1930* (Lawrence: University Press of Kansas, 2011), 47.
24. George Shulman, "White Supremacy and Black Insurgency as Political Theology," in *Race and Secularism in America*, edited by Jonathon Kahn and Vincent Lloyd (New York: Columbia University Press, 2016), 32. See also Vincent Lloyd's introduction to that volume for a more broadly focused theorization of whiteness as a metonym for the secular.
25. Shulman, "White Supremacy and Black Insurgency," 33. Josef Sorett has similarly argued that the history of what he calls "racial aesthetics" in the twentieth century is rooted in the collapsing of boundaries between religious and secular. *Spirit in the Dark: A Religious History of Racial Aesthetics* (New York: Oxford University Press, 2016).
26. Du Bois, *Black Reconstruction*, 714.
27. Lary May, *Screening Out the Past: The Birth of Mass Culture and the Motion Picture Industry* (Chicago: University of Chicago Press, 1982), 71.
28. Anon. 1915. D. W. Griffith Papers, 1897–1954. Frederick, MD: University Publications of America, 1982. Microfilm at Annenberg Library.
29. Griffith Papers; Frederick Johns, "'Birth of a Nation' Enthralling Story, 1,500 Guests See History Told on Film." *Boston American*, 10 April 1915; "'The Birth of a Nation' Film Masterwork, Says Dorothy Dix." *New York Journal* (March 8, 1915).
30. Melvyn Stokes, *D. W. Griffith's The Birth of a Nation: A History of the Most Controversial Film of All Time* (Oxford: Oxford University Press, 2007), 111.

31. Thomas B. Gregory, "'Birth of a Nation' True and Wonderful," *New York American*, (March 5, 1915).
32. Gregory, "'Birth of a Nation' True and Wonderful."
33. Richard Barry, "Five Dollar Movies Prophesied," *New York Times* (March 28, 1915).
34. Michael Rogin, "The Sword Became a Flashing Vision," in *The Birth of a Nation: D. W. Griffith, Director*, ed. Robert Lang (New Brunswick, NJ: Rutgers University Press, 1994), 287.
35. This is, to some extent, a particular version of Roland Barthes's "reality effect." *The Rustle of Language,* trans. R. Howard (Berkeley: University of California Press, 1989).
36. For more on the idea of a specifically white Christ validating the ideology of white supremacy, see Edward Blum and Paul Harvey, *The Color of Christ: The Son of God and the Saga of Race in America* (Chapel Hill: University of North Carolina Press, 2014).
37. Russell Merritt, "Dixon, Griffith, and the Southern Legend," *Cinema Journal* 12, no. 1 (Autumn 1972): 43.
38. Helmut Färber, "On the Endings of *The Birth of a Nation* and *Intolerance*," in *The Griffith Project: Volume 12: Essays on D. W. Griffith*, ed. Paolo Cherchi Usai and Cynthia Roswell (London: Palgrave Macmillan, 2003) 93.
39. Robert Lang, ed., *The Birth of a Nation: D. W. Griffith, Director* (New Brunswick, NJ: Rutgers University Press, 1994), 24.
40. Philip Rosen, "Securing the Historical: Historiography and Classical Cinema," in *Cinema Histories, Cinema Practices*, ed. Patricia Mellencamp and Philip Rosen (Frederick, MD: University Publications of America, 1984), 23. Other notable analyses of this scene are those by Katherine Fusco, "Taking Naturalism to the Moving Picture Show: Frank Norris, D. W. Griffith, and Naturalist Editing," *Adaptation* 3, no. 2 (September 1, 2010): 155–78; and Richard Walsh, "*The Birth of a Nation* and *Intolerance*: Griffith's Talismanic Jesus," in *The Silents of Jesus in the Cinema (1897–1927)*, ed. David J. Shepherd (New York: Routledge, 2016).
41. Cedric J. Robinson, *Forgeries of Memory and Meaning: Blacks and the Regimes of Race in American Theater and Film Before World War II* (Chapel Hill: The University of North Carolina Press, 2007), 104.
42. The scholarship on spirit photography and Spiritualism as a belief system is deep and, unsurprisingly, dovetails with the scholarship on aesthetics and visual culture in the period. John Harvey refers to the way spirit photography puts into relief the photographic apparatus's "double identity" as a tool for the "objective" recording of the world and "an uncanny, almost magical process." John Harvey, *Photography and Spirit* (London: Reaktion Books, 2007), 7. Simone Natale characterizes spirit photography in this way: "The circulation of superimposition to multiple technological and cultural contexts framed it as a body of technologies and knowledge that wavered between realism and fantasy, stasis and movement, fiction and belief." Simone Natale, *Supernatural Entertainments: Victorian Spiritualism and the Rise of Modern Media Culture* (University Park: Pennsylvania State University Press, 2016), 136. See also Tom Gunning, "To Scan a Ghost: The Ontology of Mediated Vision," *Grey Room* 26 (Winter 2007), 94–127; Louis Kaplan, *The Strange Case of William Mumler, Spirit Photographer* (Minneapolis: University of Minnesota Press, 2008); and Ann Braude and Molly McGarry.
43. No matter how blunt a tool, it's important to acknowledge that spirit photography was, at that time, understood by some to be a legitimate object of belief. In 1869, Mumler was brought to trial for fraud. Despite the testimony of numerous expert witnesses—including P. T. Barnum—who elaborately explained the ease with which Mumler could use photographic processes to fabricate this miraculous occurrence, the photographer was acquitted by a court of law. Even in the face of its obvious artifice, the spirit photograph lent the weight of secular modernity to the melancholy hope that this is not all there is.
44. Matthew Solomon, *Disappearing Tricks: Silent Film, Houdini, and the New Magic of the Twentieth Century* (Urbana: University of Illinois Press, 2010), 16.

45. André Bazin, *Bazin at Work* (New York: Routledge, 1997), 74.
46. Gunning, "To Scan a Ghost," 116.
47. See also Daniel Morgan, "The Afterlife of Superimposition," in *Opening Bazin: Postwar Film Theory and Its Afterlife*, ed. Dudley Andrew and Herve Joubert-Laurencin (Oxford: Oxford University Press, 2011), 130.
48. W. E. B. Du Bois, *Dusk of Dawn: An Essay Toward an Autobiography of a Race Concept* (New York: Harcourt, Brace & World, 1940), 240.
49. The film that resulted was, by any measure, a disaster. Originally called *Lincoln's Dream*, but eventually released—without the support of the NAACP—as *The Birth of a Race*, the film suffered throughout the development process from the interference of white co-producers who slowly drained the script of its most pointed challenges to Griffith. Stokes, *D. W. Griffith's Birth of a Nation*, 165. On other attempts to produce a cinematic response to Griffith's film, particularly the Hampton Institute's epilogue, *The New Era*, see Allyson Nadia Field, *Uplift Cinema*, 151–85. For more on the critical response to the film in black media, see Everett, *Returning the Gaze*.
50. W. E. B. Du Bois, "A Pageant," *The Crisis* 10, no. 5 (September 1915): 230.
51. W. E. B. Du Bois, "The Drama Among Black Folk," *The Crisis* 12, no. 4 (August 1916): 169.
52. Du Bois, "The Drama Among Black Folk."
53. The idea of a black deity, specifically of the Black Christ, whose sufferings are the sufferings of the African American community, is one that comes up repeatedly, either explicitly or by inference, in the works of many of the central figures of African American modernism, from Du Bois to Nella Larsen to Countee Cullen and Langston Hughes, and it has roots through the early nineteenth century when, as Laurie Maffly-Kipp suggests in *Setting Down the Sacred Past* (Cambridge, MA: Harvard University Press, 2010), it emerged as a figure resistant to narratives of African American genetic inferiority.
54. The limited scholarship on these stories is restricted primarily to Eric Sundquist's chapter, "The Spell of Africa" in *To Wake the Nations: Race in the Making of American Literature* (Cambridge, MA: Harvard University Press, 1993), and chapters in Edward Blum's *W. E. B. Du Bois: American Prophet* (2007) and Jonathon Kahn's *Divine Discontent: The Religious Imagination of W. E. B. Du Bois* (New York: Oxford University Press, 2009). The latter two are part of a larger movement to excavate Du Bois as a kind of hero of the postsecular moment. Of these, Sundquist's is the most thorough, though the scope of his inquiry restricts itself primarily to the three pieces from *The Crisis* that Du Bois reprinted without their original illustrations in *Darkwater*—"Jesus Christ in Georgia" (1911, as "Jesus Christ in Texas"), "Prayers of God" (1914, as "Christmas Prayers of God"), and "The Second Coming" (1917)—as well as "The Son of God" (1933), Du Bois's final Black Christ story. Only Amy Helene Kirschke's *Art in Crisis: W. E. B. Du Bois and the Struggle for African American Identity and Memory* (Bloomington: Indiana University Press, 2007) has approached any of these stories with significant attention to their accompanying images. In addition to these texts, the larger archive includes, most prominently, "The Flight into Egypt" (1918), "The Gospel According to Mary Brown" (1919), "Pontius Pilate" (1920), "The Great Surgeon" (1922), "The Gospel According to St. John, Chapter 12" (1923), "The Temptation in the Wilderness" (1924), and all of the assorted illustrations—photographs, drawings, and multimedia works—that appeared in Christmas issues of *The Crisis* during this time. The archive of Black Christ stories and illustrations is wide and by no means fully represented by those few stories Du Bois chose to include in *Darkwater*.
55. Richard Wightman Fox, *Jesus in America: Personal Hero, Cultural Savior, National Obsession* (New York: HarperOne, 2004), 458.
56. Russ Castronovo, "Beauty Along the Color Line: Lynching, Aesthetics, and *The Crisis*," *PMLA* 121, no. 5 (October 2006): 1444.
57. Amy Louise Wood, *Lynching and Spectacle: Witnessing Racial Violence in America, 1890–1940* (Chapel Hill: University of North Carolina Press, 2009), 3.

58. Wood, *Lynching and Spectacle*, 2.
59. Wood, *Lynching and Spectacle*, 205.
60. Jacqueline Goldsby, *A Spectacular Secret: Lynching in American Life and Literature* (Chicago: University of Chicago Press, 2006), 26.
61. W. E. B. Du Bois, "The Gospel According to Mary Brown," *The Crisis* 19, no. 2 (December 1919): 42.
62. W. E. B. Du Bois, "The Gospel According to St. John Chapter 12." *The Crisis* 27, no. 2 (December 1923): 55–56.
63. Du Bois, "The Gospel According to St. John," 56.
64. As I have mentioned elsewhere, the scholarship on these stories tends to focus on the figure of Christ, to discern a theology or logic to the way Christ himself is adapted in these stories. Although the compilation of such a Christology is valuable—especially in Jonathon Kahn's study of "sacrifice" in the cycle—this singular focus sidesteps the spectators of the Black Christ's lynching, who almost always become pivotal point-of-view characters, even if just at the end.
65. Wood, *Lynching and Spectacle*, 5.
66. Wood, *Lynching and Spectacle*, 5.
67. Courtney R. Baker, *Humane Insight: Looking at Images of African American Suffering and Death* (Urbana, IL: University of Illinois Press, 2015), 5.
68. W. E. B. Du Bois, "Jesus Christ in Georgia," *The Crisis* 3, no. 2 (December 1911): 74.
69. W. E. B. Du Bois, "The Son of God," *The Crisis* (December 1933): 277.
70. Du Bois, "The Son of God," 277.
71. Du Bois, "The Son of God," 277.
72. Du Bois, "The Son of God," 277.

CODA

1. Thomas Elsaesser, "A Bazinian Half-Century," in *Opening Bazin: Postwar Film Theory and Its Afterlife*, ed. Dudley Andrew and Herve Joubert-Laurencin (Oxford: Oxford University Press, 2011), 3.
2. S. Brent Plate, *Religion and Film: Cinema and the Re-Creation of the World* (New York: Wallflower, 2009), 2. On film as world-making, see also Daniel Yacavone, *Film Worlds: A Philosophical Aesthetics of Cinema* (New York: Columbia University Press, 2015).
3. David Bordwell, Janet Staiger, and Kristin Thompson, *The Classical Hollywood Cinema: Film Style and Mode of Production to 1960* (New York: Columbia University Press, 1985), 3.
4. Bruce Barton Papers, Wisconsin Historical Society.
5. Bruce Barton, *The Man Nobody Knows: A Discovery of the Real Jesus* (Indianapolis, IN: Bobbs-Merrill, 1923), 10–11.
6. Richard M. Fried, *The Man Everybody Knew: Bruce Barton and the Making of Modern America* (Chicago: Ivan R. Dee, 2005).
7. Daniel Lord, *Played by Ear* (Chicago: Loyola University Press, 1956), 280.
8. Miriam Bratu Hansen, *Babel and Babylon: Spectatorship in American Silent Film* (Cambridge, MA: Harvard University Press, 1991), 168.
9. Sumiko Higashi, *Cecil B. DeMille and American Culture: The Silent Era* (Berkeley: University of California Press, 1994), 93.
10. Richard Misek, *Chromatic Cinema: A History of Screen Color* (London: Wiley-Blackwell), 28.
11. Quoted in Richard Eyman, *Empire of Dreams: The Epic Life of Cecil B. DeMille* (New York: Simon and Schuster, 2010), 244.
12. Mordaunt Hall, "Cecil B. DeMille's *King of Kings* Is an Impressive Piece of Work," *New York Times*, April 24, 1927.

13. Eyman, *Empire of Dreams*, 233.
14. See Hent de Vries, "In Media Res: Global Religion, Public Spheres, and the Task of Contemporary Comparative Religious Studies," in *Religion and Media*, ed. Hent de Vries and Samuel Weber (Redwood City, CA: Stanford University Press, 2001), 23–29.
15. Eyman, *Empire of Dreams*, 232.
16. Alison Griffiths, "The Revered Gaze: The Medieval Imaginary in Mel Gibson's *Passion of the Christ*," *Cinema Journal* 46, no. 2 (Winter 2007): 3.
17. David Edelstein, "Jesus H. Christ," *Slate Magazine*, February 24, 2004, https://www2.kenyon.edu/Depts/Religion/Fac/Adler/Reln101/Gibson-Slate.htm.
18. Peggy Noonan, "Mel Gibson's *The Passion* Gets a Thumbs-Up from the Pope," *Wall Street Journal*, December 17, 2003.
19. Stephen Prince, "Beholding Blood Sacrifice in *The Passion of the Christ*: How Real Is Movie Violence?" *Film Quarterly* 59, no. 4 (Summer 2006): 12.
20. Roger Ebert, "*The Passion of the Christ*," *Chicago Sun-Times*, February 24, 2004.
21. Vivian Sobchack, "Embodying Transcendence: On the Literal, the Material, and the Cinematic Sublime," *Material Religion* 4, no. 2 (2008): 201.
22. Sobchack, "Embodying Transcendence," 196.
23. J. Hoberman, *Film After Film, or What Became of Twenty-First Century Cinema?* (New York: Verso Books, 2012), 22.
24. Prince, "Beholding Blood Sacrifice," 15.
25. Prince, "Beholding Blood Sacrifice," 14.
26. Amy Hollywood writes that the scene "suggests vengeance rather than salvation." "Kill Jesus," in *Mel Gibson's Bible: Religion, Popular Culture and* The Passion of the Christ (Chicago: University of Chicago Press, 2006), 166. This is one of *many* scholarly anthologies about Gibson's film to be released in its aftermath. Also of note is *Re-Viewing the Passion: Mel Gibson's Film and Its Critics*, ed. S. Brent Plate (New York: Palgrave-McMillan, 2004).
27. Griffiths, "The Revered Gaze," 15.
28. Richard Barry, "Five Dollar Movies Prophesied," *New York Times*, March 28, 1915.
29. Susan Sontag, "The Decay of Cinema," *New York Times*, February 26, 1996.
30. Lev Manovich, "What Is Digital Cinema?" http://manovich.net/index.php/projects/what-is-digital-cinema.
31. D. N. Rodowick, *The Virtual Life of Film* (Cambridge, MA, 2007), 109.
32. Manovich, "What Is Digital Cinema?," 21.
33. This view is not incompatible even with some of the prophecies of cinema's decline. Rodowick paints one of the sharpest pictures of post-cinema in his *Virtual Life of Film*, while also maintaining that something is lost in the bargain. Alexander Galloway, *Gaming: Essays on Algorithmic Culture* (Minneapolis: University of Minnesota Press, 2006); Francesco Casetti, *The Lumière Galaxy: Seven Key Words for the Cinema to Come* (New York: Columbia University Press, 2015), 4.
34. André Gaudreault and Philippe Marion, *The End of Cinema? A Medium in Crisis in the Digital Age*, trans. Timothy Barnard (New York: Columbia University Press, 2015), 26.
35. Shane Denson and Julia Leyda, "Perspectives on Post-Cinema: An Introduction" in *Post-Cinema: Theorizing 21st Century Film*, ed. Shane Denson and Julia Leyda (Falmer: REFRAME Books, 2016), 2.
36. Denson and Leyda, "Perspectives," 5.
37. Steven Shaviro, *Post Cinematic Affect* (New York: Zero Books, 2010), 2.
38. Dudley Andrew, *What Cinema Is!: Bazin's Quest and Its Charge* (New York: Wiley-Blackwell, 2010), eBook.
39. Darragh O'Donaghue, "Bill Morrison: *Ghost Trips* and *Just Ancient Loops*," *Cinematheque Annotations on Film*, no. 76, (September 2015), http://sensesofcinema.com/2015/cteq/ghost-trip-just-ancient-loops/.

40. Eva Hoffman, "Just Ancient Loops," in *The Films of Bill Morrison: Aesthetics of the Archive*, ed. Bernd Herzogenrath (Amsterdam: Amsterdam University Press, 2017).
41. Nicholas Rombes, *10/40/70: Constraint as Liberation in the Era of Digital Film Theory* (New York: Zero Books, 2014), 3.
42. Mark Cauchi and John Caruana, eds., *Immanent Frames: Postsecular Cinema Between Malick and von Trier* (Buffalo: SUNY Press, 2018).
43. Rombes, *10/40/70*, 9. Susan Sontag, writing a few years before the rise of the formalism Rombes describes, voiced a similar critique. "The reduction of cinema to assaultive images," she writes, "and the unprincipled manipulation of images (faster and faster cutting), to make them more attention-grabbing, has produced a disincarnated, lightweight cinema that doesn't demand anyone's full attention." This concern about "unprincipled manipulation" is shared across these discourses. Sontag, "The Decay of Cinema."
44. A. O. Scott, "Neo-Neo-Realism," *New York Times*, March 17, 2009.
45. Susan Sontag, "Spiritual Style in the Films of Robert Bresson," in *Against Interpretation* (New York: Picador, 1966), 181.
46. Paul Schrader, *Transcendental Style in Film* (New York: Da Capo, 1972), 63.
47. Peter Coviello and Jared Hickman, "Introduction: After the Postsecular," *American Literature* 86, no. 4 (December 2014): 647.
48. Alongside *Taste of Cherry* (1996), Steven Soderbergh's *Sex, Lies, and Videotape* (1989), Sally Potter's *Orlando* (1993), and Jane Campion's *The Portrait of a Lady* (1996) all feature provocative juxtapositions of film and video footage. *Orlando* bears the closest formal relationship to *Taste of Cherry*, in that the cut to video occurs in the final scene, but of these only *Taste of Cherry* never returns to film.
49. It seems worth noting, if only as a curiosity in line with this argument, that, just as Roger Ebert was one of the very few mainstream critics who raved about Gibson's *Passion*, he was also one of very few critics to pan *Taste of Cherry*.
50. Abbas Kiarostami, with Bill Horrigan, "In Conversation with Kiarostami," in *The Religion and Film Reader*, ed. Jolyon Mitchell and S. Brent Plate (New York: Routledge, 2007), 88.
51. Mitchell and Plate, *The Religion and Film Reader*, 90.
52. Michael Price, "Imagining Life: The Ending of *Taste of Cherry*," *Senses of Cinema* no. 17 (November 2001).

Bibliography

Abel, Richard. *The Cine Goes to Town: French Cinema, 1896–1914*. Berkeley: University of California Press, 1994.
———. *Americanizing the Movies and Movie-Mad Audiences, 1910–1914*. Berkeley: University of California Press, 2006.
Albanese, Catherine. *A Republic of Mind and Spirit: A Cultural History of American Metaphysical Religion*. New Haven, CT: Yale University Press, 2007.
Alexander, Doris. "The Passion Play in America." *American Quarterly* 11, no. 3 (Autumn 1959): 350–71.
Anderson, Carol. *White Rage: The Unspoken Truth of Our Racial Divide*. New York: Bloomsbury, 2017.
Andrew, Dudley. *What Cinema Is!: Bazin's Quest and Its Charge*. New York: Wiley-Blackwell, 2010. Ebook.
Andrew, Dudley, and Herve Joubert-Laurencin, eds. *Opening Bazin: Postwar Film Theory and Its Afterlife*. Oxford: Oxford University Press, 2011.
Asad, Talal. *Formations of the Secular: Christianity, Islam, Modernity*. Stanford, CA: Stanford University Press, 2003.
Baker, Courtney. Humane Insight: Looking at Images of African American Suffering and Death. Champaign, IL: University of Illinois Press, 2015.
Baker, Kelly J. *Gospel According to the Ku Klux Klan: The KKK's Appeal to Protestant America, 1915–1930*. Lawrence: University Press of Kansas, 2011.
Barry, Richard. "Five Dollar Movies Prophesied," *New York Times* March 28, 1915.
Barthes, Roland. *The Rustle of Language,* trans. R. Howard. Berkeley: University of California Press, 1989.
Barton, Bruce. *The Man Nobody Knows: A Discovery of the Real Jesus*. Indianapolis, IN: Bobbs-Merrill, 1923.
Bazin, André. *Bazin at Work*. New York: Routledge, 1997.
———. *What Is Cinema*, vol. 1. Berkeley: University of California Press, 2004.
Beckman, Karen. *Vanishing Women: Magic, Film, Feminism*. Durham, NC: Duke University Press, 2003.
Beecher, Henry Ward. *The Life of Jesus, The Christ*. New York: J.B. Ford, 1871.
"Ben-Hur." *Los Angeles Times,* April 29, 1888.
Bland, Robert Henderson. *From the Manger to the Cross: The Story About the World-Famous Film of the Life of Jesus*. London: Hodder and Stoughton, 1922.
Bliss, W. D. P., ed. *The New Encyclopedia of Social Reform*. New York: Funk and Wagnalls, 1908.
Blum, Edward. *W. E. B. Du Bois: American Prophet*. Philadelphia: University of Pennsylvania Press, 2007.
Blum, Edward, and Paul Harvey. *The Color of Christ: The Son of God and the Saga of Race in America*. Chapel Hill: University of North Carolina Press, 2014.

Bordwell, David, Janet Staiger, and Kristin Thompson. *The Classical Hollywood Cinema: Film Style and Mode of Production to 1960*. New York: Columbia University Press, 1985.

Bradatan, Costica, and Camil Ungureanu, eds. *Religion in Contemporary European Cinema: The Postsecular Constellation*. New York: Routledge, 2017.

Braude, Ann. *Radical Spirits: Spiritualism and Women's Rights in Nineteenth-Century America*. Boston: Beacon Press, 1989.

Burch, Noel. *Life to Those Shadows*. Berkeley: University of California Press, 1990.

Burton, Ernest DeWitt and Shailer Mathews. *The Life of Christ: An Aid to Historical Study and a Condensed Commentary on the Gospels*. Chicago: University of Chicago Press, 1900.

Bushnell, Horace. *Nature and the Supernatural as Together Constituting the One System of God*. New York: Scribner, Armstrong, 1872.

Caddoo, Cara. *Envisioning Freedom: Cinema and the Building of Modern Black Life*. Cambridge, MA: Harvard University Press, 2014.

Casetti, Francesco. *The Lumiere Galaxy: Seven Key Words for the Cinema to Come*. New York: Columbia University Press, 2015.

Castronovo, Russ. "Beauty Along the Color Line: Lynching, Aesthetics, and *The Crisis*." *PMLA* 121, no. 5 (October 2006): 1443–59.

Cauchi, Mark, and John Caruana, eds. *Immanent Frames: Postsecular Cinema Between Malick and von Trier*. Buffalo: SUNY Press, 2018.

Chandler, James. *An Archaeology of Sympathy: The Sentimental Mode in Literature and Cinema*. Chicago: University of Chicago Press, 2013.

Cheng, Eileen Ka-May. *The Plain and Noble Garb of Truth: Nationalism and Impartiality in American Historical Writing*. Athens: Georgia University Press, 2008.

Chun, Wendy Hui Kyong. "Race and/as Technology; or How to Do Things to Race," *Camera Obscura 70*, 24, 1 (May 2009): 7–35.

Cone, James H. *The Cross and the Lynching Tree*. New York: Orbis Books, 2011.

Cosandey, Roland, André Gaudreault, and Tom Gunning, eds. *An Invention of the Devil? Religion and Early Cinema*. Sainte-Foy, Quebec, Canada: Presses de l'Université Laval, 1992.

Coviello, Peter, and Jared Hickman. "Introduction: After the Postsecular," *American Literature* 86, no. 4 (December 2014): 645–54.

Crary, Jonathan. *Techniques of the Observer: On Vision and Modernity in the Nineteenth Century*. Cambridge, MA: MIT Press, 1990.

Crawley, Ashon. *Blackpentecostal Breath: The Aesthetics of Possibility*. New York: Fordham University Press, 2017.

Curtis, Verna Posever, and Jane Van Nimmen, eds. *F. Holland Day: Selected Texts and Bibliography*. Oxford: Clio Press, 1995.

Daston, Lorraine, and Peter Galison. *Objectivity*. New York: Zone Books, 2005.

Day, F. Holland. "Is Photography an Art?" In *F. Holland Day: Selected Texts and Bibliography*, ed. Verna Posever Curtis and Jane Van Nimmen, 79–80. Oxford: Clio Press, 1995.

Denson, Shane, and Julia Leyda. "Perspectives on Post-Cinema: An Introduction," in *Post-Cinema: Theorizing 21st Century Film*, ed. Shane Denson and Julia Leyda, 1–20. Falmer, UK: REFRAME Books, 2016.

de Vries, Hent. "In Media Res: Global Religion, Public Spheres, and the Task of Contemporary Comparative Religious Studies." In *Religion and Media*, ed. Hent de Vries and Samuel Weber, 3–43. Redwood City, CA: Stanford University Press, 2001.

Dinius, Marcy. "The Long History of the Selfie." *J19: The Journal of Nineteenth-Century Americanists* 3, No. 2 (Fall 2015): 445–51.

Dix, Dorothy. "'The Birth of a Nation' Film Masterwork, Says Dorothy Dix." *New York Journal* (March 8, 1915).

Doane, Mary Ann. *The Emergence of Cinematic Time: Modernity, Contingency,tThe Archive*. Cambridge, MA: Harvard University Press, 2002.

Dorrien, Gary. *The Making of American Liberal Theology: Imagining Progressive Religion, 1805–1900*. Louisville, KY: Westminster John Knox Press, 2001.
Douglas, Ann. *The Feminization of American Culture*. New York: Farrar, Straus, and Giroux, 1977.
Du Bois, W. E. B. "Strivings of the Negro People," *Atlantic Monthly* 80, no. 478 (August 1897), 194–95, 197–98.
———. "Jesus Christ in Georgia." *The Crisis* 3, no. 2 (December 1911): 74.
———. "A Pageant," *The Crisis* 10, no. 5 (September 1915): 230.
———. "The Drama Among Black Folk," *The Crisis* 12, no. 4 (August 1916): 169.
———. "The Gospel According to Mary Brown," *The Crisis* 19, no. 2 (December 1919): 42.
———. "The Gospel According to St. John Chapter 12." *The Crisis* 27, no. 2 (December 1923): 55–56.
———. "The Son of God." *The Crisis* (December 1933): 277.
———. *Dusk of Dawn: An Essay Toward an Autobiography of a Race Concept*. New York: Harcourt, Brace and World, 1940.
———. *Black Reconstruction in America, 1860–1880*. New York: Simon and Schuster, 1999.
———. "The Church and the Negro." In *Du Bois on Religion,* ed. Phil Zuckerman, 99–101. Lanham, MD: Altamira, 2000.
Ebert, Roger. "*The Passion of the Christ*," *Chicago Sun-Times*, February 24, 2004.
Edelstein, David. "Jesus H. Christ," *Slate Magazine*, February 24, 2004. https://www2.kenyon.edu/Depts/Religion/Fac/Adler/Reln101/Gibson-Slate.htm
Eisenstein, Sergei. *Film Form,* trans. Jay Leyda. New York: Meridian, 1957.
———. "Montage of Attractions," trans. Daniel Gerould. *The Drama Review* 18, no. 1 (March 1974): 77–85.
Elsaesser, Thomas. *Early Cinema: Space, Frame, Narrative*. London: British Film Institute, 1990.
Emerson, Ralph Waldo. *Essays and Lectures*. New York: Library of America, 1983.
Ernest, John. "Reading the Romantic Past: William H. Prescott's History of the Conquest of Mexico." *American Literary History* 5, no. 2 (Summer 1993): 231–49.
Everett, Anna. *Returning the Gaze: Genealogies of Black Film Criticism, 1909–1949*. Durham, NC: Duke University Press, 2001.
Eyman, Richard. *Empire of Dreams: The Epic Life of Cecil B. DeMille*. New York: Simon and Schuster, 2010.
Fairbrother, Trevor. *Making a Presence: F. Holland Day in Artistic Photography*. New Haven, CT: Yale University Press, 2012.
Fanning, Patricia. *Through an Uncommon Lens: The Life and Photography of F. Holland Day*. Amherst: University of Massachusetts Press, 2008.
Färber, Helmut. "On the Endings of *The Birth of a Nation* and *Intolerance*," in *The Griffith Project: Volume 12: Essays on D. W. Griffith*, ed. Paolo Cherchi Usai and Cynthia Roswell. London: Palgrave Macmillan, 2003.
Fessenden, Tracy. *Culture and Redemption: Religion, the Secular, and American Literature*. Princeton, NJ: Princeton University Press, 2007.
———. "The Problem of the Postsecular." *American Literary History,* 26, 1 (Spring 2014): 154–67.
Field, Allyson Nadia. *Uplift Cinema: The Emergence of African American Film and the Possibility of Black Modernity*. Durham, NC: Duke University Press, 2015.
Foster, Charles. *Stardust and Shadows: Canadians in Early Hollywood*. Toronto, Canada: Dundurn, 2000.
Fox, Richard Wightman. *Jesus in America: Personal Savior, Cultural Hero, National Obsession*. New York: HarperOne, 2004.
Franchot, Jenny. *Roads to Rome: The Antebellum Protestant Encounter with Catholicism*. Berkeley: University of California Press, 1994.
Fried, Richard M. *The Man Everybody Knew: Bruce Barton and the Making of Modern America*. Chicago: Ivan R. Dee, 2005.
Fusco, Katherine. "Taking Naturalism to the Moving Picture Show: Frank Norris, D. W. Griffith, and Naturalist Editing," *Adaptation* 3, no. 2 (September 1, 2010): 155–78.

Gaines, Jane. *Fire and Desire: Mixed-Race Movies in the Silent Era*. Chicago: University of Chicago Press, 2001.
Galloway, Alexander. *Gaming: Essays on Algorithmic Culture*. Minneapolis: University of Minnesota Press, 2006.
Gatrall, Jefferson J. A. *The Real and the Sacred: Picturing Jesus in Nineteenth-Century Fiction*. Ann Arbor: University of Michigan Press, 2014.
Gaudreault, André, and Philippe Marion. *The End of Cinema? A Medium in Crisis in the Digital Age,* trans. Timothy Barnard. New York: Columbia University Press, 2015.
Gauntier, Gene. "Blazing the Trail." *Woman's Home Companion* 56 (January 1929): 13–19, 142–43.
Goldsby, Jacqueline. *A Spectacular Secret: Lynching in American Life and Literature*. Chicago: University of Chicago Press, 2006.
Gregory, Thomas B. "'Birth of a Nation' True and Wonderful," *New York American* (March 5, 1915).
Griffiths, Alison. "The Revered Gaze: The Medieval Imaginary in Mel Gibson's *Passion of the Christ*," *Cinema Journal* 46, no. 2 (Winter 2007): 3–39.
Gunning, Tom. "In Your Face: Physiognomy, Photography, and the Gnostic Mission of Early Film." *Modernism/modernity* 4, no. 1 (January 1997): 1–29.
———. "An Aesthetic of Astonishment: Early Film and the (In)credulous Spectator." In *Film and Theory,* ed. Robert Stam and Toby Miller, 114–33. New York: Blackwell, 2000.
———. "Now You See It, Now You Don't: The Temporality of the Cinema of Attractions." In *The Silent Cinema Reader,* ed. Lee Grieveson and Peter Kramer. New York: Routledge, 2004.
———. "'The Whole World Within Reach': Travel Images Without Borders," in *Virtual Voyages: Cinema and Travel,* ed. Jeffrey Ruoff. Durham, NC: Duke University Press, 2006.
———. "To Scan a Ghost: The Ontology of Mediated Vision," *Grey Room* 26 (Winter 2007): 94–127.
Guy-Blaché, Alice. *The Memoirs of Alice Guy-Blaché,* ed. Anthony Slide, transl. Roberta and Simone Blaché. New York: Scarecrow Press, 1986.
Hall, Mordaunt. "Cecil B. DeMille's *King of Kings* Is an Impressive Piece of Work," *New York Times*, April 24, 1927.
Hansen, Miriam Bratu. "Early Silent Cinema: Whose Public Sphere?," *New German Critique* 29 (Spring/Summer 1983): 147–84.
———. *Babel and Babylon: Spectatorship in American Silent Film*. Cambridge, MA: Harvard University Press, 1991.
Harde, Roxanne. "'God or Something Like That': Elizabeth Stuart Phelps's Christian Spiritualism." *Women's Writing* 15, no. 3 (December 2008): 348–70.
Harris, Neil. *Humbug: The Art of P. T. Barnum*. Chicago: University of Chicago Press, 1973.
Hartman, Saidiya, and Farah Jasmine Griffin. "Are You as Colored as That Negro? The Politics of Being Seen in Julie Dash's Illusions," *Black American Literature Forum* 25, no. 2 (Summer 1991): 361–72.
Harvey, John. *Photography and Spirit*. London: Reaktion Books, 2007.
Hatch, Nathan O. *The Democratization of American Christianity*. New Haven, CT: Yale University Press, 1989.
Hatheway, Jay. *The Gilded Age Roots of Modern American Homophobia*. New York: Palgrave-McMillan, 2003.
Herzogenrath, Bernd, ed. *The Films of Bill Morrison: Aesthetics of the Archive*. Amsterdam: Amsterdam University Press, 2017.
Hess, Amanda. "The Silent Film Returns—on Social Media," *New York Times* (September 13, 2017).
Hickman, Jared. *Black Prometheus: Race and Radicalism in the Age of Atlantic Slavery*. New York: Oxford University Press, 2017.
Higashi, Sumiko. *Cecil B. DeMille and American Culture: The Silent Era*. Berkeley: University of California Press, 1994.
Hoberman, J. *Film After Film, or What Became of Twenty-First Century Cinema?* New York: Verso Books, 2012.
Holifield, E. Brooks. *Theology in America*. New Haven, CT: Yale University Press, 2003.

Hollywood, Amy. "Kill Jesus." In *Mel Gibson's Bible: Religion, Popular Culture and* The Passion of the Christ. Chicago: University of Chicago Press, 2006.

Hovet, Theodore. *Realism and Spectacle in* Ben-Hur. Ann Arbor: University of Michigan, 2013.

Hu, Jane. "GIF Typologies and the Heritage of the Moving Image," *Hyperallergic* (September 28, 2012). https://hyperallergic.com/57585/gif-typologies-and-the-heritage-of-the-moving-image/

"Impossible Lives of Christ." *New York Times,* January 22, 1898: 49–50.

Jackson, Gregory. *The Word and Its Witness: The Spiritualization of American Realism.* Chicago: University of Chicago Press, 2009.

———. "A Game Theory of Evangelical Fiction." *Critical Inquiry* 39, no. 3 (Spring 2013): 451–85.

Jakobsen, Janet, and Ann Pellegrini. "Times Like These." In *Secularisms,* ed. Janet Jakobsen and Ann Pellegrini. Durham, NC: Duke University Press, 2008.

Johns, Frederick. "'Birth of a Nation' Enthralling Story, 1,500 Guests See History Told on Film." *Boston American*, 10 April 1915.

Johnston, Robert K. *Reel Spirituality: Theology and Film in Dialogue.* New York: Baker, 2006.

Kahn, Jonathon. *Divine Discontent: The Religious Imagination of W. E. B. Du Bois.* New York: Oxford University Press, 2009.

Kahn, Jonathon, and Vincent Lloyd, eds. *Race and Secularism in America.* New York: Columbia University Press, 2016.

Kaplan, Louis. *The Strange Case of William Mumler, Spirit Photographer.* Minneapolis: University of Minnesota Press, 2008.

Keil, Charlie, and Shelley Stamp, eds. *American Cinema's Transitional Era: Audiences, Institutions, Practices.* Berkeley: University of California Press, 2004.

Kelly, Lori Duin. *The Life and Works of Elizabeth Stuart Phelps, Victorian Feminist Writer.* Troy, NY: Whitston, 1983.

Kirschke, Amy Helene. *Art in Crisis: W. E. B. Du Bois and the Struggle for African American Identity and Memory.* Bloomington: Indiana University Press, 2007.

Konczal, Mike. "How Radical Change Occurs," *The Nation*, February 3, 2015.

Kracauer, Siegfried. *Theory of Film: The Redemption of Physical Reality.* Princeton, NJ: Princeton University Press, 1997.

Lears, T. Jackson. *No Place of Grace: Antimodernism and the Transformation of American Culture, 1880–1920.* New York: Pantheon, 1981.

Leja, Michael. *Looking Askance: Skepticism and American Art from Eakins to Duchamp.* Berkeley: University of California Press, 2004.

Lindsay, Vachel. *The Art of the Moving Picture.* New York: Liveright, 1970.

Lindsey, Rachel McBride. *A Communion of Shadows: Religion and Photography in Nineteenth-Century America.* Chapel Hill: University of North Carolina Press, 2017.

Lindvall, Terry. *The Silents of God: Selected Issues and Documents in Silent American Film and Religion, 1908–1925.* Lanham, MD: Scarecrow Press, 2001.

———. *Sanctuary Cinema.* New York: New York University Press, 2011.

Lloyd, Vincent and Jonathon Kahn, eds. *Race and Secularism in America.* New York: Columbia University Press, 2016.

Lord, Daniel. *Played by Ear.* Chicago: Loyola University Press, 1956.

Lott, Eric. *Love and Theft: Blackface Minstrelsy and the American Working Class.* New York: Oxford University Press, 1995.

Lowenstein, Adam. *Shocking Representation: Historical Trauma, National Cinema, and the Modern Horror Film.* New York: Columbia University Press, 2005.

———. *Dreaming of Cinema: Spectatorship, Surrealism, and the Age of Digital Media.* New York: Columbia University Press, 2015.

Lyden, John. *Film as Religion: Myths, Morals, and Rituals.* New York: New York University Press, 2003.

Maciak, Phillip. "Is Beyoncé the Future of Digital Cinema?" *Slate Magazine* (November 24, 2014). http://www.slate.com/blogs/browbeat/2014/11/24/beyonc_s_7_11_video_vs_interstellar_is_this_gif_able_amateur_music_video.html

Maffly-Kipp, Laurie. *Setting Down the Sacred Past*. Cambridge, MA: Harvard University Press, 2010.

Mahmood, Saba. "Secularism, Hermeneutics, and Empire: The Politics of Islamic Reformation." *Public Culture* 18, 2 (2006): 32347.

Manovich, Lev. "What Is Digital Cinema?" http://manovich.net/index.php/projects/what-is-digital-cinema

May, Lary. *Screening Out the Past: The Birth of Mass Culture and the Motion Picture Industry*. Chicago: University of Chicago Press, 1982.

McAlister, Melani. *Epic Encounters: Culture, Media, and U.S. Interests in the Middle East, 1945–2000*. Berkeley: University of California Press, 2001.

McDannell, Colleen. *Material Christianity: Religion and Popular Culture in America*. New Haven, CT: Yale University Press, 1995.

McGarry, Molly. *Ghosts of Futures Past: Spiritualism and the Cultural Politics of Nineteenth-Century America*. Berkeley: University of California Press, 2008.

McKee, Irving. *"Ben-Hur" Wallace: The Life of General Lew Wallace*. Berkeley: University of California Press, 1947.

McMahan, Alison. *Alice Guy-Blaché: Lost Visionary of Cinema*. New York: Bloomsbury Academic, 2003.

Melville, Herman. *Journals*, ed. Howard Horsford with Lynn Worth. Evanston, IL: Northwestern University Press, 1989.

——. *Clarel: A Poem and Pilgrimage in the Holy Land*. Evanston, IL: Northwestern University Press, 2008.

Merritt, Russell. "Dixon, Griffith, and the Southern Legend," *Cinema Journal* 12, no. 1 (Autumn 1972): 26–45.

Meyer, Birgit. "Mediation and Immediacy: Sensational Forms, Semiotic Ideologies and the Question of the Medium." *Social Anthropology* 19, no. 1 (2011): 23–39.

Misek, Richard. *Chromatic Cinema: A History of Screen Color*. London: Wiley-Blackwell, 2010.

Mitchell, Jolyon, and S. Brent Plate, eds. *The Religion and Film Reader*. New York: Routledge, 2007.

Mitchell, W. J. T. *What Do Pictures Want? The Lives and Loves of Images*. Chicago: University of Chicago Press, 2005.

Modern, John Lardas. *Secularism in Antebellum America*. Chicago: University of Chicago Press, 2011.

Morgan, David. *Protestants and Pictures: Religion, Visual Culture, and the Age of American Mass Production*. New York: Oxford University Press, 1999.

Moore, Rachel O. *Savage Theory: Cinema as Modern Magic*. Durham, NC: Duke University Press, 2000.

Moore, R. Laurence. *Selling God: American Religion in the Marketplace of Culture*. New York: Oxford University Press, 1994.

"Mrs. Ward's Story of Christ." *New York Times*, November 13, 1897.

Munsterberg, Hugo. *The Photoplay*. New York: Dover, 1970.

Musser, Charles. "Passions and the Passion Play: Theatre, Film, and Religion in America, 1880–1900," *Film History* 5, no. 4 (December 1993): 419–56.

——. *The Emergence of Cinema*. Berkeley: University of California Press, 1994.

——. *Edison Motion Pictures: An Annotated Filmography, 1890–1900*. Washington, DC: Smithsonian Institution Press, 1997.

Natale, Simone. *Supernatural Entertainments: Victorian Spiritualism and the Rise of Modern Media Culture*. University Park: Pennsylvania State University Press, 2016.

Noll, Mark. *America's God: From Jonathan Edwards to Abraham Lincoln*. Oxford: Oxford University Press, 2002.

Noonan, Peggy. "Mel Gibson's *The Passion* Gets a Thumbs-Up from the Pope," *Wall Street Journal*, December 17, 2003.

Norton, Andrews. *Internal Evidences of the Genuineness of the Gospels*. Boston: Little, Brown, 1855.

Novick, Peter. *That Noble Dream: The "Objectivity Question" and the American Historical Profession.* Cambridge, UK: Cambridge University Press, 1988.
Obenzinger, Hilton. *American Palestine: Melville, Twain, and the Holy Land Mania.* Princeton, NJ: Princeton University Press, 1999.
O'Donaghue, Darragh. "Bill Morrison: *Ghost Trips* and *Just Ancient Loops*," *Cinematheque Annotations on Film*, no. 76 (September 2015). http://sensesofcinema.com/2015/cteq/ghost-trip-just-ancient-loops/.
Ogden, Emily. *Credulity: A Cultural History of U.S. Mesmerism.* Chicago: University of Chicago Press, 2018.
Parker, John William, ed. *Essays and Reviews: The 1860 Text and its Readings.* Charlottesville: University of Virginia Press, 2000.
Patterson, Orlando. *Rituals of Blood: The Consequences of Slavery in Two American Centuries.* New York: Civitas Books, 1999.
Phelps, Elizabeth Stuart. *Chapters from a Life.* Boston: Houghton Mifflin, 1896.
———. *The Story of Jesus Christ: An Interpretation.* New York: Houghton Mifflin, 1897.
———. *Three Spiritualist Novels.* Urbana: University of Illinois Press, 2000.
———. *Selected Tales, Essays, and Poems.* Ed. Elizabeth Duquette and Cheryl Tevlin. Lincoln: University of Nebraska Press, 2014.
Phelps, Elizabeth Stuart, and Herbert D. Ward. *Come Forth!* New York: Houghton Mifflin, 1891.
Plate, S. Brent, ed. *Re-Viewing the Passion: Mel Gibson's Film and Its Critics.* New York: Palgrave-McMillan, 2004.
———. *Religion and Film: Cinema and the Re-Creation of the World.* New York: Wallflower, 2009.
———. *Religion and Film: Cinema and the Re-Creation of the World.* 2nd ed. New York: Columbia University Press, 2017.
Poole, W. Scott. "Confederate Apocalypse: Theology and Violence in the White Reconstruction South," in *Vale of Tears,* ed. Edward Blum and W. Scott Poole. Macon: University of Georgia Press, 2005.
Prescott, William Hickling. *The History of the Conquest of Peru.* Philadelphia: J. B. Lippincott, 1874.
———. *The Conquest of Mexico.* New York: Henry Holt, 1922.
———. *The Papers of William Hickling Prescott,* ed. C. Harvey Gardiner. Urbana: University of Illinois Press, 1964.
———. *History of the Conquest of Peru,* ed. Mary Powlesland Commager. New York: Barnes and Noble, 2004.
Price, Michael. "Imagining Life: The Ending of *Taste of Cherry*," *Senses of Cinema* no. 17 (November 2001).
Prince, Stephen. "Beholding Blood Sacrifice in *The Passion of the Christ*: How Real Is Movie Violence?" *Film Quarterly* 59, no. 4 (Summer 2006): 11–22.
Promey, Sally. "Visible Liberalism: Liberal Protestant Taste Evangelism, 1850 and 1950." In *American Religious Liberalism,* ed. Leigh E. Schmidt and Sally Promey, 7696. Bloomington: Indiana University Press, 2012.
Prothero, Stephen. *American Jesus: How the Son of God Became a National Icon.* New York: Farrar, Straus and Giroux, 2004.
Reckson, Lindsay Vail. *Realist Ecstasy: Religion, Race, and Performance in American Literature* (New York: New York University Press, 2019).
Regier, Willis Goth. *Book of the Sphinx.* Lincoln: University of Nebraska Press, 2004.
Reinhartz, Adele. *Jesus of Hollywood.* New York: Oxford University Press, 2007.
Renan, Ernest. *The Life of Jesus.* New York: Modern Library, 1927.
Robinson, Cedric. *Forgeries of Memory and Meaning: Blacks and the Regimes of Race in American Theater and Film before World War II.* Chapel Hill, NC: University of North Carolina Press, 2007.
Robinson, Edward. *Biblical Researches in the Palestine and the Adjacent Regions: A Journal of Travels in the Years 1838 and 1852.* London: John Murray, 1867.
Rodowick, D.N. *The Virtual Life of Film.* Cambridge, MA, 2007.
Roediger, David. *The Wages of Whiteness.* New York: Verso, 2007.
Rogin, Michael. "The Sword Became a Flashing Vision." In *The Birth of a Nation: D. W. Griffith, Director,* ed. Robert Lang, 250–97. New Brunswick, NJ: Rutgers University Press, 1994.

Rombes, Nicholas. *10/40/70: Constraint as Liberation in the Era of Digital Film Theory*. New York: Zero Books, 2014.
Rosen, Philip. "Securing the Historical: Historiography and Classical Cinema." In *Cinema Histories, Cinema Practices*, ed. Patricia Mellencamp and Philip Rosen. Frederick, MD: University Publications of America, 1984.
———. "Belief in Bazin." In *Opening Bazin: Postwar Film Theory and Its Afterlife*, ed. Dudley Andrew, 107–18. New York: Oxford University Press, 2011.
Scarry, Elaine. *Dreaming by the Book*. Princeton, NJ: Princeton University Press, 2001.
Schnog, Nancy. "The Comfort of My Fancying: Loss and Recuperation in *The Gates Ajar*." *Arizona Quarterly* 49, no. 3 (Autumn 1993): 127–54.
Schrader, Paul. *Transcendental Style in Film*. New York: Da Capo, 1972.
Schwain, Kristin. *Signs of Grace: Religion and American Art in the Gilded Age*. Ithaca, NY: Cornell University Press, 2008.
Schweitzer, Albert. *The Quest of the Historical Jesus*. New York: Dover, 2005.
Scott, A. O. "Neo-Neo-Realism," *New York Times*, March 17, 2009.
Shaviro, Steven. *Post Cinematic Affect*. New York: Zero Books, 2010.
Shepherd, David J. *The Bible on Silent Film: Spectacle, Story and Scripture*. Cambridge, MA: Cambridge University Press, 2013.
———, ed. *The Silents of Jesus in the Cinema (1897–1927)*. New York: Routledge, 2016.
Singer, Ben. *Melodrama and Modernity: Early Sensational Cinema and Its Contexts*. New York: Columbia University Press, 2001.
Smith, Gail K. "From the Seminary to the Parlor: The Popularization of Hermeneutics in *The Gates Ajar*." *Arizona Quarterly* 54, no. 2 (Summer 1998): 99–133.
Smith, Shawn Michelle. *Photography on the Color Line: W. E. B. Du Bois, Race, and Visual Culture*. Durham, NC: Duke University Press, 2004.
———. *At the Edge of Sight: Photography and the Unseen*. Durham, NC: Duke University Press, 2013.
Sobchack, Vivian. *Carnal Thoughts: Embodiment and Moving Image Culture*. Berkeley: University of California Press, 2004.
———. "Embodying Transcendence: On the Literal, the Material, and the Cinematic Sublime," *Material Religion* 4, no. 2 (2008): 194–203.
Solomon, Matthew. *Disappearing Tricks: Silent Film, Houdini, and the New Magic of the Twentieth Century*. Urbana: University of Illinois Press, 2010.
Sontag, Susan. "Spiritual Style in the Films of Robert Bresson," in *Against Interpretation*, 177–96. New York: Picador, 1966.
———. "The Decay of Cinema," *New York Times*, February 26, 1996.
Sorett, Josef. *Spirit in the Dark: A Religious History of Racial Aesthetics*. New York: Oxford University Press, 2016.
"The Spirit of Media." *Critical Inquiry* 42, no. 4 (Summer 2016).
Stead, William T. *If Christ Came to Chicago: A Plea for the Union of All Who Love in the Service of All Who Suffer*. Chicago: Laird and Lee, 1894.
Stephens, John Lloyd. *Incidents of Travel in Egypt, Arabia Petraea, and the Holy Land*. Norman: University of Oklahoma Press, 1970.
Stockton, Kathryn Bond. *The Queer Child, or Growing Sideways in the Twentieth Century*. Durham, NC: Duke University Press, 2009.
Stoddard, John L. *The Passion Play*. Chicago: Belford, Middlebrook, 1897.
Stokes, Melvyn. *D. W. Griffith's The Birth of a Nation: A History of the Most Controversial Film of all Time*. Oxford: Oxford University Press, 2007.
"Story of Jesus Christ." *Phoenix Weekly Herald* 23, no. 47 (November 25, 1897).
"The Story of Jesus Christ." *The Outlook* (December 11, 1897): 915.

Strauven, Wanda, ed. *The Cinema of Attractions Reloaded*. Amsterdam: Amsterdam University Press, 2006.

Sundquist, Eric. *To Wake the Nations: Race in the Making of American Literature*. Cambridge, MA: Harvard University Press, 1993.

Susman, Warren. "History and the American Intellectual: Uses of a Usable Past." In *Locating American Studies*, ed. Lucy Maddox, 17–43. Baltimore, MD: Johns Hopkins University Press, 1999.

Tatum, W. Barnes. *Jesus at the Movies*. 3rd ed.. Farmington, MN: Polebridge Press, 2012.

Taves, Ann. *Fits, Trances, and Visions: Experiencing Religion and Explaining Experience from Wesley to James*. Princeton, NJ: Princeton University Press, 1999.

Taylor, Charles. *A Secular Age*. Cambridge, MA: Belknap Press, 2007.

Tsivian, Yuri. "Talking to Miriam: Soviet Americanitis and the Vernacular Modernism Thesis," *New German Critique* 21, no. 2 (2014): 47–65.

Turvey, Malcolm. *Doubting Vision: Film and the Revelationist Tradition*. Oxford, UK: Oxford University Press, 2008.

VanAntwerpen, Jonathan, Michael Warner, and Craig Calhoun, eds. *Varieties of Secularism in a Secular Age*. Cambridge, MA: Harvard University Press, 2010.

Van de Port, Mattijs. "(Not) Made by the Human Hand: Media Consciousness and Immediacy in the Production of the Real." *Social Anthropology* 19, no. 1 (2011): 74–89.

Wales, George. "MGM Planning Ben-Hur Remake," *Total Film*, January 15, 2013, http://www.imdb.com/news/ni44959587/.

Wall, Cynthia. *The Prose of Things: Transformations of Description in the Eighteenth Century*. Chicago: University of Chicago Press, 2006.

Wallace, Lew. *Autobiography*. New York: Harper and Brothers, 1906.

——. *Ben-Hur: A Tale of the Christ*. New York: Signet, 2003.

Walsh, Richard. *Reading the Gospels in the Dark*. New York: Bloomsbury, 2003.

Weisenfeld, Judith. *Hollywood Be Thy Name: African American Religion in American Film, 1929–1949*. Berkeley: University of California Press, 2007.

Wertheimer, Eric. "Noctography: Representing Race in William Prescott's History of the Conquest of Mexico." *American Literature* 67, no. 2 (June 1995): 303–27.

Whissel, Kristen. *Spectacular Digital Effects: CGI and Contemporary Cinema*. New York: Columbia University Press, 2014.

Wiegman, Robyn. *Object Lessons*. Durham, NC: Duke University Press, 2012.

Wood, Amy Louise. *Lynching and Spectacle: Witnessing Racial Violence in America, 1890–1940*. Chapel Hill: University of North Carolina Press, 2009.

Yacavone, Daniel. *Film Worlds: A Philosophical Aesthetics of Cinema*. New York: Columbia University Press, 2015.

Index

actuality film, 104–5, 189
agency: in postsecular critique, 60; secular, 61
Akerman, Chantal, 195
Albanese, Catherine, 62
American Historical Association (AHA), 146
American Studies: postsecular turn in, 14, 207n29
Andrew, Dudley, 192, 215n92
Armstrong, Louis, 199, 202
Asad, Talal, 11, 19; on secularism, 16

Baker, Courtney R., 171
Baker, Kelly J., 148
Bancroft, George, 33
Barnum, P. T., 206n24, 220n43
Barton, Bruce, 178–79
Baym, Nina, 68, 213n32
Bazin, André, 92–93, 105, 215n92; on cinematic realism, 105, 106, 107, 196; on superimposition, 158; on trick/actuality opposition, 108
Beardsley, Aubrey, 84
Beecher, Henry Ward, 8, 56, 80–81
Bekmambetov, Timur, 2
Ben-Hur: A Tale of the Christ (Wallace), 1, 28–31; afterlives of, 2–4, 24; disappearing Christ of, 53; eyewitness narrative of, 28, 29–31, 42, 44–47, 48–52, 56; film adaptations, 2–4, 3 fig. 1.1, 205n1; Garfield Edition (illustrated), 2, 52–53, 55; historiography of, 28–29, 31, 32, 47, 50, 74; and Holy Land travelogues, 42, 54; as homiletic novel, 47; immediacy of, 49; interactivity of, 29–30, 31, 46–47, 111, 197; Jesus, centrality of, 1; Jesus, descriptions of, 48; as Jesus novel prototype, 43, 209n3; landscape in, 44, 122, 127; mediation in, 81; miracles in, 49–51; narration of, 74; realist aesthetics of, 32; secularism, as training manual for, 54; and secular reasoning, 50, 52; temporality of, 45–46, 47, 49; theatrical adaptations of, 2, 55; and travel narratives, 28, 30–31; the visual in, 30, 44, 52–54. *See also* Wallace, Lew
Ben-Hur films: Bekmambetov (2016), 2; Niblo (1925), 2, 3 fig. 1.1; Olcott (1907), 2; Wyler (1959), 2, 205n1
Birth, The Life, and The Death of Christ, The (Guy film), 99, 112, 114–17, 123–24, 186; images of, 115 fig. 3.2, 116 fig. 3.3; special effects in, 114–17, 126; as "spectacle film," 117; as transitional, 132; visibility/invisibility, structuring role of, 115–17
Birth of a Nation, The (Griffith film), 135, 136 fig. 4.2, 183–84; antiracist fight against, 135; and cinema of attractions, 154, 155–56; cinematic responses to, 221n49; Du Bois opposition to, 139, 159–60; and Dunning School, 149–50, 156; as "historical facsimile," 151–55, 153 fig. 4.3, 154 fig. 4.4, 156; and Jim Crow, 25, 135; Ku Klux Klan in, 135, 156; Lincoln assassination in, 152–55; NAACP response to, 160, 221n49; and narrative integration, 149–50, 152; realism of, 150–51, 156, 202; reviews of, 150–51, 160; and spectacular realism, 151; and spirit photographs, 159; tableaux vivants in, 159; white savior in, 25–26; and white supremacy, 25–26, 135, 141. *See also* Griffith, D. W.
The Birth of a Race, 221n49

Black Christ Cycle (Du Bois), 25–26, 149, 161, 165–75, 221n53; and aesthetic of attractions, 25–26, 137–38, 141, 166, 170; and Dunning School, 138; Harris drawing, 134–37, 136 fig. 4.1, 157, 159; illustrations of, 166, 167, 168 fig. 4.8, 172, 173 fig. 4.9; and Jim Crow, 137–38, 141, 161, 166, 170–71; juxtaposition in, 165, 166, 167–70, 174; lynched Christ in, 135–36, 170–75, 222n64; lynching in, 166–69; and realism, 175; scholarship on, 165, 221n54, 222n64; and spectatorship, 165, 170–74; superimposition in, 165, 172, 175; temporality of, 168–69, 170. *See also* Du Bois, W. E. B.

Bland, Robert Henderson, 98–99, 127, 132, 216n1

Bliss, W. D. P., 9

Blum, Edward, 147, 165, 205n9

Bonney, William (Billy the Kid), 209n5

Bordwell, David, 177

Braude, Ann, 62

Bresson, Robert, 197

Brooks, Van Wyck, 11

Bukatman, Scott, 132

Burch, Noël, 117, 118

Burton, Ernest DeWitt, 9

Caddoo, Cara, 22

Campion, Jane, 198

Caruana, John, 22

Casetti, Francesco, 191

Castronovo, Russ, 165

Cauchi, Mark, 22

Caviezel, Jim, 176, 185, 186

Chandler, James, 219n13

Cheng, Eileen Ka-May, 33

Christianity: democratization of, 14–15; and film, 6; and Jim Crow, 25, 148–49; realist, 10; and white supremacy, 138, 147–49, 172, 175. *See also* Protestant Christianity

Chun, Wendy Hui Kyong, 21

cinema: and belief, 107–8; close-ups in, 215n89; as discourse, 6; and evidential theology, 123; and historiography, 151–52; postsecular, 177–78; and realism, 99, 105, 108, 122–23; as "screen practice," 6; and secularism, 21, 64, 99, 176–78, 190, 201, 202; secularism, as technology of, 99, 176–77, 190; and secularization, 194; and spectacle, 105; trick and actuality in, 6, 23, 99, 104–9, 123, 125–26. *See also* film; narrative integration, cinema of; post-cinema

cinema, early: and double consciousness, 165; religion in, 21; and spectatorship, 131–33; and secularization, 23. *See also* cinema of attractions; early cinema studies

cinema of attractions, 107, 111, 122, 191; aesthetics of, 107, 141–42, 145–46, 176; afterlives of, 132–33, 142, 218n44; and *Birth of a Nation*, 154, 155–56; and double consciousness, 137–38, 140, 145; and Du Bois, 145–46; and Eisenstein, 138, 141–43, 145; and *Passion of the Christ*, 183, 189; and Passion Play films, 132; and spectatorship, 189; and spirit photography, 158; and superimposition, 159

Clarel: A Poem and Pilgrimage in the Holy Land (Melville), 40–42; limits of sight in, 41

classical Hollywood style, 136, 176, 202; postsecular response to, 177; and realism, 177

close-ups: in cinema, 215n89; in Passion Play films, 215n89; in photography, 24–25, 89–90, 93, 95–96, 215n89

Come Forth! (Phelps), 70; sublime portraiture of, 71, 72. *See also* Phelps, Elizabeth Stuart

Cone, James H., 148

Coviello, Peter, 4, 12, 22, 93; postsecular historicism of, 22–23, 198

Crafton, Donald, 132

Crisis, The, 134; Christmas issues of, 161, 162–64 figs. 4.5–7; Du Bois editorship of, 134, 161, 166; lynching photographs in, 166–67; and uplift, 166. *See also* Black Christ Cycle (Du Bois); Du Bois, W. E. B.

Cullen, Countee, 221n53

Darwin, Charles, 69

Day, F. Holland, 24–25, 56–60; aesthetics of, 92; artistic approach to photography, 65; Christ series, 84–97, 85 fig. 2.1, 86 fig. 2.2, 87 fig. 2.3, 96, 196; critical responses to, 215n78; homoerotic desire in, 84, 95; immediacy of, 59; as "looking sideways," 58–59, 65; marginality of, 95–96; as medium for Christ, 59, 65, 91, 94; photos, intimacy of, 87; physiognomy in, 65; pictorialism of, 87–89; research practices, 84; and secularism, 95–97, 177, 198; *Seven Last Words* series, 89–91, 91 fig. 2.4, 94–95, 97; sexuality of, 214n76. *See also Seven Last Words of Christ* (Day photo series)

de Chomón, Segundo, 104, 117

DeMille, Cecil B., 26, 133, 176, 178, 217n29; historical parallel device in, 179; realism of, 202. See also *King of Kings, The* (DeMille film)
Denson, Shane, 191–92
de Vries, Hent, 63
Dinius, Marcy, 89
Dix, Dorothy, 150
Doane, Mary Ann, 130
Dogme 95, 195
DOMITOR, 21–22
double consciousness: and cinema of attractions, 137–38, 140, 145; and early cinema, 165; and film theory, 140–41; as theory of spectatorship, 139–40, 145; as theory of the visual, 138–40. See also Du Bois, W. E. B.
Douglas, Ann, 11, 67, 212n26
Du Bois, W. E. B., 9, 16, 133; and aesthetic of attractions, 145–46; aesthetic politics of, 137–38, 140–41; *Birth of a Nation*, opposition to, 139, 159–60; editorship of *The Crisis*, 134, 161, 166; second sight in, 138–40, 146; and secularism, 177, 198; spectatorship, theory of, 141–42, 145; *The Star of Ethiopia* (pageant), 160–61; superimposition, use of, 165, 170, 172, 175; white supremacy, resistance to, 137, 141. See also Black Christ Cycle (Du Bois), 25–26; double consciousness
Duchenne de Boulogne, 93–94
Dunning, William, 145
Dunning School: and *Birth of a Nation*, 149–50, 156; and Black Christ Cycle, 138; Christianized white supremacy of, 138, 145–47; and Griffith, 160; and Jim Crow, 56, 145–47; and Reconstruction, 155

early cinema studies, 17–18; and historicism, 21; naïve spectator myth, 18–19, 21, 109, 111, and secularization, 22. See also film studies
Ebert, Roger, 185, 224n49
Edison, Thomas, 104, 138, 145
Edison Motion Pictures, 99; Passion Play films of, 99, 108, 110, 197
Eisenstein, Sergei, 133, 166, 175, 202, 219n13; and cinema of attractions, 138, 141–43, 145; on conflict, 143–44; on Griffith, 144; narrative integration, critique of, 143–44
Eliot, George, 7
Elsaesser, Thomas, 176
Emerson, Ralph Waldo, 7–9

Ernest, John, 34
Ershadi, Homayoun, 198–99
evidential theology, 4, 26, 29, 36; and realist cinema, 123
eyewitness narrative: in *Ben-Hur* (novel), 28, 29–31, 42, 44–47, 48–52, 56; gospels as, 29; history as, 29; in Prescott, 29, 35–36, 120

Fairbrother, Trevor, 87, 90
Färber, Helmut, 156
feminist film theory, 139; and spectacle, 132
Fessenden, Tracy, 14, 16, 21, 26; on "non-specific" Protestantism, 57; on Phelps, 69; on the postsecular, 4–5; postsecular historicism of, 22–23, 198
Field, Allyson Nadia, 140
film: belief-function of, 18, 111, 189, 196, 201–2; and Christianity, 6; "death" of, 26, 178, 185, 190, 192, 195–96, 223n33; as medium, 105, 106, 202–3; and modernity, 27; and the postsecular, 5; and realism, 18; and secularization, 5–6. See also cinema
film studies: historicism in, 17–18; and narrative of decline, 190–91; and secularization thesis, 17–18; teleological view of, 17, 20. See also early cinema studies
film theory: and double consciousness, 140–41; feminist, 132, 139; prophetic mode of, 20
Foner, Eric, 147
Fox, Richard Wightman, 7, 165, 205n9
Franchot, Jenny, 10
Friesen, Dwight, 117
From the Manger to the Cross (Olcott film), 98–99, 122, 201; authenticity of, 126–30; and evidentialism, 130; historicity of, 130; images of, 127 fig. 3.10, 128 figs. 3.11–12, 129 figs. 3.13–14, 131 fig. 3.15; location shooting of, 98–99, 126–30; special effects in, 126, 127 fig. 3.10; temporality of, 130; as transitional, 132; as travelogue film, 130
Fuhrmann, Arnika, 23

Gaines, Jane, 139
Galloway, Alexander, 191
Garfield, James, 52
Gates Ajar, The (Phelps), 66–67, 68, 196; and biblical hermeneutics, 66, 212n29; mediumship in, 69. See also Phelps, Elizabeth Stuart
Gates trilogy (Phelps), 70, 213n32, 214n72; critical responses to, 67; mediumship in, 69. See also Phelps, Elizabeth Stuart

Gatrall, Jefferson: on *Ben-Hur* (novel), 48; on *Come Forth!*, 70, 71; on the Jesus novel, 43, 57, 209n3, 214n52; on sublime portraits of Christ, 70, 71–72

Gaudreault, Andre, 17, 21, 191; on Passion Play films, 105, 216n8; on trick/actuality opposition, 108;

Gaumont Film Company, 114, 117

Gauntier, Gene, 98–99, 126, 132

geography, sacred, 28, 36, 102, 122, 130

Gibson, Mel, 26, 133, 176, 195–96. See also *Passion of the Christ* (Gibson film)

Goldsby, Jacqueline, 167

gospels: as eyewitness accounts, 29; historicizing of, 122–25; visualizing of, 123

Gregory, Thomas, 150–51

Griffin, Farah Jasmine, 139

Griffith, D. W., 25, 132, 133, 144, 202; and Dunning School, 160; historiography of, 135, 151–52; and narrative integration, 137, 149–50, 152, 160; superimposition, use of, 170; and white supremacy, 25–26, 135–41. See also *Birth of a Nation, The* (Griffith film)

Gunning, Tom, 17, 18–20, 21; on aesthetic of attractions, 107; on aesthetics of Passion Play films, 110; on cinema of attractions, 111, 122, 132, 133, 138, 141–43, 145; on the close-up, 93, 215n89; on early cinema spectatorship, 131–33; historical formalism of, 23; on superimposition, 159; on travelogue films, 126

Guy, Alice, 99, 104, 112, 114. See also *Birth, The Life, and The Death of Christ, The* (Guy film)

Hall, Mordaunt, 180

Hansen, Miriam Bratu, 17, 20–21, 133, 179

Harde, Roxanne, 68

Harris, Lorenzo: *Crisis* lynching drawing, 134–37, 136 fig. 4.1, 157, 159

Harris, Neil, 94, 206n24

Hartman, Saidiya, 139

Harvey, John, 220n42

Harvey, Paul, 205n9

Hatch, Nathan O., 14

Hays Code, 133, 179

Hickman, Jared, 4, 12, 93; postsecular historicism of, 22–23, 198

historicism: in film studies, 17–18; postsecular, 21–23, 198

historiography, 33; of *Ben-Hur* (novel), 28–29, 31, 32, 47, 50, 74; and cinema, 151–52; of Griffith, 135, 151–52; of Prescott, 31, 42

history: as eyewitness account, 29

Hoberman, J., 185, 195

Hoffman, Eva, 194

Holifield, E. Brooks, 10; on evidential theology, 26

Holy Land disappointment, 24, 31, 37–42, 127

Holy Land travelogues, 33–34, 36, 42, 54, 56; and *Ben-Hur* (novel), 42, 54; Orientalism of, 102

Horitz Passion Play, The (film), 108–9, 111, 123, 130, 180, 202

Hovet, Theodore, 53

Hughes, Langston, 221n53

immediacy, 80–82; of *Ben-Hur*, 49; and Common Sense, 60–61; of Day, 59; and ecstasy, 212n15; and mediation, 64–65; of Phelps, 24, 59, 80–81; of photography, 83–84, 89; and secularism, 58; in theological writing, 59–60; and visibility, 73

Ingersoll, Robert, 42

In His Steps (Sheldon), 179

Intolerance (Griffith), 179

Iranian Revolution, 12

Islamophobia, 12

Iwamura, Jane, 23

Jackson, Gregory, 10, 29–30, 47

Jakobsen, Janet, 11, 12

James, William, 106

Jesus: in *Ben-Hur*, 1, 48, 83; historical appropriations of, 8–9; as historical figure, 4, 7–9, 205n6; and narrative of loss, 3; 19th C. biographies of, 42–43; sublime portraits of, 70–73, 75. See also Black Christ Cycle (Du Bois); gospels; Jesus novels; life of Jesus genre; *and under specific films and books*

Jesus novels, 30–31, 57, 214n52; *Ben-Hur* as prototype of, 43, 209n3; realism of, 43

Jim Crow, 145–49, 160; and *Birth of a Nation*, 25, 135; and Black Christ Cycle, 137–38, 141, 161, 166, 170–71; and Christianity, 25, 148–49; and Dunning School, 145–47; and lynching, 16, 137

Johnson, William Martin, 52

Just Ancient Loops (Morrison film), 193–95, 194 fig. 5.6; and mediation, 193; realism of, 202; and spectatorship, 194

Kahn, Jonathon, 165, 222n64
Kalem Company, 98, 99
Keil, Charles, 122, 132
Kelly, Lori Duin, 212n29
Kiarostami, Abbas, 178, 195, 196–202; postsecularism of, 198
King of Kings, The (DeMille film), 26, 176, 177, 182 figs. 5.1–2; Technicolor, use of, 180–84. See also DeMille, Cecil B.
Kirschke, Amy Helene, 221n54
Klaw and Erlanger, 108
Kracauer, Siegfried, 92, 104
Ku Klux Klan: and *Birth of a Nation*, 135, 156; and Protestant Christianity, 148

Lang, Robert, 156
Larsen, Nella, 221n53
Lears, Jackson, 11
Leyda, Julia, 191–92
Life and Passion of Jesus Christ (Zecca film), 99, 110, 117–22, 123–24, 186; images of, 118 figs. 3.4–5, 119 fig. 3.6, 121 figs. 3.7–8, 124 fig. 3.9; in *Just Ancient Loops*, 193–94; special effects in, 117, 118 figs. 3.4–5, 119, 126; as transitional, 132; the unseen in, 117, 120
Life of Jesus (Renan), 54, 56, 72; landscape in, 31, 43–44, 122
Life of Jesus, Critically Examined, The (Strauss), 7
Life of Jesus, the Christ, The (Beecher), 80–81
life of Jesus genre, 31, 42, 73, 77, 80; mediation, conventions of, 80–82, 83; pictorial life subgenre, 73
Lim, Bliss Cua, 23
Lincoln, Abraham: in *Birth of a Nation*, 152–55
Lindsay, Vachel, 20; primitivism of, 23
Lindvall, Terry, 22
literary studies: and the postsecular, 18
Lord, Daniel, 179
Lowenstein, Adam, 106, 107
Lumière brothers, 18, 99, 104, 105
lynching, 10, 16, 134; of Black Christ, 135–36, 170–75, 222n644; in Black Christ Cycle, 166–75, 222n6; in *The Crisis*, 166–67; Harris drawing, 134–37, 136 fig. 4.1, 157, 159; and Jim Crow, 16, 137; as ritual sacrifice, 147–48; spectacle of, 166, 167; and spectatorship, 170–71; and temporality, 167, 169; and white supremacy, 166–67

Macpherson, Jeanie, 179
Maffly-Kipp, Laurie, 214n52
Maguire, Thomas, 102
Mahmood, Saba, 14, 15
Male and Female (DeMille film), 179
Man Nobody Knows: A Discovery of the Real Jesus, The (Barton), 178–79
Manovich, Lev, 190, 191
Manslaughter (DeMille film), 179
Marion, Philippe, 191
Mathews, Shailer, 9
McAlister, Melani, 36, 37
McGarry, Molly, 15, 21, 26; on phrenology, 96; postsecular historicism of, 22–23; on Spiritualism, 62–63
mediation, 60; in *Ben-Hur*, 81; and immediacy, 64–65; in *Just Ancient Loops*, 193; in life of Jesus genre, 80–82, 83; in Passion Play films, 193; in Phelps, 59, 81; and religion, 63; and Spiritualism, 62
mediumship: in Phelps, 69, 76–78, 80, 82; and Spiritualism, 63
Méliès, George, 104, 105, 112, 114
Melville, Herman: Holy Land disappointment of, 40–42
Merritt, Russell, 155–56
mesmerism, 41
Meyer, Birgit, 23, 64, 96
Mitchell, W. J. T., 64
Modern, John Lardas, 14, 21, 107; on phrenology, 96; postsecular historicism of, 22–23; on secularism, 65, 82, 106–7; on Spiritualism, 62
modernity: and cinema, 20; and film, 27; and Passion Play films, 131; and secularism, 13, 198; and Spiritualism, 63
montage, 144, 219n13
Moore, R. Laurence, 11
Moore, Rachel, 18, 20
Morgan, David, 55
Mormonism, 15
Morrison, Bill, 193
Mumler, William, 22–23, 157, 220n43
Münsterberg, Hugo, 20
Musser, Charles, 17, 21; on Passion Play film, 99; on spectatorship of early cinema, 131–33
Muybridge, Eadweard, 89, 90

NAACP: *Birth of a Nation*, response to, 160, 221n49; See also *Crisis, The*; Du Bois, W. E. B.

naïve spectator myth: and early cinema studies, 18–19, 21, 109, 111. *See also* spectatorship
narrative integration, cinema of, 114, 132–33, 218n44; and *Birth of a Nation*, 149–50, 152; and continuity editing, 142; Eisenstein critique of, 143–44; and Griffith, 137, 160; and racism, 150; and realism, 143–44
Natale, Simone, 220n42
New Wave cinema, 202
Niblo, Fred, 2
9/11 attacks, 12, 185
Noll, Mark, 14
Norton, Andrews, 8, 10
Novick, Peter, 33

Obenzinger, Hilton, 36
Oberammergau Passion Play, 55, 56, 90, 94–95, 96; critical acclaim for, 102; history of, 100; as presecular, 101; spectatorship of, 100–101; Stoddard lectures on, 100–102, 108; tableaux vivants in, 87, 100. *See also* Passion Play films; Passion Plays
objectivity: and photography, 93, 106; and spectacular realism, 16–17; and vision, 206n24
O'Donaghue, Darragh, 193, 195
Olcott, Sidney, 2, 98, 132, 216n1
O'Neill, Joseph, 102
Orlando (Potter film), 228n48

pageants, 160–61
Parkman, Francis, 33
Passion of the Christ (Gibson), 26, 177, 184–89, 187 fig. 5.3, 196, 201, 223n26; CGI in, 176, 186, 187–88, 189; and cinema of attractions, 183, 189; realism of, 184–86, 188, 202; reviews of, 185, 228n49; and secularism, 190; as spectacle, 184, 186–87; spectacular realism of, 186; and spectatorship, 189; special effects in, 186; witnessing in, 184
Passion Play, The (Promio film), 111–12, 113 fig. 3.1
Passion Play, The (Stoddard), 101–2, 103–4; Orientalism of, 102–3. *See also* Stoddard, John L.
Passion Play films, 21, 55, 108–33, 176; aesthetics of, 23, 87, 110; cinema of attractions in, 132; close-ups in, 215n89; as documentary, 105–6, 108–9, 216n8; historicity of, 125–26; location shooting of, 98–99, 123–30, 217n37; and mediation, 193; and modernity, 131; as participatory, 110;
realism of, 25, 96–97, 103, 109–10, 116, 122, 189; reviews of, 109–10; and secularism, 133, 190; as special effects films, 112, 114, 117, 123, 189; and spectacular realism, 112, 122, 123–26, 199; temporality of, 125; and travelogue films, 122
Passion Plays: American Protestant resistance to, 102; and mystery plays, 100; reception of, 99; and secularization, narrative of, 99. *See also* Oberammergau Passion Play; Passion Play films
Pathé, 99, 117; color stenciling process of, 117, 180, 194; Passion Play films of, 217n32
Patterson, Orlando, 147
Pellegrini, Ann, 11, 12
Pettis, Olive G., 214n52
Phelps, Austin, 67
Phelps, Eliakim, 68
Phelps, Elizabeth Stuart, 24–25, 56–60, 212n26; biblical hermeneutics of, 66, 67; *Come Forth!*, 70; feminization of Christ, 58, 214n72; *Gates* trilogy, 59; immediacy of, 24, 59, 80–81; literary portraiture of, 84; as "looking sideways," 58–59, 65; and mediation, 59, 81; as medium, 59, 65, 69, 76–77, 80, 81, 89; on mediumship, 80, 82; physiognomy in, 72; and secularism, 69, 83, 97, 177, 198; and social Gospel movement, 69; and Spiritualism, 67–69, 75, 213n32. *See also* *Gates Ajar, The* (Phelps); *Gates* trilogy (Phelps); *Story of Jesus Christ, The* (Phelps)
photography: and Christ, visualization of, 55; close-ups in, 24–25, 89–90, 93, 95–96, 215n89; immediacy of, 83–84, 89; and objectivity, 93, 106; and physiognomy, 93–94, 215n89; pictorialist movement, 87–89; and realism, 58, 92–93, 123; as scientific performance, 91–92; and secularism, 64; spirit photographs, 62, 157–58, 159, 220n42. *See also* Day, F. Holland; *Seven Last Words of Christ* (Day photo series)
phrenology, 61, 93, 95–96, 101; and liberal theology, 95–96; and misogyny, 61; and racism, 61
physiognomy, 61; and character, 93–94; in Day, 65; in Phelps, 72; and photography, 93–94, 215n89
Pia, Secondo, 55
Pickpocket (Bresson film), 197
Plate, S. Brent, 22, 177, 205n1
Poole, W. Scott, 147
Portrait of a Lady, The (Campion film), 228n48
post-cinema, 178, 223n33; discourse of, 191–92; nova effect of, 191, 192, 195; as postsecular, 192; and spectacular realism, 195–96

postsecular, the: era of, 4–5; and literary studies, 18
postsecular cinema, 22, 26, 177–78, 195
postsecularism: and agency, 60; and American Studies, 14, 207n29; and cinema, 177; as epistemology, 93; and historicism, 22–23, 198; of Kiarostami, 198; as methodology, 93
Potter, Sally, 198
Prescott, William H., 24, 29, 32–33; eyewitness perspective in, 29, 35–36, 120; influence on Wallace, 29, 32, 34–35, 46, 54; landscapes in, 35; as romantic historian, 33–34; romantic historiography of, 31, 42; the visual in, 33–34, 35, 37
Price, Michael, 202
Prince, Stephen, 185, 186, 188
Promio, Alexandre, 111
Protestant Christianity, 59; and Ku Klux Klan, 148; liberal, 69; and scholasticism, 10; as unmarked, 15; and white supremacy, 148–49. *See also* Christianity
Protestantism, American: Catholicization of, 10; Passion Plays, resistance to, 102
Prothero, Stephen, 7, 205n9

racism: and narrative integration, 150; and phrenology, 61; scientific racism, 61, 146, 147–48
rationalism: and mysticism, 10–11
realism: and *Ben-Hur*, 32; and *Birth of a Nation*, 150–51, 156, 202; and Black Christ Cycle, 175; cinematic, 5, 99, 105–8, 122–23; homiletic, 61; of *Just Ancient Loops*, 193 and narrative integration, 143–44; of *Passion of the Christ*, 184–86, 188, 202; of Passion Play films, 25, 96–97, 103, 109–10, 116, 122, 189; and photography, 58, 92–93, 123; and science, 193; and secularism, 141; as soft propaganda, 141; and spectatorship, 177
Reckson, Lindsay Vail, 26
Reconstruction, 145–47; and black enfranchisement, 138; and Dunning School, 155; renarration of, 145
Redrobe, Karen (Beckman), 114
religion: and absence, 4; in early cinema, 21; and mediation, 63; and secularism, 219n25; secularism as, 12
religious pluralism, 13–14
religious studies: and the secular, 207n29

Renan, Ernest, 31, 43–44, 54, 56, 122, 130
Robinson, Cedric J., 156
Robinson, Edward, 36–37; Holy Land disappointment of, 37, 39; sacred geography of, 130; the visual in, 37
Rodowick, D. N., 190, 223n33
Rogin, Michael, 152
Rombes, Nicholas, 195, 196, 197, 224n43
Russian Ark (Sokurov film), 195

Sadoul, Georges, 117
Scarry, Elaine, 6, 30
Schnog, Nancy, 67
Schrader, Paul, 197
Schwain, Kristin, 84, 89–90, 215n89; on *Seven Last Words*, 92; on tableaux vivants, 91
Schweitzer, Albert, 57
scientific racism, 61, 146, 147–48
Scott, A. O., 196
Scottish Common Sense Realism, 10, 60–61, 65; and reasoning, 64
second Great Awakening, 15, 62
secularism, 12–17, 61–65, 82, 106–7; aesthetics of, 57, 106; and agency, 61; and *Ben-Hur*, 50, 52, 54; and cinema, 21, 64, 99, 133, 176–78, 190, 201, 202; cinema as technology of, 99, 176–77, 190; and cinema of narrative integration, 133; *Clarel* as critique of, 41; and Day, 95–97, 177, 198; as democratization of Christianity, 14–15; and Du Bois, 177, 198; and faith, 88; and immediacy, 58; and media, 59; and mediation, 58, 152–53; as medium, 63–64; and modernity, 13, 198; naturalization of, 82; nova effect of, 13–14, 30; and *Passion of the Christ*, 190; and Passion Play films, 133, 190; and Phelps, 69, 83, 97, 177, 198; and photography, 64; and the popular, 5; and race, 15–16; and realism, 141; and reason, 20–21; and religion, 219n25; as religion, 12; and technology, 88
secularization, 19, 130–31; and early cinema, 5, 23, 194; and perceptual vanishing, 3; and white supremacy, 148–49
secularization thesis: critiques of, 107; decline, narrative of, 11, 12–13, 15; demise of, 4–5; and early cinema studies, 22; and film studies, 17–18, 22; and Passion Plays, 99; and progress narrative, 4, 11–12; and subjectivity, 11
secular optimism, 25
selfies, 89

Seven Last Words of Christ (Day photo series), 24–25, 89–91, 91 fig. 2.4, 94–95, 97; as landscapes, 91
Sex, Lies, and Videotape (Soderbergh film), 228n48
Shaviro, Steven, 192
Sheldon, Charles, 9, 179
Shepherd, David, 114
Sherlock Jr. (Keaton film), 126
Shroud of Turin, 55
Shulman, George, 148–49
Singer, Ben, 208n46
Smith, Gail K., 67, 212n29
Smith, Shawn Michelle, 57, 87–88, 92, 215n89; on double consciousness, 139, 140
Sobchack, Vivian, 23, 188; on *Passion of the Christ*, 185; phenomenology of, 103–4, 109, 110; on realism, 123
social change: theories of, 5
Social Gospel movement, 9; and Phelps, 69
social justice: and Social Gospel movement, 9
social realism, 191
social reform movements, 69
Soderbergh, Steven, 198
Sokurov, Alesandr, 195
Solomon, Matthew, 158
Sontag, Susan, 185, 190, 197, 224n43
Sorrett, Josef, 219n25
special effects: in *The Birth, The Life, and The Death of Christ*, 114–17, 12; CGI, 176, 186, 187–88, 189; in *From the Manger to the Cross*, 126, 127 fig. 3.10; in *The Life and Passion of Jesus Christ*, 117, 118 figs. 3.4–5, 119, 126; in *Passion of the Christ*, 176, 186, 187–88, 189
special effects films: Passion Play films as, 112, 114, 117, 123, 189
spectacle: and cinema, 105; and feminist film theory, 132; of lynching, 166, 167; *Passion of the Christ* as, 184, 186–87; and propaganda, 141–42
spectacular realism, 16–17, 208n46; and *Birth of a Nation*, 151; and objectivity, 16–17; of *Passion of the Christ*, 186; and *The Passion Play* (Promio film), 112; of Passion Play films, 112, 122, 123–26, 199; as secular aesthetic, 106, 107–8, 122, 177, 189; unspectacular realism, 195; as unsustainable realism, 158–59
spectatorship: in Black Christ Cycle, 165, 170–74; and double consciousness, 139–40, 145; of early cinema, 131–33; and era of attractions, 189; and

Just Ancient Loops, 194; and lynching, 170–71; of Oberammergau Passion Play, 100–101; and *Passion of the Christ*, 189; and realism, 177; and voyeurism, 132. *See also* naïve spectator myth
spirit mediums, 62
spirit photographs, 62, 157–58, 159, 220n43; and *Birth of a Nation*, 159; and era of attractions, 158; scholarship on, 220n42
Spiritualism, 15; as counterhistory of secularization, 62; emergence of, 61–62; and mediation, 62; and mediumship, 63; and modernity, 63; and Phelps, 67–69, 75, 213n32; scholarship on, 220n42; and superimposition, 157, 159; as superstition, 63
Spiritualist movement, 4
spiritualists, 41
Staiger, Janet, 177
Stanton, Elizabeth Cady, 70, 81, 214n73
Star of Ethiopia, The (Du Bois), 160–61
Stead, William T., 9
Stephens, John Lloyd, 24, 37; Holy Land disappointment of, 38–40
Stieglitz, Alfred, 92, 95
"St. James Infirmary" (Armstrong song), 199, 202
Stockton, Kathryn Bond, 59
Stoddard, John L., 95; Oberammergau slide lectures of, 100–103, 108
Stokes, Melvyn, 155
Story of Jesus Christ, The (Phelps), 24–25, 56–57; Christ, descriptions of, 71–72, 73–74, 213n47; feminization of Christ in, 214n72; immediacy of, 80–81; mediation, conventions of, 81–82, 83; mediumship in, 76–78, 80; point of view of Christ in, 74–76, 78–81, 83, 214n52; reviews of, 70, 73, 77–78, 81, 83, 213n47; scholarly responses to, 214n72; as visual text, 83–84. *See also* Phelps, Elizabeth Stuart
Stowe, Harriet Beecher, 23
Strauss, David Friedrich, 7
subjectivity: and secularization thesis, 11
Sundquist, Eric, 165, 221n54
superimposition: in Black Christ Cycle, 165, 170, 172, 175; and era of attractions, 159; in Griffith, 170; history of, 157–59; scholarship on, 220n42; and Spiritualism, 157, 159
Susman, Warren, 7, 148

tableaux vivants, 91; in *Birth of a Nation*, 154; in Oberammergau Passion Play, 87, 100

Taste of Cherry (Kiarostami film), 198–202, 199 fig. 5.7, 200 figs. 5.8–9, 228nn48–49
Taylor, Charles, 11; on "looking sideways," 13, 19, 58–59; "middle realm" of, 13, 16, 106; on nova effect of secularism, 13–14, 30; on secularism, 12–14, 62; on secularization, 19, 130–31; secular thesis, critique of, 60
Technicolor, 180; in *King of Kings*, 180–84
Ten (Kiarostami film), 198
Ten Commandments, The (DeMille film), 179
10 on Ten (Kiarostami documentary), 196, 197
Terminator 2 (Cameron film), 188, 188 fig. 5.5
theology: progressive, 9; and the visual, 10
Theosophy, 15
Thompson, Kristin, 177
travel narratives: of Holy Land, 33–34, 36, 42, 54, 56, 102
travelogue films, 125–26; *From the Manger to the Cross* as, 130; and Passion Play films, 122
Travels in Egypt, Arabia Petraea, and the Holy Land (Stephens), 38–40, 41, 42; the visual in, 39–40
trick films, 104; double exposure in, 117
Trump, Donald, 16
Twain, Mark, 37–38

Unitarianism, 61
Urban, Thomas, 104

van de Port, Mattijs, 64–65; on immediacy, 82
Vanishing Lady (Méliès film), 114
Vine videos, 191
viral videos, 191
visual, the: in *Ben-Hur*, 30, 44, 52–54; and double consciousness, 138–40; in Phelps, 83–84; in Prescott, 33–34, 35, 37; privileging of, 206n24;

and research, 32–33; in Robinson, 37; and theology, 10; in *Travels in Egypt, Arabia Petraea, and the Holy Land*, 39–40
Von Trier, Lars, 22, 195, 196

Wallace, Lew, 1–2, 28, 209n5; historical narration, theory of, 44–47, 57, 102; Holy Land travelogue of, 56; influence of Prescott on, 29, 32, 34–35, 46, 54; religious skepticism of, 42; research of, 44; sacred geography of, 130. See also *Ben-Hur: A Tale of the Christ* (Wallace)
Ward, Herbert D., 70
Warner, H. B., 176
Weber, Lois, 132
Webster, Daniel, 135, 155
Weisenfeld, Judith, 22
Wertheimer, Eric, 32
white supremacy: and *Birth of a Nation*, 25–26, 135; and Christianity, 138, 147–49, 172, 175; Du Bois resistance to, 137, 141; of Dunning School, 138, 145–47; and historical revisionism, 145–46; and lynching photographs, 166–67; and narrative realism, 150; naturalization of, 144; and secularization, 148–49; secular logic of, 141, 148–49; and slavery, 146; victimology of, 147
Whitman, Walt, 23
Wiegman, Robyn, 147
Wilde, Oscar, 84
Wilson, Woodrow, 150
Woman's Bible, The (Stanton), 70, 81, 82, 214n73
Wood, Amy Louise, 165, 170
Wyler, William, 2

Zecca, Ferdinand, 99, 117

GPSR Authorized Representative: Easy Access System Europe, Mustamäe tee 50, 10621 Tallinn, Estonia, gpsr.requests@easproject.com

www.ingramcontent.com/pod-product-compliance
Lightning Source LLC
Chambersburg PA
CBHW021941290426
44108CB00012B/916